21ST CENTURY MANZANAR

A NOVEL BY PERRY MIYAKE

21ST CENTURY MANZANAR

A NOVEL BY PERRY MIYAKE

REALLY GREAT BOOKS

LOS ANGELES

Library of Congress Control Number: 2001096545
ISBN: 1-893329-14-3
Printed in the United States of America
10 9 8 7 6 5 4 3 2 1

"What Are You Doing the Rest of Your Life?" lyrics by Marilyn and Alan Bergman
©1969 MCA Records Inc.
Reprinted by permission of Warner Bros. Publications

Cover and interior design by Peter Grant
Cover photograph by Peter Grant
Author photograph: Glenn Hamaguchi

The characters and events in this book are fictitious. Any similarity to real persons,
living or dead, is coincidental and not intended by the author.

Requests for such permissions should be directed to:
Really Great Books
P.O. Box 861302
Los Angeles, CA 90086

Visit our web site at www.ReallyGreatBooks.com

For my wife, Jan, who makes everything possible.

PART ONE

EVACUATION, THE SEQUEL

1

When David Takeda walked through the gates at Manzanar, under the barbed wire, past the guard towers with mounted automatic weapons pointed down and directly at him, into the enclosed compound, and saw the tar-paper barracks, the dirt and dust whipping across the dry, barren yard, the city of Asian faces herded together under the American flag, he freaked.

As much as you'd ever see a Buddhahead raised in L.A. freak; which means he sighed, shook his head, looked down at the ground and trudged forward.

And his blood pressure skyrocketed, his heart raced, his throat constricted, his eyes stung and his ribs tightened into a stranglehold around his lungs, all of which you did not see.

It had only been two days since he had put his sister Kate and her kids on a train, in the same Gardena lumberyard his grandparents and his parents had departed from over half a century ago, to take them to first the horse stalls at Santa Anita Racetrack, then the American concentration camps at Rohwer, Tule Lake, Manzanar.

His folks and other Niseis just called it camp.

"We met in camp," they'd say. "We were in camp together."

"Our families lived next to each other in camp," they'd say.

Kids all thought they were talking about summer camp until they got to college and found out their parents' camp fit Webster's definition of a concentration camp.

David kissed Kate and held her tight. Little sister, forty-seven years old, married with kids of her own. He was glad they were a huggy family. Not so Japanese.

"Are you sure you don't want to come with us?" she said.

"Soon as Johnny gets home, we'll take off. By the time we report to Manzanar, Ray should be back with you guys."

Kate's husband Ray had been taken away by the FBI one week before, the day ReVac was announced. After they were satisfied that his import/export business had truly gone belly up, they would transfer him to Manzanar to rejoin his wife and kids. It shouldn't take long.

The train whistle blew.

The American soldiers, wearing helmets bearing an uncomfortable resemblance to Nazi helmets, began herding the evacuees into the cattle cars.

David's eleven-year-old nephew Graham shuffled along to his American-made Discman clone, listening to the number one hit on the Billboard charts, "I Capped a Jap (It's My Patriotic Duty)" by DJ Patriot Missile. Like everything of commercial worth, it was catchy, had high production values and no one really got the message right away.

The boy danced onto the train, no idea where he was going. A great adventure, done to the beat of a very popular song that was, after all, about them. And how often could Americans of Japanese ancestry say that?

"First time this many Buddhaheads been on time for something," David said, looking around at all the people who looked like him, thick, beige luggage tags fastened with wire to their collars.

Buddhahead standard time: either an hour early or a half

hour late.

Kate was always early. He and Johnny were always late.

At first he thought it was a family thing.

When they were growing up, they never saw a movie from the beginning. They never seemed to plan on going to a movie. They all just meandered out of the house any ol' time, tiptoed into the theater in the middle of the main attraction, saw the end, sat through cartoons and previews, then the crappy second feature, then the beginning of the first one, and just when he was starting to remember who was who and figure out what they saw before, his parents would wake up and tell them this is where they came in and they were leaving now.

He began to wonder if other families were like that, or if only Japanese American families were so irritatingly *nonki* and late all the time.

The train whistle blew, softly this time, almost whispering for them to please leave quietly.

There were no TV cameras, no Minicams to be seen.

No footage of American citizens being herded onto cattle cars for future historical re-interpretationists to throw in their faces.

The great lesson of Watergate: Never leave a paper trail.

The lesson of Rodney King: Minimize video opportunities.

David didn't see any old folks, which was good.

Standing by the ramp to the cattle car was one man with a Japanese American Citizens League badge, handing out pamphlets on what internees could expect and how to cope with this situation. The JACL was once again trying to make the best of a bad situation, hoping the President would realize the folly of eliminating law-abiding taxpayers from the economy while they tried to formulate plans to prove, one more time, to their fellow Americans that they were loyal.

Anyone with any money got out of town as soon as ReVac was announced. The smart ones and the rich *kanemochis* had already cashed out and bailed. Any Sansei with parents still alive made

damn sure no Nisei would ever go through internment again. They drove to Canada, flew to Brazil, got outa Dodge.

Only the stupid ones, like David, who still believed it couldn't happen in this country again, remained, muttering "Wait, this is America" as they were rounded up.

Graham, oblivious, face buried in his American-brand-name Nintendo-clone videogame, was the one David was worried about. Gray knew what was up and he dealt by shutting down. David had seen the same pattern in his own generation. Twenty years from now, some natural cause would kill Gray or take his mind, and no one would make the connection.

Kate straightened the tag around Mary's neck, and as the uniforms dropped the flat, plywood shutters over the windows and locked them in place, David caught a glimpse, a look of panic, that passed over her face for a brief moment, the realization that they were completely at the mercy of uncaring, uncontrollable forces.

They had no one to blame but themselves.

Fool me once, shame on you. Fool me twice…

The train pulled out of the lumberyard.

It was only half full.

2

John Takeda always hated being late and if you drive on L.A. freeways, you're always late. He hated being stuck in traffic when he was late for something important, like a deadline, and missing it would mean trouble: government, FBI, police kinda trouble. But he had to pick up his paycheck because after today there wouldn't be an address to mail it to. Coming back, Washington, Venice, Olympic Boulevards were jammed, so he got on the Santa Monica Freeway west on the Fairfax onramp rebuilt after the '94 Northridge quake. Sitting on the overpass to the 405 South, inching along fifty feet in the air, waiting to get swallowed up by the throbbing, exhaling parking lot stretched out below him for miles, ocean view obscured by the brown haze, he yearned for the good ol' days when the freeway had liquified into a stream of automobiles moving en masse at sixty-five miles per hour, three feet apart from bumper to bumper, a.k.a. smoothly flowing traffic.

He checked his fuel gauge. Three quarters full, more than enough for his best friend Greg. Greg Wiley, who had always loved this car, would take care of it for John after reluctantly driving him to Manzanar, which he morally opposed, where his friends, the Takeda's, had been ordered to report tomorrow.

John checked his watch and the sinking sun. It wasn't safe for

any Asian to ride alone after dark, especially in a primo short like this 1960 Chevy Impala.

"You Korean?"

Those were the first words out of his students' mouths his first day at Foshay Middle School and he knew the implication. He told them, think of the Korean merchant's pugnacious abruptness as similar to Greeks or Italians. Nothing personal.

Maybe it had something to do with the fact that they'd been historically trampled by everyone from the U.S., China, Japan, Russia, all the way back to Genghis Khan. Or that an average of four Korean merchants had been killed every month since the late '80s, and that never made the news on TV.

Or maybe it was the garlic.

But there was a reason someone gets off the boat from Korea and opens a store in South Central, and it wasn't because they had much choice.

When the order came down and he had to say goodbye to his students, he tried to tell them he still believed in what they had learned from each other: that he was still Mr. Tuh-KAY-duh and they were still Kalina and Jose and LaShawn and Phan, individuals, classmates and friends forever. Never forget that they shared this and they knew each other. That in spite of our government, it would always be up to them to make this country work. He thought he did get most of that across, through the tears, trying to set a strong example for the young hearts openly weeping in front of him for the last time.

The sun was sinking into the thick layer of haze on the horizon. It would be dark soon and this idiot in front of him was more concerned with her cell phone and makeup than the traffic leaving her behind.

"Hey, you wanna close that quarter-mile cushion in front of you?" He tapped on the wheel.

She looked coolly at him in her rearview mirror then wiped lipstick off the corner of her snarling mouth.

The grill of a GM pickup filled his rear window.

John looked into his rearview mirror and caught a glimpse of his own face. After hearing his own voice speaking English, no accent, just a slangy, slurry Venice drawl, he felt disconnected from those slanted eyes. He often felt so American that seeing himself in a mirror was disorienting.

His eyes stared back at him unforgivingly, accusing him of betraying them again. He spoke only English, understood only English and, as a native Californian, a smattering of Spanish. The television he watched was all in English. Except for Kurosawa and Truffaut, his favorite movies were in English. His favorite music, jazz and rock, was American. He read and wrote in English. He thought in English.

When he heard the blonde in front of him pull her emergency brake tight and saw the doors of the pickup truck behind him open, he knew his face had given him away. His round, yellow face with his small, flat nose and round nostrils, his thick, jet-black hair, and those eyes.

Small, slanted, foreign eyes.

His doors were locked; they always were these days.

The men had baseball bats.

He didn't have a gun. If he did, he might have had a chance. But he wouldn't have liked what having a gun would have done to his vibe by then.

He got out of the car.

"Wait a minute, guys," he didn't plead. "You already won, I'm reporting to camp now…"

They weren't the middle schoolers he'd had a chance to talk to and teach over the course of a semester. They were older, long-lost twentysomethings, longtime unemployed, hard-core loser

written all over them. Dumbfuck patriots who attacked anyone dark brown or wearing anything but a hat on their head because they had to kick some Ay-rab ass.

The bass amp boomed out of their good, solid American car. They were the typical audience that was still listening to rap. Uneducated, tattooed, nicotined whites who talked blacker-than-black, or thought they did.

"Yo, Jap, yuh took mah jahhhb."

It sounded like the number one song on the pop charts.

He could smell the liquor and knew the Vincent Chin rule would apply: barroom argument that got out of hand. A traffic dispute that escalated. Frustrated, unemployed Americans taking out their pent-up, booze-fed anger on an apparent Japanese.

Perfectly understandable. If the alleged perpetrators were ever caught, which was doubtful, and prosecuted, even more doubtful, and here's the topper, convicted, the American justice system would come down on them hard: A massive fine, totaling hundreds of dollars, could possibly be levied. And possibly months of probation, too.

John knew where these guys were coming from, the hopelessness they faced, the overwhelming odds against any of them ever finding a secure job and a home for their family, their anger and frustration at being passed over while others around them prospered, and you know what?

He didn't give a shit.

"Go learn to read, fuckhead—" Johnny enunciated clearly.

The first blow he deflected slightly with his palm. Then they were on him like hyenas, raining blows on him.

He fell slowly under the barrage to his knees.

Steel-toed boots lacerated his shins and groin and, when he crumpled over, punctured his kidneys and crushed his ribs.

The cars began creeping along again, now that the blonde had put away her lipstick and closed the gap ahead of her.

The number four lane filled in behind her, charging ahead at

twelve miles per hour, the drivers talking distractedly on their cell phones, staring blankly into the distance, safe in their SUVs.

John felt himself being dragged up into a sitting position and saw the white arms in the black T-shirt rear back for a home run swing.

T-shirt was gonna play T-ball with his head.

The pain would pass. The sound, a high-pitched hum filling his brain, would not. He tried to push it out by thinking of his ex-wife and his daughter Nikki. Thank God they were out of this murderous country.

Johnny felt himself being propped up again.

He heard laughter.

He thought of his students, his brother waiting for him.

He cracked open an eye and saw another bat coming in a blur. It was aluminum, which meant it was Japanese-made and the thought flittered across his mind, "These morons aren't using a Louisville slugger?"

He caught a glimpse of dark, red gel flying across the ground in front of him just before his face landed in it.

Filthy hands smelling of gas and tobacco reached for him.

A car full of teenagers boomed by, cruising, leaning out the windows, whooping and woofing and cranking their fists, laughing into their cell phones.

The sound of the bass boomed in his head, pushing out the sound of his wheezing breath.

They propped him up again.

He couldn't see too good.

He couldn't hear his breath.

He wished he could see a friendly face just one more time.

He didn't feel the last blow.

He flopped over onto the ground and lay there.

The men didn't run away.

Americans didn't need to hurry.

The patriots sauntered back to their proud, American, manly

real-man truck. They tossed the blood-splattered baseball bats into the back, popped open another beer, cracked a joke about a good workout, and they all laughed heartily.

They were going to take the car, but one of them had already set it on fire, so they said fuck it and took off.

The traffic behind followed, veering slightly to avoid the obstruction.

There is a concept called *enryo*. Very much a part of Japanese culture. Holding back, sometimes to the point of ridiculousness. It can be thought of as politeness or a stupid, unnecessary gesture of self-sacrifice.

John thought he should try to get out of the traffic lane. It would cause congestion if he died there. He tried to see if his car was all right, so Greg wouldn't have to do too much to repair it. He hoped his brother Dave wouldn't worry too much when it got dark and that his death wouldn't be too much of an inconvenience for him.

As he lay on the freeway, he saw one of the SUVs passing by, all its passengers on their own cell phones.

But there was one not averting her eyes.

She had a genuine look of concern, long-buried compassion threatening to break through layers of callous indifference and all thought of personal safety.

She looked as though she were almost prepared to tell the driver to stop and give aid.

Then John Takeda exercised his final act of *enryo*.

"That's okay," he thought he said aloud. "Don't stop and waste your time and perfectly good medical supplies on me. Save it for someone who might live."

But the words only gurgled in his throat and the SUV had already moved on.

The chill gripped his heart.

He didn't fight it.

He let it go.

He let the love slip from his body.

Then he shivered once, horribly and completely, and died.

As Johnny Takeda lay there on the ground in the slow lane of the 405 South in the quickly spreading pool of his warm, gushing blood, he thought he felt himself rise.

Get up, stand up, look at the mess he was.

He thought he felt himself floating upward, over the gulping, sucking parking lot of a freeway.

He thought he had time to do all the things he always wanted to do.

He thought he felt someone missing him.

Then he blinked and he was gone.

3

As David pulled his battered, old, politically correct American-made Chevy minivan west on Gardena Boulevard, he caught a glimpse of the beacon on top of the old Gardena theater. During the summer his mom had gotten sick, he and John and Kate had spent the summer with their cousins, Teri and Doreen, and one Saturday night badgered poor, unsuspecting Uncle Mas into taking all of them to see *A Hard Day's Night*.

Uncle Mas didn't know what hit him, here in his favorite old local theater surrounded by screaming, hysterical eleven-year-old girls. Not his girls, of course, who were craning their necks in amazement, their boy cousins slumped down in their seats shaking their heads, as a new shriek erupted with each close-up of Paul or Ringo. Not so much for John or George, this being a pre-pubescent, suburban kind of Paul or Ringo crowd.

"Jesus Ker-rist, never again, goddammit!" Uncle Mas roared as he stomped back to his reliable Ford. His girls and their cousins followed behind, amazed and trying not to laugh as they digested their first lesson among many on exactly how to piss off the grown-ups.

David took side streets out of Gardena—once the largest Japanese American community in the U.S., a ghost town now—still enough daylight so he wouldn't be driving too close to the air-

port, a federal offense for Japanese since ReVac.

He was in no hurry because he knew his brother John was on Buddhahead standard time. Late. Late for his wedding, for his divorce proceedings, for the birth of his daughter.

He drove past the billboards, stills from the commercials running on TV, only without the music swelling patriotically in the background.

"We're starting all over again, America."

"Look out, America's back and it's not Japanese."

And your basic, "Buy American, Screw Japan."

Beautiful photography, bold message in bold lettering, faces of all colors marching together, dissolving into one another. Very "United We Stand," slightly tweaked.

Americans of all colors. White, black, brown, occasionally red, and yellow if they didn't look Japanese.

Reaching a pinnacle, working together, making a difference, all people of almost all races, bringing tears to your eyes as you vow to…buy something with an American name on it, or borrow money from a bank with a real American name. So what if it's owned by the British or Dutch or Italians? Their accents are better than those gummy, toothy Japanese.

ReVac was no surprise. Executive Order 9066 revisited.

World War III became the Economic War with Japan. If the economy went down the toilet, the terrorists would have won.

If World War II was the battle to save Western Civilization from the Nazi party and the Japanese race, World War III—the Economic War became the ultimate battle to save the very soul of America: its pocketbook.

Unlike September 11, this enemy was immediately identifiable; the same economic foe, the same arch-enemy of the United States since December 7, 1941—Japan.

Restrictions became sanctions and eventually became a total ban of all Japanese products, which only made things worse.

Unemployment rose above thirty percent.

The President needed a dramatic revelation to push the concept of World War III—the Economic War into the hyperspace of public support.

Like FDR, he needed his Pearl Harbor.

It came in the form of a two-pronged rumor:

One, that the AIDS virus had originally been developed by Japanese scientists during World War II atrocity experiments conducted on captured civilians and Allied POWs. This accusation, although contrary to the conspiracy theories linking AIDS as a man-made tool of the Reagan-Bush right-wing anti-sex era, became a staple of the Internet, TV tabloid shows, radio talk shows and the other popular vehicles responsible for the mass dissemination of information. It divided liberals better than the O.J. trial.

And two, that the source of modern bioterrorist weapons being used against the American people could be traced to these same World War II Japanese atrocity experiments.

The war was on.

All Japanese businesses were expelled, investments confiscated. Japanese citizens who hadn't already left were deported.

Unemployment went up past forty percent.

It was a well-greased ugly slide as slanty-eyed, bucktoothed accent jokes started showing up regularly on network TV shows, unprotested, then familiar and accepted as humor. From there it was a natural regression from ridicule to dehumanization to blame, a small step from "Buy American" to "Blame the Japanese" to "Kill the Japs." As the economy sank like a stone, America got ugged out by anything Japanese and finally scrapped the last vestige of constitutional sanctuary against anything vaguely Japanese, and if anything was vaguely Japanese, it was a Japanese American.

Given the historical inability of mainstream America to distinguish an American of Japanese ancestry from a foreign Japanese national, David knew they were next.

The President signed Executive Order 9066-A, instructing persons of Japanese ancestry to sacrifice their jobs to real Americans by leaving the country, or be subject to Re-Evacuation, New and Improved.

The JACL filed suit in court to get a pre-emptive stay against ReVac but all their civil liberties lawyers, ex-judges, ex-Senators, ex-Representatives, ex-mayors, and ex-Cabinet members couldn't stop a presidential order in time of war. The wheels were already turning.

David was glad all his aunts and uncles and his Mom and Dad and any Nisei born and raised in America and gone through it once weren't here the second time around. Uncle Mas caught some shrapnel in France and limped for the rest of his life until the shrapnel ate away his intestines and, fifty years later, killed him. Purple Heart, Silver Star, went to all the 442ND reunions and VFW functions. David was glad Uncle Mas didn't see the official notice, this time billboard high and glo-lit, that David and his generation had only seen in uncensored history books:

INSTRUCTIONS
TO ALL PERSONS OF
JAPANESE
ANCESTRY

4

The remains of a giant paper fish from an old Boys' Day celebration hung in shreds of blue, orange and white from the upturned corner of the roof of the Venice Hongwanji Buddhist Temple at the corner of Centinela and Braddock. David slowed for the light, eyes on the crushed glass and flickering shadows of the looted building.

The colors, the paper, reminded him of something, when he was young. A paper packet, dropped into a glass bowl filled with water, blossomed like brilliantly colored seaweed with blue, white, orange leaves flowing out like fingers extending upward. He hadn't seen it in years. It was the type of children's trinket made in post-World War II Japan, the disposable kind of toy when "Made In Japan" meant cheap, poorly made—and not a threat to American jobs.

A low rider pulled alongside him at the signal.

He felt the stare of four pairs of brown eyes.

He turned slowly and looked at them, hoping his shades were dark enough to obscure his Japanese eyes.

A glint of metal shone briefly in the rear window.

He turned slowly and stared straight ahead, easy, his long, straight hair, black peppered with gray, draped down his shoul-

ders, partially obscuring his view, like a shield.

Gangs had been almost nonexistent when David was growing up in the '60s. There were Bloods and Crips inland, but back then, out here, it was still safe to say to a brother, "Hey, blood, 'sappenin?" without getting killed.

David didn't wait and turned left against the red onto Braddock.

The low rider turned east and headed back to the projects, Mar Vista Gardens.

As he cruised by, David peered into what was left of the Venice Japanese Community Center.

His Dad and other families had lived in tents on the dirt parking lot of the center when they first came back home after World War II, until they found a place to live. When David was growing up, it was a dirt lot with wooden buildings, the judo *dojo* and Saturday *nihongakko*, Japanese school. It was also the site of the carnival: *Obon* festival, traditionally a celebration of the dead, a welcome back to ancestors who've passed on.

Before the Venice Hongwanji Buddhist Church's *obon* in July, before the West L.A. folks had theirs, or Gardena or Crenshaw or the Valley, all before Nisei Week in J-Town in August, the Venice community carnival was the first of the summer. It usually coincided with the end of the school semester, so it became a beginning-of-summer festival, which was fitting for Venice.

Now it was another FJO, Formerly Japanese Owned property.

Shadows moved in the skeletons of the buildings.

The outer wall of the community center was still strung with barbed wire.

As David pulled into his driveway, he could hear barking from inside the house. With all the power outages and rolling blackouts making electricity unreliable, a big, loud dog was still the best alarm system.

"Hey, Tooz," he said as he squeezed in the door.

Tuesday was a ninety-pound black Labrador/greyhound mix who, when awake, careened everywhere, sweeping whole tables

clean with her bullwhip tail. She was the friendliest oversized lap dog, with eyes that said, "Not much happenin' here" and a smile that said, "Hyuk, hyuk, hyuk," and when aware of intruders did a fine impression of a rabid beast.

"Vic?" he yelled, then assumed their roommate, Victoria Rodriguez, was out getting arrested for protesting against anything anywhere.

David sat down next to Tooz and channel-surfed past familiar faces, whom he knew by first name. He treaded briefly over an action-detective-comedy series starring the hot new couple, coming to the aid of ordinary everyday down-but-not-out Americans battling petty criminals who in their own way were also victims of the faceless, nameless, corporate-mafia, unfair-trade-practicing dirty Japanese threatening to destroy our American way of life.

Like clockwork, with seven minutes to go, hero and heroine would come to the rescue in the nick of time, violently, with much justification and quick, witty, sexy banter, to defeat the slimy CEO of Tojo International.

Seen it. He surfed on.

David was having trouble moving. Not just relocating but actually moving from the couch. A beer and the remote and he'd be tempted to wait for the FBI to come knocking tomorrow.

David had forty-three first cousins, most of them in L.A. He wondered if any of them had had any trouble getting out of their chairs when their time came.

A deep growl vibrated through Tuesday's rib cage.

A large dark shadow filled the front porch.

A big black man. Not muscular but tall. Head shaved, goatee, shades. Trouble.

David reached slowly past Tuesday and picked up the baseball bat leaning against the end of the couch.

"Yo, Johnny T, 'sup?" The brother's voice was softer than his look, almost gentle.

David walked up to the screen. "Greg?"

"David!" Greg Wiley, Johnny's bud, beamed. " 'Sup?"

David opened the door and before he could say anything, Greg wrapped him in a bear hug and kissed him on the cheek. Tuesday worked Greg's knees over with her face and tail.

David wasn't raised in a real huggy-touchy-feely family. He didn't think any Japanese families were really huggy at all until the late '80s. But Greg and John had been friends since junior high and were always hanging around the house, staying in touch through college and after. Real Venice homeys. So by simply being there, David also became Greg's friend. Friends enough to hug and kiss upon greeting.

Plus, they both had the Venice mumble.

David had been with Jenny, very Orange County Caucasian Jenny, for about a year when she finally said, "You and your friends…" Her arms began to flail futilely. "How the hell do you understand each other? I sit there listening to you all talk and you say, *yummmbuzzzbuzzz*, and Mike says, *yeahmummmmmummm*, and you all laugh and Craig goes, *heberrommmrommm* and you all laugh and I can't understand a thing you're saying."

"Maybe it's a Buddhahead thing."

"No, I called John's place the other day and Greg was there and I swear I thought it was John, or you, or Bobby and he's white or Danny and he's Chicano. Then one day I called your folks' place and your dad answered and I thought it was you, but your mom doesn't talk like that, so I finally narrowed it down. You were all born and raised in Venice. It's a Venice thing."

The Venice mumble, gentle, like Ray Brown on bass, cruising along, a rhythm.

A rhythm, like Nisei rhythm. Not an accent.

That's why he loved Jenny. She knew the difference.

Too bad he screwed up the relationship.

The newscaster was a young, beautiful, generically ethnic anchorwoman, seated to the left of the graying, aging, male Caucasian senior anchorman with a face we all trust. The logo

behind her ear read "Re-Evacuation."

"…Thank you, Jim. Just a reminder to all you persons of Japanese ancestry," she said perkily, "tomorrow's the final dead-line to report to your designated relocation checkpoint!"

On her lapel she wore a slew of ribbons, little bows of color crammed from her earpiece to her first button buttoned. The compulsory red, white and blue loop for victims of the first attack, a red bow for AIDS victims, green for the near-extinct rainforest, pink for breast cancer, black for victims of the latest urban riot, powder blue for the victims of the most recent terrorist bombing, royal blue for victims of some natural disaster somewhere, purple, orange, magenta, mauve, aquamarine, all for victims of some sup-posedly unpreventable tragedy. Buried underneath this bouquet, barely visible on the screen above the corner window shot of the daily ongoing car chase, was her forgotten first ribbon, for some forgotten little incident, a sickly yellow, resembling something filled with pus.

"And remember," she said cheerily, "you still have the option of returning to Japan, flying first-class at the government's expense," she then frowned to convey seriousness, "which is a continuing controversy in Congress…"

"White folks," Greg shook his head at the TV, "what will they think of next? Johnny tell you, he's giving me his car?"

"You got a license?"

"Sure, somewhere. I think it's at my mom's."

"Isn't it kinda…expired?"

"Won't need no license in France."

"I was gonna give my van to Rodney Knifewing, you know, on the rez in Arizona."

David rubbed the silver feather mounted on a lapis bead on the leather cord around his neck. Jenny wore a matching one. At least she did before she moved to Houston, or was it Atlanta? This piece of jewelry that Rodney'd made for them was the only thing of value he had left.

"But if you're driving us in Johnny's car I could leave the van here with Vic…"

"Yeah, I'll leave Johnny's car with Rodney. It'll be safe there. It's a classic," Greg said. "1960 Chevy Impala, with fine speckled green paint job, tuck-'n'-roll interior—" Greg stopped when David stood up and stared at the TV, at the old American car charred black at the edges. Behind the field reporter, two men in white were loading a body bag into an ambulance.

The singed remains of the small American flag on a stand hooked to the left rear passenger window of the Chevy flapped once and didn't move.

David saw the license plate holder on the rear of the Chevy, a bright yellow plastic frame with bold purple lettering, "Los Angeles Lakers, NBA Champions 1984-85," the first year the Lakers had finally beaten the Celtics. The year John and Cindy's daughter, Nikki, had been born.

"…alleged victim, whom the coroner's office described as a probable Japanese…"

David muted the sound as the tow truck moved slowly down the shoulder behind the ambulance, lights flashing.

David said, clearing his throat, "Hey, man, there goes your car." A lame joke to keep his chest from imploding.

Greg sat there on the couch, rocking and holding Tuesday.

"Oh man, oh man, oh man."

Behind the gesturing reporter, on the Venice Boulevard exit in the distance, the ambulance's flashing rear lights turned off.

David knew his brother was dead.

5

It didn't help that Greg was huddled against the door sniffling the whole time. It didn't help that the police directed him to a hospital which directed him to County Administration which directed him to another hospital which directed him to the morgue which directed him back to County which gave him forms to fill and take back to the morgue where he was directed to three different windows on three different floors. Any inclination, any need to express how very sad he felt, was thoroughly crushed by the bureaucratic process. But he was used to the numbness.

It had started with his grandmother's death at age 101 in 1984. That was the first time David wrote a eulogy. She was a woman who'd come to the United States in 1905 with her husband, a cavalry officer who'd been decorated in the Russo-Japanese war and had seen the future of Japan. Militarists seemed to be the only ones who could cope with Japan's isolation shattered by the U.S. warships at Kanagawa. Because of U.S. immigration restrictions on Chinese and Japanese, David's Obachan had to leave her oldest daughter in Japan to be raised by her sister in Hiroshima. David wrote a very nice eulogy for her. Then other members of the family began dying, mostly aunts and uncles, Niseis in their eighties, and he did their eulogies.

But then his cousins started dying. Some before their parents. Accidents, drug overdoses, brain aneurysms, strokes, heart attacks. They said at first that maybe Sanseis weren't as strong as Isseis or Niseis, the first or second generations who went through so much. That maybe boomers as a whole were weaker than the Depression-World War II-era generation.

Whatever the reason, by the end of the twentieth century David was delivering a lot of eulogies for people he grew up with. It was difficult at first, being so close to the subjects, but as his reputation grew, strangers began coming to him. Not complete strangers, being from the community. The parents of a kid he went to junior high with or the cousin of a guy he played Bee football at Venice with or a friend of a friend who had no family left alive to mourn him.

At first they returned his *koden*, usually a crisp twenty tucked inside a sympathy card, his offering and donation to the family to help defray the cost of the funeral. The father would press it into his hands, the mother with tears in her eyes, grateful to have their son remembered in such a fine way. David would insist they keep it, that it was his pleasure to do this small favor for a friend of the family.

After he lost his very last job at the record store down in Venice near the boardwalk, when his *koden* was pressed back into his hand, he kept it. Then when they insisted on giving him a small donation for such a good job and they knew he would take it if it was phrased right, he kept that, too. So as the death rate and the word spread out of Venice to West L.A., Crenshaw, Gardena, past J-Town and out to Montebello, he made a living giving eulogies. He was booked solid.

One of the last articles run in the *Rafu Shimpo* before it was burned to the ground detailed the high rate of premature death among Sanseis, the "natural" causes outnumbering accidents, suicides and murder.

Three months later, *Newsweek* ran a sidebar to the trade war,

"Suicide among the Japanese in America: Carrying on an ancient tradition?"

David looked away from John's shattered skull. He lifted the sheet for a glance at the center of John's chest just to make sure, but he knew it was his brother. He spoke to the assistant coroner, A. BENIGNO his nametag read. Quiet, difficult jobs like autopsies and accounting would always be the realm of silent, young brown men in white shirts and dark brown ties.

"Can you cremate the remains tonight?" he asked, knowing they could. With the massive rise in sudden deaths throughout the city, disposing of remains had grown to resemble a fast-food franchise. "A friend of mine, Randy Ota, used to work here. He said you could handle it."

"Sure," he said, solemnly pocketing the twenty David had slipped him, "for a friend of Randy's, sure."

Greg collapsed onto the cracked plastic chair in what passed for a lunchroom at a county morgue. Coffee machine, out of order. Candy machine, empty except for a row of packets of peanuts that were looking a little powdery and a Snickers bar feeding a stream of ants. Soda machines out of everything except GRAPE SODA. No brand, probably something subgeneric. David fed a couple dollar bills into the slot and they both took. He always kept his dollar bills in good shape for these machines. Two bucks wasn't bad for something cold that you didn't have to risk your life going out for. He popped the soda open and shoved it under Greg's nose.

Greg took a long slug, then grimaced.

"'All-American Grape'?" he examined the label. "Can't sell this shit to Arabs in the middle of the desert."

David took a sip. It was cold and fizzy and medicinal and probably purple. That was about all you say about All-American Grape

soda. That and it wasn't Japanese.

David hated shutting down, hated swallowing the screams and storing them down in his lower intestines where he'd eventually forget about it. He hated always doing the manly, Japanese thing, but there were things that had to be done. There always were. His whole damn life.

This was no time for weakness and this country was not the place. A sign of weakness in men like them and the little corner of this country they had eked out for themselves just by surviving would be taken quickly and with little afterthought. Just another dark man with no dignity.

Shut down, so they can't see.

Those who couldn't see called it inscrutable.

When the bad times came and the vultures started circling, there wasn't time to mourn lost lifetimes of work.

Not until after they had discarded all they had labored their honest lives for and placed their few valuables in the hands of loyal friends, after they had gathered their family in less hostile territory and found a small place of solitude and a brief moment of silence—maybe then they cried.

David couldn't grieve personally for every dead person he'd ever known. He couldn't. There were too many now. He'd do what he usually did, compose a eulogy.

But this time, for his brother John, David couldn't mourn or pay tribute. It scared him. There still was too much business to take care of. But he wasn't taking care of business. He was just sitting there waiting for ashes to be delivered. There were no funeral plans to be made. No family to call. Johnny's ex and his daughter were somewhere in Canada. Maybe in a year they'd know where the rest of their family had scattered around the planet.

For now, all David could do was sit there next to Greg, holding a can of rancid grape soda, with his head uselessly floating three feet above his body.

6

Kate had seen pictures of the camps before. She had talked to her parents about them. They were very outgoing for Nisei and told her stories about how young they were and how they didn't really know what was happening and had just tried to make the best of the situation.

How all of Kate's uncles had joined the 442ND and the two oldest had won Purple Hearts and Silver Stars in Italy and France. How Uncle Dave could speak Japanese well so he went to the Pacific as part of Military Intelligence but he was sworn to secrecy and never talked about it.

How Kate's oldest auntie, Auntie Kazie, married Uncle Ich on Valentine's day 1942 and went with his family to Heart Mountain and had cousin Rick in camp, just before they left camp for a town called Seabrook in New Jersey.

How Jichan, Kate's paternal grandfather, died of pneumonia at Manzanar while his sons were still fighting in Europe and had been buried there until the family finally moved back to Los Angeles and had him moved to the family plot at Woodlawn Cemetery in Santa Monica.

Kate had heard about the mess halls and toilets with no dividers and community showers, the tar-paper barracks, the wind

and dust. This was all her college-activated, movement-inspired, sheltered-daughter curiosity could wring out of her poor, previously tight-lipped, *shikataganai*, that's-the-way-it-was-and-we-don't-wanna-talk-about-it parents.

But nothing had prepared her for the absolutely helpless feeling of standing in line with hundreds of other Japanese descendants in a camp full of thousands more. Surrounded by barbed wire in the middle of the desert, armed guards in towers aiming their rifles down at her and her children. Waiting for hours in a hot, cramped, airless mess hall to be processed, registered and assigned their living quarters. Waiting for someone to tell you where you will live, when you can eat, when you will sleep.

Wondering if she should at least have tried to smuggle her kids to Japan. Or Brazil, or Canada, or Hawaii, anywhere but here. She thought about Hawaii. No ReVac there. For the same reason there was no internment there in World War II. Too many Nikkei there. Hawaii couldn't function without them. But it was different this time. With all the unemployed, any Hawaiian job was expendable, any Hawaiian was replaceable. Plus all the mainlanders trying to avoid internment hit on any family connection in the islands and it was getting crowded. So Kate decided to wait and see how Hawaii fared.

Which left her wondering if she had made a big mistake coming here. Wondering if they would die here.

Kate was glad to be off the train—a long trip that would have taken only a few hours by car to Mammoth or Fresno, it took forever by train to reach Manzanar.

The line had started out in the yard by the flagpole. By late afternoon they'd reached the building. Now she was hoping they'd get their housing assignments before registration shut down for the night, a night sleeping in line—something she hadn't done since she tried to fly out of LAX on a holiday weekend, or since the Bill Walton years when Johnny was at UCLA.

Speaking of which, she wondered if David and Johnny were

here. They were probably late, as usual.

She was just glad Ray had been released. She could not comprehend how Obachan had handled it, when the FBI had held Jiichan from Pearl Harbor until the following November.

She was worried about the kids, leaving their friends and school, their home, the dogs they had grown up with.

God, her mother had been the same age as Graham when she had come here.

On the other hand, this could be good. Being around all these kids would take their minds off those final days, when even their best friends shunned and rejected them.

Mary was too young to know. She was eight going on nine, warm and open and trusting, named after Mary McDonnell, the actress. (Kate's favorite movie was *Dances With Wolves*. It was the only DVD she'd brought with them. Just in case.)

Mary would adjust. If she ever started talking again.

Graham was eleven years old, named after another actor from *Dances*, Graham Greene. He was another matter. He just grumbled and sat there with those headphones on, and she could hear that awful, throbbing, pounding music blasting into his head through those tiny earphones from three feet away. God knows what kind of messages they were getting. Eleven going on twelve was a horrible age under normal circumstances.

One afternoon, when she was coming to pick them up, she saw Graham and his friends at the mall. The four of them were standing around, slouching around really, about ten feet from a group of eleven-year-old girls. Sammy, the bold one, was calling, shouting rudely, in her opinion, at one of the girls.

"Yo, yo, yo!"

The object of his attention, a dead ringer for Jodie Foster in *Taxi Driver*, barely looked his way.

"Say!" Sammy persisted, "Yugah boahfren?"

"Wha?"

"Yugah boahfren?"

Apparently he wanted to know if she had a boyfriend.

"Yeah."

"So wheah's he at?"

"I dunno. Aroun' maybe."

Their built-in, very vocal audience sounded like they'd been raised on TV talk shows, whooping at every exchange.

"So whatchu doon now?"

"Nothin."

"So whyntchu come with me?"

"Where?"

"Someplace private."

"How private?"

"C'mon wit' me and find out."

This was a conversation between two white kids from the suburbs who hadn't reached puberty yet.

She knew it bothered Ray, ever since they moved to Orange County. Ray had grown up in Crenshaw. He'd shake his head and say the black kids were too busy studying, too busy trying to become doctors in their own community, too busy fighting for the survival of their people to worry about yet another part of their culture being aped and exploited and stolen, too busy trying to compensate for another A student who wanted to be a doctor and open a family practice in the 'hood getting shot by the worthless punks the white kids were glorifying.

Or maybe he just didn't like hip-hop.

Maybe it'd be better here where Graham could make more Japanese friends. Or at least Buddhist friends. She had yet to see any juvenile murderers who were raised Buddhist.

Maybe Mary would come out of her shell here, where she wouldn't be intimidated by all the loud white and black kids. And the ones who excluded her from conversation by speaking Spanish or Farsi or Japanese just as they got to the important part. Like Kate's parents used to do at the dinner table.

At least in here, they didn't have to worry about terrorists. No

tall buildings to plow an airplane into. No crowded sporting events to bomb. If a group of overzealous patriots wanted to pull a drive-by, they'd have to drive a couple hours into the desert. Then they might have to explain to the guards in the towers why they were shooting in their general direction.

She found it amazing that she could pick Ray out in a crowd from a distance. It was the shape of his head. Typical *Nihonjin* of the soft, round type. Round cheeks, button nose, round head. As opposed to his younger brother Tommy, who had the thin, angular features of their father.

He had a Japanese American walk. An American swagger, with the dip of the shoulder from growing up in a black neighborhood, and a Clint Eastwood stride like he was always walking in cowboy boots, even if he was wearing Reeboks or zories. Then from the waist down he was Toshiro Mifune in a samurai outfit, low to the ground and solid.

Put him in a crowd of Japanese tourists and you'd know he was the American, the local boy. Even in this oversized greenhouse full of JAs, she could spot him immediately.

There he was. They'd been together too long.

Kate watched Ray bobbing his way through the crowd. Ray of the weak bladder. Ray of the golf-and-football weekends.

It was his fault she was here. If his name hadn't been Yamashita, she'd be on the outside.

There was a patient at the office. Always specifically requesting her to clean his teeth. At first it was nice. Hakujin guys always seemed to be charming, or maybe it was just the ones that came on to her. She wasn't used to it, coming from a Japanese household.

Although Ray…could be charming.

One time, at a party, she heard Ray use his deep, Barry White, Theo-from-92.3-The-Beat voice.

Something cute, young and squeezed into a tight little dress the size of her sock happened to corner him and Ray didn't know

she was watching.

Kate wondered whatever happened to Theo. Did his listeners turn on him when they found out he was Japanese, even though he was born and raised in L.A.? Did it matter to them that the sexiest voice on radio, Mister *Waiting-to-Exhale*-DJ, had a Japanese last name? She'd heard rumors that he was broadcasting out of Tijuana, the way Wolfman Jack used to. Heard some of his fans were out looking for him. Kate thought about joining the search, especially when she saw Miss Laughing Tube Sock shimmying up her husband's arm.

Ray could make the girls laugh. Most men could make girls laugh. But Ray was good with women, too.

Of course, one of the women in this case would be the wife giving him the stink-eye that could dice carrots from across the room.

The wife who had options, if she wanted to. Who was being flattered and persistently pursued by...what's-his-name. Just call him Rory. After Rory Beecham, this real friendly white guy in high school who was really nice and friendly, until she and her friends, who were all Asian, too, traded notes and found out that he was really nice and friendly only to Asian girls.

So white guys who dug Asian chicks became known as Rorys.

Rory probably married a Japanese girl. And she wasn't standing in this line because her last name was Beecham.

It still wasn't too late. Outside of stretch marks and flabby thighs, she wasn't bad for an old lady.

No, she was stuck with good ol' Ray, whose Japanese name got her here. Who gave her not only his Japanese name but full-blooded Japanese kids, too, which gave her no choice. Ray broke into his broad smile when he spotted her in line. "Geez, honey, you shoulda seen the benjo. Look like army latrines all over again. Boy, good luck."

That's when she remembered why she was standing in this line in this camp in the middle of the desert.

She loved the guy.

Kate was suddenly feeling better.

She'd started the day expecting to do this alone with the kids, and now she had Ray and hopefully David and Johnny here.

"Mary's with some other little girls in the corner over there," Ray waved, "but I couldn't find Graham."

She couldn't believe he could be so *nonki*, so damn nonchalant about misplacing their child somewhere in a prison camp. Geez, typical Buddhahead.

"What do you mean, you couldn't find Graham?"

People began to stir and a rumble went through the crowd. There was movement at the head of the line.

The army officers and receptionists were packing up their briefcases and computers and marching out the door.

After they had stood in line eleven straight hours today.

"Where the hell are they going?" Ray craned his neck.

The last officer stopped and turned to them.

"Registration will continue at eight o'clock tomorrow morning. Keep your place in line. Do not leave the room."

The doors of the mess hall slammed shut, manned by U.S. Army soldiers with guns and grenades and Nazi-shaped helmets.

Children began crying, quickly hushed by their mothers.

Kate spun around, looking from face to Japanese face, a sudden surge of panic plunging down her spine.

Ray was already returning, carrying Mary on his back, God bless him.

People sat down on benches, on the floor, in their place in line.

"You better hit the can," Ray said, "it's over by the kitchen. I'll keep our place in line."

"Is that necessary?"

Ray held out an upstretched arm and intoned to the ceiling, "Brothers, sisters, we're all in this together," then muttered to her, "but I ain't losing my place in line. Go on." He put Mary down. "You gotta go shi-shi, honey? Better go benjo now, you might not get another chance tonight."

Ray watched his wife and daughter make their way toward the restrooms as other mothers got the same idea.

He couldn't protect them from harm, humiliation or whatever the government decided to do with them. He couldn't locate his son at this particular moment. He couldn't provide for them, bring them presents, take them out for Fatburgers or Chinese food. He couldn't work hard and make them proud anymore. He didn't know if he could keep his family together when the whole world was trying to tear them apart.

All Ray could do was save their goddam place in line.

7

It was an odd place to have an epiphany, at a Braves game. But if she ever saw another stadium full of white people doing that idiotic tomahawk chop and wailing that stupid chant *ever* again, Jenny was going to throw up.

A double date, helping out a gal she met back in Houston, fixed up with Jim Bob Newt South. He spent the whole time drinking beer, hacking away with a red sponge tomahawk and droning that stupid fake Indian song that was actually the bad-guy theme music used in old Westerns whenever the Indians showed up, which was the same music used in World War II propaganda movies whenever the Japanese showed up, only in a minor key and with a gong.

"'Smatter, Jenny Lee? Ain'tcha 'njoyin' the game?" he exhaled hoarsely at her during the seventh-inning stretch.

"I could do without the soundtrack," she leaned away.

"Aw hell," Jimmy Earl smiled and put an arm around her shoulder, "are you one of them California liberals all worried about offending minorities 'n' shit?"

She was leaning so far away from him she blocked the peanut vendor's path down the aisle.

"I *am* one'a them offended California liberal minorities."

"Well, get over it, babe. It's a man's world again, thank the good Lord!" Jimmy Dale shrieked, then turned tenderly toward her. "You know, if you gave it a try and joined in with all these folks, you might have a little fun," and pressed the sweat-soaked sponge tomahawk into her hand.

She dropped it like a bug. "I'm a Dodger fan."

"Dodgers?" Billy Lee looked like he caught a whiff of something moldy. "Sheeeitt."

"Yeah," Jenny saw her opening, "from waaaaay back. Jim Gilliam, Maury Wills, Koufax and Drysdale, Sweet Lou Johnson, Sutton, Fernando, Orel, Nomo. Ron Cey was my favorite."

"You mean, Garvey, Cey and them ol' boys?" A dim realization was slowly creasing Billy Kyle's unwrinkled brain.

"Yeah," she dug in, "in the 1970s, when I was...*in college*," she sat back and pinned his arm to her backrest.

She could see him doing the simple math in his head, lips moving ever so slightly, everything but counting his toes. Then she saw the bottom line come into focus in his beady little eyes as they scoured her face for wrinkles. She smiled hard.

"Hey," his eyes widened in disbelief, "this gal's old."

Billy Dale yanked his trapped arm loose, leaned forward and hurriedly began moaning, "hey-yay-yaaaaaay-yaaaaaaay," flailing away with his limp, soggy tomahawk, glancing at her for any additional telltale signs of advanced age.

It was then that she realized they had won. From the five percent controlling eighty-five percent of the wealth to the laid-off yahoos who still worshipped the CEOs who gave themselves bonuses as they laid the yahoos off. This was their country and they weren't giving any of it up. Back the President 110 percent or you're a traitor. My country right or wrong. For us or against us. Choose.

Then and there Jenny made up her mind to rejoin David, wherever he was. And since she still hadn't filed the papers, he was still technically her husband, which made her Jennifer S.

Takeda and thereby subject to Executive Order 9066-A.

Jenny never was comfortable around too many white people. And if you're a green-eyed blonde growing up in Orange County—that bastion of fleeing Southern Baptists in search of reduced humidity and a lot fewer colored folks—and you still don't fit in, you probably never will.

Being with David for so many years, she had become acutely attuned to their insensitive little remarks, their inane attempts at jokes at other people's expense. David would scold her for apologizing for stupid white people, not when her name was Takeda.

There she was, tall and blonde, looking over a room full of heads of black hair, and as soon as their eyes met across the room, she felt more at home than home.

With any decision she'd ever made, once the excruciatingly complicated process of making the decision was done, a feeling of complete relief swept over her, which made the rest of her evening with Jim Bob Billy Lee a lot more fun, especially once she'd convinced him she used to be a man.

She didn't sleep that night. She hauled bags of food, clothes and shoes downstairs to the women and children living in boxes on her street. She gave them everything but what she would carry into camp.

She'd catch the I-20 east out of Atlanta, straight and flat all the way through Mississippi and Louisiana. She'd be in Dallas in fourteen hours if she didn't stop and she wasn't stopping for anything. Not for hurricanes, not for the Mississippi if it overflowed again. She wanted to get the hell out of this humidity. She wanted to hit the desert and cook. She wanted to be back with the people she felt comfortable with, even if it was in an internment camp at Manzanar.

She got on the road as the sun was coming up, popped a Nanci Griffith tape in the player and set out on the highway.

8

David stayed on Washington all the way west, steering the van from oasis to oasis of light, eyes peeled for incoming projectiles from the burned down, bombed out, permanently occupied ruins, crawling with dark figures hovering in the shadows, groups of scabrous men gathered on corners screaming at cars that dared pass through the city at night.

And this was Culver City, former home of M-G-M, home of former Sony.

Greg stared silently at the corpse of a city he once knew, cradling the tin containing Johnny's ashes.

"You sure this is him?"

"I watched him go into the oven."

"But…" Greg stopped. He didn't want to state the obvious, that the disposal system was so large and impersonal that he might be holding a dog's ashes for all they knew.

"He's dead, man," David snapped. "S'all that matters."

David popped a tape into the van's player.

He tried to let the clear, pure, little girl voice with a twang push the mean thoughts from his mind, make a space in his heart for comfort as they drove in silence past the dark underside of the city—past the skeleton of American success and those who were

always beyond its reach and its sight, past Hmongtown and Little Sarajevo—while Nanci Griffith sang about foreign fathers and American sons and the soul of America's pride.

On every block, among the waterlogged cardboard boxes, rusted shopping carts, black plastic piles of uncollected trash lining the curb, were *altarcitos*, sidewalk shrines.

A faded picture of a loved one, a cross, handwritten notes and signs, "We Love You Bobby," "R.I.P.," surrounded by bunches of dead flowers tied with frayed ribbon, and several *veladoras religiosas*, the Virgin Mary wrapped around a candle. A makeshift memorial on the spot where someone fell.

A kid hit by a car. A young man waiting for a bus. A little girl walking with her dad, going to get ice cream. A mom distracted for a second and didn't see danger coming.

Someone had to remember them.

When David pulled into the tiny parking lot behind the row of shops on Centinela Avenue, Greg was asleep in the passenger seat. David walked past the faded sign hanging askew from a rusted wire on the back gate. It read *Kenny's Cafe*.

David entered like the regulars always did, through the back door—past the sink where Victor had washed the dishes, past the crumpled remains of the preparation table where Kenny's neighbor and assistant, Mrs. Nakamura, had chopped vegetables, past the thick iron grill that still sat unscarred and immovable where Kenny in his apron and blue baseball cap had cooked thousands of meals, happily distanced from his former job as a bank VP.

Kenny and Kay retired and closed up shop Christmas '98, but after Tracy gave them a couple grandkids and Cathy got married, they got antsy. Only so much fishing you can do. So when the *taquería* went under, they reopened in their old space. Sank their savings into new booths, a new counter, new chairs, stools, silverware, dishes, cups and bowls.

Foolish, given the political climate, but it was perhaps their statement that the Japanese American community of Los Angeles,

specifically Venice, California, was still alive and well.

Unfortunately, they reopened exactly one month before ReVac was announced.

The vultures offered Kenny ten cents on the dollar for his brand new equipment, and like his parents had done in March 1942 with their farm equipment and new icebox, Kenny gave it all away, but only to friends and neighbors he already knew from before.

David crunched through the broken glass littering the floor. The counter was splintered and broken, the booths shredded and soaked with urine, the walls once graced with framed prints and collages of snapshots of their happy customers seated at their meals now smeared with dried feces and spray-painted by barely literate goons.

A cool breeze panted through the shattered front window, green and pink bits of neon tubing from the diner's sign dusting the floor. David took a quick breath through his mouth. He couldn't remember the smell of frying bacon anymore.

He saw, sticking out from below the collapsed boards of the counter, a menu. He yanked the black plastic folder from under the weight, battered but dry, and slipped the paper menu from the sleeve.

Kenny's Cafe
JAPANESE AMERICAN COFFEE SHOP

He didn't need to open it. He knew it by heart already.

His favorite, the royals. Eggs fried up with onions and a light teriyaki sauce with your choice of cha-shu or bacon or Portagee sausage or whatever you want on a big oval platter of hot rice. Spam and eggs with fried rice, ginger chicken, fried noodles, *saimin*, marinated steak and eggs, Spam *musubi* and bento box lunch that you had to order a day ahead.

He was staring at the cover, wondering where Kenny and Kay were at that moment, when he suddenly realized there was someone in the room behind him.

"You must be David."

He jumped away from the husky, female voice behind him and turned, crouched, ready to strike or run.

She was sitting in the shadows of the corner booth.

He stared into the dark corner.

"I heard you were the last *Nihonjin* in Venice." She leaned forward into the dim light from the street. Asian, young, twentyish maybe.

David glanced quickly around the room, past her to the back door, to the front door, a way out.

"My name's Celeste. Celeste Saito." She came into the light. A plain girl with greasy, matted hair. The weariness on her smudged face, the bags under her reddened eyes, she could've been anywhere from eighteen to thirty. "The guys down at the record store in Venice told me you stopped in to say goodbye yesterday and might be going my way."

"Which record store? Tower?"

"No, not Tower, it was a funky little place near the columns."

Benway defined the cool, funky little record store. It was David's last regular job, until it got to be too much of a hassle for Ronn to keep answering his customers' inevitable inquiry, "What's *he* doing here?" when they caught sight of David. Ronn tried to keep David in the back, cleaning and pricing LPs and stocking shelves. But David couldn't ask Ronn and Kelly to keep vouching for him when things got hostile.

"I need a ride," she said.

David turned around and walked out.

She ran after him. "Please, you gotta give me a ride."

Greg sat up quickly when he saw someone follow David out Kenny's back door.

David looked at her again. In the back-alley light, he saw she was too pretty to be unattached. "Who the fuck are you?"

Celeste smiled woodenly, "Celeste Randy, I'm Japanese, my husband's American, and you can call me Emiko."

"You a runaway konk?"

Japanese Americans married to Americans of non-Japanese ancestry were allowed to accept secondary citizenship status and avoid the whole camp experience.

So, when single JA females got their notice to report and finally realized it applied to them, they grabbed the nearest citizen and headed to Vegas. Derogatorily referred to as concubines, or konks, women exempt from ReVac because of their conveniently newfound marital status engendered more than a little jealousy and resentment on both sides of the wire.

Which meant nothing to David, except that this one was trying to get to a camp. She was on the run. Class-A felony.

"I just need to get to Manzanar," she tried not to let the desperation show.

"Forget it," David climbed in the van.

Celeste wedged herself into the doorway and grabbed onto the steering wheel. "He doesn't know I'm gone yet."

"If I get stopped, I show my papers, they let me go," David squeezed the door on her. "If I get stopped with you, I'm harboring a fugitive and I go to jail."

David pried her fingers off the steering wheel. She latched onto him, pressing her breasts against his arm.

"I'll make it worth the risk. It's a long ride, man."

David stuffed a crumpled bill into her chest pocket.

"Take a bus." He shoved her out, slammed the door shut and tore down the alley behind Centinela.

"Chick like her knows what to do."

"Probably find herself another sugar daddy tonight."

David pulled into the driveway past a battered, brown Buick station wagon parked in front of the house.

A beautiful brown-skinned woman with a tattoo of another beautiful brown-skinned woman on her left bicep opened the front door. A dark shadow, the Tooz, whipped past her knees.

Vic looked quizzically at David. "Taking passengers?"

Celeste hopped off the rear bumper and smiled at David, in hopeful anticipation.

"Get inside," he grumbled to both her and Tooz.

David gave Vic a peck on the lips and squeezed her tight. "My life used to be so simple."

"Yeah? When was that?"

Vic was pulling a bag of submarine sandwiches out of the fridge when David walked in with the tin. "What's that?"

David looked down at the tin, not registering for a second. "They got Johnny on the freeway today."

"Ohhh, *mi hijo*," Vic pulled him close and held him as they did for each other too often. They both had lost family to the gang wars of the '90s, to thieves with guns, to the random violent death that now defined L.A.

David had known Vic since she was a Mexican tomboy, before she was a Chicana activist and then a Latina lesbian socialist. He played Bee football at Venice High with half her brothers and she listened to them all commiserate about Coach Rose, who held Lombardi/God-like status back then.

He did the eulogy for her older brother, Joey, a fellow lineman and classmate since Short Avenue elementary school. The manager of a McDonald's, husband and father of two girls, he was shot dead as he was locking up the store. Thieves got away with nothing, except murder.

"You gonna scatter his ashes in the ocean, like your folks?"

"No time. Maybe the desert."

"Maybe out on the rez somewhere." Vic nodded at Celeste, who was being charmed in the living room by Greg. "Who's your friend?"

"Runaway konk that needs a ride."

Vic pushed Tuesday aside and handed Celeste a sandwich. "Hungry?"

Celeste ripped one of the foot-long cylinders apart with her teeth and collapsed on the couch, chomping vigorously.

"Guess so," Vic said, counting her fingers.

"Get up," David reached behind Celeste for a strap.

Celeste swallowed and jumped up as David heaved open the fold-out bed. Squeezed between the frame and the waffle-thin mattress were two duffel bags, all he would be allowed to carry into camp.

"I have to take a shower," Celeste announced as she crammed the last of the sandwich into her mouth. She saw David's irritated look. "I won't be long, promise."

"Take a right," Vic yelled as Celeste ran into the hallway. "Your other right."

After they wolfed down the sandwiches in silence, Vic smiled at David. "Where'd you find her? She's lovely."

"Shh," Greg leaned an ear toward the street, "hear that?" He crept toward the front door.

At that moment, amazingly, the helicopters that usually circled directly overhead, searchlighting the 'hood for probable suspects, weren't. The incoming jets landing at LAX were circling over downtown L.A. The cruising lowriders with over-amped bass speakers that registered on the Richter scale had shuddered their way back to the projects. And the block was temporarily soaked in an unexpected, short-lived silence they only experienced when LAX was shut down and everyone stayed inside to watch the city burn on TV.

Greg and Vic and Tuesday moved to the front porch but only Tooz listened. Greg and Vic were distracted by the crystalline sounds of drops of water, echoing in the shower, falling, one by one, off God knows which part of Celeste's naked body, and a towel vigorously buffing her clean, scrubbed, naked flesh.

Greg and Vic turned to go in and froze as they beheld Celeste standing in front of David, wearing only a towel.

A shower did wonders for her and underneath the dirt and baggy clothes, she certainly was pretty darn good looking. Now this was something this girl had learned to take advantage of and

had probably been terribly exploited by, given the value this society places on the attractive Asian female, David kept explaining to himself as he dug through his bags and tried not to get an obvious boner.

She smelled great. He didn't know what it was about women, at least the women he'd been with, but they could be using industrial soap and they'd come out of the shower smelling like beauty warmed over, freshly blooming flowers, something that gripped him primally.

Or maybe he just had a shampoo fetish.

"I've been wearing these same clothes for a week," she waved disgustedly at the dark, damp pile by the back door, "and I just couldn't bring myself to put them on again, not after such a wonderful shower, so…"

They all gasped as she tugged at the top of her towel. "…David's gonna lend me some of his clothes."

Celeste beamed at Vic, who managed to lift her lower jaw just high enough to close her mouth, and at Greg, who was wincing painfully at the sight of her.

"I think you're closer to my size." Vic shook out her keys and walked past Celeste to her bedroom. "Come on."

Vic flopped down on her bed and managed to not audibly whimper when Celeste let her towel drop to the floor.

"I really appreciate this," she frowned as she dug through Vic's closet, wondering just how many flannel shirts this girl had.

Vic thought she had an odd coquettish way of standing off-center, like a model. Then, as Celeste tugged on a pair of Vic's really old cut-offs from the '70s, Vic caught a glimpse of a thick, dark, deep-purple bruise on her rib cage below her left shoulder blade.

Celeste caught her looking and covered herself quickly.

"Just his way of showing affection," Celeste said.

Vic opened a hidden door inside her closet and pulled out a worn brown leather jacket with a Los Lobos logo on the back.

"Here. The winters are cold in the desert."

"All right," Celeste caressed the soft leather, then put it on and squatted like she was riding a motorcycle, cranking the handles up high. "Rrrroommmm…"

"A friend of mine painted the back herself."

Celeste looked on the back, "Los Lobos?"

"Well, los lobos means the wolves."

"Oh yeah, like there's wolves out in the desert."

"But it's the name of a group."

"Like a gang?"

"A band. Local guys, from East L.A., Los Lobos did everything from rockabilly to Mexican folk songs, and David Hidalgo had the best voice in rock since Roy Orbison…"

Celeste nodded blankly. "I like P.I.D."

"Is that a group?"

She didn't sigh, exactly. "Post-industrial dissonance."

After rap had become the sole province of suburban white teenagers and acceptable to the recording industry as big business, and therefore unacceptable to teenagers doing their best to piss their parents off, industrial and its more grating nonmusical cousin, post-industrial dissonance—which often consisted of thirty minutes of an amazingly accurate re-creation of a dental drill on molars or the sound of worn-out brakes or multi-tracked recordings of garbage truck and jackhammer duets—became the rage. Twentysomethings with hearing aids would testify to its popularity.

"Thanks for the cool jacket."

"You're welcome."

Celeste folded the thick leather into a plastic shopping bag with handles.

"You know, Terence is probably looking for me."

"I know."

"I'm his property and he doesn't like to lose. Think I should tell the guys?"

Vic put an arm around her as they walked out.

"They know."

David and his forty-three first cousins were raised in Venice, West L.A., Gardena, Crenshaw, Montebello, East L.A., Orange County. They got good grades and flunked. They went out for sports or worked after school. They cruised and drank, smoked cigarettes and grass, popped pills and snorted coke. Or they abstained and stayed healthy. They went to college and got degrees or dropped out and found jobs. Worked steady and got laid off. They met the right person or didn't. Married or just lived together, had kids or didn't. They survived or died too soon. They were cops and druggies, ministers and felons, doctors and drunks, go-getters and slackers. Making it or barely making ends meet, treading water or sinking fast. They were family you only saw at funerals or were next door neighbors.

They were *not* Americanized. They were American.

What they were, what David was, was ingrained into this country, as deeply as this country was ingrained into him.

As inhospitable and dangerous as it had become, the U.S. was still his only country. And as crazy as it had gotten, he always came back home. To Venice.

His Venice, on Centinela Avenue near Culver. Mago's, the 24 - hour burger/plate lunch joint with its avocado *cha-shu* burgers, Centinela Sporting Goods, and Aloha Market with its daily homemade tofu. Hawaiian royals at Kenny's Cafe. The Submariner, next to Betty's Music where in the '60s Betty Norup had sponsored half the garage bands on the Westside. M&S Pharmacy where Shaw Sakamoto filled prescriptions and cashed checks for working people, and all the neighborhood boys used to read Marvel comics after school. Fresh *menudo* at El Indio, south to Braddock and the Venice Hongwanji Buddhist Temple, the Venice Japanese Community Center to the Venice Methodist Church, up to the bridge over Ballona Creek.

His Venice was how he could feel a part of this country.

The real America that never got on TV.

David stood in the backyard, on the spot where Fred, their German Shepherd, had died, a month after diagnosis, of kidney failure. Wasting away, while they sat up with him in shifts until that last night. The way Fred looked at him, they both knew it was time. Jenny got up at dawn and David went to bed. An hour later, he felt her hand on his shoulder, stumbled out of bed, past the brown-stained wads of paper towels, out the back door. Fred lay on the grass on his side, panting, eyes wide open, dry mouth parted, tongue drooping out the side. David lay down next to his old dog.

"It's okay, Freddie boy, daddy's here."

He put his ear to the dog's chest. He couldn't hear a heartbeat through the rushing in his ears and thought he was gone, then Fred would take a quick breath.

"I'll be back, Fred."

As David walked into the house to get a blanket, he thought he saw Fred look for him to see where he was going.

By the time David got back, Freddie was gone.

David stood on the spot where Freddie had died and looked up at the full moon glowing bright in the summer night sky as it peeked between telephone lines. He took a deep breath. He could smell summer coming.

It felt familiar and he was losing it.

"You know," David said to the sky, "I never felt like a part of this country."

Greg exhaled and tapped his joint on his lawn chair and said, "Who does? Nobody I know."

"But I never did. Never. Not for one damn minute did I ever feel like someone wasn't gonna tell me I don't belong." David turned to Greg. "This is my fuckin country," David spat.

"Come with me to Europe, Dave man. Wait for the revolution."

Except for the sign and the mural on the wall facing Centinela Avenue, Aloha Market was gone. Kenny's was finally closed.

Mikasa restaurant, Mago's, El Indio, Centinela Sporting Goods, Baba's Mower Shop, all folded. Finally Janice closed Sakura restaurant. Shaw's daughter Carrie, herself a pharmacist, kept M&S Pharmacy open 'til the end.

His Venice was dead.

"This is the revolution and we lost."

The screen door opened, and Tuesday launched herself around the edges of the yard.

Vic closed the door behind her.

David held onto Vic. God, he loved her.

When Mom and Dad told him about the Spencers and how they'd kept Grandma and Grandpa's photo albums and anything from their family in Japan and stored them during the war and had even visited them at camp, back when it was an all-day drive in their old Ford pickup, he didn't appreciate it.

He didn't know there were good people in this world you would trust more than family. People who wouldn't desert you when the government and the law told them it would be unpopular, illegal and dangerous to stand by you.

Now he knew.

David had Vic. Greg. Ronn and Kelly.

He saw the sadness on Vic's face, this woman he'd trust with his life, and the regret that she couldn't carry this fight to the next level. But it was over. This fight was over.

"Getting late, *mi hijo*," Vic said.

"I know."

9

His old neighborhood dark and empty like a mausoleum in the rearview mirror behind him, David crossed the bridge over Ballona Creek, keeping an eye out for underdwellers ready to pounce on slow-moving vehicles. He pulled into the left-turn lane under the freeway and waited for the arrow. Greg was just getting comfortable in the passenger seat when the screech of locking tires on asphalt and high-beams filled the back of the van. Celeste jumped up from the beanbag chair and screamed and they all braced for the crash, but it didn't come.

A yellow Mercedes came whipping up from behind them and stopped on the island to the left of their left-turn lane, next to David, who sat and waited at the signal as the occupants of the Mercedes laughed drunkenly. The Benz was festooned with more American flags-on-a-stick than a Midwest college football tailgate party.

The driver, a young man of Middle Eastern persuasion, leaned over his date and shouted out the open passenger window, "Whoy don' you luhn to dribe?"

David pointed to the signal and said, "Red light."

"Whoy don' you go back to Tokyo, you."

The worst part about this ReVac shit wasn't watching your run-of-the-mill redneck assholes strutting around like they had

government approval for their bigotry, which they did.

It was these recent arrivals, who had tons of money and barely spoke English and were perhaps the worst drivers in the history of transportation, treating his people, who had been here for generations, many of whom like David were former professional truck drivers, like the foreigners.

Oh great, now the others were screaming at him, too.

David thought about going through the red, but then Greg launched himself out the door, around the front of Mercedes, and pulled the driver out by the throat.

His companions didn't move, content to voice their objections loudly from a safe distance as Greg methodically pounded the driver's head into the hood.

The hollow metallic thumping over the gaggle of Farsi sounded like the latest in World Music.

David calmly slid a leg, then a hip, in between the driver and Greg and muscled in backwards like getting into rebounding position. "Okay, that's enough, Greg. Greg," he said quietly and eased Greg off the hood and, looking around for any patrol cars, pushed him away. Given Greg's past history with the police, the SWAT team should've opened fire by now.

David shoved the driver back into the Mercedes and saw the passengers. Kids. Rich kids with Daddy's Mercedes and Mommy's gold cards. But, good for the economy.

"Take off," he pointed.

The driver, his head bouncing like a bobblehead doll, whipped the Mercedes straight past the onramp, doing ninety toward Jefferson Boulevard and Playa Vista.

Strangely, David was encouraged that suspected Muslims could now travel safely at night. Maybe Joe Six-pack could finally distinguish between pro-bin Laden pro-Taliban terrorist sympathizers and fellow capitalist swine who happened to be Arab Americans.

At least that war was over.

As they rolled over the overpass from the Marina east to the 405 North, David could see the fires dotting the city terrain all the way downtown. Helicopters from Century City's private security force hovered over the orange-lit oasis to the east. If they could get to the Santa Monica freeway, they might be able to get out of town in a few hours.

No such luck. As they rounded the overpass, the stream of red taillights broke below them like a wave, crunching the double-dotted rows to a coughing, belching halt.

David jerked the wheel to the right and hit the gas. The van bounced along the littered shoulder, over the dismembered fenders and exploded tires, gliding over debris the highway bush-dwellers hadn't yet scooped up into their shopping-cart mobile homes. He caught a glimpse of Celeste's feet flickering past the rear window as she rolled around the back of the van when he hit the offramp.

The huge shrubbery lining the Culver Boulevard exit were like the trees of Sherwood Forest, loaded with bandits waiting to drop onto unsuspecting travelers.

He had no intention of stopping and halfway down the ramp, through the smoke of the oil-drum fires, David saw an opening, small but do-able by L.A. standards. He'd be across Sawtelle Boulevard, which the Culver Boulevard exit actually emptied out onto, no sweat, with a little luck and timing.

Except, there always was some idiot who drove too slow to begin with and always slowed down for everything. Someone like this idiot on Sawtelle Boulevard, who upon seeing a van hurtling down the Culver Boulevard offramp directly at him, instead of pressing his accelerator and getting the hell out of the way, decides to slow down or more inexplicably stop.

Someone who did not belong on the road, not in L.A.

David hoped, for just a nanosecond, that Mr. Moving

Roadblock would recognize the situation, defy the odds and take action to remove himself from jeopardy.

But no. Mr. Roadblock just sat there like a speed bump and watched the van careen toward him, switching this way and that, waiting for him to move.

No, he wouldn't move. If the van hit him, Mr. Roadblock's insurance would cover it since none of those people qualified for insurance anymore. Because he was right and the van skidding towards him sideways was wrong.

Wrong, wrong, wrong.

He braced himself and waited for impact, already calculating how much to claim for pain and suffering.

Instead, his car only jostled and rocked back and forth on its tires. The stench of burning rubber seeped into his sealed compartment as, against all laws of physics, the van locked into a counterclockwise fishtail and accelerated into a ninety-degree turn, missing his front end by inches. Mr. Roadblock, instead of taking his foot off the brake and creating an actual flow of traffic again, sat contemplating recent developments and didn't notice the cars behind him honking, cursing his unmoving status and eventually going around him.

Nor did he notice that his hubcaps and the contents of his trunk were missing until the trunk popped all the way open, waving goodbye like a cue card in his rearview window.

"That was close," Greg observed.

"I know." David had wanted to hock a loogie across the Roadblock's windshield as he was skidding by sideways, but in a crisis situation perhaps it was best if your first reaction wasn't to bring up phlegm.

"Real close," Greg reiterated.

As David glided under the Sawtelle overpass to the signal at Culver, he saw the Caprice in his sideview mirror pulling up

alongside them. "Don't say anything," he warned Greg.

Four dark faces glared up at Greg from the low rider.

"They're packin'," David watched the signal. "You know they're packin', so don't say anything."

Greg looked out his window. "Whatchu lookin' at, punk?"

David floored it, half a second before he heard the pop-popping behind them.

"Are they shooting at us?" Celeste, who'd finally regained a sitting position, asked incredulously. "Those guys are shooting at us!"

David ran the red light west onto Washington Place and stomped the accelerator through the floor.

The Caprice was gaining. Arms and heads hung out of either side, dusted by puffs of smoke.

"Here it is," Greg said when he saw the signal at McLaughlin three blocks ahead and braced himself.

Just as Celeste saw the Caprice skid to a halt behind them, David yelled back to her, "Hang on!"

The van smacked nose-first into the dip then flew up into the air like a wounded whale. They were airborne for a long second, then all bounced simultaneously when the van hit the ground. David stomped around, trying to find the brake pedal before they hit the second dip.

He hung a right onto McLaughlin and crept straight across Venice Boulevard, past the tent camp in the deserted DWP lot on the left, past the cardboard city lining the drain outlet on the right.

It was amazing how quiet this city got at night. But it didn't look any different. No apocalyptic mass destruction, not since the early 1990s. No *Blade Runner* futuristic mutation of the American way of life. And especially no technological advances of the *Star Wars* variety.

Everything just ran out of money. Buildings that were burned the first time around didn't get rebuilt, new buildings

under construction were never completed, skeletal structures still red-tagged from the last earthquake were occupied just the same. *Star Trek* got co-opted by the war effort.

The population living out of shopping carts, lining the sidewalks since the Reagan administration, were visible during the day; but at night the screamers and crazies became shadows in doorways, rustling in bushes, the lightless distance to the freeway you hoped to God your car never broke down in. They became whole families huddled around poisonous, oily ashcan fires on cold nights, families gathered into larger families for protection from the predators who traveled in packs.

The biggest new city lay ahead of them: Mar Vista Park. David turned right onto Palms Boulevard. If it was clear, it'd take them to Overland and the Santa Monica freeway east.

"Can I sit up front? It's hot back here."

David saw Greg turn in his seat, staring behind him. He had that pained expression on his face again, his mouth puckering up like a fish.

Celeste had removed a shirt or two. She was wearing one of Vic's really old tank tops, a tie-dye job with "No Choice, No Peace" in faded black letters on the front, which was plastered to her ample breasts like a wet paper towel.

Then David saw the ugly red welt, a fresh abrasion, on her right hip, where her cut-offs split.

"He do that?"

"No," she retreated instinctively into the shadows. "Some kid threw a rock. I forgot I was," she used the term for not being in the company of a white man, "unprotected."

David's Obachan, his grandmother on his dad's side, once told him about the farm in Venice. Since her husband and sons worked the farm, she'd have to walk into town for supplies. Boys, little white boys, would throw rocks at her and call her Jap. She always mentioned the two actions together, as though each was equal and, separately inflicted, would

hurt equally.

A hundred years later, same old story.

Mar Vista Park was packed, ringed by the lit *altarcito* candles of the sidewalk shrines lining the street and parking lot. Baseball diamonds and soccer fields lumpy with trash-bag tents and cardboard shelters, slivers of light peeking out of the cracks. Some kid reading by flashlight, hope against hope.

As they cruised by slowly, they could hear a basketball bouncing on the courts behind the pool under the only official L.A. City streetlight still working, every dribble echoing across the park.

Bwaaaang...bwaaaang...bwaaaang. Cashank.

The basket had a net, a few strands of chain welded onto the rim, so you'd know if your perfect jumper was good or not.

"Someone's gonna kill that guy," Greg warned quietly.

David wondered how many times the jump shooter'd been threatened tonight and if it really mattered to him.

Bwaannng...bwaaannng... head fake, put him in the popcorn machine, quick step to his right, put it up.

Cashank. Good.

Jump Shot threw his head back. They could hear his voice, deep and gravelly, wafting across the tops of the tents, his head bobbing as he called his own play-by-play.

"Hamma blamma jeebowza-yes!! Hezabo-hezabo-hebop—yes! World chamama-mama! Hahahahahahaha!!"

Palms Boulevard was blocked. Too many taggers hitting the signs or someone took a dive off the overpass onto the 405.

Bwaannnng...bwaaannnng...

As he turned north onto Sawtelle, David thought of Raymond Lewis. One of the great playground players to come out of L.A. Skinny dude with a huge natural and a rainbow jumper. Went from Verbum Dei High School to Cal State L.A.

David, Johnny, Greg, Mike and some buddies went to the Cal State L.A./Pepperdine game at the Sports Arena around '73.

William "Bird" Averitt, who came in leading the nation in scoring, took Pepperdine to a big first half lead. Late in the second half, Raymond Lewis, who was second in the nation in scoring, brought Cal State L.A. back. Started throwing in his rainbow jumpers from way out, with or without the Bird in his face. Just crossing center court and firing. He was unconscious. Then he finally missed a couple shots at the end and Pepperdine held on to win.

Raymond Lewis should've made it big in the NBA, but he didn't. The Connie Hawkins of the L.A. playgrounds, who was hitting threes before there were threes, ended up dead at forty-eight.

David could see fires burning at the top of the hill and headed west. They'd have to try Lincoln.

Jump Shot clutched his basketball. He threw his arm up in the air and walked in a circle, radiating in the applause and affection showering down upon him. He waved to the crowd and walked slowly off the court. He smiled up to the heavens.

David coasted down the hill on Grandview, past the combination Episcopalian church/Jewish synagogue, right on Venice Boulevard, away from Mar Vista Bowl, graveyard headquarters for nightly gang shootouts.

They cruised slowly past Venice High, deathly still at night, spotlights on the white statue of Myrna Loy in front of the administration building, illuminating it like a shrine.

Miss Loy, then a sixteen-year-old student, had posed for the sculpture which, with and without arms, had survived homecoming week paint attacks, the erosion of weather and several dynamitings. It had been housed in a thick hedge, a picket fence, a cast-iron bird cage and finally a bulletproof, explosive-resistant, paint-resistant acrylic dome, which deterred everything but the infamous seagulls.

Celeste was hanging out her window, trying to cool off.

Taking one last look at Myrna, David didn't see the group of men gathered behind the bus stop across the street.

"Close the window!" Greg yelled.

An arm in a tattered coatsleeve and the back of a matted head of hair thrust itself into Celeste's open window.

David floored it. Greg's punch was absorbed by the densely matted hair, so he ripped at the dweller's ear.

David skidded around the corner onto Walgrove and saw the dweller's body rolling in the intersection behind them, then the glint of bottles in hands in the alley ahead of them.

"Close the window!" Greg screamed at Celeste, but she froze as a barrage of bottles flew at them.

The corner of the windshield cracked like a spider web.

A bottle shattered against the doorjamb. Cheap wine and broken chunks of glass sprayed into the van.

Celeste tried to scream.

David pulled over past Mark Twain Middle School and flicked on the interior light.

Celeste, her face covered in blood, gasped in quick breaths, her hands fluttering around her face.

Greg brushed broken glass from her shoulder and arm. "Let me wash some of this blood off." Greg unscrewed the cap from a bottle of valuable, uncontaminated drinking water.

"No, don't touch it," Celeste pleaded.

"Baby, you got a chunk of glass sticking out your cheek, but I can't see anything unless we wash this blood off, okay?"

She cried out at the shock of cold water dribbling down the side of her face.

David saw the whiskey label and the side of the bottle jutting out from Celeste's trembling, blood-gushing cheek.

"We gotta get to a hospital," Greg said.

"No," Celeste protested. "I can't."

"If we go to a hospital," David said, "they'll run a check and

most likely identify you and ship you back to your husband. But you need a hospital."

"I can't," Celeste cried.

Then, as she spoke, the shard of glass slid out of her face. She didn't gasp until it hit the floorboard and shattered.

David hit the gas. "I know where we can go."

10

As they unloaded onto Rose Avenue, they heard a whack and saw, over the top of the barbed wire lining the brick wall behind them, a tiny white golf ball sail deep into the night sky. Then a muffled thud.

Penmar golf course was the last of the public courses.

In 1923, it was the land David's grandparents were farming when his dad was born.

David pushed the buzzer under #2 — Magwili.

Keith Magwili — part Filipino, Chinese, Japanese, Portagee, Polynesian — was your typical Kanaka. In their senior year of high school, Keith won the lottery, or almost did, but almost counted since it was for the draft, so he joined the Navy and became a medic's assistant. When he got out, he became a paramedic.

An angry, fuzzy voice buzzed over the speaker.

"Keith?" David answered. "It's Dave. Buzz me in."

When they got to Apartment 2, it wasn't Keith Magwili standing in the doorway. It was a thickly muscled, pot-bellied, balding blond white man in grimy sweats, stained green at the knees, a beer can crinkling in his stubby fingers.

Strapped to his back, held by two thick leather belts cinched diagonally across his chest, seemed to be a wafer-thin, coffee-and-God-knows-what-else-stained twin mattress.

"'Dave's not here'," he slurred, a mischievous look in his eye. He stood in the doorway smiling at them.

David knew the reference. Cheech and Chong's first album.

The voice was familiar. High and raspy and smelling of alcohol, an older version of someone he'd played with…

"Pudge?"

"Take a bleacher lap, bonehead!" Pudge yelled then put a finger to his lips. "Oops. Shh. How ya doin', Dave?" then he shook his hand the old-fashioned way, grabbing thumbs.

Calvin "Pudge" Clark, Keith's bud since high school, former star running back for the Venice High Bee football team, one of those tough-as-nails diggers it took no less than three defenders to bring down, the kind of runner every lineman likes to open holes for, looked more like Pudge-and-a-half now, packing well over two hundred pounds on his five-foot-four frame, most of it jiggly.

"Pudge," David said, "we need your help."

"Sure—hey, what happened?" Pudge backed up into his mattress as Greg carried Celeste in. "Greg?"

"Where's Keith?" David closed the door behind him.

"He's in Hawaii," Pudge stared at Celeste. "Oh wow, she's bleeding like shit."

"He's in Hawaii?"

"Yeah, he married Margie Sakaniwa, you know. They got in on his uncle's big ol' farm, but it's crowded—Hey!" Pudge pointed wide-eyed at David. "What're *you* still doin' here?"

"Trying to leave," David said, holding a T-shirt to Celeste's face.

"Oh wow," Then he turned and yelled, "Hey, honey!—Oh, hey, honey," Pudge smiled at a tiny Asian woman in the doorway to the kitchen. "Guys, my wife, *Doctor* Dora Clark, M.D."

Dora silently examined Celeste's face.

"Pudge, what's with the mattress?" Greg asked.

"Ees my job, mon. Ball retriever on the driving range. Just got off. You gotta take your bucket and mattress home with you or they'll steal it. Oh, honey, these are two of my old Bee football

buddies from Venice, Dave Takeda, Greg Wiley." He looked at Greg quizzically. "No, I didn't play with you. Or Johnny."

"Take her into the kitchen, please," Dora said to Greg.

"Hey, so where's Johnny?"

"He got nailed on the freeway today," David said.

"Awww, man," Pudge kicked a pile of empty beer cans out of the way and sat down on the couch, his mattress folded up around him. He put his head in his hands and rubbed what was left of his hair. "Awww, man," he looked up with eyes more reddened. "What has fuckin' happened with this country?" he croaked and slammed back into the couch, shaking loose a pinch of stuffing that floated to the floor.

"Man," Pudge flung his arm out at Greg coming back from the kitchen. "Johnny was a lousy football player, but he was a good guy."

Pudge sat there splayed out on his working mattress and stared at the ceiling that always reminded him of gold mountains on the moon.

He waited. Expecting an answer at any moment.

He finally looked at them and said, "Let us pray."

Pudge clasped his hands tightly and screwed his eyes shut.

David and Greg both bowed their heads and waited.

And waited.

They finally heard the low rumble of guttural snoring.

Looking up they saw that Pudge had passed out, head slumped to one side, hands still clasped.

Dora glided in and calmly unbuckled the straps from the mattress and slowly rolled the snoring Pudge onto the couch. She unfolded a blanket and covered him with it.

"Why are you here?" Dora said without looking at them.

"We thought Keith would be here," David said.

"No, I mean why are you still here in town?"

"I'm on my way to Manzanar."

"And is your friend also reporting?"

"Yes."

"Let's get her stitched up then," she picked up her medical bag. "Come on, I'll need your help."

Three hours later, Dora flopped down on the living room couch next to David.

"Calvin didn't go out, did he?" she looked around.

"No," David smiled. "He and Greg crashed in the den."

"Now he'll really be confused," Dora vigorously shook the fatigue from her head and dragged one of her medical bags up onto her lap. She held up three blue vials. "For the pain, no more than four a day."

"Thanks."

As they sat next to each other in silence, David wasn't surprised that Pudge had married an Asian girl, no more than any of his friends were surprised that David had married a white girl. Or that Frank Gonzalez married Greg's sister, or that Keith Magwili married Margie Sakaniwa. Everybody in Venice was light brown. "What are you?" was becoming a complex and irrelevant question. With Asians, David usually narrowed it down with a few food questions.

"How are you guys doing here?"

"Okay, as long as the water holds out," Dora shrugged. "Or until they start rounding up Jews, too. Then I'll have to find a new husband."

They sat slumped on the couch, shoulders touching, staring straight ahead at the TV that wasn't on.

Dora was tired, a good tired, like the end of a double shift at the emergency room. She glanced at a clock.

"Hmm, kinda late for a shower. But I can't sleep with a day's dirt and grime on me."

"I can't sleep with clammy feet."

"That's a Japanese thing, bathing at night, isn't it?"

"I think so," David said. "Or a manual labor thing."

"Yeah," Dora sat up. "I doubt if coal miners work all day in the mines, come home, eat dinner, watch TV, relax, then go to bed all covered with soot, then get up in the morning, take a shower, burn the sheets and go back to work." She pushed herself up, grunting, "*Ok—kosho.*" She said it like his mom.

Dora began taking out small tuppers and yogurt containers from the fridge. "Hungry?"

David rolled off the couch and staggered over to the kitchen table, then stood in shock.

He couldn't believe this spread. It was like being at Grandma and Grandpa's on New Year's Day. Sashimi, *cha-shu*, teriyaki chicken, octopus, flank steak, *sunomono*, *mazegohan*, *gobo*, *nori-maki* and, of course, footballs and macaroni salad.

As she fixed him a plate, he gazed in wonderment. "How did you get this? Isn't most of this stuff banned?"

"You can find a reasonable equivalent in most Asian food stores," she steered him back to the couch. "*Tabenasai.*"

She handed him *ohashi*, not the disposable chopsticks you break apart. The shiny, lacquered, souvenir kind with an orchid painted on the side.

"*I-tada-kimas',*" she said, the way her dad had begun each meal, and watched him dig in.

"The only thing hard to find is short grain rice," she said, nibbling on some sushi. "Mochi rice is impossible, or I would've made *ohagi* or *sekihan*. The red rice with *azuki* beans? But that's for celebration. This is my little protest against the evacuation."

She always enjoyed watching men eat.

"Or *yokan*. That's nonexistent anymore."

"You're killing me here," David managed to gurgle, pushing out thoughts of *ohagi*, the pounded sweet rice and *azuki* confections his mom used to make, or *yokan*, the red *azuki* or green lima bean jellied slices on New Year's Day.

When he came up for air, he asked, "Why didn't you and

Pudge go to Hawaii with Keith and them?"

"I have no intention of leaving."

"Ohhh. Yaka-head."

"Stubborn as a mule," Dora laughed. "I didn't think anyone outside of my family said yaka-head. Definitely not proper Japanese." She shook her head. "My dad, boy, this would've killed him. Mom, too. How about your folks?"

"Both dead."

David had done so many eulogies he just assumed there weren't any Niseis going back to camp.

Dora reached over and took his hand. "Who else?"

"I've got my brother's ashes in the van. Yesterday. On the freeway."

"God, I'm sorry."

He shrugged. Move on, please.

"Cancer got both my folks," she said.

David hadn't discussed his mother's death with anyone, not with Kate or Johnny or his dad.

"Five years ago, my mom was shot during a car-jacking."

He stared at her hands holding his.

"These fucking assholes…" he shook his head, not wanting to remember the stupidity of murdering thieves. He pulled his attention back to the food. "This is great. *Oishi*," he smiled. "When there still used to be salmon, my Uncle Kiyo would bring some down from Seattle and my mom would salt down the eggs and make *suzuko*, the *kasu* kind, soaked in sake curd. She and my aunties were the best cooks. They learned it from my grandma. All of our family gatherings were like New Year's Day."

Dora saw that although he never looked at her, he was quite animated, which surprised her since she had assumed he'd be like her father, stiff and uncommunicative—that was what all the Asian men in her life had been like.

"Dad only lasted a year after that. He put up a strong front. But you could tell he was…incomplete without her."

It suddenly struck David that he would never have a home-cooked meal like this again.

Like the ones his mom and aunties and Bachan made.

Ever again.

He cleared his throat. It was difficult to swallow. "Thank you," he put his empty plate down. "Gotsosama." He wanted to say more but could only say, "This is really nice," before he had to look away again.

Dora was about to correct his pronunciation, then changed her mind. There'd been too much correcting lately.

It was kind of nice to hear a Sansei mispronounce something again, one last time, instead of the stick-up-the-ass proper Japanese.

The way they'd learned and misheard things as kids, all the Nisei slang that came out of Hawaii and World War II, was like a dying language from a disappearing people.

Her dad was named Takashi. Everyone called him Tak, pronounced tack, because he was a Nisei.

Instead she wrapped her arms around David. She pulled him to her and held him.

David felt the warm softness of her breast against his face and thought, *This is heaven*.

He hadn't been held like this by a woman since, since…

He broke away from her, pretending to have to cough. She took his face in both her hands and looked directly into his eyes. It was like looking into a mirror.

He felt her warm hands caressing his face. Her breath smelled familiarly and sweetly of *takuwan*, daikon radishes pungently pickled in salt and sugar and vinegar. He suddenly realized his hands were resting on her waist. He leaned forward slightly and kissed her.

She was surprised how soft his lips were. How bristly his stubbled face was. How his tongue tasted of chili pepper and shoyu from the *gobo*. She pressed her body against his.

She was firm and soft beneath her dress. Her neck was salty

from sweat. Her bare shoulders smelled of Ivory soap and strawberry shampoo and, despite having labored over Celeste's wounds for hours, she tasted fresh and sweet.

Then just as unexpectedly, they broke apart. Unheard and unseen, a light flashed, a whistle sounded, stopping them.

"It's all right," she said.

She hugged him and when he tried to let go too soon, she hung on tighter and squeezed the breath out of him.

It was odd. She had never felt sexual with an Asian man.

Friendly, sisterly, familiar. Like best friends, it never occurred to her to be intimate with an Asian man. There was too much resemblance to her father, and she would understand if he wasn't attracted to her because of her resemblance to his mother.

She tried to read his feelings through his eyes but all she saw was regret.

Passing ships and all that. Who'd never meet again.

Greg latched the gate lightly behind them as David carried Celeste to the van.

It was early, hinting at sunrise.

A sharp tick and a golf ball sailed up into the musky, brown morning sky.

A silent second later, it thudded against a mattress strapped to someone with a job.

11

As she peered into the darkness and tightened her grip on her daughter's hand, Kate had the feeling that she had made a serious mistake, not only by ignoring her first instinct to flee the country when Executive Order 9066-A was just a rumor, but with her whole life.

Hot desert sun flooded in from the doorway behind her. Dust-lit lasers pierced through the cracks between the boards of the ceilings and walls of her assigned barracks.

This didn't look like a family barracks. Her mom told her how when they first arrived in April 1942, they had to make their own walls, but Kate couldn't see any blankets strung up to cordon off sections for families. Only rows of lumpy cots, filled with snoring, snorting lumpy men.

"Close the door!" a hoarse voice croaked from one of the lumps. "I'm trying to sleep!"

"Mommy…" Mary tugged at her hand.

Kate picked up her suitcases and Mary's Disney backpacks and crept quietly outside.

"You okay, hon?" Kate was concerned about Mary. She hadn't spoken much, only hushed one-word answers, since they had left the house. The train ride was long and hot. All the medical pre-

cautionary tests were more traumatic for the adults than the kids, who were used to giving blood or urine on command.

She saw Ray—and Graham!—trudging toward them through the dust, overloaded with their suitcases, followed by a short, dark woman with sunglasses and a large straw hat.

"I found it," Kate said, as cheerfully as she could.

"Yeah, look who I found," Ray jerked a thumb at Graham scuffing along behind him, headphones blasting. "This is Annie," Ray nodded at the fortyish, Hawaiian woman.

"Howzit, seestah," Annie took Kate's arm and steered her away. "You no wanna stay heah. Dees da men's barrack," she pinched her nose. "*Kitanai.*" Then as a warning, "Kinda *abunai*, too. Mo safe ovah heah. Come on," Annie took Mary's hand and they started walking slowly toward the east end of camp.

"Honey, wait," Ray set Kate on the first step and put both hands on her shoulders. "I had them look up Dave and Johnny on their computer. Now, this might be wrong, but…"

Kate hated getting bad news from Ray. It made it harder for her to want to listen to him at all.

Ray took a deep breath and said, "Their computer says John was reported killed yesterday. Dave's missing so he's got a warrant out for his arrest."

"I knew it," Kate mumbled. "I felt it on the train."

"It's just a police report so let me check it—"

Ray jumped at a buzzing sound he thought was a wasp but it was the noise coming from Graham's headphones.

Graham was shuffling in the dirt to the music.

"Gray," Ray caught his son's eye and pointed to his ear.

Graham lifted one speaker halfway off his left ear, still shuffling and bobbing.

"We think Uncle Johnny might be dead…" Ray started.

Graham stared at Ray with dull, apathetic eyes. Ray thought he saw Graham smile as he started bobbing and chanting, "I capped a Jap, it's my patriotic du—"

The back of Ray's left hand caught his son flush on the jaw-bone below the ear. The force of the blow lifted him off his feet. He landed on the other side of his face, three yards away from where he had been standing, his headphones and player tumbling past him.

Ray was on him so fast, Kate had no time to react.

He lifted Graham to his feet by his shirtfront, popped the CD out at Graham's feet and stomped on it.

"Your Uncle Johnny's dead," Ray hissed, inches from his son's face.

Ray vowed that his kids would not behave like spoiled little punks because no one ever taught them that there were consequences for their actions, especially for the smart-ass things they said. Life wasn't a stupid TV show.

But he saw, increasingly lately, that he was in danger of losing his son.

To ignorance, to indifference, to propaganda.

To this rude, stupid world.

He knew he was losing him and that scared him mightily.

If Graham had put on his cool, don't-give-a-shit face, Ray would've killed him on the spot.

But fortunately for Graham, a rare display of emotions surfaced on his normally exclusory face, specifically fear and regret, so he lived another day.

"Sorry, Gray," Ray swatted the dust off and straightened Graham's shirt, "but your Uncle Johnny's dead, and your mom needs comforting now."

Graham took a few tentative steps toward Kate.

Kate held out her arms.

Graham ran to her and forced an audible "I'm sorry" through the buried tears.

Kate kissed and stroked her son's hot, short-cropped black hair, murmuring, "That's okay, baby, I love you," as they got up and followed Annie and Mary.

Ray kicked himself every time he turned into his hard-ass old man. He also found himself grateful that Gray hadn't said "My bad" as a form of apology, which would've set him off again.

Ray picked up Graham's CD player and headphones and jammed them into his shirt pocket.

The CD he stepped on again and ground it into the gravel.

12

Greg hated driving in L.A., especially during the day when it was easier to see that he was, and could be pulled over for being, a black man driving in L.A.

A hostile black man with a don't-fuck-with-me attitude and I-may-be-a-killer-or-a-jazz-musician shades.

But Greg had to drive because David had been up all night. Greg didn't want to tell him this, but he hadn't driven a car since the first Bush Administration.

Worse, they were in Santa Monica, which had more really old people, completely lost tourists and obnoxious little rich pecker-heads per square block than anywhere except Westwood, which had obnoxious little rich college peckerheads whose lawyer-doc-tor-studio exec fathers couldn't get them into SC or Stanford or some place with contacts that would guarantee them a job after graduation. Snotty boys who'd sue you for breathing, although the litigious atmosphere in Westwood was tempered slightly by the presence of gangs cruising in high-quality automobiles, who, if involved in a minor fender-bender with Biff or Todd, would smoke Biff or Todd like a lox before he had time to get huffy.

Greg kept one eye in the rearview mirror as the little bastards dove around him like Spitfires in little Italian and German cars.

Second-generation yuppies defying the federal government's anti-foreign edict by buying themselves Porsches and Lamborghinis, those rebels.

They were chatting up the hot babe in the passenger seat, talking on their cell phone, programming their CD player, blow-drying their style-cuts. All at the same time.

"Eee—eeeeeeeee!" the little gnats screeched as they swarmed by, 200-dollar sunglasses glinting in the sun and earrings fluttering in the breeze, as they cursed Greg for daring to stop in front of them, for obeying the rules of behavior that didn't apply to these sons of the ruling class.

Sitting patiently at the red light, Greg looked around and saw chumps. Chumps in pickup trucks and station wagons; women chumps and old-men chumps; black, brown and yellow chumps who broke sweat for a living and cherished each well-earned paycheck like manna from heaven. Chumps like him. All waiting their turn while the boys of privilege went first, as always.

Officer Chuck Khountavong loved being a cop and he was lucky to have a job, which was the new national motto: Lucky to have a job.

Especially since he was passing. Passing for eighteen years younger than he was. Passing for a Laotian orphan raised by a white couple in Ohio, God rest their souls.

People remarking on his lack of accent found an Oriental Charles Khountavong Jones raised by his adopted white parents more acceptable than Chuck Yamamoto, third generation Japanese American. Charles Yamamoto, forty-eight-year-old Sansei raised in West L.A., was dead. Chuck Khountavong would make detective by his thirty-first birthday. No family, no culture, no past. And especially no Japanese blood to ruin his life. It was a tenuous existence, but with the police department desperate for recruits with no felony convictions or recent history of mental instability, he was safe, as long as Laos remained low on the totem

pole of economically threatening countries—safe, and bored, at his post by the Lincoln Boulevard onramp, watching the daily, daylong monolithic crawl of traffic onto the Santa Monica freeway east.

Lincoln Boulevard north of Pico was the armpit of the Westside. Too far north for Venice, too far south for Santa Monica, it was a two-block stretch that moved so slow it was possible, if you were so inclined to risk direct eye contact, to examine in detail the body shops and fast-food joints that rotated in and out like used tires, the sidewalks filled with dayworkers, homeless sign-holders, families pushing the family home-shopping-cart filled with possessions and small children. And in and out of traffic, hawkers with the big-selling item:

"Piss cup, piss cup, five bucks," they'd work the line, waving old, empty jumbo popcorn tubs and large Slurpee cups. "Pick it up on the way back."

Disposal was included, which meant they'd dump it in the gutter, give it a shake and start down the line again.

Suddenly the crowd half a block up scattered with the high pop-pop-pop of small-arms fire. Smoke trailed up from an open passenger window, chasing away an overly persistent entrepreneur.

No one budged from the line heading toward the onramp, not for a few warning shots.

Officer Chuck Khountavong had the shooter cuffed by the time his first backup arrived. He put him in the back seat and waited until that suspicious white minivan with the broken windshield crawled up next to his patrol car, then stepped out with his 9mm Glock.

"Both hands on the wheel!"

Greg grasped the steering wheel a little tighter.

"You!" Chuck motioned at the female, "grab some dash!"

Celeste said, "What?"

Greg, not moving his hands, said calmly, "The officer would like you to place your hands on the dashboard."

Chuck saw movement in the rear of the van.

"Everybody out!"

Geez, the circus is in town, Chuck thought, as the van emptied. We got Shaft at the wheel. This babe who looks like a Saigon hooker who got slashed recently. And this old, longhaired Asian guy crawling out of the back of their cracked-up minivan, obviously a local from Venice judging by the length of his ponytail, who looks like he might be a suspected Japanese…and there weren't supposed to be any left in town, so he'd better run a check—

"Don't I know you?" David called out as Chuck picked up his radio mike.

Chuck said, "No," and depressed the button.

"Didn't you go to Unihi?" David gave him the local name for University High School in West L.A.

Chuck released the button and put the mike back.

He walked over to David and motioned for him to turn around. They were probably about the same age, decades older than they appeared.

"No, I grew up in Ohio," Chuck said.

"Khountavong," David squinted at Chuck's nameplate. "Is that Cambodian? Thai?"

"Laotian."

"Ohh, Lao," David held his gaze a long time.

Chuck stared back at him through force of will. He was not giving him anything. No doubt, no wavering, no fear.

David had seen that look before. Mostly on women and indentured servants. It said, "Don't blow my gig."

"Hey, I'm from Ohio," Celeste called. "What city are you from?"

"Cleveland."

"Me, too, down by the stadium. How about you?"

"Look, officer," David said, "my cousin and I are supposed to report to Manzanar today, and we're going to be late enough as it is. I have our papers here." David nodded at the envelope in his chest pocket.

Chuck turned to Greg. "What's your story?"

"I deliver them. I get the van."

David played his hand. "I swear you look like this dude I played football against. From Unihi. Or maybe it was Westchester. Crenshaw?"

"I'm from Ohio. Cleveland."

"Never been there."

Neither had Chuck. But he knew he could pass for someone from the Midwest by talking louder, and enunciating.

Finally Chuck said, "You're supposed to report to Manzanar today?"

"Yeah."

Chuck stared at David a long, long moment.

"Better get going."

They scrambled back in the van.

Chuck windmilled his right arm and pointed north. "Move!"

As David passed by, he looked at Chuck.

They both knew the Man could've dusted them just to be on the safe side and if he ever took a chance like this again, it might cost him his life.

"Take care of yourself, brother."

Chuck nodded back impassively.

David wanted to apologize to this cop, for playing his fears off their future.

Sometimes someone had to do the ugly job.

Maybe next time it would be Officer Chuck Khountavong.

13

Bad things always happen on a Friday night. Saturdays are for families and dates and hanging out. Friday nights are for blowing off steam from a whole week of being stuck in a lousy job taking shit from a boss you'd like to kill.

On this Friday night, Jenny was crossing the Mississippi. It was not overflowing. Highway 20, cross the Texas-Louisiana border, on the way to Dallas, where she'd drive carefully, because it was Friday night.

In March 1989, there had been a murder in the parking lot at Mar Vista Bowl. On a Friday night.

Someone approached a car occupied by three similarly dressed and similarly coifed teenaged male African-Americans and smoked the driver.

The parking lot emptied. Mar Vista Bowl emptied. Nobody saw nothing. An arrest was made.

A year later, Jenny was called for jury duty. This was before she and David had separated and, ready for a break from work and especially from David, she reported, expecting to get stuck with some piddly-ass illegal U-turn case.

Instead she got on the jury for the murder that had happened at the local bowling alley, whose coffee shop she and David knew

served great pancakes and Spanish omelettes.

During the trial she learned the names of all the local gangs and who was affiliated with whom on the other side of town. Who controlled which neighborhood and how close it all was to where they lived and maybe she did have reason to be a little scared when those big, old, bass-pounding American cars with those angry, dark, young faces slouched down in their seats, barely peeking above the tops of the doors, staring sullenly out at her, passed slowly, slowly by.

She also learned why the courts were so backed up and why only the rich had confidence in the criminal justice system.

It was one of those cases where, if it was a TV show, the judge would berate the D.A. for wasting the court's time and the taxpayer's money by bringing such a flimsy case to trial.

Witnesses' testimony kept changing. But basically, the ballistics didn't match.

And although he was a gang member and it was time for the law-abiding members of the jury to send the message to all the gang criminals that we would no longer stand for their complete disregard for human life, in this case, the gun they'd found in the suspect's room wasn't the gun that fired the bullet into the victim's head.

Jenny was surprised it took two whole days to vote for acquittal. But once the bullying stopped—didn't these people remember Lee J. Cobb in *Twelve Angry Men?*—the arguments began and eventually the message-senders agreed they had the wrong guy.

From the beginning of the trial, the prosecutor had painted the defendant as the worst kind of predator, a cowardly parasite, evil incarnate.

Jenny had been the last juror seated and didn't see the defendant until she was in the jury box.

He was a kid. A tall kid, but still a kid. Who'd been locked up in the adult men's jail for the past year. No one from the projects makes bail on a murder charge. He looked like he'd aged ten

years. He looked like an old woman.

She had been determined not to let his appearance, or what he had undoubtedly been through after a year in the men's prison, affect her judgment. The prosecutor kept showing the defendant's mug shot when he was younger, more defiant, several pounds heavier and less completely defeated. He kept reminding them the defendant was a known gang member. Jenny knew the defendant had probably committed some crimes, and as much as she wanted to do something about the gang problem, convicting this man of a crime he did not commit wasn't going to do it. She wished the prosecutor had presented a better case, but the ballistics just didn't match.

When the verdict was read, Jenny leaned forward to get a clear view of the accused.

If he smirked and shook his public defender's hand, if he tried to be cool and not show any emotion, if he stood up and arrogantly glared at the jurors like they owed him, Jenny would have felt betrayed.

When the judge read, "Not guilty," the accused threw his head back and looked up as though he were trying to see through the soundproofed ceiling tiles, clear through to the hazy blue sky above. He covered his face with his hands and threw himself onto the table and wept. Huge, lurching sobs wracked his entire body. His public defender patted him on the back as the jury was dismissed and filed out of the courtroom.

On the steps of the courthouse, facing the beach and the Santa Monica Civic Auditorium, a cool ocean breeze fanned Jenny and another juror, an elderly black man, as they breathed in the fresh air, looked at each other and smiled.

"We were right," she said.

"Yup," he said, looking off toward the ocean. "I just hope that boy has an aunt or grandmother he can stay with, far away from here. Maybe then he'll have a chance."

She never knew if that kid ever got out of L.A. or if he became

another statistic lowering the average life expectancy of the black American male.

But at least there was a trial.

Jenny cruised through Dallas, Abilene, coming up on Odessa, El Paso, Las Cruces.

Just outside El Paso, somewhere smack in the middle of Texas, her martyrdom disappeared.

Rather then surrender herself and put both of them in the same predicament, she would find a way to get him out, so they could both resume their lives in freedom.

That is, if he still wanted her.

She'd work out the details along the way. She had plenty of time to think.

Saturday morning was inching up and all she had ahead of her was flat, arid miles of nothing and Nanci Griffith on the stereo.

Texas was the longest state in the world.

14

Celeste marveled at women traveling alone, smartly dressed professional career women with good jobs who got to wear nice clothes to work and, like everyone else on the freeway, talking busily into their cell phones. She wouldn't mind trying that. She absolutely wanted to do that—

Celeste bolted forward in her seat. She knew that guy. He was famous. Right next to their van. She knew him. She'd seen him on TV. On a prime-time network series. A star.

Darian something. Laughing into his cell phone and, despite the fact that his Mercedes 1150 convertible was not moving, his hair was blowing in the breeze, thanks to the twin eight-inch oscillating fans built into his dashboard.

"Move up he's famous I wanna say hi hurry hurry," Celeste bounced excitedly in her seat.

Celeste could barely contain herself until the cars were even and she was looking right down on him and she could lean halfway out the window and nearly touch him.

"Hi, Darian!" Celeste gave it all the teeth she had.

Darian automatically jacked up the voltage on the famous smile and looked up at Celeste.

Then, to her horror, his mouth fell open. Beneath his designer

shades, his jaw went slack. A look of disgust momentarily wrenched the cool from his face and he nearly stopped smiling. He looked away quickly, visibly shaken, leaned down to get farther away from her, and cranked his custom-designed sound system up higher.

Celeste sat back and rolled up her window to drown out the rasping, double-hernia vocals of the heavy-metal oldies the jerk was listening to, stunned at the turn of events.

She couldn't believe what had just happened. She didn't understand. This had never happened to her before.

She absently put a hand to her face and felt…bandages.

She tugged the rearview mirror around and found herself staring into the face of a disaster victim.

"Get us outa here, Greg" she slumped down. "Hit it."

"I thought I was hitting it," Greg said, as he accelerated up to five miles an hour.

She was confused. Never had she ever been considered even remotely unattractive.

Granted, it wasn't her fault and it was only temporary, but how could someone as perceptive as a successful actor be so insensitive and still be so cute?

"I wanna drive," she needed a challenge.

Greg, in danger of dozing off, gladly slid over, "Come on."

When she took the wheel, she was almost overcome by a feeling of exhilaration, of freedom, of control over her own destiny. She'd spent her entire life as a passenger. Now she was in control of where she went.

She tugged at the wheel and felt the van respond immediately. She swung back to the other white line.

She wanted to floor it just to see what kind of pickup this baby had, but since she only had about six feet of space to work with ahead of her, she yanked the wheel back and forth, veering from white line to white line. She pressed the brake and let go, pressed and let go.

She alone was in charge of this lurching, bucking, veering vehicle.

"What are you doing?"

"Just seeing how she handles," Celeste said in her best Richard Petty pit-crew drawl.

"I believe if you wait until you can get up past, say, eight miles per hour," Greg said patiently, "it might give you a better indication of how she handles."

Awakened by the lurching, David opened his eyes a crack. Deep in the bean bag chair, he got a faceful of late afternoon sun hovering above the big old-fashioned rectangular clock crowning the tallest building in the hazy brown downtown Santa Monica skyline. His family doctor, Dr. Stanton, who'd delivered David and most of his cousins, had his practice there, which he took over from Dr. Koski, who'd delivered his dad and all of his aunts and uncles.

When David heard Celeste say, "Uh-oh," and not like she'd made a driving boo-boo, he sat up.

"What's that?" Celeste asked, looking ahead of them.

No smoke or sirens, no sudden packing into one lane to go around a collision, but something was happening.

Greg spotted it.

Little homeys scurrying between cars, holding poles with small baskets.

Offering baskets.

Anyone passing through gang turf, which now included freeways, paid a toll to these walking toll booths.

At first it had been a blood bath.

When the collectors threatened or overreached with their demands or gave the passers-through the impression that their lives were in immediate danger, guns were drawn, bullets were exchanged, people got killed, which made for messy traffic jams.

Eventually a system evolved where the drivers acknowledged that, despite being on the freeway, they were in fact trespassing on

certain gang territory and agreed to pay homage with a small honorarium per visit. Most agreed a dollar-a-car was a win-win situation that provided gang members with a decent living while offering commuters an alternative to having a gun shoved in their face on a daily basis.

"What should I do?" Celeste said worriedly.

"Toss this in," Greg tucked some coins in her right hand. "Make it sound like a lot."

Celeste hoped the sweat from her hand wouldn't blunt the sound of the coins clinking into the basket.

"Yo, mama-san, whatchu got fuh me?" the Yankee Cap demanded, shaking the basket on the end of the pole in her face, leering at her.

All she could see was his brim and a dangling toothpick.

Celeste threw in the money. It barely made a sound, muffled by the bills tamped down in the bottom of the basket.

"Wha' zat?" the Cap squeaked. "What is that?"

Celeste jumped when the Cap stuck his face in the window, his toothpick nearly touching her breast. He licked his lips and was about to make her a more lucrative proposition when he saw she had a passenger.

A brother. A big brother who definitely looked pissed. Pissed, like a Muslim-who-feels-he's-being-dissed-while-in-the-presence-of-white-folks pissed.

Cap got his ass out the window.

"Go," Greg said. He loved his shades.

Celeste closed the three-yard gap in front of them, her eyes never leaving the rearview mirror as the Cap and his partners snaked their way through the moving parking lot.

Then she heard the familiar pop-pop-popping behind them.

"Stay below the top of the seat," Greg crouched down. The seat backs were reinforced with steel, which wouldn't do much good against anything Teflon-tipped, but it would stop the small caliber shit these little back-shooters used.

When the firing stopped, Celeste peeked in the side mirror and saw a dark pile of clothes on the shoulder.

It was the Cap, his pole in his left hand, the basket upside down, bills blowing away, still holding a .38 that dwarfed his eleven-year-old right hand. A quickly spreading pool of dark red blood framed the spot where he lay dying.

The Cap's partners emptied their guns into the Chrysler, into the man who had shot the Cap, the man who had decided that he would not put up with this one last indignity and, like some asshole in a movie, went out guns a-blazin'. Now he was a short delay in the number-one lane.

When the smoke cleared, the Cap's partners tucked their guns into their waistbands. One pulled out a pint. Each one said a word, raised it and took a drink. Then they emptied the rest of the bottle onto the Cap and tossed a match.

Celeste loved L.A. Driving at night was exciting and dangerous and nonexistent in the law-and-order stupor of Whitebread, Ohio. All her husband Terence wanted to do was stay home, watch the home entertainment center and have sex every night.

But in L.A. there were young people in cars, heading for the hot new club, dressed all in black and—Oh God—listening to post-industrial dissonance. She inched forward, straining to hear the maxi-pumped stereo from the purple convertible in the next lane as the little shaved, tattooed, pierced heads of its inhabitants bobbed up and down, on their way to the hot new club in the heart of industrial Hollywood that no one knows about except through word-of-hip-mouth.

She wanted to go with them. She wanted to dance. She wanted to wear a black leather patch over her scarred right eye and butt heads with her dance partners. She wanted to suffer partial permanent hearing loss in front of massive floor-to-ceiling banks of speakers as the latest undiscovered band or DJ ripped the latest

sound before a major label signed them to a multi-album contract and they sold out.

As the convertible cut out and disappeared down an offramp, she thought she heard their stereo crank out the grinding, buzzing, screeching, ear-piercing wail, but it turned out to be a solid waste disposal unit with bad brakes pulling up beside her.

"Where are we?" David said groggily from the back.

Celeste looked over at Greg, who was curled up in the passenger seat, asleep again, then up at the nearest sign.

"Western…" she read.

David was hoping she was going to say Western Barstow. Western British Columbia. Western Europe.

"Western Avenue?" he read. "It took us one whole day to get twelve miles from home?"

He was now officially late for reporting to Manzanar.

15

As David settled into the driver's seat, a horn honked. Not the usual, obnoxious refugee from Jersey leaning on his horn a microsecond after the signal changes. This was a friendly reminder.

Dit-dit...dit.

"Let's close it up there," it suggested.

To David, that friendly horn meant Dad was rounding the corner in his pickup truck and, after a long day's work cleaning up a dozen other people's yards, saw his two sons playing catch in his front yard.

If Mom didn't have dinner ready yet, maybe, just maybe, Dad would play some catch with them for a while if he wasn't too tired. And no matter how many times he had lifted his mowers off of and back onto the truck, how many lawns he had mowed or hedges he had trimmed, how many times he had washed off and rolled the hose back up and slung it on top of his truck that day, he always had time to lob 'em some long bombs or loosen up his arm and show off his ol' American Legion ball stuff. They'd play 'til the last glimmer of daylight was gone and would always be disappointed when Dad called it quits and went in to shower up for dinner.

David was just merging onto the 60 when he first noticed that Greg and Celeste had ended up in the back of the van.

David was used to being treated like he wasn't there, but not by Greg.

And as much as he and Greg had done together, fucking in each other's presence had not made the list.

David turned up the stereo.

He was zipping along at thirty miles per hour on the Pomona freeway.

He put on some Hendrix to drown out their moans and gasps and shrieking.

"He's asleep," Celeste smelled hot and musty when she climbed up into the passenger seat. "Terence always fell asleep, but he expected me to stay in bed afterwards."

David didn't know how to respond to that. He saw her picking at her bandage. "How's it feel?"

"Wanna take a look?" she slid over onto the milk crate and switched on the cab light.

David gently eased the bandage away and winced when he saw her skin stretch and cling to the tape. He was expecting the worst: mottled, discolored skin slashed apart and resewn with Frankenstein-size barbed-wire stitches. But when her skin finally let go of the adhesive, it reformed and regenerated into the relatively smooth cheekbone she had before. Dora's stitches stood out dark against her bruised fair skin, but they were tight and in place, laying out a pattern of careful needlework.

"Looks pretty good," he glanced back and forth between her face and the road, "considering how bad it looked."

"Really?" she turned the rearview mirror around. "Think it'll leave a scar?"

"Maybe not. Are you prone to keloids?"

She examined her cheek closely in the mirror, dabbing at the stitches, trying not to touch them too much. "Prone to what?"

David looked at her puzzled, innocent face. Then he turned toward her and pulled his collar down in front, revealing an ugly, dark-purple welt, like a two-inch leech planted in the center of his chest. "Something like this?"

Celeste's eyes widened. "That's what Greg has on his chest!" she said in an excited whisper.

David released his collar and turned back in his seat.

"What is it?" she asked and reached out, hesitated, stopped halfway, reached and stopped again.

"Ever hear of the Secret Society of the Scar?" he said conspiratorially. "An Afro-Asian gang whose initiation is to kill three millionaires before they brand you as a member?"

"No," she said, entranced.

"Well," he smiled, "this ain't it. It's a keloid. A buildup of scar tissue."

"From what?" she said, eyes never leaving his chest.

"Nothing."

"You must've done something. A pimple, wart, skin disease? Radiation exposure?"

"It's pretty common in people of Asian or African descent."

"Can I see it again?"

"No."

She rested her chin on his right shoulder. Her fingers lightly stroked his collar, flicking at the top.

David could smell her hair, salty with sweat, as she rubbed her left cheek up and down his neck and shoulder.

"Please?" her lips brushed his ear lightly.

Boy, she was good. David yanked his collar down.

Celeste scooted around down in front of David, her face inches from his chest. "You got three of 'em!" she whispered excitedly. "One on top of the other. Can I touch it?"

David sighed impatiently. "Go ahead—Ow!"

"I'm sorry, I'm sorry, I'll be more careful."

Celeste delicately stroked the three horizontal welts on the center of his chest, staring in fascination.

"I once saw this exhibit on A-bomb survivors," David said. "They had keloids removed from victims' bodies preserved in jars. Big, ugly things."

"Is it contagious?" She didn't recoil too suddenly.

"It's just scar tissue. There are tribes in Africa that use hooks and needles to create designs with keloids."

"Eeyuuu."

"Kinda like 3-D body art."

"Ohhhhh."

He'd seen enough decorative holes in young girls' bodies at the record store to know that would impress her.

David didn't mean to, but he gasped when Celeste leaned forward and kissed his keloids. All three of them, slowly, gently caressing them with her lips and a flick of her tongue.

She pushed herself away and sat back in her seat.

"Cool," she pronounced, and wrapped her arms around his right arm and pressed his hand between her soft, damp thighs and curled up to sleep.

As they got farther and farther out of town and picked up speed past fifty miles per hour, a strange sense of peace started coming over David. Not only was he leaving L.A. behind, but he was leaving all his troubles, all the day-to-day, minute-by-minute worries that come with living under siege.

A huge burden was slowly lifting off David's shoulders. He would no longer have to worry about getting robbed, bombed, shot, stabbed, kidnapped, harassed or otherwise abused every time he left the house. He wouldn't have to go anywhere.

By the time he saw the sign for Ontario and turned north onto Highway 15 over the mountains, the poundage of L.A. living was lighter than the ponytail on his shoulder.

Then he saw the billboard on the overpass. Across the top, lit up by a half-dozen floodlights, in thick, bold print it read:

JAP BURNING RALLY & SWAP MEET
EVERY SAT & SUN COUNTY FAIRGROUNDS

Below it, an amateurish illustration of a bonfire stacked with television sets with slanty-eyed dials and bucktoothed speakers and little cars with bucktoothed grills and tight-eyed headlights with thick glasses.

To one side, the Statue of Liberty wielding a sledgehammer.

On the other, a sleeveless Uncle Sam with massive, buffed arms holding a flamethrower in one hand and a chain saw in the other.

"God's country," David said quietly.

Sun was barely peeking over the mountains by the time they merged from the 15 north to the 395, heading up to Death Valley, past the Air Force base, Greg at the wheel.

David sat up in back with Celeste, watching carefully for the first opportunity to exit the freeway, but it was still too city, too close to the spillage of civilization.

Celeste clung to David's arm. She was proud of her newfound courage, shaky as it might be at the moment. She had traveled across the country and found David and Greg, been wounded and probably scarred, driven through L.A., and now they were almost there—almost to Manzanar—where she truly didn't know what to expect.

She felt safe with him. Safer than she had felt with any other man, and this one had no control over his life.

He kissed the top of her head, all over her fragrant, sweat-tinged hair.

She drew her legs up into a tightly curled ball and burrowed her face into his chest.

He enveloped her with his arms and legs and face. He

squeezed her tight. He wanted to squeeze her right into his body.

She felt dampness on her face. A warm trickle down her cheek and onto the corner of her mouth.

She tasted it. It was salty. A tear.

It couldn't have been hers. She didn't cry anymore.

She felt a warm, overflowing feeling welling up inside her, a rush of heat that started deep in her stomach and sprayed out to her toes and up through her chest and took her breath away, unlike anything she had ever felt before.

It wasn't physical. It wasn't sexual. So she didn't know what it was.

Then she started crying. Softly at first. Then in huge, silent sobs that convulsed her entire body.

She buried her face into his chest and he held on for their lives.

Greg saw it as he came over the hill. Miles of flat desert and at the bottom, a small road going off toward the mountains on the left, the Sierra Nevadas, past Sequoia, past Inyo. If they didn't do it now, they'd be at Manzanar.

"Is this it?" David called softly.

"Yeah," Greg turned onto the small road toward the low purple mountains lining the horizon of the barren flatland.

David's shirt was soaked wet under Celeste's peaceful face. She clutched a handful of his T-shirt in her tiny fist, a spiderweb of creases across his chest.

Greg went all the way up to the top, where the road turned into a small cropping of rocks.

They were on the crest of another valley running up to the Sierras, the largest bowl of oatmeal in the world.

The dull, purple mountain rim stretched around them like the edge of forever: flat, empty, brown, beige and pale yellow cut in two by the two-lane asphalt highway.

And if they hadn't been blown away by the immense, barren vastness engulfing them, they might've noticed the brown sedan

turning off behind them, onto the road they had taken.

David blamed himself for not noticing they were being followed.

Greg blamed himself. He was driving.

But they were both looking for the best place to scatter Johnny's ashes, which they were able to do, before they were captured.

Earthquakes. Early in the morning, while he was still asleep. Been through so many he just waited for the first one to pass, roll over and sleep through the aftershocks.

Bouncing on cold, hard metal. Back of a truck, in a cage. Wrists manacled to a chain around his waist.

Felt like he had a nail stuck behind his right eye. The one that saw the police baton coming down.

David lurched himself upright. He spat out the mucus and blood clogging his nose and throat.

Air coming through the cage was hot and dry. Desert air.

Two uniforms up front, wearing hats. Not prison guards. Khaki. Army. U.S. Army regulars.

"What happened to my friends?"

"You lucked out, *ese*," the young Latino corporal riding shot-gun said. "By the time we got there, your buddy, the brother, was almost dead. Took a .45 in the chest. He went to a prison hospital 'cuz he gots warrants out the wazoo. FBI took that fine-looking broad back to her husband in Ohio. And you could be going to jail cuz you got a warrant, but we're taking you to…there."

He nodded up ahead, mountains rising to the west of a small patch of bungalows on the outskirts of a city of barbed wire fences and guard towers that stretched across the desert.

David's duffel bags lay beside him, zipped open, the contents rifled, anything of value gone.

He looked down for the silver feather mounted on a lapis globe hanging from a leather cord around his neck.

In its place was a wire twisted to a thick, beige tag.

PART TWO

SWEET HOME

16

David wished he could remember all the words to just one Nanci Griffith song. But they all came back to him in rushes, flying in and out of his brain in brief, incomplete flashes. He could hear her crystal-clear voice and her delicate melodies, but her words came to him like an AM radio station fading in and out.

All those years working in record stores were wasted, too, but that had more to do with the quality of music released in the '90s. Not one memorable tune or set of lyrics. Not one song that he could remember, although that may have had more to do with his age, but he doubted it.

Instead, he could only remember the words to songs he hadn't thought about in years.

Songs from his adolescence, by obscure artists who only figured in the diehard's history of rock 'n' roll. "You Were On My Mind" by We Five. "Girl Don't Come" by Sandie Shaw. Dobie Gray's version of "The In Crowd."

When he was growing up, his mom and dad had an old-fashioned record player with the heft of cast iron and an eight-pound tone-arm with a needle resembling a wood staple.

All of his parents' record albums were exactly that: big, thick, cardboard-covered digests resembling a large photo album with a

picture on the front and paper sleeves with holes in the middle so you could read the labels on the dozen heavy, black 78 rpm platters.

His mom and his aunties' favorite was Rodgers and Hammerstein's *South Pacific*. They had written the lyrics in pencil on stenopads and kept the sheets in each record's sleeve, even "Dites-moi," phonetically (approximately) since they didn't know French.

Lyrics or no, as David began his daily ritual in the westside men's latrine, he would sing just to drown out the loudspeaker announcements. Tinny, barely decipherable blurting over little horns like the ones in school or at the carnival. Daylong announcements for children's activities, school, dance, music classes, Japanese school, prayer groups, support groups, groups designed to help residents adjust to life outside camp, in the new non-Japanese U.S.A. And movies.

"Today's triple feature video showcase begins at 5:30 in the recreation hall with *Across the Pacific*, directed by John Huston, starring Humphrey Bogart and featuring Keye Luke as a Japanese spy, a Nisei who went to UCLA. Also showing, *Black Rain*, starring Michael Douglas as a tough New York cop who goes to Japan to fight the Japanese mafia. And as always, every night ends with the Jerry Bruckheimer blockbuster, *Pearl Harbor*, a stirring story of love and bravery. Another reminder to all readers, there are still plenty of copies of Michael Crichton's *Rising Sun* in the facility library. Read the book, see the movie…"

Every morning after the second breakfast shift, David would walk out of the mess hall to the southwest end of camp, unlock the maintenance shed and gather his supplies: pail, cleanser, long-handled brush for the toilets, small round brush, flat scrubbing brush and old-fashioned string mop for the floors, two triangular plastic Wet Floor signs and thick rubber gloves. He'd take his supplies to his place of work, latrine number four on the west end of camp, where he was the maintenance supervisor.

Originally he was a simple maintenance engineer, but after

the first week of scrubbing toilets, David noticed that he was the only one maintaining this particular facility and, when he asked a uniform if there was anyone else working with him, was immediately promoted to maintenance supervisor and given a two-chip-per-week raise.

In the beginning, some uniform with stripes would inspect his work each afternoon, put on his white gloves and stick his head into each commode and sniff around while David stood by like a maitre d' waiting to get greased. When the uniform was satisfied, he'd sign a form in triplicate and give David the green copy, which David would exchange for credit chips.

The first to go was the form in triplicate, then the daily inspections, then weekly inspections and eventually the duty of latrine maintenance and inspection became one strictly on the honor system. The uniforms figured they'd hear the complaints when it got too disgusting.

Or, more likely, that the residents themselves, being Japanese, would keep their facilities clean if not sterile.

While not a glamour job like kitchen patrol, toilet scrubbers earned the most credit chips except for scorpion patrol, and all the headbanging high schoolers had snagged those jobs, getting paid for doing something they were doing anyway—killing any little pests that made the mistake of wandering under the fences, not realizing until it was too late where desert ended and camp began.

David would start at the far end of the latrine, blocking off the last twelve of the thirty-six commodes and two of the six horse-trough urinals. If he was lucky, no one came in to take a giant dump until after lunch.

He could now work through anything, even the stinkiest case of the runs. He'd just light a cigarette and breathe through his mouth, which was another reason to support whatever actions the Rice Committee took, if not simply to improve the quality of bowel movements.

It was actually a good job, cleaning toilets.

No one hassled him in there. No one came in unless they had to. He believed it was the Lysol that kept them away.

When David first began scrubbing the latrines, if he started singing out loud, a trustee would stick his head in the door and tell him to shut up.

At first David did. Back then, it was against the rules to sing anything but Japanese songs. Lillian had even hired a Japanese teacher to teach the residents Japanese songs. The teacher turned out to be this Yonsei girl who learned her *Nihongo* at Torrance High and the only Japanese song she knew was *"Kimigaio,"* the Japanese national anthem, and *"Sho, sho, sho jo ji,"* a children's song everyone knew, which turned out to be on the unapproved list. By then, she had wangled a sponsor up in Toronto, said adios to Manzanar and split. The only other qualified music teacher was Ozzie Lewis, who knew *"Kokonisachiari"* phonetically, but it was banned, too, because it was Japanese and a love song, and eventually he was happy to get anyone besides Bradley to come to singing class. So they ended up singing show tunes.

Despite the blatancy of the act, singing out loud in English while scrubbing toilets was not worth enforcing. Most of the everyday enforcement of camp rules was left to the trustees, fellow Japanese American internees who ratted people out for extra privileges, credit chips and passes, wink-wink-nudge-nudge with the guards around the high school girls' barracks.

Occasionally a trustee would yell at David, but being the only one willing to scrub toilets for a living had its advantages; once he started pouring the Lysol and began scrubbing, no one came in who didn't absolutely have to.

He grew bolder, singing out loud even when there were others present. Maybe it was the acoustics.

Although this was no prim and proper private lavatory. No tile floors and walls and ceilings. Or running water. Or dividers with doors.

Their latrines did flush. An ingenious yet simple way of, first, storing and heating water from the creeks in a series of storage tanks above the showers and kitchens. Then all the dirty water was used to flush the day's waste through a larger canal out into a treatment facility a mile and a half east into the desert. The liquid treated waste was dumped back into the Owens River, the solid into huge settling ponds.

It was designed by a twelve-year-old engineering whiz, whose Yonsei father parlayed it into a one-way ticket to Switzerland for their whole family.

No, his latrine was guys stepping on the throne, dropping their drawers, sitting down and opening the sports page and taking a dump in full view of anyone in the vicinity.

More importantly, his latrine was no gang hangout, no place for the vultures to prey on little kids who just needed to relieve themselves in peace. Harking back to a safer day, the public restroom, his latrine, wasn't a place where predators could gather and wait.

"You done?" he'd stalk menacingly toward any dawdlers, his long-handled toilet brush still pungent and dripping. "You finished with your business in here?" and they would scamper or saunter away.

Here, at his job, he was in charge of his little kingdom.

So David sang. Out loud. Which he never could do safely on the outside.

The only danger was taking a lungful of disinfectant, which he used in large quantities to get his latrine clean.

Not just a whiff or lingering odor. It was an ever-present, choking, industrial-strength hovering cloud of Lysol or any of the other sinus-numbing germ-exterminators his mother used to clean the toilets.

Every time he went over to Mom and Dad's house, the home he'd grown up in since he was two years old, as soon as he walked through the back porch, it would hit him. Burrowing up his nasal

cavities like a poisonous gas cloud. He didn't need to look into the bathroom to know that the toilet was freshly scrubbed and wallowing in Lysol.

A thorough scrubbing with Ajax wasn't good enough. The offending bowl needed to luxuriate in disinfectant a good half day to exterminate any lingering potential germs that had dared survive.

He hated the smell of Lysol.

How ironic then that he ended up here in Manzanar, and his primary daily responsibility, outside of learning how to be Japanese, was scrubbing toilets.

17

Every morning before he started his latrine duties, as he had done every morning for the last ten months, David took a seat at the same table in the back of the drafty west end mess hall at the beginning of the first breakfast shift, away from the mothers hauling their screaming kids in after a long night in the barracks, to check out the new faces. Retreads mostly. After almost a year of ReVac, all the JAs that had tried to make a start in Japan or Brazil or Canada couldn't and came back. Their new countries, whose economies were tanking worse than the U.S.'s very politely encouraged their recent mass influx of refugees to turn around and get the hell out.

It also meant that every morning David had to sit through Lillian's salutatory address to the incoming inmates—uh, arriving internees—uh, temporarily relocated voluntary residents—whatever.

"My name is Lillian Bunkum. I am the Executive Director of this Temporary Relocation Center. I want you to call me Lillian, because this is, after all, your new home."

Then she smiled and with all her might, tried to hold that smile as long as she could before getting back to the business at hand.

"In accordance with the provisions of Executive Order 9066-A,

this is TRC 1A, Temporary Relocation Center, Number 1A, the Manzanar, California, facility. It is my sworn duty to maintain the legality and integrity of…"

If David could find Celeste again, he knew that just seeing her, knowing she was alive, having her near, being able to touch her once more, would somehow save him. That after nearly a year of scrubbing toilets and trying without much success to learn Japanese, finding Celeste was his only hope for salvation.

"There are no free rides here. Your housing, utilities, meals, lessons are being generously provided by the American taxpayers but not at their expense. You must earn credits by performing specific duties in maintaining the upkeep of this facility for which you will be paid in credit chips that may be exchanged for goods at the base PX."

Lillian caught herself shifting into drill instructor mode, so she stopped and bared teeth again.

"Because after all we are a family here and this is our home. Right now, I want you to think," Lillian's soothing voice echoed to the back of the mess hall, the steady gaze of her steely blue eyes scanning the tables lined with huddled masses of blankets and black hair, down jackets and yellow skin, dishonest shifting gazes that never looked you in the eye. "Think back, and try to remember a time in the not-so-distant past. A bleaker time, when the future of this country was truly in jeopardy. And I want you to ask yourselves," Lillian queried gently, "Is this country better off now than it was then? I think we all know the answer." Lillian eyed the roomful of black heads in front of her for a glimmer of acknowledgement. "We're all…" she nodded her head in affirmation, searching for the slightest bob of the head in agreement with her, even if they weren't looking up, "…better off. Yes, we are. But we must always remember that this is a temporary relocation center, and that the purpose—your purpose—here is to move on."

David used to be a night person. If he could follow his own body's clock, he'd be up until three or four in the morning and

sleep 'til noon. He definitely wouldn't be up at the crack of dawn, waiting for "Reveille" and mouthing the words of a speech he knew by heart.

"And in order to move on, you must learn to fit in. To fit into a new America that is entirely non-Japanese. Or as Japanese anywhere else but America…"

David had tried, but he was just too old to learn another language. At first he went to class religiously every afternoon after he finished latrine duty, but something prevented him from catching on. He was no closer to passing for Japanese now than he was back then.

Unfortunately for David, being the grandson of Japanese immigrant farmers who passed down their memories of a Japan that no longer existed (and probably hadn't since the turn of the nineteenth to the twentieth century), his entire concept of what it meant to be Japanese was out-of-date.

Worse, all his memories were unacceptable: They reminded him of his previous American, or worse, Japanese American, past; and thus worked against his new transitory status.

Occasionally something sounded familiar. A phrase that rang a distant bell in his faded memory. Something he remembered an auntie saying to him when he was small. Or his grandmother in her kitchen. None of which he remembered now. None of which was relevant now. Only those memories that were specifically, correctly Japanese were acceptable.

For that, they needed lessons, from which David retained nothing and started finding reasons to skip class until finally he stopped going altogether.

When Lillian started talking about volunteerism, David snapped his blue, knit watch cap into place and hurled himself out the exit door. He could see the new arrivals from the flagpole if he needed to.

The crackling cold spanked his cheeks and stung his eyeballs before he took two steps away from the mess hall.

March in the desert, up against the Sierra Nevadas, meant snow and harsh cutting wind—colder than anything David had lived in before.

Two older Sansei dads, probably his age, who used to perform this ceremony in Boy Scouts with their sons, buckled the American flag to the rope running up the flagpole in the compound, then stood at attention and stared up at Mount Williamson and waited for the bugler.

When David had asked his father why he and the other Niseis fought for this country in World War II, when their families were still in camps, his father said, "You know *bushido*?" David only knew it from the movies, something bad when John Wayne was going up against the maniacal enemy.

Dad said, "*Bushido* doesn't mean dying for the Emperor. *Bushido* means loyalty to the flag you were born under and owe allegiance to," and pointed to the American flag. "That one."

David peered through the plastic film into the mess hall.

He never understood why Buddhaheads, his parents and friends and family, always did things in large groups that either made them look like a busload of tourists, or, now that they were surrounded by barbed wire and guard towers, like people who were all probably guilty of something.

David saw one of the trustees, standing like a shadow behind a guard, reach out and smack an antsy kid on the back of the head. The mother glared at the trustee but didn't say anything. The guard laughed approvingly.

At least the mom didn't hit her kid for causing trouble.

David wondered, just to exercise his brain, if any of the trustees differentiated between the flag and the Constitution or Lillian and the government or if it was all the same to them. Not that it mattered anymore.

David was about to leave for work but stopped when he saw Ozzie Lewis, the hakujin music teacher, dash out of the latrine, holding his trumpet with one hand and his pants up as best he

could while running with the other. His face was dark red against his silvery gray hair.

The machine gun in the tower, sights trained, followed him across the yard. If he wasn't white, they could've blown him away for running toward a fence. Or the trustees could've kicked the crap out of him for being late, or running.

David reluctantly unpeeled his cap from his steaming head and held it over his heart as Ozzie skidded to a halt and began breathlessly tacking "Reveille" as the Stars and Stripes was raised within the barbed wire compound.

Ozzie Lewis' father taught at the first Manzanar. He was a Quaker who had visited the camp with his congregation and decided to stay for as long as there were children who needed a teacher, which turned out to be the duration of World War II. When ReVac was announced, Ozzie had cut through the bureaucratic red tape to volunteer his teaching experience, which now included Japanese language and music.

As Ozzie squeezed the last little geese fart out of his bugle, David saw a dozen new arrivals filing into the mess.

This was his excitement for the day, the arrival of more newcomers, but it was always the same ol' thing. Baby-boomer Sanseis and their kids. Too stupid to bail when they'd had the chance, they'd ended up losing everything in the evacuation sale, which had left them with no seed money to start over in another country. So they'd joined the overloaded cut-rate exodus to Canada and Mexico, which couldn't handle the numbers and now they were back. Just looking for a quiet, peaceful, uncomplaining existence away from the outside world, which had beaten them.

No babes. Babes always had options.

Someday a twenty-two-year-old babe with a whiskey-bottle scar on her cheek would be coming through.

But not today.

18

Mary was glad they were all back together. When Mommy found out Uncle David was in camp last summer, she was so happy. And sad, because Uncle Johnny was dead.

Mommy cried a lot that week. She and Uncle David spent a lot of time together. For almost a whole month, Uncle David lived with them in their barracks, until he said he couldn't stand the noise anymore, all those kids, and moved to the single men's barracks. By then Graham wasn't coming home from the junior high boys' hangout, and Daddy was always out looking for Graham, so it had been just the three of them.

Mary liked to watch Mommy and Uncle David together. Mommy acted younger, kinda like a little girl, whenever she was with Uncle David, who liked to tease her a lot. Mommy said that's what they were like as kids.

"You know what I found this morning?" Mommy had asked Uncle David like it was really serious.

And then she whispered to him in Japanese, just like Grandma and Grandpa used to when they didn't want any of the kids to know, "*Nezumi!*"

"Mice?" Uncle David didn't even look up.

"Mouse," Mommy said, very ashamed. "One mouse."

Mary and Uncle David followed Mommy around the corner.

"Over there," Mommy pointed.

Uncle David took one step and stopped.

It was hairy and ugly and dead. And about a foot long.

"Jesus Christ, that ain't no *nezumi*," he shouted. "That's a fucking rat!"

"Sshhh," Mommy made a real stern look and a big sideways nodding motion at Mary.

"Geez, look at the size of that thing," Uncle David broke a long splinter off the steps and crept toward the dead rat that lay stiff and openmouthed on the ground.

"Don't touch it," Mommy tiptoed behind Uncle David.

"God, it looks like some kinda mutant armadillo."

Uncle David inched closer and closer and then, just as he was reaching out and about to touch it, Mommy said really loud, "Is it dead?" which made him jump.

"I hope so," he said, breathing real hard. "I hope I'm not just irritating the hell out of it," he said as he poked the rat with the stick. It didn't move.

"Are there anymore?" Mommy looked around cautiously.

"Doesn't look like it," Uncle David kept one eye on the rat, like he really didn't believe it was really dead.

"Good," Mommy was relieved. "Maybe it was the only one."

"Nooo," Uncle David squatted down, "judging by all the tracks, I'd say this one got caught in a rat stampede."

"No, it didn't," she was trying not to laugh, "There was no stampede," Mommy started chasing Uncle David, laughing and swatting at him.

"Look at the tracks," Uncle David danced away from them, "they go right under your barracks."

"No, they don't," Mommy made that *amabo* whiney sound.

Mary ran after them both, grabbing for them with both hands and giggling like hiccups.

"Didn't you hear it?" Uncle David bounced away from them,

doing this thing he told Mary was the Ali Shuffle, from his child-hood. "Musta sounded like a herd of buffalo. The running of the *nez*. Right under your bed."

Mary liked watching them together. Mommy out of breath from laughing and chasing and swatting at Uncle David. They made her laugh. It was fun.

At first Kate had been a little jealous when she'd see Mary walking with David—how eagerly she joined him everyday for their little stroll, how she talked so easily with him.

Kate had never been a very confident person. Growing up with two older brothers was tortuous when she was young.

They'd pick on her, thankfully only after they were done harassing and chasing and fighting with each other. Then, when they were older, they doted on her. And harassed, chased and fought, if necessary, any undeserving boy who looked at her. All her dates had to pass a strict test before they even spoke to her. But she supposed any younger sister of football-playing brothers got that.

In school, if she did well and heard the snide comments attributing her success to being Japanese, she thought it might be true. She did work hard and study hard, hours a day, reading instead of watching TV. Which could be Japanese traits.

She'd worked hard to achieve. None of it came easy to her. Maybe this was how her grandparents felt.

Migrant farmers, finally able to get a long-term lease on some land where there was nothing growing before. Useless, dead land they worked and worked to bring to life, like Isseis did up and down California.

People hated them for their success and jumped at the chance to take advantage when circumstances turned.

Did Ojiichan get the same looks that Kate got boarding the train to come here from the people buying his tractor for ten percent of its value?

Did Obachan see the same smug smile on the faces of people who felt justified to take everything she'd worked so hard for?

They all ended up here in Manzanar, so maybe this was *bachi.* Maybe this is what they all deserved.

Hey, no *monku.* Don't complain.

She had a tendency to whine. *Amabo.* Big baby.

Johnny always used to call her that.

Kate returned to her clipboard before she got sad again. She had a job to do.

Ironic then that Kate ended up here, working almost as a nurse and rising fast with all the people transferring out, in the medical field and enjoying it.

How did Obachan keep the family together?

Graham was the same age that her mother was when she went to Tule Lake. Twelve is a pretty helpless age in a normal situation. Your body is a slave to massive physical changes and raging hormones. You start middle school and are suddenly shuffled from room to room on the command of bells. You're hurtling toward adulthood while being told exactly what to do.

Her dad was older, just out of high school. At least he was able to channel that pent-up frustration in the service.

There'd be no 442ND for Graham, not that he felt like he had to prove anything to anyone.

Maybe it'd be better if he was a little older, a little wiser and more experienced, although he certainly couldn't be more cynical.

Mary, she worried about. She was the opposite of Graham. Always there but hardly ever expressing herself.

But even if she could lock Graham in their cubicle and make sure he wasn't under someone's bad influence and could get Mary to start talking and eating again, Kate felt like she would never fully be in control.

Something had broken and would never be the same again.

Every afternoon after he finished his chores and took a shower and didn't go to Japanese school, David swung by the med center and picked up Mary for their daily walk. They avoided the south side and visited the family side of camp, where all David had to worry about was that Mary didn't seem interested in playing with kids her age.

"There's Dr. Sid-the-shrink, and Ozzie-our-music-teacher," Mary chattered as she danced in a circle around David. "Mom said I could talk to her if I want so I did but all she did was sit there and go, 'Uh-huh…go on…how did that make you feel?' and I thought, 'What kind of doctor is this?' That's when I knew she was a shrink. I don't need a shrink." Mary kicked at a rock. "It's not like I used to have a TV series and now I'm all screwed up or something."

According to Kate, Mary had hardly talked during the last year on the outside, and even less since they'd gotten here.

But apparently she'd been saving it up because every time she was with David she didn't stop, which was fine with him.

If sulky, moody Gray brought out all the reasons why David knew he wouldn't make a good parent, his eight-year-old niece was just the opposite.

Pleasant and intelligent, she entertained herself, asking David an endless supply of questions that, if he didn't have the answer, he could easily make up.

"Mom said Dr. Sid used to charge 250 bucks an hour, that's a lot, huh? There's Gray, he's really pissy ever since his player died and he can't play doodles anymore. Mom said they used to be called Nintendo until they banned Japanese things, but I just call them doodles because all those guys playing them, they all sing along with the songs on the computer and they sound like they're going, 'doodle-doodle,' don't you think so? Mom said we should all take advantage of Dr. Sid being available for free and talk to her," Mary worked her toe into a small indentation in the dirt, kicking at it thoughtfully. "Mom says Dad should go talk to Dr.

Sid, but Dad says he's too busy."

David didn't know how to help Ray and Kate. At least Gray nodded sullenly at David whenever David happened to see him, which was more than he did to his parents.

The boys just withdrew into their own little corner and every night would venture over to 33S, the junior high girls' barracks, and call over to them, "Say, yugah boahfren?"

At least they couldn't do too much damage in here outside of an occasional shakedown.

"When Daddy's digging up ground for our spring garden, he doesn't even hear me when I ask him questions," Mary said.

David would see Ray laboring for hours trying to put a dent in the dry, packed, rock-hard ground with a pick he wielded like an executioner's ax.

"I asked Daddy if he ever wanted to come to singing class with Ozzie. He said it sounded fruity. What's fruity mean? Did you ever talk to Dr. Sid?"

David answered the easy one. "I talked to her once."

"What'd she say?"

" 'Uh-huh…go on…how did that make you feel?' "

Mary laughed and skipped around in a circle. She had a marvelous, lilting laugh. David hadn't seen her laugh like that in years. She always laughed as a baby. Now she'd celebrate her ninth birthday next month in here.

But all he had to do to make Kate happy was to get Mary to eat, although with the food they served in here, a lack of appetite was probably the best thing for her.

To Ray, watching the big game, the seventh game of the World Series or NBA championship, the Final Four, any playoff game, anything live on TV was the one, last, uncomplicated, unspoiled activity he was able to enjoy. For those three short hours on a weekend in March or October or January, just leave him alone.

For those precious few hours he needed to get away, the world could move on without him.

But at the end of the day, when he did retire in front of the illegal TV, Ray would sit watching sports and hope Graham would show up.

They used to watch sports together. Even the two-minute report on the evening news. Ray would yell for Gray and, until his grandparents gave him that damn video game, Gray would drop his homework or comics or whatever he was doing and come running out to check out the only thing father and son had in common.

If Ray could've taken Gray fishing or to a ball game or something on their own, maybe he could've salvaged their relationship. But in here, there weren't any father-son activities, unless they were fortunate enough to both be assigned to septic detail or scorpion patrol.

Gray had been hanging out, sometimes all night at 31S, one of the deserted barracks on the south side, with all the other junior high boys who didn't want to live with their families anymore, until one day he stopped in while they weren't home, grabbed his duffel bag full of the banned Japanese video game cartridges he'd smuggled in and that was the last any of them had seen of him.

Every day, Ray strolled by the young people's barracks on the south side, watched them scatter, pushed his way into the gambling rooms, past the zombies sitting around tables, holding cards, tossing chips with a mumble, cigarettes dangling from their mouths. None of them ever looked up from his game. No reason to unless the building was on fire, and even then, play out the hand.

In the corner was a box of cell phones. High currency at first, until the trustees got a monopoly on re-chargers. But, it became too depressing for the kids to call their friends on the outside who didn't seem to miss them. For a while they called each other like they used to converse while riding in the same SUV, but that got old.

The young guys' tables were funny, more arguing about which

game they were playing and what was wild and what wasn't than actual poker, but the older guys were serious. Reminded Ray of the high-stakes tables at the Normandie Club in Gardena or the big clubs on the strip in Vegas. This wasn't fun, this was business.

And it was all tolerated. Barracks were electronically swept every week for illegal satellite dishes or cable taps, anything that could connect them to the outside world. All information coming in was controlled and limited to ESPN or soaps in the rec hall. And movies.

He scanned the faces on the edge, the young guys watching, trying to learn something, trying to see how to act like real gamblers. Enjoying the action, the risk, the high you get betting the last two credit chips in your pocket that were supposed to get you through the rest of the week.

Graham was never there.

Ray'd walk right into the junior high boys' barracks, up and down the aisles, scanning the hostile, indifferent faces through the haze of smoke from cigarettes and sweet burning chemicals, but never found Graham's.

When he did find him, Ray expected to see a changed boy. At that age, in a month your son could walk right by you and you'd never know it.

But Ray was certain he could still recognize his son.

He knew he could still salvage something.

They'd gone to ball games, played catch, gone fishing, camping, hung out together for too long for it all to be forgotten.

Ray had been a good dad.

Even with all the lost jobs and struggle for money, he still spent all his free time with his kids.

Graham did not grow up not knowing his daddy.

Ray knew if he had the chance to talk to him again, everything would be all right.

But first he had to find him.

"Anybody seen Graham Yamashita? Call him Gray?" Ray

pleaded to the silent room. For all the response he got, the room may as well have been empty.

Ray looked directly at one of the few who actually looked up from his smoke and comic books.

"I'm looking for my son," Ray held up an old photo of Graham that probably bore no resemblance to him now. "Have you seen him?"

The boy could've been Gray's brother.

Even among *Nihonjin*, who don't all look alike, whose faces are thin or round, whose eyes are big or small, whose noses are pointed or flat, this boy had the same facial structure, the same haircut, the same old-fashioned baggy clothes and the same damn apathetic attitude as Graham.

Then the boy blew out smoke and gave Ray the same don't-give-a-shit shrug that Ray had seen too many times from Gray.

That hostile, blase act of indifference that said, "I'm too fucking bored to death by the thought of expending any energy on you so…whatever."

Ray flinched, physically.

He involuntarily experienced a quick contraction of muscles that preceded smacking the boy's smug little face, before he caught himself.

"Well," he tried to keep his voice from shaking as he unclenched his fists and took them out of his jacket pockets, "if you see him, tell him his dad wants to talk to him."

The boy stared at him blankly.

Ray leaned forward and invaded his space and smiled down at the boy.

"Know wum sayin'?"

The boy jumped back, his bravado dissolved by a brief flicker in the old man's eyes.

Because he knew this ol' fart was showin' teeth and could kill him if he wanted to.

And it looked like he really really wanted to.

19

When David first arrived last summer, there were still activists in camp. Veterans of the early Asian American movement, of civil rights and Vietnam, the fight against the foreign takeover and bulldozing of Little Tokyo, the constitutional struggle for redress and pilgrimages to the ten World War II Japanese American concentration camps including, ironically, Manzanar. They had deliberately subjected themselves to ReVac and once interned, protested living conditions, rotten food, lack of hot water, harassment by guards, rape, extortion, and finally the murder of an eighth-grade kid slammed on crystal meth who cut a hole in the barbed wire with a pair of homemade pliers—the presence of which later became the source of more concern than the drugs— and started walking toward the mountains.

The kid may not have heard the guards shouting at him or the siren. He may not have heard the crowd gathered at the fence cheering him on, the crowd that kept cheering until the 50 caliber machine gun in the tower diced him into road kill.

After almost half a year of lawsuits, negotiations, peaceful demonstrations, a silent protest, many petitions, a boycott and several committee meetings with Lillian, the most vocal leaders of the opposition gradually disappeared. Called in for a conference

never to come back. Taken out of mess hall by guards and never heard from again. Woke up one morning and their little cubicle was cleaned out. One by one, until there was only one last activist left in camp.

Wayne.

Wayne was a patriotic American. His dad was a decorated 442ND vet, staunch Republican, VFW member. Wayne was drafted and did a tour in Vietnam, came back, finished his commitment, went to college, became radicalized, then an airline mechanic.

He and his dad didn't agree on much politically until the first attacks in September 2001. After that they both flew American flags proudly on their houses, cars, fences.

One day last November David saw Wayne in the mess hall sitting at a rear table, staring at his coffee.

"You okay, man?" David asked quietly.

Wayne didn't answer, didn't look up.

It looked like he was gonna cry. It looked as if he were finally thoroughly defeated.

"Let's get outa here," David offered. "Take a walk, have a smoke." David waited.

Finally Wayne said, "I'm all right."

"You sure?"

"Yeah. Go on." Wayne pushed David toward the door as he stood up and started walking up front to the food line.

Then, as he got to the front of the hall, Wayne stepped onto the bench and up onto the new guest table in front of Lillian and turned around to face his people.

"They would like us to believe that yellow people first arrived in this country the day the last F.O.B. stepped off the boat," Wayne said loudly through the noise.

Lillian signaled the guards, who were busy dozing or scoping junior high chicks.

"They would like us to believe that yellow people did not die

laying track for the first intercontinental railroad." Wayne paced the length of the table as he spoke with growing confidence. "They would like us to believe that yellow people did not volunteer to fight for this country while we were incarcerated as whole families by this, our own country."

The mess hall grew silent.

"They would like us to believe that yellow people did not comprise the most decorated fighting unit in the history of the United States military."

Lillian snapped her fingers at the uniforms who were slower to react than the trustees, who were already closing in around the row of tables as Wayne skipped down the center.

"They would like us to believe that yellow people did not take arid, unused land and turn Central California into the fruit and vegetable producing capital of the world." Wayne's voice grew louder as he saw the trustees climbing up on the ends of the table, the uniforms closing in on him.

"They would like us to believe that American is a racial designation meaning non-Asian, that American means anything but Asian."

He shouted desperately, "They would like us to believe that we haven't been a part of this country for over a century."

Hands grabbed for his feet, finally snagging a cuff, latching onto him like an octopus, slowly dragging him down.

But Wayne kept screaming.

"They would like us to believe that Japanese Americans never existed. That we…never…existed."

And with that, trustees stuffed a rubber ball into his mouth and bound his face, wrists and ankles with duct tape, wrapping him up for the uniforms to carry out of the mess hall.

Past David who was standing outside the doorway.

Where Lillian waited, silently, seething.

She examined Wayne with distaste, then bent down close to him. Her lips brushed his ear.

David heard her whisper, "I'm going to make you disappear."

They all knew what that meant. She'd find a charge and Wayne would go to prison. Maximum security, overcrowded with violent offenders whose only remaining reason for living was to pounce on fresh, unprotected meat. If he lasted a month, it would be a month too long. And when he found that brief second of freedom to take a header off the third-floor tier, official hands would be clean.

When Wayne didn't react, Lillian waved him away with a flick. Dust, lint, troublemakers, gone.

Then she smiled the Smile.

The one that said she'd just realized God had given her the power.

David looked away just as she turned her eyes on him, before she could lock on.

"This is for your own good," she reluctantly admitted, like a parent who has, against her will, been forced to administer punishment to a naughty child.

David found himself absently nodding in agreement.

The next morning, David looked across the barracks at Wayne's cot. The cot was bare, the walls empty where there had been photos of his kids and his ex-wife tacked to the wall. The stack of books on the floor next to his bed and the bundle of old letters rubber-banded together that had sat on top were gone. Later that morning, an announcement was made that the head of an illegal Ecstacy lab had been arrested.

David saw Wayne's jacket in the PX the next week, the rust-colored down-filled jacket with Hendrix patches on the velcro flap pockets and an American flag patch on shoulder.

He bought the jacket.

It was going to be a cold winter.

20

At first David tried to warn the new arrivals about the food. But those guys never listened. They'd been on a train for days and they wanted to eat.

They pushed their way to the front of the line, eagerly sliding along as steaming spoonfuls of gray, green and brown glop were expectorated onto their tin trays. They sat down at their table of honor up front, looked uncertainly at each other and waited for the hungriest, bravest one to take the first bite.

"How is it, Dino?"

"Not bad," the chowhound shrugged through a mouthful of something congealed, more concerned with volume than flavor.

They watched him eat ravenously, salivating against their will, waiting for him to start gagging or wheezing or exhibit signs of acute toxic food poisoning. But when Dino didn't, and hunger overpowered good sense, they began eating, too.

"Stick to oatmeal and toast at first," David sat down next to them. "Something not so greasy."

"Hi, I'm Ruth Uyeda," a fiftyish woman who looked like one of his cousins snagged his arm. "And this is my husband Dean, we call him Dino," the chowhound who, to her horror, was going up for seconds.

"Where you from?" David sat down at their table.

"I'm originally from Modesto, but my husband and everyone else is from Fresno. California. In the Central Valley—"

"I know where it is," David said gruffly. "I know Kumagai, Sakai, Hayashi in Fresno."

"Kumagais went to Canada. Sakais are dead. The rest, I don't, but this is…" and Ruth rattled off a dozen names around the table that David knew he wouldn't remember a minute later so he didn't bother listening. "Do they have N.A.U. here?"

"It's not called that, Nisei Athletic…"

"You know, basketball league for the kids?"

"The name was banned. Used to have a league, but there's no interest from high school or college kids here. No volleyball either. Junior high kids just swap Game Boys in their barracks. Young kids play soccer on the baseball field—dirt lot on the north side. Girls have this dance class."

"Dance class? What kind?"

Just as Ruth was about to put a forkful of slop into her mouth, a shrill frantic voice screamed, "Don't eat that!" A thin wisp of a man with black horn-rimmed glasses and hair wildly long on top and immaculately cropped on the sides slapped a badly photo-copied flyer on the table.

"Do not eat this alleged food—Ah, *kusai, ne*?" Bradley winced. "Join us in a food strike." He stopped in mid-pitch. "Hi, David!" and squeezed David's shoulder.

Bradley, naturally, taught the dance class.

David waved his coffee cup, "New guys, from Fresno."

Bradley made his way down the line as Ruth started rattling off names. "Bradley Kuwata, hi, don't eat that," he shook each one's hands. "Hi, Bradley Kuwata, charmed, don't eat that…" and sat down across from David and beamed at him.

When Bradley first heard David's lovely baritone echoing out of the latrine one beautiful fall afternoon, singing, absentmind-edly David claimed, Bradley's favorite song, "(I'm in Love With)

A Wonderful Guy," which he had last sung in the Seattle Gay Men's Chorus, Bradley thought he had died and gone to heaven and soon arranged to occupy the cot next to David's in Men's Barracks 13W, much to his frustration.

One night at the beginning of his first winter, David was bundled up on his cot under every piece of clothing he possessed when he heard, from the other side of the hanging sheet, Bradley's panicked cry.

"What are you doing?" he shrieked. "That's mine!"

As David kicked frantically out from under the pile of clothes, he heard Bradley cry out in pain and the deep thud of body blows landing. He grabbed the baseball bat he kept by his head and swept aside the sheet.

Half a dozen boys, about junior high age, were kicking at a groaning body on the floor. Two more were trying to lift Bradley's stash, a latched and locked wooden crate full of canned goods that weighed about three hundred pounds.

David bulled his way through the boys to Bradley curled up on the floor, knocking the middle schoolers aside.

"Get outa here!" he thrust the bat at them.

"Step back, G," one of them squeaked at him.

David stifled a laugh when the puny one doing the talking drew out something sharp and metallic from his belt.

"Don't fuck with us," Puny said, wiggling the blade at David.

"You wanna try me? Huh?" David waved the bat, his voice reaching octaves higher than he thought possible.

Puny defiantly thrust out his bony chest and pointed at David, slipping his shank back into the sleeve hanging down past his fingertips.

"We're gonna remember you." Then he jerked his head toward the door and they all filed out, past the trustee on his cot by the door who barely looked up from his sports page.

"You okay?" David unpried his fingers from the bat and helped Bradley to his feet. "You need a doc?"

"I'm okay," Bradley moaned and slowly unfurled on the cot, sucking in shallow gasps.

"Punks," David looked around to make sure they were gone. "Who are those guys?"

"Junior high boys."

David didn't want to know about Bradley's nighttime activities and crossed back behind the sheet wall.

"You gonna be okay?"

"Yes." Bradley called to David before the sheets closed shut, "Thank you, David."

David could tell Bradley wanted to hug him. He nodded silently and slid his blankets closed. David wasn't opposed to hugging guys. Just not guys who wanted to slip him the tongue.

What neither of them mentioned the next day was how no one else tried to help or even looked up as they pretended to sleep. The trustee limited his enforcement duties to calling lights out. Not that he or anyone else was going to notify anyone of this incident. They all knew the squeaky wheel gets the shit pounded out of it.

So that made David and Bradley friends of sorts. They informally began looking out for each other's stuff. They were friendly faces that returned greetings.

The daily, habitual, "So how was your day, honey?" inquiry that kept things human.

Bradley reminded David of the overeager kid who never got picked when they were choosing up sides. The kid who waited nervously, who thought his chances would increase if he smiled bigger. If David and Johnny and Kate had a younger brother who was a gay theatre major, it would have been Bradley.

David and Mits, one of the few Nisei in camp, occasionally had dinner over at Bradley's. Sitting on crates around his cot, dining by candlelight, an entree of canned ravioli heated by sterno, canned julienne green beans, a can of Hi-C orange drink and real Snickers bars for dessert. It was a treat.

It was David that Bradley turned to when he wanted to gripe about the little everyday problems that followed them to camp, the little messes they were left to deal with.

Like rodent droppings—on the floor, underneath cots, on the crate next to your glasses, in folds of clothes, next to your pillow—estimating the size of the visitor by the size of his droppings.

At first Bradley had set out poison pellets he'd bought from the camp PX, but the droppings just increased, as though he had provided them with massive quantities of a new snack.

Then Bradley tried the sticky trays, which he thought would be a nice, nonviolent alternative to the vicious spring trap slamming down on the head of an unsuspecting rodent.

They didn't work at first, even when he baited them with peanut butter.

Then one night as he was about to turn in, just when he was ready to give up on them, he looked down and there, stuck by its feet to the tray, was a mouse.

Not a big, ugly, red-eyed, yellow-toothed rabid rat.

This was a mouse. A cute, little, furry, round-eared, two-inch-long mouse who could've been named Tiny or Squeak.

Bradley waited and watched as it struggled to free its stuck feet. He assumed that as a delicate little member of the rodent family, it would quickly have a heart attack like rabbits did when they knew they were doomed.

He waited as it tugged and wiggled and looked around for a way out and did everything but free itself or die.

Then it stopped moving and Bradley thought he had lucked out and all he had to do was discard the tray, mouse and all.

But when Bradley's trembling fingers brushed the tray, the mouse reared back as far as its trapped feet would allow, and screamed.

A clear, high, tiny-little-animal-in-terror scream.

"Oh, God," Bradley cried.

David thought about pretending he was asleep, but Bradley

was already pounding on his sheet wall.

"Can you give me a hand?" Bradley pleaded. "David?"

David saw the mouse. "Get me a stick."

Years before, the first time he'd seen a trapped mouse, David had thought seriously about leaving it for Jenny to find in the morning. By then it would be dead, he hoped. But with his luck, it would've gnawed off its stuck paws like a raccoon caught in a steel trap and, as Jenny opened the kitchen door first thing in the morning, it would greet her, flopping around, a bleeding, squirming stump straight out of *Eraserhead*.

He knew now he'd have to kill it fast, a quick blow to the skull, so it'd never know what hit him.

Unless, like that first time, it saw the stick coming and whimpered and flinched like a scared puppy.

David could still hear that sound.

"Here you go," Bradley handed David a two-foot splinter off the oven logs.

David reached in with the stick and scooted the tray out of the corner so he'd have room to swing.

The little mouse looked up at him with its pleading little brown eyes and cowered.

"I'm sorry," David said quietly and brought the stick down on its head.

Bradley gasped. He thought David had missed. The stick was planted in the adhesive next to the mouse's head. Then he looked closer and saw the blood on its head and its eyes closed. He thought he saw the mouse move, but it was David's shaking hand holding the stick stuck to the tray.

As he walked out into the compound toward the trash bin area, David thought, this is not humane. It was easier to toss it away still alive and thrashing and let it slowly rot to death in a garbage dump. If he didn't have to hear its screams, out of sight would be easier.

But not for the mouse.

"Felons eat better than this," Bradley said, sneering at the plates of hardening grease. "Murderers, thieves, rapists, gank-stahhhs. Sickos who've killed people with kitchen utensils. They eat better than this!" he hissed and pounded the flyer on the table. "Join me in protesting this food. Next week, we're staging a rice strike."

"Rice strike?" Ruth had to ask.

"The Food Strike Committee has issued a statement demanding that we be supplied with the most basic staple of our diets as persons of Asian ancestry. Rice. And not that fluffy ass Uncle Ben shit either. Rice, man. Real live, down-home, home-grown, short-grain, stick-together, white, motherfuckin' GO-han, baby. Pardon my French."

Bradley saw a trustee looking his way.

"Gotta go," he slid out of his chair. "Nice meeting you." He squeezed a shoulder then waggled his fingers at David, "Bye-bye, David, see you at home," and started tiptoeing away crouched over, all hunched up like a big, bouncing question mark, which made him more conspicuous than if he'd simply stood up straight and goose-stepped away, singing at the top of his lungs.

"Is this legal?" Ruth held up the flyer.

David quickly snatched it from her and slid it under his tray as the trustees converged on the table. If questioned, which was doubtful, he'd just tell them he found it and was turning it in and no, he didn't know where it came from. A guy who not only willingly scrubbed toilets plus had some weird connection with Bradley, who had something on every trustee and guard in camp, which David did not want to know anything about, was not someone to mess with.

"Like everything here…" David got up, "…at your own risk."

21

The army regulars assigned to Manzanar had to sink pretty low on the priority scale to avoid duty in the Middle East, especially to get out of minesweeping duty. Most of them were ex-gangstas or first-time felons who were given the choice of prison or military service. Most of them had been shipped out of any outfit that required enough skill to not accidentally kill your fellow squad members and were harmless except for the arsenal they carried.

Trustees could be worse. Their position made them feel above the rules everyone else had to follow and, being Japanese, they'd come down hard on anyone who stepped the least bit out of line.

But some trustees cooled it when they realized they were out-numbered by men who'd lost everything and had nothing to live for and were so cranky when awakened prematurely (which was anytime they were sleeping) that slitting someone's throat in order to insure that there wouldn't be a second occurrence was their first option. Old Buddhahead bachelors with sour dispositions to begin with.

The rest of the trustees were left unsupervised with only one directive: to maintain order in the compound. And, as is usually the case when people who can't handle authority are given too much of it, began blatantly abusing it and became the blood-

sucking pimp and dope dealers of the camp.

They ran the gambling rooms. Operated poker games in the deserted barracks next to the high school boys' quarters, all hours of the day or night, blankets on the windows to block the light from inside, no entrance or exit after curfew just to avoid an ugly situation with a new guard who hadn't been bought off.

A pirate satellite mini-dish mounted in the rafters fed ESPN to a small portable TV built into a crate to provide wagering opportunities on everything from football to baseball to basketball to golf to horseracing to female bodybuilding.

Mostly poker and some blackjack. There used to be craps, but it was too noisy and attracted too much attention. Last spring, one of the new trustees reported the noise to his supervisor and made the mistake of filing a report on illegal gambling activities with Lillian. It may or may not have gotten to her, but it did result in the tragic, accidental drowning death of the new trustee in the sewage canal through which a day's waste products were flushed out into the desert—unless it was a larger object that got caught in the screen by the barbed-wire fence, like a body.

The older guys ran the adult room, straight stud or draw poker, a little blackjack. No sissy games with wild cards or split pots. They left those to the junior high boys, trading their computer-game cartridges and candy bars and crack.

The older guys took in credit chips and canned food, clothes and shoes and liquor. The older guys didn't have to worry about paying off the trustees. They were the trustees. David was warned by Wayne and Bradley his first day in to avoid the trustees and he did, for a month. He did his job. He didn't gamble. It was easy enough.

Until one day, rounding a corner after work, he walked into the middle of a shakedown.

He thought they were a gang mugging an old man.

Which they were.

Which was how he met Mits.

David saw these trustees, immediately recognizable in their

orange Day-Glo highway-repair crew vests, pushing around this ol' jiisan, had him in a circle, shoving him back and forth.

"Give it up, old man."

When Jiisan spoke, he sounded like David's dad.

"Hey! What the hell's wrong with you guys?"

It was just like a Nisei to challenge them. They were bigger, younger, possibly stronger, and they outnumbered him.

But he was right.

Fortunately, at the time David was carrying his favorite tools, the long-handled brushes still dripping with Lysol and feces, which made for an effective weapon in chasing off the pack of hyenas who skulked away vowing retaliation.

David caught a glimpse of the guard manning the 50 cal. in the tower, watching them disinterestedly.

Anything they did to each other inside the fences, they'd just as soon clean up afterwards. It was like fencing off the projects and the only thing the police did was make sure no one got out.

The only blessing so far was that there were no guns. It was back to the days of the Sharks and the Jets. There may have been weapons, but you had to be close enough to stick it in, which reduced warfare to strength and numbers; with numbers depleting daily, forces realigned constantly.

David thought it was a bad sign when the yogores started hassling anyone who might be JACL. JACL ran all the normal life things in camp: school, Japanese school, extracurricular sports, dance and music classes, Scouts, Christmas shows and spring musical productions, camp newspaper. No JACL, no appearance of order.

David helped the man to his feet. With his tanned forearms and weathered face, he looked like one of the many gardeners David would see when he went gardening with his dad and he'd swing around to Sawtelle Boulevard to pick up fertilizer at S&M Nursery or George's Hardware to get his mower blades sharpened.

Turned out he was a gardener.

Before the war, Mits' family had a celery farm south of David's dad's family's farm in Venice, on property they lost during World War II—property that eventually became Marina del Rey. Instead, they came back after the war and had to start over again.

David couldn't remember if Mits had had any kids he might've gone to school with or played against, if they'd gone to Venice or Uni. He didn't want to ask. Since Mits was alone, he'd probably lost everyone. Plus Mits was old. By the beginning of winter, David was pretty sure Mits was the only Nisei left in camp.

"See this barrack? My family live here during the war. I live in the same one now. Ironic, huh?"

Occasionally David would go with Mits to the rec hall to see a movie, but it was always the same ol' World War II shit, which Mits seemed to enjoy mostly because it was the stuff from his childhood. Nostalgia in an odd kinda way.

Mits liked the rec hall. With all the kids running around it reminded him of Ma and Pop's old house near the Coliseum. Ma and his sisters cooking in the kitchen, sitting in the dining room talking, men yelling at football games on TV, all of them big Los Angeles Ram fans, kids running up and down the hall and out in the backyard playing with the toys Pop kept in a box for when they visited, everybody settling down that evening to eat again while the old folks watched Lawrence Welk.

Rec hall was like that. Except you had to watch what you said with all the kids around.

People brought their own snacks to the movie. They shared. Pretty soon it was like bringing *omiyagi*, so you don't come over empty-handed. Whatever's left at the PX: tortilla chips, crackers, pretzels, Milk Duds, six-pack All-American grape soda. Movies are good, too. No cussing or naked people doing all kinda things. Embarassing for an ol' guy like Mits.

22

Last September, at the end of his first baking-hot summer at Manzanar, Kate had told David that someone in the terminal ward was asking for him.

He hated going into the med center, white and sterile with its ever-present smell of alcohol, let alone the terminal ward, which had already overflowed into nearby deserted barracks as the country asserted that real Americans had priority over death beds as well as real jobs and shipped any dying Buddhaheads to Manzanar.

He crept past the rows of barely breathing skeletons until he got to the number Kate gave him.

The skeleton squeezed opened its eyes and peered at him.

"Hey, David," the old woman said,."Remember me?"

David cursed Kate for not telling him who this was.

"Long time, huh?" she smiled at him like it hurt.

But as David stood in the middle of the terminal ward, steeped in the smell of alcohol and disinfectant, staring at the frail old woman who looked no different than the other dozens of emaciated faces—sheets up to their chins, tubes and wires poking out of every orifice, doped outa their minds and waiting to die—he did not have a clue.

Smiling blankly, his eyes were probably doing pinwheels as he zipped through the ol' long-dormant brain cells, trying to drag out a long-forgotten name to put with this face he just did not recognize, at all.

Someone's mom? A young Nisei about his Auntie June's age, a friend's mom, friend of his folks, family? Auntie?

Nothing more embarrassing than not recognizing an auntie.

"Let me see your hair," she twirled her finger weakly.

He turned around slowly, futilely trying to connect the old face with its younger version.

"Wow, did you keep it this long all this time?"

All this time? His hair hadn't been this long since college. Only in college. College…

"No, sometimes it was short, sometimes long, depending," he rambled, surprised she couldn't see the smoke coming out his ears.

Finally he admitted, "I'm sorry. I don't remember your name."

"C'mon, David, don't disappoint me."

Oh great, make him feel even worse. "Give me a clue."

"Okay…We met at Long Beach State in the early seventies," she began slowly, "in Jim Matsuoka's Asian American studies class. We hung out between classes, at Movement dances. We run into each other about once a decade, at East West Players, the Venice carnival, Kenny's Cafe."

"Christine Okada," he tried not to let the disbelief show on his face.

But she probably knew.

She always seemed to know what he was thinking.

From the first time he saw her, the grad student active in the Asian American Movement at Long Beach State, she had that worldly, sophisticated, knowing quality that intimidated the hell out of him, especially when he was a freshman in his second semester of college, who had no idea of the Movement and all the protests that she had not only attended but organized, who knew nothing about who he was and where he stood in the world, and

was still a virgin to boot.

She was beautiful, radical. Speaking gently in angry words, the Angela Davis of the Asian American Movement.

On a first-name basis with the Movement leaders.

"Warren's coming down from UCLA," she'd announce as she came into class late and out of breath. "We're going up to S.F. State and give S.I. some shit, that fucking banana."

"Joanne split off from Chris and she's going solo as Nobuko," she'd tell the teacher after class.

"Bruce's got a new article in *Gidra*," she'd inform the class despite the fact that none of the stupid freshmen cared.

"Tatsukawa's got a new short film," she'd say as they sat on the grass between the psych and sosh quads, when he dared speak to her and, generous and gracious as she was, she'd ask him where his next class was and walk with him.

They had a free period between classes and he'd wait for her on the grass between liberal arts buildings up near the library. He'd see her walking toward him, firm breasts jutting through a tie-dyed halter top, tight ass squeezed into faded Levi's held together with a crazy quilt of patches, Japanese silk headband, and he couldn't believe she was coming to see him. She was older, unattainable. She had her degree.

As unlikely as it seemed, when he got back to school in the fall of 1972, it was Christine that he told about losing his virginity.

In an Asian American psych/sosh class, assigned to pair off and tell each other a significant event in their life, David and Christine, who had been working together on the campaign to prevent Nixon's re-election and on Proposition 19 to decriminalize marijuana, just huddled up and continued their normal wideranging conversation. The others, mere freshmen and superficial sophomores, finished in minutes, while David and Christine discussed sex, which David was grateful to have actually experienced with another person by then.

"She's hakujin?"

"Yeah, from Vegas."

"Ooh, sophisticated."

"No, the opposite. She was a virgin."

"And you told her you were a virgin, too?"

"Yeah."

"Congratulations, you're a man for telling her."

"Well, not at first. But I was having trouble…"

"Getting it up? Ooh, that coulda been traumatic."

"Yeah, she coulda killed me, but she was really calm and patient, you know? It seemed like it took forever, but I guess not 'cause we had this record on and we took almost all of side one. Is that good?"

"She sounds like a terrific girl."

"She is, but it's over for now."

"Because you're down here?"

"Yeah, we didn't have that much in common. Plus I was beginning to feel like a traitor."

"To your race?"

"Yeah."

"Did I mention that my first was hakujin?"

"Really? You?"

"You see, it's more about societal standards of beauty affecting perception and self-esteem, the assignation and interrelation of power based on perception, sexual mobility of white males and Asian females based on those standards."

"Oh, yeah." David nodded, feigning understanding.

"So you really lucked out finding this white female who was unprejudiced enough to look beyond the cultural taboos against Asian men with white women, which is what this U.S. intervention into the civil war in Vietnam is really about."

"So you think I should call her?"

"No, just don't treat her like a trophy. My first was a talker. I was the talk of the locker room after that." She grabbed David by the back of the neck and pulled him closer. "If you ever do that

to a woman, I'll kill you."

"I wasn't doing that," he tried not to whine.

"No, no, this was okay. I'm talking about speaking disrespect-fully of a woman. Don't do that," her voice was stern but her eyes were pleading. "Okay?"

He nodded quickly. "Okay."

"Thanks," she kissed him lightly on the cheek, "and congratu-lations."

They hugged, aware that the other members of the class, long since finished and bored, were all watching them.

"So how did you all do?" Professor Hank asked eagerly.

Shrugs all around. The usual, disappointing reaction from the vanguard of the apathetic '70s.

"Well," Christine's deep, mature, real woman's voice filled the classroom, "David and I had a great time." She smiled. "We talked about our sex lives."

The children oooohhed and whooped and did everything but go, "Ah-mmmmm, shame-shame." David sat casually next to Christine and did his best to imitate her knowing smile.

He felt like he had been knighted.

Now, the dying queen, despite her frail condition, once again drew the knight to her, as tightly as she was able. David sat awk-wardly on the bed next to her, bent over her sunken torso. He could feel the bones in her ribs and chest.

"So," David looked at the emaciated face that bore a skeletal resemblance to his ideal woman in college, "what brings you here?"

"Well, my excuse is, as you can see, I'm dying."

"Of what?" he asked, barely getting the words out.

"Emphysema," she said in a whisper. "The damn Newports. Plus I got a touch o' liver failure and sarcoma." She threw her unplugged hand up. "If it ain't one thing, it's another."

"God, I'm sorry."

"I'm not," Christine said, her voice weak but determined.

"It's a good time to leave this planet to its own destiny. I'm tired of fighting it," then she reached for her oxygen mask and seemed to sink down into the surface of the bed. "When I'm rested, I can actually carry on a conversation for minutes at a time."

From that point on, David tried to be there for every one of Christine's few minutes.

He looked in on her after breakfast, before he started scrubbing.

Then after his shower, before he picked up Mary.

He sat with her until dinner, usually just watching her sleep.

Waiting for her eyes to flicker open and that painful smile that meant she still recognized him.

A few minutes a day of conversation.

Every time he brought her another fry bread, it meant that Christine, his old long-lost friend from college, had survived another month.

23

David didn't want to tell any newcomers they'd just missed fry bread day, the monthly visit from the Tribe.

Their only regular visitors were Quakers, who brought clothes and books—which the guards confiscated and later resold at the PX—and the Tribe, who made them fry bread: balls of dough hand-molded into thick pitas and deep fried, then sprinkled with honey and powdered sugar or topped with beans, cheese, lettuce, tomato and salsa to make an Indian or Navajo taco.

David lived for fry bread day.

Every time they came, he thought he saw someone he knew. Someone in the Tribe who looked Nisei. Except for the necklaces or bracelets or decorations in their hair, they dressed like Nisei, golf shirts and polyester pants, cotton dresses from the Sears catalog. They really did look Nisei, except some of the guys had braids.

But facially, he could swear, and nearly called out more than once to someone who looked like family.

"Mits," David whispered, "That guy looks like my Uncle Ich," pronouncing it the Nisei way, itch, because he was talking to Mits, pronounced mitts.

"I know what you mean," Mits looked around. "That gal over

there look like my sister-in-law Esther. And this fella here look like my bradda George. And they're both dead."

"I wonder if they're thinking the same thing?"

"You know what this remind me of?" Mits said. "Pancake breakfast the Crescent Bay Optimist used to have on Sunday morning in the parking lot on Centinela. You know, over where Grace Pastry and Thriftimart use to be."

David had always wondered who the Optimists were and if they really were all that optimistic. He wondered about all the clubs and organizations his folks and his uncles and aunties belonged to. Nisei Bowling League, 442 Bowling League, Optimists, Lions, Eagles, VFW, NAU Basketball, Young Buddhist Volleyball League, YMCA Indian Guides, Boy Scouts, Girl Scouts, Cub Scouts, Brownies and all those large groups.

The best part was that fry bread was served out in the sun. The guards and trustees tried to hover nearby at first, but standing in the sun was too much work. So mostly it was quiet. No traffic, no car stereos, no TV, no radio—even the loudspeaker announcements shut down for fry bread day.

The only thing David missed was the flatbed truck where every local garage band with instruments from Betty's Music did the Stones doing "Everybody Needs Somebody to Love" or Archie Bell and the Drells' "Tighten Up" or Cream's "Sunshine of Your Love" as soon as they could learn it by playing the grooves out of the 45.

There was just talk and laughter and the sound of people enjoying the fry bread and giant tacos floating out over the barbed-wire fences, disappearing up into the smogless desert sky like wisps of smoke melting into the clouds.

Navajo Uncle George looked at David's long hair. "Say, what tribe are you from?"

David pondered, then said, "Niigata-Hiroshima by way of Venice, California."

"Ohhh." He thought it must be a very obscure tribe and placed

two pieces of bread on the napkin. "Here you go."

David always made sure to get two fry breads to go. One for himself and one for Christine.

David especially avoided mentioning fry bread when the effects of mess hall food hit the newcomers. He had just finished scrubbing the last horse-trough urinal when Bradley ushered in the chowhound from Fresno. Dino had probably set the record for mess hall consumption that morning, and it was time to suffer the consequences.

"Hi, David," Bradley wiggled cheerfully. "Here," he handed Dino a newspaper. "These are your walls. Just act like we're not here."

David felt for the new guy. He knew very well the burning, cramping, seemingly endless misery of the human body's response when invaded by government food.

Especially embarrassing if done in full, unobstructed view of dozens of onlookers, some of whom were quite vocal about the resulting odor.

"We've protested the lack of dividing partitions between commodes in the men's room." Bradley leaned over and confided, "When I first got here, I didn't poop for a week."

David hurriedly gathered his supplies and shooed a couple boys taking a leak, who were trying like hell to finish because they knew what was coming and dashed outside as Dino's onslaught began. When the big rush hit, the last thing the poor guy'd want would be company, or an audience.

"Just…go…away," Dino grimaced as he squeezed his burning, splattering intestines into the toilet.

"If there's anything you need, just call me," Bradley called from the door.

Nice guy, Dino thought through the pain. Queer as hell but that didn't bother Dino. Not anymore. He was back.

Now playing first base for the Dodgers... number 32... Dino... Yoo-WAY-dahh!! Look out, Ichiro! (If Ichiro hadn't been the first *Nihonjin* booted back to the Oryx Blue Wave.) The boy was back!

Oh, God, it burned.

Dino hoped the girls were okay. They only ate bread, so they should be all right. And, as much sheer agony as this was right now, Dino wasn't worried. He was here, Ruth and the girls were here, back home in the good ol' U.S. of A.

They had tried Japan, working as domestics. He was used to abusive bosses and Ruth was used to harassment and petty jealousy in the States, but those hard-ass *Nihonjins* were tough. Especially that ol' baaa-san. Geez, she musta been the broad in charge of kamikaze school.

Hai, I'll go! I'll go! I volunteer to plow my ass into a ship just so I'll never have to look at your grumpy-ass horse-face again!

They were slaves, basically, with fewer rights than Koreans, which was less than zero.

But Dino would've stuck it out in Japan until one day he realized that his girls—four-year-old Nicole, now going by her middle name Keiko, and six-year-old Stephanie, now Kyoko—were fluent in Japanese but barely knew English.

Worse, they were forgetting everything about their life in the States.

And Stephanie, he didn't know what kind of history lessons she was learning in school, but he could tell it was as revisionist and biased as American schools. She was starting to look at him the same way all them snot-nosed school punks in the States used to look at him.

As the enemy.

Which pissed Dino off to no end. He said, "This is bullshit. If I'm gonna get fucked, I'll get fucked in my own damn country." So they renounced their Japanese green cards and reclaimed what was left of their American citizenship.

With great diplomatic difficulty and much to the girls' regret, they returned to the U.S.

Where they would be speaking English, goddammit.

Like goddam Americans.

Ahhh, geeezzzz, wasn't it over yet? He was gonna havta check and make sure he still had an asshole left after this. But that was probably what ol' Bradley was hangin' around for. Maybe it was a good thing he got the shits the first day.

He still didn't have time to figure out exactly what their situation was in here, except that some guy in the mess hall had already told him where to find the poker game.

In the meantime, Bradley left him his jar of Vaseline. Under ordinary circumstances, the last thing Dino would ever do would be to stick his finger in a jar of Bradley's Vaseline.

But Dino was in too much pain to care.

He dug his finger deep into the jar, down to the safe part that Bradley might not have touched yet, and tried to put out the fire in his okole.

24

"Do you realize that of all the hundreds of men who pass through here everyday, we usually bathe alone, together?"

It must've looked strange. Three cement rooms, six lines of pipe overhead, a dozen showerheads sprouting from each pipe, walls of tarpaper on the outside and leftover kitchen linoleum floor on the inside, bathing facilities for seventy-two, men only please. In the middle of the afternoon, the earliest hot water was available if the solar grids were operating at maximum capacity, only two men occupied the entire showering facility, bathing side by side, one never taking his loving eyes off the other who never looked back except to glare menacingly when his reach was impeded by his admirer's proximity.

Like when David reached around to scrub his back, only to bump into Bradley.

Or when Bradley—"Oops"—accidentally brushed David's right buttock.

David gave him a stink-eye to rival all stink-eyes.

"Sorry."

David waited for Bradley to take his customary half-step back, then resumed scrubbing.

"When's the last time you got laid?"

"What time is it?"

"Shibai," Bradley scoffed. "You can't get laid in this place without everybody knowing about it."

"Maybe I hit the south end of camp every night."

"For the boys or girls?"

"Take a guess."

David never ventured over to the south end of camp. Giggling adolescent girls had pretty much the same effect on him as they did in junior high school, plus he'd heard "old hippie" muttered behind his back.

He'd resigned himself to a sexless life, but he was used to that. He'd been married.

At the end of his first week in camp, David discovered the high school girls' barracks by accident.

He got picked up in the mess hall.

After the third dinner shift, he'd been lingering. Kate and the kids had gone off to the last movie in the rec hall that night and he didn't need to see *Guadalcanal Diary* or fucking *1941* again.

While the kitchen patrol cleaned up around him, he suddenly realized someone was sitting next to him: a beautiful young girl, which startled him. Anyone beautiful, young and female had already been "situated" outside.

It was the first time since he'd arrived at Manzanar that he was reminded that Celeste was on the outside somewhere.

She said her name was Felice and that she'd chosen David to spend the night with.

He was flattered and panicked for a brief moment when she took him into the high school girls' barracks. He had flashbacks of walking into a classroom full of women in college or past a small group of girls in junior high school. Or walking into a dance.

He'd only gone to a few dances, in the early '70s, when he was still single, at Rodger Young Auditorium or Japanese Village and Deer Park, usually because Johnny wanted to hear Carry On do the long version of the "Make Me Smile/Colour My World" suite,

which was almost all of side two of Chicago's second album, a two-record set.

These dances were put on by one of the SC or UCLA fraternities or sororities but were heavily attended by the social clubs from Dorsey or Crenshaw High.

Buddhaheads who were into James Brown, not Motown. Slick guys with creased black slacks and shiny black shoes and long-sleeve powder-blue dress shirts, top button only unbuttoned.

With perfect '50s hair like George Chakiris in *West Side Story*, like the guys at Manila Barber Shop next to Betty's Music on Centinela.

Bad Buddhaheads who talked Black, walked Black and most importantly danced Black. With heavily mascaraed, poofy-haired Rita Morenos on their arms.

David would usually watch the best dancers from Venice, Daryl or Roland and some of the guys on the C basketball team, get out on the floor and hold their own.

Occasionally there were disputes, usually a territorial thing, but they usually waited until after the dance and took it out to the parking lot. And those were real fights with fists and, depending on how traditional your upbringing was, feet. This was before automatic weapons turned a party into a slaughterhouse because someone looked at someone else wrong or funny or a fatal millisecond too long.

But one time, Keith Magwili was out there spinning around like Smokey Robinson and he bumped into the wrong person.

A tall guy. Of Asian extraction. With perfect hair.

A Bad Buddhahead.

George Chakiris' long-lost brother who, judging by his foot speed, apparently knew Bruce Lee personally.

Keith and Mr. Chakiris gave each other the stink-eye, which was how the fights usually stayed until some girls quickly intervened and pushed the eyeballers to neutral corners. But this one escalated too quickly.

It was a beautifully executed side-kick to the center of Keith's chest, catching him halfway between "Come awn" and "Suckuh."

Keith flew backwards, arcing beautifully across the dance floor, landing on his rounded upper back, his chin tucked into his caved-in chest.

Fortunately Rodger Young didn't get crowded until 11 and Keith was still sliding unimpeded across the polished-wood deserted dance floor and was almost past the bar when David and Johnny scooped him up and kept on going all the way out to the parking lot.

Which David felt like doing when he walked into the girls' barracks. But Felice hung on.

They picked out some music and dashed over to the specially reserved honeymoon suite, the deserted barracks next door.

And by the time he'd found out she was keeping score, the high school girls competing to see who'd be first to hook up with the newest arrival, he didn't care.

He thought it was sad that young girls considered it some kind of accomplishment to get a guy into bed.

His parting shot to her, as she was booting his ass out of the honeymoon suite, was that getting a guy to fuck was like coaxing him to exhale.

He'd been celibate since. Saving himself for Celeste or some other fantasy.

Plus, he knew it was getting harder and harder to get rid of that disinfectant odor that lingered on his hands and in his hair and nostrils and lungs, no matter how long he bathed everyday.

When Grandpa was sixteen, his father left him behind in America while he went back to Japan to find his son a wife.

Grandpa found a job at the *kamaboko* factory in Little Tokyo, where he'd live until his father returned. After making fish cakes all day, he'd go to services, in the basement of the old Union Church, and when the other Isseis saw him coming they'd sniff

exaggeratedly and say, "Oh! Here comes Takeda-san!"

David hoped the people in the mess hall weren't wrinkling up their noses when he walked by, "It's the toilet scrubber."

"Can I wash your back?" Bradley was leaning dangerously close again.

"Get away from me with that soapy hand."

"Just let me scrub that part you can't reach."

"Get away from me."

"Are you getting a hard-on?"

"No, I am not getting a hard-on."

"I think you are. Look."

"I don't need to look." Especially since he could already feel— God, no—a woody coming on.

David knew how it looked with Bradley doting on him like that. He knew that was the main reason why they showered alone. Everyone assumed Bradley, being flamingly queer, had AIDS and that David, with those strange welts on his chest, was equally diseased, and that the two of them could just infect each other and the others would just come back later when it was safe.

But David preferred it that way. He hated crowds. Especially in public-bathing facilities. It left him more hot water to wash the stink out.

He even joined Bradley singing show tunes, which really kept the others out.

Even the trustees wouldn't stick their head in to yell at them to shut up when they really got into "I Feel Pretty" or "I Enjoy Being A Girl."

And if he hadn't been distracted at that moment, trying to finish washing and arguing with Bradley about whether he had a chub or not, David would've noticed Dino stumble in.

Right into the middle of what Dino assumed was an argument between that homosexual-type married couple bickering about erections and he hoped to God he could ease his way back out before they saw him, because Dino sure as hell didn't want

to witness the make-up part of this little spat.

Bradley saw Dino moonwalking back toward the door.

"Hi, Dino!" Bradley sang and waved. "Come join us!"

Dino just wanted to wash his poor, tired, chafed, raw, burning ass and find a cot to collapse on and—Oh God—they were both coming toward him.

He did not need to be fighting off a coupla fags in the shower, especially the one that kept inviting him to come sing show tunes, for cryin out loud.

But then, the old hippie walked right past Dino, grumbling, "He's all yours," and slammed out the door.

25

Lillian was worried. She thought the World War II-era wooden guard towers and barbed-wire fences would be nostalgic and harken back to a simpler, more clear-cut time. But the jackals in the liberal media used them as a lightning rod for their anti-Homeland Security paranoia. They often used unauthorized terminology, like detention camp, internment camp or, in the free communist smut rags, concentration camp—referring to the facility as something other than what it in fact and definition was: a temporary relocation center.

As usual, the liberal media allowed their bias to distort the purpose of this facility, which was to temporarily provide free housing and food for evacuees who were here voluntarily, of their own accord, doing their part in the continuing economic war against Japan by sacrificing their jobs and property for real Americans.

As usual, the liberal media completely ignored the big picture: to win the economic war against Japan.

The American people would do what it took to win this war— Need she say it?—otherwise the terrorists would win.

She would even go so far as to say, this facility could be a model for pre-emptive security measures in the future.

This was a happy temporary relocation center that would be

self-sufficient by the end of summer. The labor-reward system awarding meal chips for each task performed was working splendidly, especially with football season approaching and the most able-bodied men being the most enthusiastic to work for their right to see football or basketball or baseball on the recreation hall big screen. Plus, as long as the water supply held up, there would be a garden providing serenity and fresh vegetables, which was important in Japanese culture.

As a bonus, another thing she loved about the Japanese, the traditional Japanese cultural emphasis on education was now paying off with a surplus of former medical professionals for the incoming terminally ill, who were transferring in from overloaded care centers around the country and could help alleviate the strain on the system by dying a little quicker. Their refusal to die in a timely manner also put a strain on the remaining health care workers and the supply of painkilling drugs, whose increased requisition was getting harder and harder to justify.

Of course, Lillian's most difficult assignment—critical to the whole concept of Re-Evacuation—remained: to relocate the remaining able-bodied population either back into the mainstream as a non-threatening work force or out of the country altogether.

She knew the Japanese weren't like those other colored welfare cheats who would probably be content to sit in these newly built facilities and sponge off the American taxpayer for the rest of their lives. Although she did notice a hardcore group of apparently fit residents who seemed to lack the capacity to move on.

Lillian knew that the non-disclosed enhancement of the food and water supply with high levels of mood-levelers and violence-depressors insured that they would not be a threat, but their prolonged lack of motivation could turn Manzanar into a ghetto/barrio/reservation-type situation.

These slackers just did not want to better themselves.

In the meantime, it was her responsibility to insure that this temporary relocation center always projected the appearance of a

happy place. Where everyone was happy doing their duty to God and former country. That the image beamed to the rest of the world by the nosy, meddling but ultimately pliable media was one of contentment and acceptance.

For that, Lillian was grateful for the full cooperation of the entire population of this temporary relocation center.

If they couldn't get out, at least they weren't standing on corners looking surly and threatening.

Now why couldn't all those minorities be like them?

"Good morning, Dr. huh-YEAH-shuh-Duh," Lillian cheerfully sang to Dr. Sidney Hayashida, the dourly dressed little woman hunched in the chair across from her. Lillian wanted to trust her resident medical staff. After all, this one was a doctor, a psychologist, a self-made woman who had used her education the way Americans were supposed to. Unlike other minorities who used their race for unfair gain back when liberals controlled higher education. She could provide Lillian with valuable insight as to why these last few stragglers were stagnating and not temporarily.

Dr. Sid wished she could be more useful like her younger brother Milt, a brilliant neurosurgeon before anti-Japanese preferential quotas forced him to settle for emergency room physician on the outside. Milt was the head physician at Manzanar and Sid couldn't imagine how uncaring the medical care in this facility would be without Milt there to administer it.

So Sid settled for what she did best. Helping others, listening to them. Sitting around and shooting the breeze without acting like your mother.

She'd been so out of touch on the outside, barricaded in her Century City office, a security tunnel away from her Century City townhouse. And now, surrounded by barbed wire, guard towers and cameras everywhere, she was free to explore a world she'd previously avoided.

It took months to work out the protocol. As American as these internees were, they were still Japanese in attitude toward outward expression. The younger generation, raised on cell phones, public demonstrations and private conversations for all to hear, were isolated in their barracks. The older ones, though Sanseis, didn't feel comfortable airing any laundry in public.

It was quite by accident that she finally stumbled onto a way to invite those who needed her help. Her afternoons free, she began taking walks around the perimeter of the compound.

Others did, too. And one day, she was joined by a mom with a teenaged son who'd disappeared into the junior high boys' barracks after a dispute with his father, who'd hit him. And a daughter who hardly talked to her but couldn't stop talking to her uncle, her older brother who hated kids.

After that, if someone wanted her help, they strolled out to her during one of her walks—near the barbed wire fences, away from the barracks and cameras, only a few strands of wire away from standing alone in the middle of the desert, in plain sight of guards, family, community—and talked, sometimes for hours.

They'd squat, like the old Nisei who grew up farmers and, having no place to sit, sat on their heels and talked and picked blades of grass from their front lawns.

At first they'd stand stiffly, trying to find a place to put their hands, the women with their arms folded tightly beneath their breasts, shoulders hunched over.

Initially she attributed this posture to the unnaturalness of their situation, until she observed groups of women, chatting idly, all assuming the same constricted posture.

So Sid took the lead and squatted down, and her women consultees, tired of talking down to her, would spread out a small handkerchief or sweater on the ground and sit next to her, resting on an arm and a hip, legs demurely to the side, and complain about the drafty walls, noisy neighbors in the next sector, snorers and farters, bad food, cold toilet seats, benjos with no dividers, the

weather, the kids, the constant lack of privacy, parents who were lucky to die so they didn't end up here again, the uncertainty, the hopelessness, their own moments of despair they kept hidden and always, the self-control they could never lose, not for a moment.

There was no clock, only so many hours of sunlight in the short winter days.

Unfortunately, this also put her in a vulnerable position where Lillian wouldn't hesitate to drill a hole in her skull and drain out every detail of every conversation she'd been party to.

"Oh, come now, Doctor," Lillian put on her sincerely concerned face. "No little tidbits of information that would aid me in providing comfort to our residents? Notes? Documentation? Anything would help."

"No," Dr. Sid tried to sound *nonki*, unconcerned.

"We don't want our residents to stagnate here at taxpayers' expense, do we?"

"Of course not."

"Now I expect you to report any situations that could cause problems for me. It's for their own good. I do care about them, you know," Lillian said, warmly and sincerely.

Ever since the Reagan administration, it had become an absolute must that all successful elected officials do a good "sincere." Warmth was optional.

"If I observe any situations that I feel would be proper to call to your attention," Dr. Sid phrased carefully, "I certainly will," declining to add the codicil about hell freezing over.

"Thank you, Doctor," Lillian stood up. "It's good to know I have you and your brother's cooperation. I think it's best for everyone concerned. Don't you agree? I knew you would."

Lillian watched admiringly as the good doctor strode away briskly, eager to continue her good work.

That's why she loved the Japanese: they accepted becoming non-Americans for the good of America and continued to demonstrate their cultural values of hard work and sacrifice.

All-American virtues held so dear by those so foreign.

Sidney and Milton Hayashida. Funny names for Japanese.

The girl-shrink said they were named after their great-grand-parents' friends. Jews who helped their family during World War II, stored furniture, even visited them at their temporary reloca-tion facility.

Their parents must've known they'd be doctors.

26

It took Jenny almost half a year to finally get in as a file clerk in the administrative compound a half mile outside the actual camp. The turnover was high for civilians in this desert outpost, and she slowly worked her way up the ladder, duties increasing and security clearance rising until she was finally assistant administrative clerk at the on-compound facility. She was inside the outer perimeter, just outside the barbed wire fences. She was on the computer, in the files, entering names and numbers into the computer logs as she waited for an opportunity to present itself.

"All these Jap names are driving me nuts," the last senior administrative officer had decided. "I'm outa here."

Jenny was proud of herself. She hadn't even flinched when the former high school Tolerance Day organizer said "Jap." She didn't blush and her breath remained deep and even. She could now pass for an insensitive, faceless paper-shuffler.

"Name?" Jenny asked the last of the dozen new arrivals. Jenny checked the medical report: returned by her husband, obviously abused, an old broken arm, a recent gash on her cheek and a newly broken jaw. Jenny saw no swelling on her face, only a thin, discolored line on her right cheekbone.

What this girl looked like, besides beautiful, was in shock.

Like she'd been trained not to respond.

"Name?" she repeated gently.

The girl looked at her dully. Jenny could see she was older than she appeared. Thirty maybe. She checked the files. She was only twenty-three.

Her eyes were dead, but they were dead eyes in a doll with porcelain skin.

"What am I doing here?" she sounded confused.

"Ten months ago," Jenny read from the screen, "last May you ran away from your husband's home in Ohio. You were recaptured a week later in California and returned to him."

It could've been a coincidence that she was arrested the same time and place as David, which was the only information Jenny had gotten from the police report at the time of David's arrest. And that he was sentenced to Manzanar.

"One month ago, in return for dropping charges of destruction of property your husband renounced his ownership of you. You were taken to a federal correctional institution hospital where you refused deportation, which landed you in here. Now, I have to confirm your identity. What's your name, sweetheart?"

The girl blinked at Jenny. "Suzie," she said slowly. "Suzie Creamcheese. Suzie Wong. Connie Chung."

"It says here your name is Celeste."

"Celeste Randy, that's mah name, don't wear it out. Mah American name from mah American husband."

"Your husband disowned you. You're back to Celeste H. Saito now. What does the H stand for?"

"What am I doing here?"

"This is a prison camp for Japanese Americans."

"I'm half-Japanese and half-American?"

"No, you're an American of Japanese ancestry, like everyone else in here."

"Ohhhhh," Celeste let it digest, a pained look on her face as she peered out the windows into the dusty barbed-wire com-

pound. "Emiko. No, wait, Terence called me Emiko because he couldn't pronounce Harue. My middle name's Harue."

"H-A-R-U-E or Y-E?" Jenny typed into the computer.

"Just E."

Celeste noticed that this clerk lady typing Celeste's file into the computer, when she asked Celeste her mother's maiden name, Uyematsu, pronounced it correctly. Weh-MAH-tsu. Plus, she knew Saito was pronounced Sigh-toh, not say-tow. And she did pretty good on Harue.

Celeste thought it was unusual.

Jenny said quietly, "Do you remember when you were captured last May just south of here, just off Highway 395—?"

They both jumped when Lillian barged into the room.

"What are you doing?" she accused, scanning the computer screen quickly.

"Processing this last registrant," Jenny calmly resumed clicking away on the keyboard. She hoped Lillian couldn't hear her heart thumping in her head.

"Aren't you done yet?" Lillian accused, her eyes darting from screen to files, double-checking.

"Almost," Jenny kept typing. "Why don't you go ahead and I'll bring this last registrant over when we're done?"

"That would be a good idea," Lillian eyed Jenny suspiciously, "except that you don't have clearance to enter the compound. Yet."

"Okay," Jenny sighed, "I'll just finish up here so you can take everyone over at once."

"When did you start processing registrations?" Lillian pressed.

"This week," Jenny said as calmly as she could. "Since Phyllis left."

"And you received security clearance that fast?"

"Yes—" Jenny tore the computer printout halfway out the carriage and handed it to Celeste. "Don't lose this number."

"By the way, Jennifer," Lillian said nonchalantly, now in no

hurry, "I noticed an error in your public address announcements today, the one for the classic World War II action drama, *Purple Heart*."

"What was that?"

"You must know," she said patiently, "if the script reads 'sadistic Jap torturer,' that's how I want you to read it."

"Don't you think it might upset the inmates?" Jenny tried to maintain a subservient demeanor, averting her eyes to avoid a confrontational attitude with Lillian.

Keeping her eyes down, she noticed the papers clutched in Lillian's hand. Across the top, it said, "Medical Report."

"Temporarily relocated residents," Lillian corrected. "And no, I don't think it would upset them. None of them have ever complained to me. And if it's good enough for the movie guidebook, it's certainly good enough for you. All right, dear," Lillian lifted Celeste to her feet. "Dinner time!"

Jenny caught the near-panicked look on Celeste's face as Lillian towed her out the door.

As she was being dragged through the gate, Celeste looked up at the guard towers, eerily lit from behind, spotlights following her through the barbed-wire fences, casting jagged shadows over the bare, cracked ground. She glanced back over her shoulder and saw the clerk lady standing in the lit window on the other side of the fence, watching her intently.

Kitchen patrol moved like a machine, a pit crew in a previous life, clearing and wiping the table as David raised his cup of coffee and slice of bread protectively.

Just as David was about to leave, Lillian marched two lines of new arrivals in and sat them down at the front table. Families of brats and old folks headed for the chow line.

Then the last of the newcomers rose and he saw her.

Her hair was cut in an F.O.B. pageboy and she hid her face as

she stared down at her tray, but he recognized her.

David picked up his cup and slid into line behind her. "Get lots of potatoes," he whispered, "and bread."

Celeste knew him. From somewhere. This year? Back in Ohio? On the way out to California? On the way back?

David saw a faint glimmer of recognition in her eyes.

"Is there a problem here?" Lillian demanded, hovering as usual. She eyed David suspiciously, especially when he wouldn't look her in the eye. "Oh. Second helpings?"

"Nope," David looked down into his ever-present coffee cup. "Just getting more coffee."

"Yes," Lillian addressed Celeste like a five-year-old, "have plenty of corn. And beef stew. We must have our protein. More," Lillian glared at the kitchen help, who dolloped big greasy clods on top of Celeste's previously unpolluted instant mashed potatoes.

As they sat down, Lillian looked back to make sure David actually was in line for seconds and, sure enough, the sneaky little bastard jerked his head away again.

As Celeste unearthed the clean potatoes from beneath the slop and gobbled her slice of bread and plenty of corn, she glanced over Lillian's left shoulder at David giving her an ixnay-oodfay frown. He held up a dirty plate.

He had written with his finger in the congealed layer of cold gravy, "13W."

David was here.

Jenny couldn't stay accessed to the files long without Lillian getting suspicious when she checked the log the next day (and she always did); but Jenny'd found him.

Thousands of people had been processed in and out, mostly out of the country, a few to specific addresses in Canada, France, Brazil, Peru, but most of them took the government's offer of a one-way ticket to destinations unknown in Japan.

Lately, the only ones leaving were the occasional individual transfers to federal prisons.

And the only ones transferring in were the ones with nowhere else to go or the terminally ill, some of them dying days after arrival.

She hurriedly completed the latest arrivals' data entry and had time, before she would beat curfew back to her apartment in the American quarters a half mile outside the compound, to search David's file.

Arrested…a hundred miles from here, on a warrant for his failure to report…late as usual.

Arrived in camp…assigned to barracks 24E. The family sector? Boy, he must love that. The guy who'd get up and leave a restaurant if there was a child under five present.

Work assignment: latrine maintenance.

Cleaning toilets. About time.

Kate was here with Graham and Mary. Ray joined them after release by the FBI. Arrived the same day.

All together in…24E. With David.

Where was Johnny? Why wouldn't they report together?

She checked David's arrest report again. In the company of one black male and one Asian female. No Johnny.

She booted up the search function and entered Takeda, John Tadashi.

"Johnny T," his friend Greg called him. Was Greg the black man arrested with David? And this Celeste?

Oh, no.

See Deceased File.

Please be a mistake.

She booted it up.

John T. Takeda…died…in Los Angeles, traffic-related incident two days before David was arrested.

What happened?

Jenny hoped Kate was all right. Kate had worshipped Johnny. Jenny had grown close to Kate.

John was another matter. For the first three years she was with David, Jenny was certain that John and his parents referred to her as "that hakujin girl," which they pronounced like "white she-devil." It wasn't until her hysterectomy that they seemed to accept that David would never dump this infertile Caucasian, and his parents actually seemed disappointed they wouldn't have any beautiful *happa* grandchildren.

Jenny had to admit she cared more about Kate than Johnny.

And more about Mary than Ray and Graham. She tried not to show it but Mary was her favorite, her niece who was particularly fascinated with her blonde hair.

Jenny hadn't seen Mary in over three years.

She'd be very different now.

Lillian winced as she downed the last of her cough medicine and set the tumbler back on the nightstand, on top of the crumpled and sweat-soaked medical report.

She didn't like the effects of alcohol. Besides making her tingly down there, it made her self-pitying, which she hated, although she had a right to complain.

It was she who had been betrayed.

One of them was pregnant.

As much as Lillian wanted to deny that any immoral sexual activity had been taking place in her Temporary Relocation Center, she was especially disturbed that her semi-trusted resident medical personnel may have been trying to prevent that information from reaching her.

Her reliable sources in the medical center informed her that Dr. Sidney Hayashida sent a disturbed young female to Dr. Milton Hayashida, her brother, for a routine physical examination, during which he discovered the little slut's condition. And neither of them had told her.

A direct violation of the new federal laws requiring doctors to

immediately inform government officials in matters of alleged privacy.

For God's sake, the girl was fourteen years old.

And the father, if the trollop was to be believed, had just turned twelve.

She didn't get it. All she asked of them was to act more Japanese. They already *were* Japanese. What was the big holdup?

Perhaps they had become too Americanized, the purity of their blood too diluted to resist temptation.

Still, she expected their pride in the motherland to be undying. But, contrary to her stated objectives, these Japanese didn't seem to want to return to the motherland.

No, by engaging in behavior unbecoming a morally traditional race, by succumbing to temptations previously attributed only to other colored races, Lillian finally had to admit that they were taking advantage of her good will.

There.

As much as she wanted to trust the Japanese, when every other American wanted to exterminate the whole sneaky little race, she had to face the fact that they had betrayed her.

She couldn't believe that young people were still having unprotected sex.

Wasn't that was the whole purpose of AIDS? To make a whole generation scared of sex?

As Lillian drifted off to sleep, she vowed to punish the little sinners. If they hadn't learned it before, she would teach them God's basic law: Sex equals punishment.

At least those Muslims understood that. Not that she was ready to hand her facility over to the next occupants. Yet.

She had to take care of her Japanese problem first.

She would hold the little fornicators up to their parents and the rest of the community.

She would shame the rest of them into policing themselves.

It was so basic. It was covered in the manual.

The Japanese respond well to shame.

If they didn't, she had a way to nip this problem in the bud, so to speak.

And if it worked here, it could work on a larger scale in more economically deprived ghetto communities.

It could be her ticket to Congress.

If worse came to worse, there was always the Plan.

27

David stared out through the barbed wire fence at the snow-covered mountains looming over the camp. The clouds seemed magnetically drawn to the mountains, brushing the flat desert camp with a brief dusting of snow like an afterthought. He lit his cigarette and spat out a puff. It tasted dirty. He rolled the glowing wad of embers off the end, pinched the scorched paper like a joint and put it back in the hard pack that had lasted him a month now. He'd save it for when he really needed it, when he was scrubbing toilets.

It was quiet. Desert quiet. Compared to L.A., this was outer space.

Even during the day, all you'd hear was the sound of humans talking, yelling, laughing, arguing, walking, running, playing, as natural as can be in a pen in the middle of the desert. It also helped that the humans, being of Japanese ancestry, were soft-spoken.

He had a place to stay. It was cold and drafty and he shared it with dozens of other men, but he wasn't ripped off or harassed or threatened everyday like he had been on the outside.

He walked to work. He walked home from work. He walked to the benjo and the showers. He walked to meals then he walked home. He took a walk after dinner every night and smoked half a cigarette, at his leisure. He didn't drive anywhere anymore.

The traffic, gas prices, the freeways, the shootings, the daily

incidents of rudeness. He didn't miss those at all.

David stared out at the white dusted mountains. They didn't move and neither did he. They were all he could see of the outside world and that suited him just fine.

He had his family with him. Christine and now, finally, Celeste. And none of them were going anywhere.

He looked out at the stars in the clear, desert sky and the moon laying a blue film on the snowcapped mountains. He breathed in the clean, clear, searingly cold, winter air and let it sting his lungs. He exhaled in a cloud.

He'd found her at last.

The thought of staying like this forever flickered across his mind, comfortingly.

"Freeze!" a voice cracked behind him.

David pulled his gaze away from the blue snow on the mountaintop and turned to see a young white boy in an army uniform pointing an M-16 at David's chest.

"Take your hands outa yer pockets!" the eyes bulged.

"All right," David slowly eased his warm hands from deep inside his down-filled parka and showed the boy his empty, open fingers. "Take it easy."

"What are you doing so close to the fence?"

David thought a moment then said, "I was trying to get a view less obscured by the barbed wire."

"Why?"

"So I could look at the whole mountain."

"Why?"

"So I wouldn't have to see the barbed wire."

If David talked any slower or any more deliberately, he'd put them both to sleep.

The boy in the uniform readjusted his grip on his rifle.

"Careful with that," David said calmly.

"Freeze!"

David didn't like looking down the barrel of a gun, especially

when it was framed by two buggy eyeballs and fingers squeezed white around the trigger.

"Move away from the fence."

"All right, I'm going."

"Okay, take off."

David strode slowly away from the boy.

"I don't wanna see you here no more, y'hear?"

"Yessir," David didn't look back.

Even when the boy remembered his authority and said, "Jap," to his back David kept walking and didn't breathe until he got around the corner.

Things hadn't changed.

He was still ducking punks with guns.

Kev unclenched his fingers from the rifle stock. That long black hair fooled him and when that old hippie turned around he thought it was a fag with AIDS, cuz that's all they sent to this place.

Nearly squeezed off a shot outa instinct, but luckily he dint cuz that woulda been a bitch ta splain to the sergeant. An' a lotta paperwork.

Dang, Kev was cold.

He dint know why he was here. He shoulda been on TV or modeling or doing commercials or somethin famous.

Sure, he coulda been a homey in Dickwood like the rest of his Posse, pumpin gas or changin mufflers or doin the sales thang. He wuz good at that. That's why he racked up so many points. With his looks and his gift for talkin the pants off anything female, he wuz King.

Okay, he could be in prison right now, but instead here he was out in the middle of the desert. Like a fox guarding the chickens. Sweet 'n' sour chickens.

Dang, he wuz good. He had the personality and the looks little girls wet their panties over.

Cuz when you got it, you got it.

Kev was just rounding the corner when he saw a shadow move in the unfinished barracks on the north end.

"Out kinda late, aren't you?" Kev said, friendly-like, cool this time.

"Depends."

The voice was high, but Kev couldn't tell if it was a chickie or not. "Step out into the light."

"You step into the dark," the voice whispered, "with me."

As his foot came down, a hand caressed his crotch.

"You got something for me?"

"Boy, do I," Kev moaned. It had been a long time since anyone other than himself had touched him down there.

"I mean, in terms of payment."

"Oh yeah," he whipped it out. "Here."

"Spam?" The voice was disappointed, maybe disgusted.

The guys told him Spam would work like a charm with these people. Especially with the shit they wuz serving in the mess hall.

But Kev was too worked up to stop now. He emptied his pockets of cigarettes, chocolates, anything.

"Here, take it all," he panted, emptying his pockets.

"Thanks," the contraband disappeared and the voice sounded older now, possibly even male.

But then the shadow eased Kev back against a partial wall, dropped down in front of him and yanked his zipper down.

Kev caught a glimpse of the bobbing head of slicked back hair and close-cropped sides and thought it might be male, but at that point he didn't care.

Then it turned around, dropped trou and bent over.

Now Kev was almost certain it was a guy.

Shit, he was committing a homosexual act. He and his Posse used to hunt down funny guys like this and kick the shit outa them.

But it had been too damn long for a healthy American boy to go without.

So, like the guys told him how, he just closed his eyes and couldn't tell the difference.

That way, this meant he wasn't a fag.

After Kev was done, the guy, and now he was sure it was a guy, stopped in the door frame and said, "Next time, bring batteries, double A," and disappeared.

Kev was struttin the resta his shift. This was how it wuz spose ta be. American soldiers gettin theirs.

What'd they expect, good healthy young all-American boys standing guard over all this pussy and they weren't supposed to take advantage?

Wunt that why they put them here? Wunt that why white men were put on God's green Earth?

He's gonna count this one as a ho. Around sixteen years old. Sixteen-year-old Jap pussy.

Mucho points, dude.

28

Kate was checking the charts on the back end of the terminal ward when she saw something move in the shadows. It had been so long since she had had to worry about the shadows that she didn't react at first.

"Can I help you?"

Graham stepped out of the shadows.

"Hey, Ma."

Kate almost didn't recognize him.

When your son is twelve, a few months can be the difference between a boy and a man.

She walked slowly and quietly toward him, as though trying not to startle a fawn lapping from a creek. He had grown at least an inch. They were almost eye to eye. He looked terribly thin. When she hugged him, she could feel his ribs and shoulder blades beneath his thin, muscleless skin.

"How ya doin, baby?" she kept her voice from shaking.

"A'ight."

She tried to remember if he ever looked directly at her.

Not since he reached puberty.

"Are you eating?"

"Yeah. Real good."

"I never see you in the mess hall."

"I don't go there."

"Where do you eat then?"

"We have it delivered."

Kate didn't believe David when he told her he always smelled meat cooking whenever he walked by the southside barracks where all the junior high boys lived. She thought her brother was dreaming of food again.

"Why don't you visit us sometime?" she offered.

"Sure."

"Mary misses you. We all do."

"Uh-huh."

Kate didn't see Gray look over her shoulder at the pharmaceutical cabinet between the lobby and the main room. She was too busy pulling teeth.

"How are you surviving?" she asked.

"I rent out my video games."

"Ohhh. How?"

"They gimme a battery or a can of chili or spaghetti or Spam, and they get to use one of my cartridges for an hour. Just like at Blockbuster."

"Where do they get those things?"

"They work. Dig ditches, scrub sinks, KP, hunt rats and scorps, all them chump jobs."

"So as long as your video games are working, you don't have to."

"They got the players and batteries. I got the software."

"What happens if it breaks or gets stolen?"

Graham stared a hole through her.

"Well, gee, Mom, I don't really plan for the future in here," he said bitterly. "My options seem to be limited."

As he got angrier, Graham seemed to grow up before her eyes, skimming by the past year when she had hardly seen him.

"I suppose I could be honing my skills for future employment, going to J-school, majoring in get-the-fuck-out or learning how to

wait on real Americans."

He aged another year. Then another.

"I guess I could be workin' on my career," he spat, fully a sullen, resentful teenager.

"Getting my degree in F.O.B., specializing in houseboy."

He finally looked accusingly at her. "If my Discman was still workin', I'd be cleanin' up."

"Your dad is very sorry he hit you, but what you did was insensitive and cruel."

Graham looked away and exhaled a long, drawn out hiss.

"What you said hurt me very much, when I had just found out that my brother, your Uncle Johnny," she said for emphasis, "was dead."

Graham was just about to walk away rather than deal with this, but then he said, very softly, "Sorry."

"It's all right, baby," Kate put a hand to his face, which he ducked.

"Gotta go, Ma."

Kate grabbed him before he could go and hugged him desperately.

Graham let her hang on for a moment before he shrugged out of her grasp.

Kate had the sinking feeling that if she didn't throw a net over him, she'd never see him again.

"It was good seeing you again," she called after him. "Graham. Stop in and see me anytime."

" 'Kay."

Kate wiped her face. Her collar and the front of her white nurse's blouse were drenched with tears.

She turned to pick up her clipboard when she heard glass rattling, a window pane in a locked cabinet door, the soft tapping of bottles on a glass shelf.

The soft click of a lock being tried.

She stopped and peered into the unlit lobby.

A dark figure slid quickly through the lobby and disappeared.

Kate watched for a moment, silent and unmoving, staring

intently into the darkness.

She called softly, "Gray?"

David was warming his hands at the wood stove when the barracks door opened and closed quickly.

Then Celeste was standing next to him, holding her palms outstretched and motionless over the grill. The orange glow accentuated the weight lost from her face, the scar on her sunken cheek at a sharper angle.

She shivered and wiped her running nose, cold and red from the night air, never taking her eyes off the grill. She found herself leaning against him. She closed her eyes and rolled against his chest and melted into his arms.

"I thought I'd never see you again," he whispered to her, then kissed her lightly above her right ear.

David pulled the sheet wall closed and lowered the wick on the kerosene lamp on the orange crate next to his bed.

Celeste sat on the foot of the bed. She looked cold and tiny. She didn't move.

"Here," he dropped to one knee and unlaced her boots.

Her stockinged foot popped out steaming like a knockwurst out of boiling water. It smelled horrible.

He stood there, awkwardly looking down at her bundled up in his bed, her mouth tight and ungiving.

"I didn't know what happened to everyone," he said. "I don't remember anything after Greg was shot."

"He was still alive when the ambulance took him away."

"Good," he said. "They took you back to your husband."

"Yeah. We're divorced now. It didn't work out." She spoke in a detached monotone. "Am I taking up too much room here?"

A single cot barely accommodated one person.

David pulled the blankets around them.

Celeste draped herself across his chest as soon as he settled in.

Her hair smelled oily. He caught a whiff of musty armpit. He was used to smelly newcomers. He just wasn't used to sleeping with one on her first night here, before she'd had a chance to bathe.

Did he think she was dirty? Not unclean in the hygienic sense but unclean as in been with too many men?

Maybe he was getting old. Maybe it was the cold or the snoring from the other side of the sheet wall or maybe they'd increased the poundage of saltpeter in the food.

For months, the only proposition he'd gotten was from Bradley and now the beautiful young woman he had been waiting for all this time was in his bed, and he was laying there like a dead fish.

"Hold me," she said softly.

He squeezed her until he heard her gasp for breath. He kissed her oily, dirty hair.

She tilted her face up to his, her lips parted, waiting. He leaned down and kissed her.

Then, to his great relief, he discovered he wasn't that old.

Celeste was trying to pull the covers over David, who was curled up beside her snoring, trying to find a little warmth for her shoulders, when a man opened the sheet hanging on the clothesline and stuck his head in.

"David, I—" he stopped.

He stood there looking at her, his arms full of canned goods. Spam, chili, soup, pork and beans, a few candy bars.

The surprised look on his face turned to hurt.

"Sorry, I didn't know he had company," he said and flung the sheet closed.

Now Celeste knew there was decent food to be had inside the compound and, more importantly, that this man, whom she remembered from last summer but seemed so long ago, his name was David.

29

"It saddens me to make a very painful announcement," Lillian said as the first breakfast shift went silent. "Are the parents of Amber Darlene TAN-uh-YAM-uh, are Fred and Donna Taniyama present?" She watched the sea of craning black hair and yellow faces crest like a small wave toward two meekly raised hands. "Will you stand up, please?"

Fred and Donna were in trouble. Everybody there knew it. Fred knew it. Donna knew it. They gripped each other's hands as they slowly stood up.

As they listened to Lillian,and saw everyone in the room slowly look away from them and down at their grease-hardened plates, they felt the tips of their ears burn, the pit of their stomachs drop, tears well up in their eyes.

They were being held up as bad parents, prime examples of how a failure of parental guidance can undermine the entire moral structure of a highly traditional culture.

They hadn't even seen Amber in months. She lived in the junior high girls barracks on the south end, but every time they went by, anytime any adult got close, a group of kids disappeared into the barracks, leaving an unresponsive committee to meet the intruders with blank stares.

Kate and Ray sat at their table with Mary between them, resisting the urge to smother her in their arms. They watched their new friends, Fred and Donna, stand there humiliated, as Lillian chastised them like little children.

They felt their humiliation. Shared it as a group, very Japanese. Especially when it could just as easily have been them.

Then when Lillian said the unidentified father had just turned twelve, their hearts sank.

Kate squeezed Ray's hand in both of hers, as hard as she could. She opened her mouth to speak to him then she saw his face.

It was expressionless. Stone cold. No concern, no worry.

She was about to ask him what they should do, then she saw the others around them whispering to each other. Then she knew they couldn't speak. They couldn't do anything to give away Graham's identity. Ray was right. Don't give anything away.

Kate nearly jumped when Ray leaned over and kissed her on the cheek.

"I'll take care of it, hon," he whispered and smiled at her, very casually, as though he'd just said, "Thank God that's not our kid, I'm going to the hardware store."

Ray had already made up his mind. Whatever it took to get them out, he'd do it. If they had to walk across the border to Canada or Mexico, he'd carry all of them on his back if he had to. He should've known when the FBI picked him up, there was no hope for them in this country. Things were not going to change for the better, not anytime soon. He'd file their papers today. They were getting out of here.

But first he had to find his son.

Gray the man. Gray the man.

The rest of them punks wuz just air, man.

Gray could talk the talk, cuz he walked the walk.

And she fiiiiine. Not like them skinny little bitches barely got

their period. Fourteen fuckin' years old.

Big ol' butt and titties out ta heh.

Bitch ain't been around lately.

Goooood. Now he don' gots ta look at her mopey-ass face.

He don' gots ta give her his famous Nuthin look.

He just hang wit his boys.

Scopin' out the rest of the ho's.

Cuz his boys know. Everybody know.

3-1-S is his turf.

And he the chief.

Ichiban, number one.

Gray the man.

Yeah.

In the first place, Amber Darlene Taniyama did not feel that her behavior warranted a session with Dr. Sid the shrink. Sure, she'd been irritable, but God, who wouldn't be? She'd been feeling so shitty lately, she sorta knew. She just didn't want to admit it.

All her life she'd been told that sex was dangerous, sex was bad, sex was life-threatening. Then they all end up in here and the urge hits her like a ton o' bricks. I mean, what else was there to do in here? Study Japanese? Go to Ozzie's lame-o singing class with the gays? No way.

Okay, he was young. Real young. But he was the only one that took the first step and that took guts. It would've been harsh to put him down in front of everyone.

Plus it was so noisy, like trying to have a conversation at a really big basketball game in a really little gym.

All she heard him say was something like, "Yougah boahfren?" and she said, "What?" and before she knew it they were alone in the south end of 32S, which was reserved for these occasions and they were stuck on which tape to play. He wanted to play rap, but she thought rap was passe. She preferred the latest boy band,

which he hated. She had serious doubts they were ever going to get past the music until he dug up an oldies retro-techno compilation that gave the place a movie-like feeling, like he had just picked her up at a dance club and couldn't wait to get her back to her apartment before tearing off her clothes.

It was cold and she wanted to get under the covers, which he interpreted to mean she wanted to get it over with quick, because he jumped on her and barely got it in before he came. The first song hadn't even gotten to the singing part.

It was bad enough when he wouldn't even talk to her afterwards. It was almost a week before he even looked back at her, and everybody knew it.

Then, when she started throwing up and stopped eating then started eating like a horse then started jumping down everybody's throats, that's when the other girls told her to go see a doctor before they killed her.

She didn't know why they kept her in the hospital wing. Right next to the terminal ward where all the AIDS patients were kept. It was creepy.

Lillian told Amber her parents wouldn't have to be involved in the decision and needn't even be present.

As was standard procedure regarding pregnant females, her problem would be decided strictly by the presiding government official, in this case, Lillian.

They'd keep her informed, but Amber wouldn't have to make any of the decisions.

Which was fine with her.

Through Dr. Sid, Jenny was able to confirm that David was in the camp and which barracks he was actually living in, the general dissatisfaction with the food and the formation of a rice strike committee and the stretching of medical facilities and supplies to the breaking point by the dumping of AIDS patients and the

terminally ill into the camp.

She didn't tell Dr. Sid at the time, but Jenny also discovered the existence of a proposal in Congress.

A radical solution as America found itself teetering on the verge of its greatest threat in the history of the country: economic domination by an enemy alien nation.

Because the American people knew that like their electoral system, victory went to the one who spent the most. And if the economy collapsed and they couldn't maintain high levels of security, all of America would be vulnerable to more terrorist attacks.

ReVac had produced hundreds of bottom-level jobs for real Americans and reduced the unemployment rate by a solid .03 percent in this quarter alone.

But it still wasn't enough. The American people, frustrated by the agonizingly slow and seemingly unending hunt for terrorists and dissatisfied with the arrested development of economic recovery, demanded action. Something dramatic and emotionally satisfying to a generation weaned on Rambo-like immediate gratification. Something that would guarantee permanent results.

So Congress passed the Plan.

It would be ethnic cleansing, American style.

Unlike the slaughter in Bosnia-Herzegovina, there would be a medically approved and executed plan to produce a generation of clean, healthy Japanese boys and girls who wouldn't breed like rats and produce future Japanese who would compete and, knowing them, take college admissions and good jobs away from deserving, potentially hard-working, real Americans. Not to mention screwing up the curve in the math and science classes.

Rumor had it that it was, like most things, a revival of a congressional proposal first made during World War II, not when the war was going badly and it looked like the Japanese empire would control most of the Pacific, but after Midway, after the tide began turning in the Allies' favor, after Japanese Americans from Hawaii

and the mainland formed the 100^{TH} Battalion/442^{ND} Regiment of the U.S. Army and were fighting in Europe and serving in U.S. Military Intelligence in the Pacific.

Rumor had it that while these Japanese American men were fighting for the United States, Congress was debating whether to sterilize the families that these men had left behind.

Rumor had it that this first proposal during World War II had been defeated by one vote.

And now it had been revived and was approved as a workable solution compatible with American principles, as they had adapted and evolved in times of war.

It was the Plan.

A certified letter to the executive director of the only temporary relocation center still in operation had arrived that day, authorizing her to proceed with the execution of the order on an "As Deemed Necessary" classification.

Jenny's hands trembled as she carefully refolded the letter and resealed it. She could bury it for a day or two, but she knew high-level communications were always followed up with a confirmation phone call.

Jenny just hoped she could get word to Dr. Sid or possibly gain entry into the compound before Lillian could get the machinery cranked up.

Lillian would be itching for a way to get back into the good graces of the Abstention League.

Now all she needed was an excuse.

30

For the first time in months, outside of the occasional looking-at-yourself-in-a-coffin death dream, David had a vivid dream of summer.

Lisa and the summer of '72.

The one he'd told Christine about.

That summer, he and Lisa had worked together at an ice-cream shop in West L.A. and went home every night smelling of sour milk and chocolate. Out on break from Las Vegas, she was staying with her cousin Nancy for the summer, thinking about moving to L.A. if she liked it here.

One night, after one of many arguments with his parents, David did the mature adult thing. He partied with his buds and crashed at their parents' houses for several days until he wore out his welcome and had to decide if he was going home after his shift at work.

Lisa was closing with him that night. She offered him her couch, neglecting to tell him that if her cousin happened to be home that night the couch was also her bed.

He gave her a ride home, as he always did when they closed the shop together, to her apartment in a row of cottages down by the canals in Venice and crashed on the couch while she took a bath.

By the time she put the new Seals and Crofts album on the turntable and finished her bath, David was snoring, a *Rolling Stone* draped over his face.

When the low sunlight awakened him early the next morning, David didn't know where he was, although by then he was used to that.

He crept into the bathroom and, to be quiet, sat down to take a leak. He washed his face and rinsed his mouth with a dab of toothpaste and slowly eased the bathroom door open.

The sunlight fell into the bedroom, across the bed, where Lisa lay on her side, her back to the door, completely nude.

An eighteen-year-old virgin, David didn't know what to do, except stare. He hadn't noticed her figure before, but there it was, laid out in front of him. Yes.

Lisa stared silently out the window, wondering if she'd see the familiar sight of Nancy dancing up the walk, back from a night with her boyfriend, satisfied and carefree, at this inopportune moment.

She'd heard David go into the bathroom, quiet as a mouse, trying not to wake her. That was so sweet of him.

Unless he was trying to sneak out on her.

She almost sighed audibly with relief when he sat down on the bed next to her.

He touched her lightly on her shoulder, "Lisa."

She rolled over immediately. "Hi."

"Thanks for letting me crash here," he tried not to stare at her bare breasts, which she made no move to cover up.

"You're welcome. Anytime."

She couldn't believe she was laying there in front of him, naked, with her boobs hanging out.

For the first time since she'd left Las Vegas, she felt free.

"I guess I should go," he said, not moving an inch.

"Okay," she had the feeling she'd be crushed if he just got up and left her, without one word of appreciation for her nakedness

and newly discovered freedom.

"Well, thanks again," David leaned down to hug her.

Lisa reached up and kissed him on the mouth. She parted her lips and felt his tongue meet hers. She thought momentarily about morning mouth, but it was too late.

David had devised millions of scenarios for this momentous occasion. None of them fit this one.

Lisa thought, maybe she was supposed to come out to L.A. and live in freaky Venice and lose her virginity to this nice Japanese guy who is nothing like the rednecks and shit-kickers and black-jack dealers' sons that only seemed to be interested in getting drunk with each other and never asked her out.

She never would've imagined it happening this way, so this must be the way it was supposed to happen.

David tried not to panic. He flipped on the stereo.

The same record was on the turntable from last night.

By the time "Summer Breeze," the fourth cut on the first side, ended, neither of them were virgins anymore.

They were spooned, his arms folded across her chest, her breasts cupped in his hands.

His right thumb was resting on what he thought was a clump of hair, but when he tried to brush it aside it didn't move.

"Don't," Celeste asked, "that hurts."

David turned her over onto her back and saw the pit of pur-plish scar tissue on the outside of her left breast, an inch wide crater almost under her armpit.

It didn't look like an out-of-nowhere keloid like his.

A cigar would have had to've been pressed into the same spot for several seconds to make a burn that deep. Hard.

"Did he do this?"

She nestled back into his arms, rubbing her face against his neck like a cat.

"I'm one of you now," she said quietly.

When David woke up, he was alone.

On the other side of his sheet walls, the sounds of coarse, male movement.

No sign of Celeste.

He looked around.

Had this all been a dream?

31

Mary saw Uncle David coming to pick her up.

He was early. Maybe he decided to take a vacation from scrubbing the benjo today.

He was walking fast. He usually strolls, real *nonki*.

He walked right past her.

She ran up behind him and slipped her hand into his. "Hey, babe," she chirped at him, "whatcha doin'?"

"Hey, peanut," he seemed surprised to see her. "I'm looking for someone."

"Who?"

"A girl."

"Yugah girlfren?"

"I...don't know, exactly," he said, pondering whether to tell her about his night with Celeste; it may have been a figment of his imagination.

"You don't know?"

"We just met. Again."

"So you knew her from before?"

"Yeah."

"Where does she live?"

"On the east side. I looked. She wasn't there. I checked the

mess halls, too."

"So what's she look like?"

"Young."

"My age?"

"Older."

"Mom's age?"

"Younger."

"Closer to eighteen or thirty-five?"

"Early twenties."

"Is that her?" Mary pointed at the nearest female.

"Too young."

"Is that her?"

"Too short."

"Over there," she jabbed. "Her?"

"Too tall."

"Attention, temporary relocation center residents," the loud-speaker hissed. "Today's special quadruple-feature moviefest begins with the three o'clock matinee *Behind the Rising Sun*, the story of an American who undergoes plastic surgery on his eyes and teeth in order to infiltrate the top-secret military hierarchy in Tokyo during World War II…"

"I saw that," Mary said, skipping along beside David. "He looked weird. He had putty all over his eyes and big buck teeth, but he still had a big honker. Like all those Charlie Chans. Is that her?"

"No."

"…plus Steven Spielberg's *Empire of the Sun*, the story of a young boy caught in the Pacific…"

"I saw that," Mary said, "he was cute."

"And as an added attraction, the World War II film classic, *The Sands of Iwo Jima*, starring John Wayne as the tough marine sergeant who leads a ragtag bunch of raw recruits into the most important battle of…"

"I remember that one," David said, "from when I was growing

up. They sneak up on the Duke and shoot him in the back. Or else they pretend they're dead and wait for him to go by then pop up and shoot him in the back. Or else they all bayonet him, in the back."

"Is that her?"

"No."

"…topping off our night with, as usual, *Pearl Harbor*, the Jerry Bruckheimer blockbuster, a story of love and…"

"Does she have any distinguishing characteristics?" Mary asked analytically. "Birthmarks? A limp?" She always watched the syndicated reruns of *Murder, She Wrote* after *Oprah*.

"She's about this tall," he held up his hand to his nose, "she's full-figured,"—with tits to die for—"short hair, and she's got a small scar on her cheekbone below her right eye."

Mary quickly scanned the compound. "Is that her?"

"No, too old."

"Her?" she pointed.

"No, but she's close." Only she's got a luscious mouth, pouting lips and delicate tongue…"Her hair's shorter."

"What's her name?"

"Celeste."

"Well, why didn't you say so?" Mary huffed, then took a deep breath and yelled as loud as she could, "Celeste!"

"Sshhh, don't do that."

"Why not?"

"I'm trying to be discreet."

"Ohh, okay," Mary nodded knowingly, making a mental note to look up "discreet" in the big dictionary in the camp library. "Is that her?"

"No, too big."

"Is that her?"

"No, younger."

"Is that her?"

"No, hair's too short."

"This is fun, huh?"

"Hey, are you asleep?"

Christine's breathing remained even but shallow.

"I had the strangest dream last night. You know, last night I coulda sworn…Do you ever regret taking drugs? I mean, it's not like I was a crackhead or anything. When my folks asked, I told them I tried marijuana. I experimented with it. Experimented. Yeah, like daily."

He thought he saw her eyelids flutter but she didn't open her eyes.

"Maybe if I didn't turn beet-red just smelling the cork, I would've drunk more. Or if I didn't get all congested with beer. But it's not like I did that much. Hash. Shrooms. Never dropped acid. Never did heroin. Or coke, believe it or not. All during the '80s when everybody was, well, I was with Jenny. She smoked pot once. She liked it, but she's just not someone who needs to get stoned. You know, for the middle two decades of our marriage, we were pretty happy."

David heard his voice echo down the end of the terminal ward.

"Okay," he whispered, "I'm pretty sure she was in my bed last night. This morning I could still smell her. She'd bathed since the first time, which lemme tell you, wasn't pleasant."

He straightened the sheet over Christine's shoulders.

"You know what I miss about getting stoned? Listening to records."

David watched quietly to make sure she was still breathing.

"Remind me to ask you if you have any dreams."

Graham couldn't hide from him forever. Ray was hoping to foil the network of kids helping each other hide from their parents by spotting Graham ducking into a latrine somewhere.

But the only one he recognized was his old hippie brother-in-

law with Mary tagging along after him.

"Is this the same one as yesterday?…What kinda clothes was she wearing?…Are you sure she's here?…What if she's not here?…Do you think she got out?…How'd she get out?…Do you think we can get out, too?…What's that mean, figment of your imagination?"

Ray marveled at David's patience. He would keep walking along, calmly replying to each of Mary's questions, eyes scouring the shadows in the distance.

"Is she a ghost?"

"Maybe."

Ray sometimes thought David was having a flashback from his stoned-out-of-his-mind college days. Usually he looked harmless, okay for Mary to be around. But today, David looked like he didn't have a clue.

By mid-afternoon the sun was starting to set. Ray was tired from walking, but mostly he was drained from days of searching with no results.

The blanket strung on the clothesline was pulled open so Kate was off somewhere. She kept busy. She was used to taking care of lots of details.

Without one main job to keep him occupied, Ray was lost. Probably a guy thing.

He could take up golf, but the courses around here were lousy. You keep losing balls through the barbed wire. And no one kept up the greens. And the nineteenth holes were for shit.

Ray laid down on his creaky cot.

He wanted to tell Gray he was sorry he hit him. But every time he saw his own son's face, uttering those ugly words, mocking John's death, in front of Kate and Mary…

He still shouldn't've hit him.

Ray had his father's temper.

He wondered what his dad did, when he was nineteen years old and stuck in camp the first time. How did he keep from tearing the place up?

What did he do the first year and a half behind barbed wire before he got into the 442ND and went off to war?

Ray blamed himself. He thought it was so important for his kids to grow up in a safe, white neighborhood that he forgot how lost they could get, how they could forget who they were while trying to blend in with all the other kids.

Ray closed his eyes.

He let the anger drain out of him.

Ever since Kate had started meditating, she would subtly, in her own wifely way, offer different ways for him to release the rage that boiled constantly inside him.

It seemed to help. He wasn't busting up furniture all the time, although he found that raising a chair over his head and smashing it into the floor and watching it explode in his hands was an excellent release, until they started running out of furniture.

Ray took a deep breath.

He would find Gray. He would tell him he was sorry he had hit him, but he was afraid Gray was falling into that self-hating trap this society laid for anybody of color.

He would tell Gray what the damn X on his cap meant.

He would tell Gray he loved him.

As soon as he found him.

But right now, he was tired. He had time for a quick nap before the first dinner shift at the mess hall.

Kate always liked to eat on the early shift so she could get Mary to bed early.

Yeah, he'll just close his eyes for a few minutes and things'll look better tomorrow.

Ray went to sleep and never woke up.

32

"Uncle David," Mary asked, "what's a ped-o-phile?"

That got his attention. He brought his focus out of the lengthening shadows and turned to his niece.

Jesus Christ, how old was she now? Six? Seven? No, she just had a birthday.

"What?" he said smoothly. Like Don Knotts.

"Some boy called you a ped-o-phile," she looked innocently up at him. "What's that?"

He thought, Christine would know how to handle this situation with tact, but she was having fewer and fewer lucid moments these days, so he was on his own.

Okay, how much did Mary know in the overall scheme?

More importantly, how much did Kate and Ray *want* her to know right now?

He couldn't explain deviant behavior to someone who didn't know what that behavior deviated from, especially if Mom and Dad would kill Uncle if he gave their daughter the info they were hoping to avoid until she reached puberty.

Nine, she was nine. But she'd always be a little baby girl to him so no way was he gonna explain any of this to her.

This was just the kinda thing that made him avoid parenthood.

"A weirdo?" he offered, hoping it'd suffice.

"Oh."

Yes. Okay, that took care of that.

They strolled along the barbed wire fence.

Just as David started to feel safe, she struck again.

"Is that like a pervert? How come he called you that?"

"Where'd you hear all this?"

"One of those boys in the junior high barracks."

"Well…Don't listen to them."

"Okay."

Of course. Why shouldn't the little punk think the worst? An old guy was walking along with a little girl. He could tell him Mary was his niece and the little smart-ass would snicker, "Yeah, right."

Or, David could tell him he was really looking for another little girl, an older one, one only half his age.

If David kept snooping around, he would become a target.

But he had to find Celeste.

Now, how to explain it to his nine- (or was she eight?) year-old niece who was always tagging along with him.

Unless he lucked out and she didn't follow up on her line of questioning—

"Is a pervert like a rapist?"

Geez, what were these kids learning in school these days? "Not necessarily…"

"What's the difference?"

Say, Kate, you know, on our walk today, even though you thought your daughter was too young to have that special talk yet, I explained to Mary what rape and perversion were, and I also threw in bestiality and necrophilia.

Mary was skipping along beside him, but David felt like he was being grilled by the Iraqi secret police.

"Well, a pedophile isn't always a pervert—no, the other way around, a pervert isn't necessarily a pedophile—" He flashed on

the "Jap-Chink-Gook-which-is-and-which-isn't" bit. "But a rapist is…violent and…bad," he lunged desperately, "and a pervert isn't necessarily violent. He's just…weird."

Now if that didn't cover it, she would just have to go ask her mother.

"So how come he called you a ped-o-phile?"

Maybe they saw him with Celeste, who's only half his age. That would be good, because that would mean she really exists and he isn't crazy.

"Don't listen to them. They grew up watching Jerry Springer."

Then she asked quietly, "Are you gonna get in trouble because I'm always hanging around with you?"

He saw the terrified look in her eyes. The certainty that she was the cause of everything that had gone wrong. That all things bad emanated from her.

He had seen that look in his own face, in the faces of his family. It was hard enough being a kid, but when it was compounded by being blamed for everything Japanese…

"I'm not gonna get in trouble," he tried to be firm without letting the anger seep through, "because of you."

"But they said—"

"They're wrong. I'm your uncle—"

"Most cases of incest—"

"Geez, incest?"

"They said most victims know the attacker."

"Who's teaching you this—?"

"They said they'd lie to you—"

"Mary, I wouldn't do anything to hurt—"

"That's what they said they'd say—"

"Mary, I love you—"

"That's it! That's what they said you'd say—!"

"Stop it!" he grabbed her by the shoulders.

"You touched me, you touched me!" she cried, eyes brimming with tears and bulging in panic.

He wanted to let her go but couldn't.

He started to put a hand over her mouth then quickly jerked it back, afraid what it would look like.

He said, "Shhh, shhhh," gently, started to caress her cheek, then, afraid what that would look like, pulled back.

He held his hands up in surrender and sat back on his heel and helplessly watched this child of the late '90s, who was taught at an early age that sex kills and to be suspicious of everyone, sobbing before him.

He had a deep yearning for the '60s. It may have been idealistic and naive and satirized to death by smirking cynics, but at this moment he ached for the days when he could hug someone just because he was glad to see them.

But all he could do was wait for her to stop crying and hope she didn't run away and hope no one was watching.

"You okay?" he touched her, safely, on the shoulder.

Mary nodded, rubbing away the tears.

"I'd never hurt you, you know that."

She nodded.

"You've known me all your life. Are you gonna listen to me, or some ignorant little bozo you don't know from Adam?"

"You," Mary wiped her nose with the heel of her hand. "Adam who?"

David laughed, lightened with relief, and held out his arms. "C'mere, shug."

Mary leaped into his arms and he stood up, cradling her and smothering her thick, black hair with kisses.

He twirled around with her in his arms, holding her and hugging her.

He was so relieved, he didn't notice they were surrounded.

"Well, lookie here," a voice squeaked. "It's the perv."

A dozen prepubescents with tough-guy cigarettes dangling from fuzz-topped mouths had them backed up to the barbed wire.

David could feel Mary freeze in his arms.

"Where you goin' with the bitch, perv?" Squeakie said.

The tallest one on his left, gangly and awkward and towering over the others, hadn't grown into his height yet. Stretch was twirling a pair of nunchuks in a manner that indicated that he may as well have been holding a big stick.

David assumed the others were armed and, if they all rushed him at once, could slice him to bits in a minute.

The uniform in the guard tower manning the mounted automatic weapon leaned on the rail and looked directly at them. Then he dropped his cigarette stub and lit another one.

He'd fire a few rounds into the air after someone lay dying in a pool of blood.

They must have sensed the anger building inside David and assumed martial arts stances. A couple even said, "Hi-yah."

He said, "You got to be kidding." Anyone who went around saying "hi-yah" got their martial arts training by watching Mighty Morphin Power Rangers.

"Say," Squeakie sneered, "whynchu leave the ho here so we can put her to good use?"

David hadn't practiced since junior high, but the Okinawan-style Shotokan karate being fairly basic, the target being so low and overconfident, a front kick to the throat was easily executed. Plus the thought of these hairless little punks renting his niece to some guard for a pack of Marlboros made David disregard the odds.

Speaking of Adam, David's right foot caught Squeakie square in the windpipe, accompanied by an appropriately explosive *kiai* with purpose, flipping Squeakie onto the back of his head, followed by his legs flopping up into the air.

Iha *Sensei* would've been proud.

The kick was balanced and retracted quickly, enabling David to dig and churn two full strides, lower his shoulder to spear Stretch in the chest and break through the line before the rest of the prepubes could react.

Coach Rose would've been proud.

David cut around the corner, cradling Mary like a football on a fullback plunge with both arms wrapped around the precious cargo and heading east down First Street.

Clear path to the end zone if they weren't caught from behind, which meant David had to keep running.

"Are they after us?" David huffed.

Mary unclenched her eyes and peeked over David's bouncing shoulder.

"Don't stop!" she squealed.

The chilly desert air scorched his lungs, but he kept his weakening legs moving. He wanted to use his arms to pick up some power, but he was carrying Mary so he tried to gain momentum by thrusting his head forward.

He got the feeling all he was doing was the Chuck Berry duckwalk, lower and lower to the ground.

His thighs burned, his calves were numb and his feet were no longer leaving the ground.

He was churning up a huge dust storm shuffling toward the east end of camp.

He looked like the Little-Train-That-Was-About-to-Die.

"Halt!" A uniform stood in front of them, rifle raised.

David collapsed to his knees, setting Mary gently down to the ground before he fell on his side, legs curled up with cramps, lungs pumping furiously and futilely, unable to suck any air past his rasping throat to save his life.

"Where are you going with this girl?"

Oh, great, another quick lesson on "pervert."

David raised his head and wheezed at him.

"Answer me!" the muzzle of the rifle demanded. "What were you doing with this girl?"

David looked up into the barrel of the M-16 and tried to talk, but all that came out were great heaving gulps.

"Excuse me, corporal," Mary tugged at his sleeve, "this is my uncle and some boys just tried to kidnap me."

"Where?"

"Back there by the fence."

"Okay," he looked at David. "Are you all right, sir?"

"We're all right now," Mary said reassuringly as she helped her still-gasping uncle to his knees. "Thank you," she called to the corporal as he sprinted around the corner.

Thrown into the mix of today's armed forces—a great majority of whom were ironically felons convicted of hate crimes against gays and people of color—were Mormons who were drafted when they returned from their mission. This corporal was obviously a Mormon since he called David "sir" and didn't shoot them before asking questions.

Funny thing though. David hadn't seen too many Black Mormons.

He'd figure it out later, when he could inhale.

In the meantime, he noticed that most of his major muscle groups were starting to contract.

Mary let him lean on her right shoulder to stand.

"You're all sweaty," she observed correctly.

"Don't be afraid, it's a normal condition for fat, out of shape, old men."

"You aren't that fat."

"Thanks," he said, gritting his teeth in pain. He could see the family barracks from where he bent. "Can you make it back home okay?"

"Of course I can, silly. Are you okay?" she persisted.

"I'm just gonna go take a hot shower and that'll loosen up my back." And his legs and arms and every aching muscle he hadn't used since high school.

He turned back to her, the line of his shoulders at a forty-five degree angle to the ground.

"You remember the Ten Commandments?" Sunday school, now that was a sure thing.

"Thou shalt not kill," she began reciting, "thou shalt not steal…"

"There's one in there about not bearing false witness. Know what it means?"

"Lying."

"Right. Lying about other people. Accusing them of things they didn't do and testifying against them. Now if someone like those boys"—the little assholes talking shit—"says something you know is wrong about someone else, you don't believe them, plus you don't think any less of the person they are saying bad things about," he stopped for air. "You know who you know and you know who you can trust. Okay?"

"Okay," she chirped and skipped away.

He stood there like a human question mark, crooked and aching.

" 'Okay'?" he bleated. "That's it?"

He threw up his hands.

God, he was glad he wasn't a parent.

33

Dino opened the door to the showers and thought, Oh great, I've stumbled upon the sodomites in the act.

"Aahhhhhhh, geez!" David cried.

Dino thought about coming back later, but these were supposed to be public showers open to everyone. Everyone male, that is. They might as well make them coed if this kinda thing was gonna be going on. He spun the nearest handle and quickly soaped up and tried not to look.

If David had seen Dino enter, perhaps he would've stopped moaning like a bull in heat, but he didn't and the effect of Bradley's tremendously strong fingers on his aching lower back was too agonizingly ecstatic for him to remain silent.

"Uuuhhhhh, yeah," David moaned.

Dino scrubbed like hell, as fast as he could go without putting out an eye. Geez, these guys were really going at it.

Bradley could feel the contraction in David's *latissimus dorsi* beginning to diminish. Finally. It was like trying to untie a knot through a leather coat.

"Ohhhhhhhhh, Godddd…"

Dino threw down his facecloth, rinsed off as fast as he could and skidded his way out of the shower before those two

consummated the act.

"Thanks, Bradley, I owe you."

Before David could stand up, Bradley attached himself to his back, clutching him with both arms and a leg. David could feel something else jutting up between his legs from behind but did not want to look.

"Bradley..."

Bradley held on.

"Bradley, no."

"It felt good, didn't it?"

"Yeah, but that was just a massage."

"It was more than that."

"No, it was a massage and it was great but that's all it was," David patted Bradley's hand. "Okay," David said gently, an okay that meant end of conversation.

Bradley sighed and gradually fell off in pieces.

"I just want you to be my friend," Bradley said sadly.

"I am your friend. Just not your lover."

"Then what good are you?" Bradley spun him around angrily. "Don't you think I want to get off sometime?"

"Bradley, I'll watch out for you but I'm not gonna—" David glanced around, "—fuck you, for cryin' out loud."

"Fine," Bradley snatched a towel off a pipe.

"Haven't you ever heard of a platonic relationship?"

"Yes," Bradley said, buffing himself violently. "They're extremely painful."

"That's the way it's gotta be."

"Well," Bradley said, wrapping the towel around his waist, "I'm sure you'll be happy with your new girlfriend."

"What?"

"I saw you two last night," Bradley said and banged out the door.

"You did?"

Dino had washed out his socks outside the latrine in the

trough they call a community sink and had just lathered up for his shave, his razor poised against his cheek when the two funny boys came prancing out of the showers, first the flamboyant one wearing only a towel, then the longhaired moaner.

"What do you mean you saw us last night?"

"Are you gonna deny it now?"

Oh great, now they're gonna have a lovers' quarrel right in front of him. Dino tried not to slice off his lips.

"No, no, I wasn't sure I didn't dream it," David jabbered, trying to bring a clear picture of Celeste's face into his mind. "She was there last night and this morning she was gone, and I haven't seen anything that doesn't prove I didn't dream it."

"Can you babble in a few less negatives?"

"You saw a woman in bed with me last night, right?" he was almost begging.

Bradley saw the desperation in David's eyes and thought, one more Buddhahead hitting the wall.

"What don't you understand?" Bradley said patiently. "Am I speaking Japanese? Shall we simply nod and grunt?"

"Did you?"

"Yes," Bradley said cautiously.

"Yes!" David hopped twice. "What'd she look like?"

"Gee, killer, I have an excuse, but weren't you looking?"

"Please, Bradley, just describe her for me."

"Black hair, short, probably of Japanese ancestry," he said flippantly.

"Bradley..." He was gonna hit him.

"...round face, big eyes, nice boobs for a *Nihonjin*," Bradley went on nonchalantly.

David would have killed him right then if it wouldn't have stopped the flow of information.

"Naked and," Bradley finally looked right at him, "a small scar on her cheekbone below the corner of her right eye, which may or may not cause the muscles on that side of her

face to react just a tad slowly, giving her a lopsided but allur-
ing look. Very Jane Seymour."

"Yes!" David cried in relief, "that's her!"

"Told you so," Bradley eyed David suspiciously.

Insanity had never been in his repertoire before.

"So...I'm not crazy!" David whooped, laughing.

No, but you're on your way, Bradley thought, a wooden
smile plastered on his face.

"Thank you, thank you, thank you," he giggled and hugged
Bradley. "I owe you one. Not that one. Something."

Bradley snuck in a quick kiss while David was within strik-
ing distance before he went dancing away.

Get it while you can.

Dino patched up the gouges on his face, grabbed his drip-
ping socks and got his ass outa there before the happy couple
started looking at him funny.

As soon as David came bopping around the corner of the east-
side barracks and saw Mary curled up on the bottom step, her
face cupped in her hands, staring down at the cold, dry, sandy
ground, he knew something was wrong.

He sat down next to her.

"My dad's dead." She didn't look up. Her voice squeezed
out between her hands, beneath her knees.

"What?" he asked gently, no surprise in his voice.

"Mom came home and found him on his cot. She tried
CPR, but it looks like he had a heart attack." She stood up,
still not looking at him. "I'm supposed to bring you."

"God, I'm sorry, baby," he started to pick her up.

Mary shrugged away from him. "I can walk."

David didn't know what to do.

"Okay," he held out his hand. "Let's go."

When she took his hand, David silently exhaled in relief as

they walked away from the setting sun, east toward home.

"Graham L. Yamash'ta, report to the medical center," the woman's voice rasped out of the tinny loudspeaker.

Mary looked up at David in amazement.

"They're calling for Graham!"

"Graham L. Yamash'ta, please report to the medical center. This is an emergency."

David liked her voice. It wasn't Lillian.

And she pronounced the name right.

Jenny turned off the loudspeaker microphone and buzzed the medical center.

A female voice answered.

"This is communications," Jenny said in her most businesslike voice. "Has Graham Yama—" she caught herself, "Yam-a-sheetuh reported yet?"

"Spell that—oh, the youth, nope, not yet."

"And who is he supposed to report to?"

"Me."

"And you are…"

"Registration."

"Okay, thank you, so…what's this all about?"

"Classified."

"I know that," Jenny said patronizingly and held her breath and waited.

Then finally, the voice said, "Father croaked."

"His father? Graham's father?" Jenny tried to keep her voice from shaking. "That would be Raymond Yam-a-sheetuh?"

"Right." Click.

Jenny pulled the cord on the ancient Venetian blinds, the kind that her mom used to have, David's Obachan, too.

Ray was so proud of his kids. He reminded her of her Nisei

father-in-law. When Kate had gone back to work as a dental hygienist, Ray slid easily into the modern husband role, making dinner, getting the kids to help out around the house and clean up. It wasn't until he started losing jobs, then was out of work permanently that Jenny caught a glimpse of Ray's frustration. Never violent, but Jenny could see Ray struggling to keep it bottled up inside him.

The last time she saw Ray was in her rearview mirror as she drove away, alone. He was playing catch with Graham.

Poor Kate. Poor Mary.

Where was Graham?

She was going to have to ask Ozzie or Dr. Sid for help. She hated putting them in jeopardy but—

The intercom buzzer jolted her. She quickly blew her nose and stabbed the blinking button.

"Communications."

"Why are you asking questions about this announcement?" Lillian's demanding voice vibrated the speaker.

A civilian employee must've answered the phone. Military personnel wouldn't have bothered telling Lillian.

"I thought of it after you left," Jenny said smoothly. "The notice didn't say who the boy was to report to."

"He doesn't need to know. He just has to report to the medical center."

"Okay."

"Why did you want to know the nature of the emergency?"

"The emergency announcement was last minute—"

"It wasn't last minute. Why'd you ask?"

"Well, the boy's father died…"

Jenny heard the low whistle from Lillian's nostrils.

"So?" Lillian said coldly. "People are supposed to die. If they die here, all the more convenient for everyone involved. What they aren't supposed to do while they're residing in this temporary relocation center," she was almost

shouting, "is get pregnant. Is there anything else you'd like to know?"

"No," Jenny mumbled. "Just curious."

"Don't be curious."

Click.

34

" 'Sup, G?" James stood over Graham's bunk.

"Same ol', J," Gray said glumly.

The young man who would've been a senior in high school sat down on the next cot and lit up.

"Heard your name on the PA."

"Yeah."

"So what up?"

"My dad died."

"Get out. He a young dude."

"Wuz."

"Damn," James shook his head, then looked up. "They killed him."

"No, my contact said natural causes, heart attack."

"Aw, shibai!"

Gray knew, the way his day would say, "Awww, sheeee-byyyye," there was no doubt it was Buddhahead for *bullshit*.

James spat angrily, "That's what they want you to believe. It's just a coincidence all our dads died around the big four-oh of natural causes—at least the ones that didn't get shot or beat to death by unemployed white boys. Jus' one big motherfuckin' coincidence. Shi-fuckin-bai."

Nothing surprised Gray. Not ReVac, or his old friends on the

outside turning their backs on him, or his dad dying.

If you expect the worst, you'll never be surprised. Or disappointed.

"So, ain't your mom around?" James said.

"Probably."

"How about your sister?"

"Yeah."

"How come you ain't with them?"

"I dunno."

James sat back and eyeballed Graham.

"Well, don't you think you ought to be with your family right now?"

"I guess so."

"They family, brah."

"I know."

"Well?"

Gray trusted James. He helped him out when he first moved in and never asked for anything in return.

Never.

Which was saying something in this place.

He was like the big brother he never had. The father he wished he'd had.

Gray stood up.

"Guess I better go."

"All right," James tapped fists with Gray. "Now's the time when our women need all that comfort 'n' shit."

"There he is," Mary squealed excitedly. She wiggled out of David's arms and fell in beside Graham. She slipped her hand in his, which he dealt with for a few steps then decided he didn't like the way it looked and jerked away.

Mary continued walking alongside him, watching him to make sure she wasn't making him madder.

"What's goin' on, Gray?" David said.

"'What's goin' on?'" Graham mocked.

"That's my generation's version of 'whatup?' " David snatched the cigarette out of Graham's mouth and crushed it, "and ours came first. What's goin' on?"

"Nuth-thin'," Gray over-enunciated. "Nothin's goin' on."

"You know about your dad?"

"Yeah. He croaked."

David held a deep breath a long, long time, until he was sure the urge to kick the smirk off his nephew's face had passed.

"You know what that means?"

"It means he won't be hitting me no more." That's what Gray would remember about his dad.

"It means you got business to take care of."

"Like what?" Gray challenged.

"Funeral business, wills and estates—"

"No funerals here. Wills and estates?" Gray spat. "What's he got to leave us?"

About the same as the rest of us, David thought. Whatever he carried in here. Sum total for a lifetime's honest work.

"You got family obligations."

"Like what?"

Comforting each other and being together, you little shit, David cursed to himself, then realized that maybe this overly sheltered, spoiled child of the '90s had never been to a funeral. That he was allowed to avoid all the unpleasant things and just stay home and play Nintendo until his parents returned home and he might notice they were dressed in church black instead of club black.

"Talk to your mom about it." Talk to her about anything, just talk to her. "We're meeting her at her work."

"Awww, man, I don't wanna go there."

"Why not? Scared?"

"No," he said defiantly, automatically as he always did in

response to that question.

"Don't touch any open sores and you'll be fine."

"Eeyuuuhh," Mary grimaced.

David forgot Mary was still there. He picked her up.

"Don't worry, sweetheart, it isn't dangerous."

"Sheee-it," Graham tried not to shudder, "fuckin' AIDS gimme the creeps."

"They're just tryin' to die with dignity."

"Same way they got it, takin' it up the—"

"Keep your dick in your pants and you won't have anything to worry about," David boomed. "Okay, slick?"

Mary gasped. "Ah-mmmmmm."

David wasn't a parent because he was doing enough damage as an uncle.

"C'mon, let's go find your mom."

David started down the empty hallway, his heels echoing hollowly off the bare walls and buffed, polished floors. He'd never been to this end, the terminal end of the terminal ward. Luckily.

Mary's mom used to ask her if she wanted to go inside, but she didn't like the smell in the doctor's office.

She followed closely, clutching David's hand, urging her brother to keep up, unable to move her feet any faster, going deeper and deeper into the scary place her mother worked. It was even scarier at night.

Graham followed sullenly, trying not to be uncool and hang too close, but he didn't want to get left behind.

David carefully opened the first door on the left. A body lay in the one bed, covered up to the chin with a grayish white sheet, its face emaciated and shrunken, wires and tubes coming out of all ends of its body. David jumped when the body coughed weakly and smacked its parched lips.

This was the last-rites room. Christine always made jokes about this being her next residence.

The door suddenly jerked out of his hand and David nearly

screamed.

"Oh!" It was Kate. "You're here."

"We found Gray," Mary hid behind David, who was attempting to push his heart back down his throat.

"Did you want to come in and say hello?"

David and Mary both shook their heads no.

"I'll be right out."

From the hallway David and Mary saw Kate press her ear close to the body's mouth, then pat the shrunken hand lying across the top of the sheet and close the door behind her.

"How come he gets his own room?" Mary asked.

"Because he's dying, sweetheart." Kate looked at Gray. "Would you like to pay our last respects now?"

"What if some family don't got no respects to pay?"

Please let me hit him, David prayed to Kate, just one little smack.

"Then," Kate said calmly, "you finish up any business you didn't take care of while he was still alive."

"Now?" Graham demanded in a tone that reeked of self-importance. Like, I got more important things to do besides drag my ass to look at my ol' man's corpse.

"We'll just go say goodbye then," Kate said steering Mary and Graham down the corridor.

Graham made like he was saying a prayer or being respectful or something he saw Pacino or DeNiro do in a movie once. Mom was saying all kindsa shit about how Daddy's in a better place. She was right about them not having the stuff to keep stiffs from going bad. Dad looked like shit.

Then he saw that honky cow Lillian open the door and before she saw him, Gray eased on outa there and started checking the clinic for trade value.

But, just his luck, the first door he opens, he runs smack into

fuckin' Amber, sitting up in bed, reading her stupid soap maga-
zines, and she sees his stupid face poke inside the stupid door and
starts screaming and—aw, God, now she was cryin' and nose-drib-
blin' and shit. Goddammit, of all the stupid luck. Gray jumped
into bed and put his arm around her just to shut her up.

"Ssshhh, baby, yeah, I just came to see how you doin'," he
cooed. "You feelin' a'ight?" He kissed her head and stroked her
big ol' titties. Sho did miss those.

"So, how come you in here, baby?"

"I'm pregnant."

"Huh?"

Damn if his voice didn't crack like a punk.

"I said I'm pregnant."

"Oh?"

Damn, now the boys gonna know he lost his cool and chucked
the rubber cuz he wanted to hurry up and stick it in before he
came all over the sheets.

"You're the father."

"Oh?" They got tests to prove it one way or the other.

"You're the only one."

Uh-oh.

"Ever." She was watching him.

"So," he cleared his throat, "whatchu gonna do?"

"What do you mean, what am I gonna do?"

"You know," he said, "have the baby, not have the baby…"

"I don't know. What are you gonna do?"

"Whatchu mean, me? What can I do?"

"I mean, you're gonna be a daddy."

The words hit Gray dead-center in the chest, which started
sinking slowly down into his stomach, which started sinking slowly
into the bed. If he kept sinking, he could hit the floor running and
get his ass on outa there fast.

Gray suddenly felt, for the first time since he arrived in camp,
for the first time in his life, trapped.

Then something strange happened.

Gray heard his dad talking to him. He was dead and everything, but Gray heard him saying something he told him a long time, like a year ago.

Something about taking responsibility for your actions and doing the right thing.

"Okay," he kissed Amber on the forehead, "so what *we* gon' do 'bout it?"

Amber's eyes welled up with tears.

"You said 'we'!" She kissed him and rolled over on top of him and he felt those big ol' titties smooshing all over his chest and he started rubbing her butt and getting a woody.

Then he remembered this was what got him into trouble in the first place.

But then he thought, hey, she already knocked up.

Wha' she gonna do if he nail her again, get more pregnant?

He started grinding.

"So," Amber babbled, "I gotta give it up for adoption, then they'll tie my tubes and," then she said, completely ruining the mood, "if Lillian ever finds out it was you, she'll cut your balls off."

35

On the seventh day after Ray's death, David assumed a service would be held, as was Buddhist custom.

Kate hadn't asked David to do the eulogy but he was expecting it.

It had been a week since David's visit from Celeste, whom he still couldn't find. But he had more important things to think about. It was fry bread day.

Besides Optimist Club pancake breakfasts and Battle of the Bands, the smell of frying oil on fry bread days reminded David of Ketchie's.

Ketchie's was a real hamburger stand on the corner of Sawtelle and LaGrange in West L.A., a block north of George's Hardware, Sawtelle Garage and S&M Nursery, where his dad and all the gardeners hung out.

First time his Auntie Tomo took him there, he wasn't exactly sure what to make of this stand that was smaller than anything he'd ever seen not on wheels, barely big enough to accommodate its ten red-vinyl stools.

The man cooking the burgers, Lonnie, this slow-talking, clean-cut Oklahoman, seemed to know everybody by name.

"Here's your burger, Juan…Onions on your chili tamale,

Fred?…You want hot sauce on that taco, Yosh?…"

He even called this old Issei, "*Ojiisan*," and he pronounced it right, so it came out "oij-sahn."

"Here's your eggburger, oij-sahn."

On brisk, winter Saturdays, after he and Johnny helped his dad with a half-day's gardening—mowing and raking and washing off till their fingers were numb and red—Dad would take them to Ketchie's for lunch.

David would grab the back stool and huddle against the plywood wall under the corrugated tin roof, sip a scalding hot chocolate made from a packet stirred into hot water with a wooden popsicle stick in a plastic cone and holder. He'd watch Lonnie slap patties and toss buns onto the grill, slide the toasted buns off the grill and give them a quick swipe with mustard and mayonnaise, a scoop of sweet relish, a pinch of dill pickles, shredded lettuce, sliced tomatoes and diced onions. He'd slide the patty on top, wrap it all up in paper and set it down in front of you as he snatched up empty wrappers and cups and kept a running tab in his head.

Late one night in the early '80s, a drunk barreling down Sawtelle jumped the curb and leveled the poor little stand.

Lonnie had no insurance, and by then the developers had descended on Sawtelle, buying out the old Niseis. They had no desire to see that little eyesore hamburger stand whose clientele rode up on bicycles or drove up in pickup trucks loaded down with lawnmowers, edgers, trimmers, rakes, hoses and kids, resurrect itself on their upscale property.

So Lonnie retired a few years earlier than he'd planned and shortly thereafter he died.

His people missed his burgers, the best burgers in town.

Mostly they missed Lonnie, the ol' boy from Oklahoma who remembered everybody's name and pronounced it right.

"Here's your taco, Mits," Navajo Uncle George said.

Every Nisei had a brother George.

As David dribbled honey on his pieces of bread, dusted them with powdered sugar and headed for the terminal ward, he saw Mits munching on his Navajo taco, talking to the two Navajo people who looked like his dead relatives.

He didn't know it then, but that would be the last time he'd see Mits in quite a while.

Because at that moment Mits was being asked by Navajo sister-in-law Esther, "Excuse me, are you a Nisei?"

"Yeah," Mits said, always surprised when any non-*Nihonjin* knew the term.

"One of the men in our tribe, he's Nisei. His family was in this camp during the war, joined the army, fought with the 442ND, went back to Oxnard after the war, didn't like it out there, came back to the rez and stayed."

"He's still living on the reservation?"

"I hope so," she laughed. "He's my husband."

Every time he entered the terminal ward, David looked ahead for Christine's bed. He didn't want any nasty surprises. When he saw she was still there, he let go of the breath he'd been holding and sat down next to her. He leaned down and kissed her on the forehead.

Her eyes flickered open, slowly rolling into focus, finally settling on David and she smiled.

"Hi," she croaked, then cleared her throat. "Morning."

"Morning," he beamed at her.

She exhaled and closed her eyes. "Is that a breakfast burrito or are you just glad to see me?"

It was like watching Death laugh at him. The bones in her face stood out. The tubes hung out her nostrils and arms like puppet strings. He could smell her breath, stale and poisoned, from

three feet away.

He wanted to spend the rest of her life with her and he probably would.

"Fry bread," he unfolded the napkin.

David tore off a small piece for her. She reached out with her unpunctured left hand. The fry bread looked huge in her boney fingers and it fell back on the napkin, white flakes of powdered sugar puffing out. "Shit."

David picked it up.

She aimed her grasp, squinting, and latched onto the bread with her tiny talon-like fingers and bit down into the soft dough.

Then she stopped and yanked the bread from her mouth. A bloody incisor was stuck in the fry bread, root and all.

Christine looked at her broken tooth in the bread. She looked like she was about to cry, then she laughed.

"Damn," she flicked the tooth away. "I'm falling apart."

She chewed with her molars, a thin rivulet of saliva trickling out of the corner of her mouth.

David wiped the corner of her mouth and popped a large hunk of fry bread into his mouth, licking the powdered sugar from his fingers as he chewed heartily. Before he knew it, the entire piece was gone and he was starting in on his second.

Christine was still working on her first bite.

"Mmmmm." Her left hand flopped down in his lap, sugar sprinkling his pants. "*Goch'so-sama.*"

"Have some more," he said, wiping her fingers.

"No, I'm done." When he finished cleaning her hand, she let it rest on his thigh.

He quickly finished off the second piece.

By now they knew the story of their lives and had caught up on the missing years and the fates of their common friends and acquaintances. They knew their likes and dislikes and how they had changed over the years. Third-date stuff.

Now they were at the "now what?" stage of a relationship,

except that they both knew what.

She was going to die soon.

They knew their paths had crossed once again, as they had so infrequently but inevitably over the past thirty years, for a reason, if only because they were meant to know each other for a little while longer.

At this last moment, she'd found one person who knew her. She wouldn't die alone, which she found comforting.

She knew her body was failing her. And it must've been an instilled-til-death *enryo-to-da-max* trait of considering others before herself, because she was worried about the effect her slow death would have on David. So Japanese.

Then something kicked in, whatever drug she was on, because she started forming complete sentences.

"They're gonna move me to the last rites room pretty soon," she said bluntly.

"Why? You seem fine."

"Yeah, for all of three minutes a day," she turned to look at him. "You know, you don't have to come around anymore, because I won't recognize you."

"I want to."

"Okay, but you gotta promise me one thing. You can't remember me like this. I'm still that twenty-two-year-old grad student hangin' out in the Asian American studies class because I care where we fit in this country."

"I know."

"I got long, thick, jet-black hair, tits up to here and an ass that stays in the general vicinity when I walk."

"Yeah, you do."

"I know my name," the tears ran down her face. "I know my name." She smiled, "I know yours, too."

"That's right."

Christine sat up and gripped his arm, hard.

"I didn't do anything wrong," her eyes were clear and focused.

"I know you didn't," David caressed the back of her head and slid forward to hug her as he lowered her heaving, trembling body back down to the thin mattress. He kissed her face, all around the oxygen tubes in her nose.

Then he kissed her on the lips. She opened her mouth and he felt the newly created gap in her teeth with his tongue. She tasted mediciney and the smell of death crawled down his throat, but her tongue responded to his and he stayed until she lost strength. He kissed her on the lips again, firmly, until he could hear her sucking in air through the tubes.

He leaned back to make sure he hadn't suffocated her. She had her eyes closed. She was smiling. In his humble estimation, dreamily.

"I've always wanted to kiss you."

"Shit, in college, you just wanted to jump my bones."

"Nah, I was too intimidated by older women in college."

"Then where were you when I needed you in the '80s?" she laughed, "and '90s?"

"Married. I've always been married."

"Good," she laid her head back on the pillow. Her matted hair slowly fell away from her head. "You're a good guy."

David could tell she was slipping off. He wadded up the napkins and dabbed the sweat from her forehead and neck. He pushed the wet strands of hair off her face and brushed her hair back with the tips of his fingers.

He kissed her on the forehead.

"I want to make love to you," he whispered in her ear. "I always have."

"Mmm…suicide," she muttered.

"I know. I still want to make love to you."

"You're a sick guy…" she drifted off.

David stared at her ghostly face and started planning her funeral.

36

No one said anything. They just knew it had been seven days and that this was what was supposed to happen. Since unauthorized church services were outlawed within the confines of camp and even though most Buddhists had left the country when the U.S. became a constitutionally ordained Christian nation, an informal funeral service began in the mess hall.

The obligation, so Japanese, was understood.

It was your typical combination generic-religion funeral service and public dining occasion. No incense, just one line for lunch, the other to pay respects to the grieving widow and children and Ray's ashes sitting on the table in front of them in a cookie tin.

People would bow to the tin before shaking Kate's hand or giving her a quick hug and a sorrowful look.

For their *koden*, some offered a couple credit chips or a chocolate bar wrapped in a sheet of paper tied with string.

Mary saw all the friends she saw every day. Stephanie and Nicole and their parents, Dino and Ruth. Dr. Sid and Ozzie. Her friends, Robin and Alexander and Janelle, who lived in her barracks, all of them looking real sad.

And she had to introduce them all to Gray, because none of

them had ever seen him. Most of them didn't even know she had an older brother. Those who did knew he was a *yogore*: bad news, troublemaker, gangsta.

Gray just sat there like a lump, like he'd been all week, arms crossed, one eye peeping over his upturned collar. Never exposing his face to Lillian or any of the uniforms, glancing up to give the folks passing by a dead fish handshake or poke his nose at them and say, " 'sup?" He'd glare at the trustees or anyone that looked like a cop, staring them down, daring them to turn him in.

Finally, Gray stood up.

If he was gonna be standin' in the world's longest police lineup, he was gonna stand in the world's longest po-lice lineup. Fuck them.

He done this before.

Fuckin' pigs stop him and his boys for nothin', roust them, take them down to the station every time one o' dem Oriental shopkeepers gets popped.

First time he scared shitless. Nearly pissed his pants. The next eight times it started to get old. It got so old that his mom complained to the police chief. For all the good it did.

Little rinky-dink shit-kickin' Barney Fife motherfuckers tellin' them they're lucky they didn't knock down their front door at seven in the morning and handcuff every damn one of them, even the little girl, like they do in Fountain Valley. Fuckin' Nazi Klan motherfuckers.

Gray sent out da stink-eye to every uniform and ass-kissin' trustee in the mess hall, unaware of the vibe he was putting out to the well-wishers as they filed by his mom and sis.

"Poor boy, he looks so hurt…"

"*Kawai-sooo, ne*? Sad, huh? Losing your father at that age…"

"He's so angry, it looks like he's going to cry…"

David had just sat down next to Mary when Lillian began rapping her spoon on her glass, repeatedly, annoyingly, until she had everyone's attention.

"I'd like you all to welcome the newest arrivals to our tempo-

rary relocation center," she paused then announced grandly, "from beautiful Ha-va-ii!"

Lillian gestured grandly to the dreary little group at one table who looked like they had all paddled in by canoe that afternoon. They waved weakly as they prodded their food. Some waved back or reached over to shake hands, but everyone knew what their presence meant.

The grand experiment in Hawaii had failed and they'd be getting more newcomers. One more alternative had been eliminated.

"As I'm sure most of you have heard," Lillian intoned solemnly, "one of our residents, Mr. Raymond T. YAM-uh-SHEE-tuh, passed on in his sleep a week ago today. I am sure we all extend our deepest sympathies to his widow, Mrs. Katherine YAM-a-SHEE-tuh, and their children, Mary and—" she brightened when she saw him, "Graham!"

"I'm outie," Gray bolted for the door, then skidded to a stop when it turned into solid uniforms.

"In the meantime—" Lillian began.

"I got one announcement," came a voice from the other side of the food line.

A hand waved. Then she stood up. It was Annie from Hawaii.

"Howzit," she said. "My name Annie. I clean da toilet"—Lillian winced at the improper terminology—"fo' women's benjo on east side and I jus wanna say…No eat da haole food, 'kay?" she said to the newcomers. "Specially you new folk. No eat, no eat, 'kay? Ees gonna geeve you diarrhea 'til you wanna DIE. Then it cake up and get hard as one ROCK and I'm sicka cleanin' up aftah you. Ees deesgahsteen. Not jus' da rahns, but it geeve you da *butsu-butsu* all ovah you NECK. So do yo' okole one favor an' no eat dees kukae. 'Kay?"

The room broke out in applause.

Lillian banged a coffee cup on the table.

"Order! Order!"

"That's right," David suddenly heard himself say. "I clean the

men's westside john and it is disgusting," he said, carried forward by some mysterious force. "And the thing is, it doesn't have to be this way. If we had rice, we wouldn't need that much meat. Don't eat the rainbow meat. Give us *gohan* instead."

"Yeah," Annie shouted, "and none o' dat fluffy kinda stuff come in leetle box. We want beeg feefty-pound SACK, real, American-grown, Sacramento Valley short-grain rice!"

A chorus of cheers, resoundingly loud even by Buddhahead standards, filled the hall.

"We want rice! We want rice!"

"Order!" Lillian banged. "I must have order!"

David joined Annie in the middle of the mess hall, high-fiving, leading the charge.

He sensed in her, and smelled in the lingering fragrance of disinfectant, a kindred spirit.

Someone who truly understood the futility of scrubbing diarrhea-encrusted porcelain day after pointless day.

"We want rice!" they pounded on the tables. "We want rice!"

"I will not stand for this insubordination!" Lillian shouted, pounding her cup until it shattered.

"We want rice!" they stomped on the floor. "We want rice!"

Lillian drilled David with a stare from across the room.

"I'll get you for this," she whispered.

David looked away quickly to break her spell.

But it didn't matter. He suddenly realized that no one left in camp was going to get out intact. They'd lost. This was their last stand. They would go down swinging.

"We want rice!" he shouted.

"We want rice!" they stomped. "We want rice!"

Then he was knocked down. He looked up from the floor and saw the trustees closing in. Trustees with clubs, uniforms with rifles barring the door. A hand knocked his glasses off. Another tried to force a rubber ball into his mouth. Three or four more trustees piled on. He tried to kick, move his arms, keep the breath

from being squeezed out of him.

From the bottom of the pile, he could see all around him people being beaten. The trustees were going LAPD on Rodney King.

His co-conspirator Annie screamed. Her head spurted blood and she fell to the floor.

He couldn't move his arms or legs. He expected to be lifted up and carried from the room.

It didn't really matter.

They could all disappear now.

Then he realized that the screams had been replaced by shouting. Women shouting. Angry, accusing. Scolding.

"Stop that!"

"What's wrong with you?"

An admonition that stopped the trustees dead in their tracks.

It was like hearing their moms or aunties or neighborhood moms scold them for being bad.

"You know better than that." Women standing in front of trustees shaking a finger in their faces, hands on hips, planted.

Fortunately the trustees weren't so far gone that the sound of their mom's voice didn't bring them back to humanity. They backed off.

The weight crushing David was suddenly gone. He looked up from the floor.

He was in the middle of a standoff.

If the world had started going to shit when boys were no longer taught to respect women, is this how the world would be saved?

Lillian shouted one last order to the uniforms, "Clear the room, phase one alert, immediate curfew," and stomped out.

Then the chant went up again. Triumphantly.

"WE WANT RICE! WE WANT RICE!"

37

The wind swirled off the Sierras from the west, kicking up a wall of dust with its icy fronds, and smacked into the west side of camp like a wet paint brush, winter's last gasp, the first sign of spring blowing in.

Mits was glad he wouldn't have to spend another spring sitting in his barracks plugging up cracks in the tar-paper walls.

The woman who looked like his late sister-in-law Esther was named Rose and she had been to Manzanar before when she was a little girl; her mother had brought her to visit these Japanese who were being kept in the camps.

The man who looked like his late brother George was named Sam. He was the one who first suggested that Mits come with them when they left.

Mits laughed at the idea at first, but then the winds came up, which caused Mits to realize that he'd spend another spring plugging up cracks in the tar-paper walls, trying to keep from being buried in dust inside his barracks. While he was helping the Tribe pack away their portable stoves, dispose of the cooking oil, break down and load up their tables, clean and pack up their cooking utensils and all the tools they traveled with to make fry bread, he reconsidered.

So when the Tribe lined up to get back on the bus, Mits lined up with them.

It was easier than he thought, mostly because there was some kinda commotion over at the westside mess hall just when the winds kicked up and, between the guards running around and people hustling onto the bus with their faces covered from the wind, counting Indians was not a big priority.

As the bus pulled slowly through camp, he saw women and children running for their barracks.

He saw David running into the medical center.

He saw that *itazura* Yamash'ta kid run to the east end.

He saw Lillian and her armed escort heading toward the medical center, Lillian gesturing angrily.

If he ever had any second thoughts about leaving, the sight of Lillian on a rampage was enough to convince him it was time to go.

Guards were dropping the shutters on all the barracks, locking down the windows and doors and it wasn't dark yet.

He saw the fully armed guards running toward the north end. Whole units.

When the bus pulled around the south end and headed for the gate, he looked behind and saw army regulars break down the door to the south side barracks, then lines of young boys with hands clasped over their heads being herded out and marched to the north end of camp.

Looked like a big ruckus.

Gray couldn't believe it. Whistles blowin', uniforms openin' the doors. He wuz gettin' outa there.

One minute he's kissin' his nuts goodbye, the next they're kickin' all of 'em loose.

All cuz that ho and Uncle David started a riot.

Then someone grabbed Gray and nearly got stomped for it. But it was speakin' o' which, Uncle David, who asked him to go

to the east end mess hall and tell Bradley—ol' sperm-breath—the rice strike wuz on, which was a'ight with him.

Gray rode the crowd like a wave carrying him out to freedom.

No punk guards gonna stop him.

Not Lillian. That bee-yutch. No way.

Nobody gon' catch Gray.

Cuz Gray the man.

As they pulled through the front gate, Mits felt guilty about leaving everybody behind.

He looked around the bus at these strangers who all looked vaguely familiar.

He hoped he wasn't getting them in trouble.

"We heard the Quakers gave someone a ride out earlier this week," Rose said.

"Oh yeah?"

"Yeah," Sam said, "young girl, round face, straight hair to here."

"Pretty. Little scar on her right cheek," Rose added.

"Oh," Mits didn't know her.

If the armed guards manning the front gate had bothered to look, they would've seen a bus full of black hair and brown faces, somber at the thought of leaving their new friends behind in a barbed wire camp, pensive at the thought of driving past white men with guns yet lightened by the memory of their just completed visit, all their faces solemn.

Except one.

Who couldn't contain his elation at the thought of leaving Manzanar a second time, when he thought he'd never leave either time.

Mits was beaming happily as he passed by the guards.

The last thing Mits saw through the dust storm obliterating the view behind him was Kate stumbling toward the west end fence,

leaning at an angle as the wind buffeted her toward the barbed wire.

Funny, he thought, it looked like she was wearing a skin diving mask.

Damn them. Damn them all to hell.

If she didn't act on this quickly, she might as well submit her resignation now and go back to retail.

That would not happen. Her career would not be derailed because of them.

Damn them.

Lillian jerked the syringe out and flung it across the room. She uncapped a second one and stabbed it into the catheter leading to Christine's IV.

James had a bad feeling. He didn't like the north end. Too damn close to the med center. He hated hospitals.

And he had the really bad feeling they were close to the terminal ward. Where all the AIDS patients were.

Which gave him the willies to no end.

"Where are we, man?"

"What are we doin' here?"

"Why'd they bring us here?"

Little brothers looking to him for answers.

He had none.

"Shut up, man," James barked at them. "D'jou forget where we are? They can do anything they want to us in here."

"Ohhh, man…"

"Shut up. Nothin' we can do. So just sit tight."

James sized up the situation. Standard barracks, double doors at each end, four-pane windows eight to a side, fifty beds, twenty-five per side.

"Blockade the doors," James ordered. "If we ain't getting out, they ain't comin' in. Start checking for loose floorboards, too. There's all kindsa ways to get outa here. We just gotta wait for the right time."

Assuming they had time.

James tried to maintain a semblance of cool as the youngsters scurried about gettin' busy.

Damn, first time he lets down inside the walls, enjoying the Jack Daniels he scored, and he gets busted for it. Worse, he let down the little brothers. Kickin' himself. Now, he was gonna havta show some leadership ability.

If it came down to sacrificing all the brothers or takin' a bullet, he was gonna havta take the bullet.

'Sides, the offer Lillian made him wun't half bad.

This was great.

Just when Bradley was ready to disband the food strike committee, it was time for them to finally take action. As they waited for more information to filter in, they allowed themselves the luxury of discussing, in anticipation, their favorite rice dishes.

"Bacon fried rice," one of the kitchen patrol said smacking his lips. "Dice up some ba-connn and one small on-ionnn, fry it up in a big frying paannn, throw in all the leftover rice from the night beforrrre, get a almost empty ketchup bot-tlle, put a little hot water in and shake it up and pour it over the rice and break the rice up and fry 'em all up. A lotta pepper to taste, wit a couple fried eggs on top. Mmmm. Delicious."

"*Tamago gohan*," another one chipped in. "*Chawan* fulla hot, steam rice, crack a raw egg in the bowl, take that white stuff out and pour shoyu in the yolk. Beat it up, mix it up with the rice, slurp 'em up. Delicious."

"Scrambled eggs and rice."

"Spam and eggs and rice."

"Portagee sausage and eggs and rice."

"Teriyaki wienies and rice."

"*Ochazuke*," a dishwasher drooled. "At the end of the meal, just plain old rice and hot tea. Eat it with all different kinds of *tsukemono*. *Takuwan*, *nappa*, cucumber."

"Maui onion…"

"*Kim chee*…"

"Mustar' green…"

"*Umeboshi*," Bradley nodded. Pickled, sour plums their mothers used to give them when they were sick. Years later, on the health food kick, they'd discover that rose hips tea tasted exactly like *umeboshi*.

"*Maze-gohan*…"

"*Norimaki*…"

"Footballs!"

"When we were kids and didn't have nothing to eat," a cook had his eyes closed, "we had a avocado tree, so we'd just have avocado and rice with a little shoyu.

"*Manju*, the green kind with *kinako* on top and—"

"Don't get carried away, brah."

Bradley wasn't sure what happened in the west end mess hall, but it must've set off something major.

Reports were coming in from all over camp.

Apparently, after the lunchtime/funeral service began:

Annie from the women's latrine either casually mentioned or got totally pissed off about the condition of the latrines after a bad meal and started screaming.

Then, David either formally seconded her objection or jumped up and whipped the crowd into an anti-food frenzy.

Then, either an orderly procedural motion in favor of the suggestion that rice be added to the menu was passed or a full-scale riot began.

Then, either the trustees began beating everybody with clubs and everyone in the mess hall rose up and fought them off or the

trustees turned on Lillian and joined the strike.

Then, either the soldiers stormed in and shoved everybody outside or everybody inside tore up the place and threw their food at the uniforms and stormed out.

Then, the junior high and high school boys' barracks either got busted for contraband food or drugs or alcohol—most likely all of the above—or were being held hostage, which made no sense since no one knew who was living in those barracks in the first place.

Then, Lillian either ordered an emergency curfew because of the rice strike and had called in military support or (and this was the topper of rumors) she was executing an order to go *My Lai* on the camp beginning with the little troublemakers in the junior high and high school barracks.

All because Amber Taniyama got knocked up and wouldn't say who did it.

Bradley happily witnessed the first sign of excitement and relief in camp since he'd been there.

He was also sad because he now had to leave.

The wheels were rolling, and it was time for him to play the role he'd waited for his entire life.

Dr. Milt always seemed to fidget in front of his older sister, Sidney, who'd caught up with him in the med center.

"Lillian said if I didn't perform the operations she'd bring in some butcher to do it," he tried not to whine.

"Milt, if you go ahead and find some lame excuse to sterilize all fifty of those boys, then you start on the girls just getting their first period, do you realize how this will affect the survival of our people?"

"What people? Our fellow inmates? Is there some kind of posterity factor I'm overlooking here?"

"We're still alive, Milt."

"But we lost, Sid."

"No, Milt. If you start acting like a goon following orders, that's when we've lost."

"Don't get self-righteous with me, Sid," Milt snapped back. "Not after you've been geisha-ing for Ozzie."

"What does my relationship with Ozzie have to do with mass sterilization?"

"You say you're worried about survival of our people. Are you planning to leave camp as Mrs. Lewis?"

"How dare you accuse me of selling out?" she sputtered and tried to rebut him but was too angry for words, so she punched him on the shoulder. "Take it back!"

"Ow!" he cried.

"Take it back!" she stalked forward menacingly.

"All right, all right," Dr. Milt seemed to be eight years old again. "I take it back."

"God," she steamed, "I can't believe you said that. Ozzie's a good friend for all of us. You think he'd be here otherwise?" Sid stomped around. "Besides, I think he's going with Bradley. We've never discussed it, but I get that feeling." She sighed. "So what are you gonna do, Milt?"

"I've been relieved of my duties as the camp physician. I expect some very efficient professionals to arrive shortly. I don't think consent or counseling will matter to them. Either that or they'll start transferring large numbers out to the base at China Lake and do the operations there. I'll stall Lillian until then. In the meantime, I performed one." Milt met Sid's glare, "He volunteered. I just wanted to make sure it was done right. He's recovering in one of the last rites rooms. Look in on him, will you, Sid? His name is James."

"What are you gonna do, Milt?"

"Something. Must be something we can do."

Christine's eyes fluttered open. She saw a hakujin woman pulling

a syringe out of her catheter.

"Where's your friend?" The woman was smiling but she looked angry.

"Huh?"

"I want your troublemaking friend. I know he visits you several times a day."

Whatever Lillian gave her was kicking in, hard.

"I don't get any visitors," Christine said.

"You get one," Lillian sat back. "I'm told the two of you are inseparable. How much does he mean to you?"

"Look at me. I'm almost dead."

"Not quite. You seem quite lucid."

"That's your drugs talking."

Lillian stared at the emaciated face.

"I hear morphine's the only thing that makes these last few hours, days, weeks bearable. I understand the pain is quite excruciating without it. Especially when the vital organs are failing but the brain is still sharp, fully aware and responsive to a degree of pain that's supposedly beyond human comprehension. Even with extremely high amounts of morphine, the last stages appear to be very uncomfortable at least from what I've witnessed. But I don't suppose you could appreciate the full extent of your pain while you're going through it, except for the usual crying and screaming."

Lillian leaned in closer and smiled.

"Let's just see then, shall we, if you're the kind of independent, liberated woman that doesn't need American taxpayer-supported morphine. What I should've asked in the first place is…how much do you mean to him?"

38

Kate wished she had grabbed David so he could say a few kind words for Ray, but when the devil wind came up she knew she had waited long enough to take care of Ray.

Long enough to fall in love with another man, a patient of hers who'd lasted longer than expected, long enough for her to look forward to seeing him every day she came to work, and now she had Alan's ashes, too.

Kate fell to her knees and crawled to the fence, pushing the two tins in front of her as the brutal winds whipsawed through her thin cotton dress and stung her back.

She had wanted to do this right, take her time and say a little something for each man.

But the wind…

She thanked her stars for Bradley. How he found a pair of scuba diving goggles here in camp was beyond her, but it was saving her eyesight at this moment.

She tucked the handkerchief tighter around her face and hunched down over the first tin just to hide from the direct blast of the wind and collect her thoughts.

About Alan. A man she'd known briefly but intensely.

They never would have met on the outside. But here in camp,

there was no place to go. His wife was dead. He was dying.

And Ray had changed. Losing everything he had earned, losing the ability to support his family, losing all hope for the future had broken him. He had shut her out and all she could do was watch.

Perhaps it was because Alan had already lost everything and had already worked through anger and denial and had reached acceptance that he was so attractive to Kate.

Funny and helpless and dying—an irresistible combination. Kate began spending all her free time at the terminal ward, there whenever Alan was alert and talkative and funny, there whenever he needed attention, when he needed to feel useful. Which he was to Kate, who had been too long with infants and children and an absent husband and just needed to be held sometimes, as much as Alan needed to hold someone.

Her tears ran tracks halfway down her dusty face then evaporated in the blasting heat.

"Goodbye, Alan. I love you. Thank you."

She lifted the lid and before she could tilt it, the wind sucked the ashes out of the canister.

She scooted Ray's tin in front of her. She pressed her forehead to the lid and tried to catch her breath.

Sweat dampened her dress and her goggles began to fog up.

She didn't know what to say and cursed David for not being there with her. He did so many of those eulogies sometimes she thought he just plugged the names into a computer and, voilà.

She had been losing Ray ever since things started going bad. He was a simple guy who just wanted to work and earn a living and be a good neighbor and father and husband. In the end he couldn't be any of those, but she never stopped believing in him, even when it seemed he had given up on himself. That day in the mess hall, when she'd held his hand and he kissed her, she knew.

Tears started filling her goggles. She was gagging on the sand as she cried through her handkerchief.

She tried to remember how they first met, or when she knew he was the one, or their marriage ceremony, or when Graham was born, or Mary, but the wind pushed all thoughts from her head.

She shrieked in frustration but couldn't even hear her own voice through the wind. She pounded the tin in anger. Thought about just opening it and dumping the ashes out and saying, "Rest In Peace" and let it go at that.

Then she couldn't get the lid off and cursed Ray for not being there to help her open it.

She sank down and rested her forehead on the tin, trying to catch her breath without inhaling sand.

Then she remembered his walk. That samurai-Mifune-Clint Eastwood walk that she could spot in a crowd from a football field away. That solid, low-to-the-ground stomp that was so Japanese melded with a swagger that was so American.

She could see Ray.

She pried open the lid and looked up.

The fence loomed high in front of her.

The wind whipped the handkerchief from her face.

She stood up, arms wrapped tightly around the can, and steadied herself, leaning back as a huge gust nearly lifted her up into the barbed wire.

She saw him walking. Walking away from her.

She lifted the lid and held the canister over her head.

The ashes blew away from her in a cloud.

"Go, Ray," she called.

Her words whisked away into the dust as soon as they left her lips.

Ray's ashes sailed through the barbed wire fence, unimpeded. As if there were no fence at all.

"Go, Ray!" she shouted.

She dropped the tin and threw off her goggles.

She blinked through her tears.

The white cloud of Ray's ashes sailed across the desert, riding the devil wind, away from the mountains, away from the barbed

wire fence, out toward miles and miles of empty, unimprisoned desert.

"You go, baby!" she cried.

Free.

He was free.

No one could stop him.

"Go, Ray!" she screamed as loud as she could, hoping her words would grace the cloud of ash as it disappeared into the orange wall of dust whipping away from her, higher and higher, up into the endless, eternal sky.

"Go!"

39

James woke up.
 Slowly.
 James woke up.
 Wheels rolling.
 Jumble in his brain.
 Gone.

Graham made fun of her for bringing her *Little Mermaid* goggles
to the desert, but when the winds came Mary was glad she had them.

Still, the sand stung her arms and no matter how tightly she
pressed her lips together, she couldn't keep the dust out of her
mouth.

She squatted down against a building and covered her head
with her sweater and tried to breathe. She coughed and spat and
lifted her shirt over her mouth. The wind pinpricked her belly.
She curled up to wait for it to die down.

Then something lifted her off the ground. She looked up
through her *Little Mermaid* goggles and saw a giant insect stand-
ing over her.

Its giant insect head with its big insect eyes was bobbing at her

and making a buzzing sound.

It was preparing to eat her.

Ever since she watched that old movie *Them* with Uncle David, Mary knew that a bug would get her in the end.

If she could've opened her mouth, she would've screamed.

Then the insect wrapped its green arms all around her and picked her up and flew away.

James woke up. This time, he could open one eye.

Yeah, he was back.

He knew he would be.

He was just hoping to be in a different place.

But there he was, in the camp hospital. Somewhere in the terminal ward.

He was slammed, like, massive dope, chased with a 40.

He tried to get the smell of alcohol out of his brain.

He thought he smelled powdered donuts and *churros*.

Then a shadow moved in the corner of the room.

"Hey," James nodded.

"So I hear you had an operation," David stepped out of the shadows. "What was it, appendix?"

James looked at David funny. "I got a vasectomy."

"A vasectomy?"

"Yeah. All the brothers are getting 'em."

"Why?"

"So we can't make babies, man."

"Why are fifty healthy young men getting vasectomies?"

"It's the deal they offered us. We get fixed, they set us up with a job on the outside."

"Whose idea was this?"

"I don't know, but it came from high up. Higher than Lillian. Man, you know the story. They want our brains to make money for them. They don't want us competing with them, and they sure

as hell don't want us fucking their daughters."

"Like a eunuch houseboy."

"If we're out there, we're always giving up something. In here you knock up some ho, they take away her baby and give it to a white couple, like Gr—" James caught himself.

"They're doing this because Gray knocked up that girl?"

"It's only a vasectomy. It ain't a fuckin' lobotomy."

A voice came from the doorway behind David.

"How about if I give myself up?"

It was Graham.

"Yo, G, 'sup?" James raised a hand to slap.

"How ya feelin', J?" Gray clasped fingertips with James.

"Kinda sore, but the doc tol me to expect that."

"This all happenin' cuz I poked that ho."

"This all happenin' so we can get out."

"Gray," David said, "apparently the government is offering a deal: You get a vasectomy, you get out."

"Plus," James said, "a job and everything."

"Live-in houseboy," David said.

"I ain't gonna be no houseboy," Gray said.

"It's a job and a place to stay," James said. "That's more than we had on the outside."

"But you gotta get fixed," Gray said shakily.

"If you don't get fixed, you don't get outa here. If you don't get outa here, you can knock up any ho you want and they'll always take your baby away. So you might as well take the deal and get outa here."

"I gotta think," Gray held his head like it hurt.

"Take the deal, G," James lay back on the pillow and smiled at David. "By this time next week, I'll be eating steak and watching ESPN."

James was still smiling when David got one hand on his throat and jammed the pillow over his face. James clawed at David's face, but his arms pushed feebly against David's shoulders. His

legs flailed and kicked wildly.

David leaned into the pillow and muffled James' screams.

James' kicking grew weaker.

Then suddenly David felt small, powerful hands pulling at his shoulders and flinging him off the bed.

To David's surprise, it wasn't Gray.

Dr. Sid stood over him.

"What are you doing?" She tossed the pillow away as James heaved air back into his lungs.

David sat on the floor, waving his hand weakly, trying to formulate a rational explanation for what he'd tried to do.

"Are you crazy?" Dr. Sid was shook.

David thought it an odd question coming from a shrink.

"He's the front man," David finally said.

"For the government sterilization plan," Dr. Sid nodded.

"You know about it?" David said.

"My brother's supposed to execute it."

David had a bad feeling. Like he had just walked into something deep and dark and the exit was a long way away.

He looked over his shoulder at the door, expecting to see it blocked by a uniform with a gun. But it wasn't.

Dr. Sid wasn't making a move to block his exit.

"David," she ordered, "get over to Christine. It's her time to be moved to the last rites room."

"No, it isn't."

"This time it is. It's safe right now. Just go."

David was halfway through the door when James shouted.

"I'm bleeding!"

A dark, red stain spread slowly on the sheets out from his groin.

"Lie back," Dr. Sid gently pushed James down. "Just relax and let me take a look."

James was close to hyperventilating as Dr. Sid lifted his hospital gown and slowly began lifting the tape holding the gauze around his genitals.

David thought he must've torn some stitches loose during the fight, which he felt bad about, considering he was trying to kill him. "I probably did that."

Dr. Sid stopped and looked closely.

This couldn't be right. She tried to register what she was seeing. This man had undergone a vasectomy. Performed by her brother. This couldn't be right.

David stood up and got a perfect view of something he wished he hadn't seen.

The tip of James' penis had been removed. The head had been severed, cleanly and deliberately.

James saw the look on both of their faces and knew something was terribly wrong.

"What is it?" James asked weakly, fearing the worst. "What's wrong?"

Dr. Sid quickly replaced the bandage.

"Go get my brother," she said to Gray.

"What's wrong?" James' voice started to get shrill.

"David, help me move him," Dr. Sid gave Gray a push toward the door. "Hurry!"

Gray finally pried his eyes away from the blood-soaked bandage and ran out the door. He ran down the hallway and out the back door into the blistering wind and, as his shoes began crunching the desert sand, he could hear James scream.

When Mary opened her eyes, the insect was making a clicking sound as it swatted her bottom.

Then it flew back out into the dust storm.

Mary was in the lobby of the med center. It was empty.

She thought she should try to find her mom, but she knew as soon as she did, the insect would pounce, so she waited.

She could hear lots of boots stomping and running around the medical center, all going to the north end of camp.

Then she heard lone footsteps, echoing slowly down the hall, from the terminal ward.

Mary stood absolutely still and didn't move a muscle.

The footsteps got louder and louder.

Mary covered her ears.

Then a door opened at the far end and a giant shadow fell across the length of the hallway.

Frankenstein walked by, carrying a rag doll in a nightie. He kicked open the door to the last rites room and carried the rag doll in and closed the door behind them.

She was just about to breathe again when the insect kicked through the lobby door carrying her mom in its arms.

Mary would never move again.

The insect set her mom down beside her.

Her mom was filthy. It looked like she had rolled in dirt like their dogs used to do. Her hair was sticking out all over the place and her knees were skinned.

The insect started rubbing its big, long, fuzzy, green forearms together. It was now preparing to eat both of them.

Then the insect popped off its head and said, "Can you believe this weather we're having?"

It was Bradley, his hair buzzed, wearing a gas mask, his khaki uniform covered with dust like a layer of pollen.

Mary knelt down next to Kate and pulled her shirt sleeve down and started wiping the dust off her face.

Kate finally opened her eyes. She grabbed Mary and held her tight. So tight Mary couldn't breathe, but Mary didn't want to disturb her mom so she just held her breath.

"What were you two doing, wandering around in this dust storm?" Bradley scolded them. "You could've been trampled by the SWAT team out there. Cool goggles, but *abunai-yo*."

"What were you doing out there, honey?"

Kate brushed Mary's hair back. "Where's Auntie Ruth and your friends?"

"They're all scared. I wanted to go to Daddy's funeral."

"I know, sweetheart," Kate dusted off Mary's clothes. "You don't have to worry about Daddy anymore. He's in a very beautiful place. Come on," Kate stood up shakily with Bradley's help. "Let's go get cleaned up."

As they walked down the hall, Mary wondered if she should tell her mom about Frankenstein and the rag doll lady.

Mary never took her eyes off the door to the last rites room until they were all the way down the hall.

When Christine awoke, it was dark. She thought she might be dead.

Then she realized she was nestled in the arms of a man with no clothes on.

"Sorry I didn't recognize you," Christine said in gasping breaths. "It's been so long since I had a naked man in my bed," she laughed weakly. "What was I supposed to think?"

"It's okay," David said, adjusting her pillow.

David cradled Christine's ravaged body in his arms, her bones pressing through her translucent, sore-caked skin.

She was breathing easily for the first time that night.

He was just glad he hadn't given her too much of whatever it was Bradley had scored for him.

Before she drifted off, her eyes got wide and she said urgently, "Watch out, Lillian's around."

"I know."

"Don't let her— "

"I won't," he said soothingly. "She's got bigger things to worry about."

He could see the flickering shadows and hear troop movement outside the window, reinforcements gathering around the north side barracks.

It didn't matter. Nothing mattered.

Kate was right about the last rites room being the nicest in the camp. It had insulation and a glass window with a view of the mountains through the barbed wire.

David cradled her in his arms and listened, over Christine's shallow breathing, to the wind.

40

Lillian had to admit, Pearl Harbor was perfection. As a unifying catastrophe and public relations event. There was no doubting the villainy and, yes, infamy of the deed.

Not even the insinuations that it bailed out three terms of liberal New Deal programs that failed to solve the Depression or that it gave FDR the excuse he needed to prevent England from being bombed back to the Stone Age or even the unsubstantiated questions raised decades later about the White House receiving a declaration of war from Japan a full week before December 7TH and sitting on it—none of that communist propaganda could detract from the absolute perfection of Pearl Harbor.

Everything since then had been a public relations nightmare. Korea, Vietnam, Beirut, Iran, Columbia, all those little weekend wars with foes you forgot a week later.

Even September 11, as horrible as it was, didn't give America an immediate war to win, a nation or flag to conquer, an enemy race to hate.

Pearl Harbor set the standard. No event would ever be as unifying. No event could ever be as perfect.

No, no one would ever forget Pearl Harbor and no one could ever forgive Japan.

Her Japanese were safe.

Japan would forever remain America's number-one enemy.

Truly, in its heart, hated forever.

Now, with her medical personnel being taken hostage by the barricaded terrorists, it was turning into an emergency situation that required a forthright solution. Possibly an unpopular one. One that would be second-guessed by the vultures in the media.

Unless there was an event that would justify any actions she might take from now on.

In the name of national security, imminent danger, America's best interest.

She'd think of something.

Dr. Milt looked across the roomful of silent, hateful faces. The odor of fifty teenage boys who hadn't bathed in weeks, mixed with the sweet smell of anything smokeable, hung in the air. The walls were tagged with elaborate variations on an emblem symbolizing barracks number 31-S.

They all looked like his son, the last time he saw him.

His voice had just started changing, and he had a little peach-fuzz on his upper lip. Perhaps if Milt could've maintained a private practice instead of working for the county, he could've sent his son to a private school where the metal detectors always functioned, one attended by some executives' or congressmen's children to guarantee real security. Then he wouldn't have been called away from his rounds for an hour to come down to identify his son's body.

Dr. Sid was relieved her brother Milt had slipped through the shutdown. This wounded boy required a real physician's care.

When David had helped them bring James over and was about to leave, he asked Sid if she was coming with him.

She was tempted. Then she looked around and wondered why it was easier to get crack or opium or a helicopter into this place

than it was to get rice. She told him she'd stay, not needing to add, "otherwise these guys have no chance."

Dr. Milt walked warily down the center aisle. The boys w e r e all looking at him like they didn't trust him but had no one else to turn to.

Sid whispered hurriedly to him, briefing him on James' vitals. Milt tried not to let the shock register on his face when he examined James. He looked at Sid, bewildered, confused, innocent. He was trying to make some sense of it when James spoke.

"Don't let him get you," James drifted out again.

The boys looked at him, accusingly.

"D'jou botch the operation, doc?"

"What up, doc, how come James say that?"

"What'jou do to James, doc?"

Dr. Milt turned to the advancing faces and held up his hands. "All right, there's been a slight complication." He got nothing back but panic and anger focusing on him. He could see the blades they were cuffing.

Dr. Sid picked up the frame of the empty cot next to James and banged it on the floor several times.

"Excuse me, gentlemen," Dr. Sid called loudly. "But this man was not injured by this doctor. This doctor performed an operation that this man volunteered to undergo. The same operation that you have all signed consent forms for. A vasectomy. Correct?"

They shrugged but did not say anything.

"The operation I performed was successful," Dr. Milt jumped in. "However, there were complications in post-op. Until we make a complete diagnosis of the situation, no further operations will be performed."

Just when Dr. Milt thought he had diffused the tension, a voice came from the back.

"Damn right they won't."

Gray walked slowly out of the shadows.

"Nobody gets cut, specially by you," he strode through the

crowd as they parted for him and stood in front of Dr. Milt. "This butcher's workin' for Lillian. He supposed to mutilate us, same way he mutilated James." He turned on Sid. "And this bitch supposed to prepare us psychologically to get mutilated."

The faces surged forward, surrounding both docs.

"That isn't how it happened," Dr. Sid tried to reason.

"I heard you two talkin' 'bout damage control."

Dr. Milt knew how impersonal any medical procedure must sound to a young friend of the victim and was about to explain it to him.

Sid looked at her brother.

Milt had a surprised look on his face. His mouth was open, but no sound came out, except a scream, from Sid.

Gray stepped back.

Dr. Milt fell to his knees, staring down at what appeared to be one of those old-fashioned oil can spouts protruding from his lower abdomen. It appeared to be cylindrical in shape, perhaps an old tin can that had been flattened and rolled up into a long tube and then cut diagonally to give it a razor-sharp point. He estimated, judging by the rapidity with which his blood was spurting through the open end of the spout that he would be losing consciousness soon.

He looked at his big sister Sidney one last time and tried to tell her he was sorry but, to his frustration, nothing came out. He pitched forward onto the floor.

As fog clouded over his eyes, he hoped that Sid could convince the boys that he had tried to do his best.

"God…damn, Gray…"

They relaxed their grip on Dr. Sid, and she fell to her knees in the spreading pool of dark-red blood. She pulled the shank out of Milt's gut and tossed it aside. It rocked back and forth on the floor, wet and warm.

Sid wadded up her handkerchief and stuffed it into the open, gaping wound, but the dark-red blood kept flowing out of Milt's

body. She helplessly felt for a pulse, a heartbeat, the warmth that was rapidly leaving Milt's body.

"Man, you killed him, G."

Gray jerked himself away from the pack and sat in the darkness by himself.

Sid tried to lift Milt. "Can you give me a hand?"

No one stepped forward. Not out of hostility or fear of breaking rank. They had just never helped with anything.

"Damn you," Sid grunted as she dragged Milt to a cot.

A few of the faces drifted over to the windows and peeked out the cracks, just to confirm what they already knew.

Reinforcements, a double shift of uniforms were taking up positions around the barracks.

"It's army commandos."

"No, it's the SWAT team."

"Nah, these are just ROTC fucks."

"National Guard on weekend maneuvers."

"Man, there ain't even a tank out there."

"Man, this is weak."

"Ohh, man," the Talker whined, "this dude pissed his pants," and kicked a leg of the cot Milt's body lay on.

Sid resisted her initial urge to break that leg off and beat the little punk to death with it and said, "Yeah, well, that'll happen when you kill someone."

"Lookie here, dude shit his pants, too. Man, that's disgustin'."

"If you'll lean in closer and take a good sniff," Sid said with undisguised loathing, "I think you'll discover that the deceased has pretty much completely evacuated all waste products from his body. It's one of those dead things."

"Aw, man," the Talker turned to Gray, "G! This dude's stinky ass has got to go."

Gray looked up from his bunk in the corner as though he had just noticed there were other people in the room.

"So get rid of him," he said quietly.

"All right," the Talker pointed at Sid. "You. Pick him up and dump him out the door."

"Not her," Gray yelled without looking up. "She might make a break for it." Then he muttered under his breath, "Moron."

"Oh," the Talker concentrated, "that's right." He discovered he was still pointing at Sid. "Stay there, bitch, don't try nothin'."

Sid hadn't moved.

"All right, you guys toss this dude out the door."

No one moved. They just grumbled.

"C'mon, man," the Talker was starting to whine again, "we gotta get rid of this dude."

"Whatchu mean we?" they grumbled.

"Yeah, how come we gotta do it?"

"Do it y'self, punk—"

"Goddammit!" Gray roared from his corner. "Get off your lazy asses and throw him outside!"

If Gray had been paying attention, he would've been impressed by the response.

Six boys jumped to their feet and carried Dr. Milt to the door. Another two jimmied open the door and they threw the body out the door.

He hit the top step, his head konking hollowly on the wood, and rolled down, settling in a cloud of dust on the ground.

41

Jenny heard it as soon as it came over the intercom: "Phase two tactical alert." This was bad. Military reinforcements had already started arriving.

Lillian had called up army regulars, possibly even special forces. Then something worse. Medivac and shield. For body retrieval: "Fiftyish Asian male, unconscious, no discernable pulse or heartbeat, apparent wound to lower ab."

Things would be happening soon. Jenny opened her bottom drawer and stuffed the envelope filled with forms into her bag and begged God that it please not be David.

"Did they ID the victim?" Lillian was standing in the doorway.

"Not yet," Jenny quickly straightened up. "When the reinforcements arrive and if they go tactical," Jenny asked, "should I prepare an order evacuating the camp or evacuate the north end for safety?"

"Evacuate an evacuation center?" Lillian looked at Jenny quizzically, then smiled. "Temporarily relocate a temporary relocation center?" Lillian walked down the hallway to prepare her next move and looked to the heavens to give thanks. God had provided.

Jenny looked out the window and saw a fleet of vans barreling flat out across the desert, the tip of a rolling cloud of exhaust and

dust lit up blue in the full moon, heading straight for her tiny communications center like a bullet train off the 395.

As was usually the case with stories with the potential for sensational video, the crews from local TV news, reality shows, syndicated TV magazine shows and local freelancers were in position before police reinforcements arrived.

The first van fishtailed to a stop in front of Jenny's building, the driver yelling as she got to the door.

"Did they remove the body?"

"Yes."

"Damn!" he slammed the steering wheel.

The TV van caravan skidded up behind him and spit out crews who rushed Jenny, blinded her with their lights, jabbed her with microphones, hurled questions at her.

"How many hostages are there?"

"How many terrorists?"

"How many have they killed so far?"

Through the noise and chaos, Jenny noticed that one of the larger vans, from a station in Fresno, was sitting by itself near the outer fence.

She thought it odd that its occupants, a bald black man and a Hispanic woman, wore sunglasses in the middle of the night.

"We believe the terrorists, whom we have identified as a gang calling itself Three-One-S are part of a drug- and firearms-smuggling ring that was recently uncovered. We have video of the hostage slaying incident," Lillian announced. "Please be warned that the footage is graphic and violent."

Jenny had seen the original footage of Dr. Milt's body being rolled down the steps.

The film-school whiz kid arrived a half hour after that. His finished product would be brutal and bloody, cleanly edited with optional soundtracks and would get saturation airplay on the

local, cable and network news and newsmagazine shows for weeks. Jenny set out videocassette and videodisc copies of the incident on the press table as Lillian screened the award-winning filmmaker's latest work.

A well-impressed groan went up as the video showed Dr. Milt standing at the top of the stairs, a short, slender young man in a ski mask behind him; Dr. Milt's chest exploding outward, his body bouncing down the stairs and, in slow motion, settling in the dust until he came to a final, dead stop.

"I would just like to say," Lillian made eye contact with the network cameras, "that we as a nation will not stand for any acts by terrorists, no matter what their age or nationality."

"What are their demands?"

"How heavily armed are they?"

"Who's their leader?"

"Are they connected with Al Qaeda?"

"Libya?"

"Tokyo?"

Lillian was unperturbed by the barrage of questions constantly interrupting her. She was determined to fulfill her duty to disseminate official information despite the questions, which she felt it was her duty to ignore anyway.

Gray finally picked up the phone that had been sitting on the bunk nearest the door. The voice kinda sounded familiar; she put him on hold. Then the Wicked Witch got on again.

Gray tossed the phone onto a cot. "Get James."

For James they moved. Carried his cot to the door. They removed the two-by-fours jammed against the door.

"Okay," Gray called out. "We're bringin' him out."

Gray stood on the porch as his boys set James down at the foot of the steps and quickly ducked back inside.

There was no movement, no response, nothing. He closed the

door and propped the two-by-fours against the door.

He listened carefully at the door, crunching in the dirt, whispered words of command, footsteps down the porch and hurried shuffling in the dirt fading into the distance.

The phone started ringing.

Gray picked it up, clicked it on and said, "Hello?"

Gray was knocked to the floor as the west wall exploded. Metal and wood splinters sprayed the room, cutting down dozens of boys with a wall of shards, their cries drowned out by a second concussion on the north wall, then a third on the south, followed by a dozen smoke grenades and tear gas canisters exploding.

Then, through the smoke, uniforms and masks. Pop-pop-popping, flashing lights, his boys dropping all around him.

The uniforms stalked forward, silencers pumping muffled bullets, sweeping across walls and bodies, wasting everything in their path.

Shoot first, sort out the pieces later.

Dr. Sid looked up from the floor, through the dust and debris, and saw Gray churning through the smoke, up the middle aisle, low to the floor, metal glinting dully in his right hand.

She tried to grab him, but something made her hesitate and she could only watch helplessly as the smoke cleared for a brief moment and a uniform appeared through the haze.

Gray stuck his forearm into the uniform's chest, lifted the flak jacket enough to expose the unprotected midsection and jammed the shank into the uniform's belly.

Gray, his mouth open and contorted, his eyes evil and glazed, roared as he cranked the blade around and evenly filleted the uniform's intestines, like a sashimi knife slicing through a fresh slab of Hawaii tuna.

Gray slipped on the blood gushing out onto the floor. He braced his feet, re-gripped the blade and shoved it higher and deeper into the pig's gut.

Pigs hassling him and his family back home. Punks hassling

them inside this pen. Pimps waiting to pounce on them, taking their women. Kill 'em all.

Kev cudn't believe it. These little Japs wun't spose ta fight back.

Delighted by the look of shock on the uniform's face, Graham roared like he had just slam-dunked the winning basket at the buzzer of Game Seven of the NBA Championship.

"Fuck you, muthafucka!" Graham got up in his startled, uncomprehending face.

Kev clutched onto Gray, hanging on like a sissy.

"Yeah, punk, I did it!!" Graham held him up so he could spit in his face. "I killed you, bitch."

They turned their weapons on him.

Dr. Sid screamed as Graham's body exploded.

As the anti-terrorist squad made sure there were no survivors, they failed to notice, through the smoldering fumes, that a screaming woman, the hostage they were supposedly rescuing, not that they cared, was being swallowed up and dragged through the floor by a large insect, which was now looking at them, its big buggy eyes peeking up through the floor, as it replaced the floorboards and disappeared.

42

The second time Lillian had instructed her to dial the number, Jenny realized who had answered the phone.

His voice was deeper than she remembered it, a little slurred and he sounded tired, but it was Graham, her nephew.

And when he answered the second time, and Lillian had picked up the walkie-talkie and said calmly, "Now," Jenny heard the explosions and realized what was happening.

As the press room scrambled with activity, in the commotion, Jenny grabbed an unissued security pass and slipped out and headed for the north end of camp.

The med center was dark and deserted when she entered the lobby, her heels echoing down the hallway.

Then a doorway at the other end of the hall opened and a little girl came out.

"Mary?" she called to her.

"Auntie Jenny?"

They ran headlong down the hallway to each other. Jenny hit the floor and skidded on her knees to a halt in a James Brown slide, and they collided into each other's arms.

"God, I can't believe I found you," Jenny cried.

Mary laughed and tried to take a breath as her auntie with the

blonde hair smothered her with kisses.

"How did you get here?" Mary asked.

"I've been here," Jenny caressed her niece's face and jet-black hair, "but I haven't been able to get inside." Jenny grunted as she picked her up. Mary was getting big. "I'm sorry your Daddy had to leave us, Mary," Jenny stroked the hair out of Mary's face.

"Did you sneak in?"

"Kinda." Then Jenny heard a gasp at the end of the hall and saw Kate running toward her.

When they finally broke away, Jenny put a hand to Kate's face. "I heard about Ray. I'm so sorry, Kate," Jenny stopped, "and Johnny, too."

Kate nodded helplessly, then said, "How did you get here?"

"I've been working in the communications center," Jenny said, "but I couldn't get clearance to get inside."

"Auntie Jenny snuck in," Mary clarified.

"You did?"

"Sorta."

"I don't want you to get in any trouble," Kate said.

"Don't worry," the icy voice hissed behind them. "She already is."

Lillian glared at them. Especially Jenny, whom she examined like an impaled frog she was about to dissect.

"'Auntie Jenny', huh?" Lillian paced.

Mary tried to bury herself between Kate and Jenny. She tried not to look at Lillian or let Lillian see her. She covered her ears so she wouldn't have to hear the Wicked Witch's evil voice.

"Am I correct in assuming that Auntie Jenny is not a term of affection but does in fact reflect a familial bond?"

"Yes," Jenny said. "This is my sister-in-law and my niece. They didn't know I was here."

"Apparently not, judging by the reception you were receiving." Lillian turned to Kate. "If you cooperate, this won't be held against you," she turned her steely eyes on Mary, "or your family. And you," Lillian turned on Jenny and the traces of a smile crept

onto her mouth, "you're under arrest for treason."

James woke up. Slowly.

James could hear voices. Laughter.

His nose itched. He tried to scratch it, but he couldn't lift his hand. Either one. Both strapped down.

His left nut itched, but he couldn't scratch it. He tried to move his legs, but he couldn't move his feet. Both were strapped to the cold steel railing on each side of the bed.

Apart.

His knees were raised. Spread.

A light was on. Down by his feet.

He could see the ceiling, walls, the sheet held up by his knees. Silhouettes on the sheet.

And voices.

"Man," one laughed, "I hope they used antiseptic."

"Anesthetic, stupid."

"Whatever."

"Antiseptic's like Bactine. How'd you like to get your dick trimmed on Bactine?"

"Makes my ass pucker up just thinking about it."

James didn't want them to look at him.

He swallowed. It hurt his throat. His lips stuck together when he opened his mouth to talk.

"What are you doing?" James whispered dryly.

He could hear murmuring. "Hey, he's awake...So dope him again...I was gonna use it myself...We're supposed to keep him doped..."

"Get the fuck outa there!" James croaked.

"Hey, hey, you be quiet now. We got your painkiller here and by the looks of things, you gon' need it, boy."

They laughed.

James collapsed back on the bed. His head was spinning.

"Probably did it with a Ginsu knife. Hi-yah!"

They were laughing at him.

"Billy, think he could still beat off?"

"Yeah, like this. Dugudugudugu!"

They roared.

He could see them making slicing motions toward between his legs.

He wanted to tell them to stop laughing at him.

"Hoo-wah!" they howled.

"Whazahhh!" they whooped.

Little punks imitating Bruce Lee. A man's accomplishment. A man's life. Reduced to material for their jokes. So they could have something to laugh at.

Bruce Lee. Brandon Lee. Dead.

They wouldn't let our heroes live, he squeezed the tears from his eyes. They wouldn't let us have heroes.

"Goddammit," James screamed, "Get away from me!"

"Shut up!"

"Give him the shot, man."

"I don't know how. You give him the shot."

"Just hit him on the head and keep the dope."

"Help me!" James screamed as loud as he could. "Help!"

A hand covered his mouth. Foul breath in his ear.

"I swear to God if you get us in trouble, I'll cut the rest of your dick off. You got that, Jap?"

James lurched to one side, raising the bed off the floor before more hands grabbed him and held him down.

"Hold him still."

James lurched from side to side and saw a hand jab the needle into the bottle drawing out a syringe full of bubbles. He kicked and thrashed, screaming through the hands covering his mouth, holding him down. He hoped they wouldn't notice the air bubbles they were about to inject into him.

"Hurry up. Stick him, Billy!"

Holding the syringe like an ice pick, the man stabbed the needle into James' catheter and jammed it down.

As soon as he saw the bubbles go in, James relaxed.

James was prepared to answer to everyone he had wronged in his life. He was ready.

He could hear their voices down there.

"Ching chong," they sang.

"Ping pong," they chirped.

"So solly," they bowed.

"Ahhh soooo," they slitted their eyes.

James smiled through his tears, "Fuck you all."

Then his brain exploded.

43

Ruth sat in the rec hall by herself watching CNN. The smoking building, windows blown out, the elite rescue squad relaxing after the battle, the cache of weapons and drugs recovered during the rescue operation, the replay of Dr. Milt's execution, the familiar face of a reporter she trusted and Lillian's press conference.

"This is a tragedy of enormous proportions," Lillian intoned, distressed and sincere. "One brave American servicemen and both hostages, Japanese medical personnel, are dead. There was little our hostage negotiation rescue team could have done when faced with fifty armed terrorists."

Good riddance, Ruth steamed. Thieves and parasites, preying on the older people, waiting to pounce on anyone walking alone. Now she wouldn't have to constantly worry about her little girls with those filthy boys around and she was glad. No, she wouldn't miss them at all.

Dino didn't like it when she told him how she'd arranged for them to get out. But it wasn't like she betrayed anyone. Lillian just wanted to be kept informed. This was all his fault anyway.

She saw Kate being escorted to jail. With Mary. Fine example to set for your own daughter.

She actually felt sorry for Kate. It was bad enough that her son

had died, but he was the leader of the terrorists. He'd killed Dr. Milt, which was only a misdemeanor. But he had also killed an American soldier. And that was unforgivable.

"This video taken during negotiations is graphic…"

Ruth saw the grainy op-cam footage of the soldier holding up the white flag. He was cute, like a boy-band guy.

Then suddenly a ninja leaped at him.

A flash of a samurai sword, and his head flipped right off his body.

Then the maniacal fury of the ninja, Kate's son, as he charged them with his samurai sword before the American rescue team shot him in self-defense.

She knew she did the right thing. She would never forget the horrible sight of that handsome young American being beheaded.

She was ashamed to be Japanese.

David woke with a gasp and immediately felt for Christine's breathing. He was afraid of sleeping through her death, but he was exhausted.

Christine's eyes were open. She was looking at him.

"So how was I?" she asked, her voice throaty and sexy.

He was crushing her, his right arm draped across her chest, his right leg over hers. He pulled away quickly.

"That bad, huh?" she smiled, her sunken eyes crinkling at their sleep-crusted corners.

"No, no," he tried to wake up.

"So, was it as good for you as it was for me?" she asked, that familiar knowing smile hanging from the corner of her wide, luscious, ravaged mouth.

"It must have been. I fell asleep."

"Oh," she laughed, "is that your criteria for good sex? You fall asleep afterward?"

"Yeah, if it was great I'd be out in the living room with a burger

and a basketball game right now."

"I should be flattered you were snoring in my ear, then."

"Was I? I'm sorry."

Christine turned toward him and laid her head on his left bicep. David rolled onto his back and she curled up on his left side, her head on his chest, her broomstick left leg winding around his.

He kissed her head and stroked her thinning hair.

"Thank you," she said quietly.

"For what?"

"Having the stomach to get into bed naked with me."

"Anytime, sugar," he purred as he pulled the sheet up over her spiny, splotched back, over her bruised, bloodless, scab-encrusted legs. "Been waiting for my chance."

"Are we in the last rites room?"

"Yeah."

"Just hold me," her voice was frail and small like a little girl, "okay?"

He cradled her tiny, shrinking, dying body in his arms.

"Tell you a secret," she said.

"Okay." He waited, watching as she swallowed, cleared her throat and looked up at him.

"None of this exists." She sank back into her pillow. "It's all in your mind."

"Okay," David said, once again clueless.

With great effort, Christine raised her head to look at him. "I have a last request. Don't let me die here."

"Okay."

"And don't let me suffer."

"You won't suffer. I promise."

"You'll make sure I don't suffer," she looked directly at him, "the same way you made love to me?"

David held his breath.

She waited. Then she reached down and grabbed his penis.

Her boney fingers felt like pinchers.

"You couldn't get it up for me, not the way I am now."

"Yes, I did."

"Liar," she sneered. "I've seen tofu harder than this. The thought of touching me makes you shrivel."

She swung her hips over his and pushed herself up until she was sitting on top of him.

He could feel the wiry hairs on her pelvic bone grinding into his. He could hear her bones snapping as she straightened her spine. He felt her hips pop out of their joints as she straddled him. Her fingers gripped his chest and dug into his keloids, the joints disintegrating as she screamed and pulled the tubes from her nose.

"You don't love me," she cried. "You don't love me."

"Stop," he gasped and grabbed her arm.

The two thin bones in her wrist crumbled beneath his fingers.

He tried to hold her body together, but she was coming apart in pieces.

She fell limply on top of him like a toy animal that had lost most of its stuffing.

She shrieked in startled pain when he slid out from under her and gently rolled the sobbing woman over onto the bed.

God, she was a mess.

He tried to straighten her out on the bed, the slightest movement accompanied by a voiceless gasp and the sound of cracking or the powdery mush of bones disintegrating.

He looked down helplessly at her, her mouth frozen open in silent, drooling anguish.

She was in pain. She was in pain.

Then she looked at him.

And he recognized, within the sunken, withered sockets, beneath the ash-gray pallor, beyond the pain and disease that had drained them of their life, her soul.

And he remembered her as she was.

Squeezed into faded, patched, low-riding jeans, slapping along

in zories, gold wire-rimmed glasses, in a wildflower print halter top with no bra, thick straight black hair down to her waist.

In the fall of '72, a lifetime ago.

As she wanted to be remembered.

"Be kind," she asked him gently. "Be kind."

He bent down over her, careful not to touch her broken body, and kissed her on the cheek.

He held her face in both his hands and kissed her gently on her sweat-drenched brow and her temples and her cheeks and over her tear-soaked eyelids.

He kissed her fully and gently on her wet, salty, quivering lips.

She kissed him back, expending what little energy she had into her lips, to tell him, for the last time…

"I love you, David."

"I love you, too, Christine."

"Thank y—"

He snapped her neck.

He softly laid her head back on the pillow.

He stretched her out flat on the bed.

He pulled her legs straight down beneath her, her arms at her side, her hands flat against her hips, the bones grinding and snapping painlessly with each movement.

Then he lay down beside her, both of them still naked, and held her, now that he could without hurting her anymore, and waited for the footsteps to reach their door.

PART THREE

CONGREGATION

44

David heard voices. Snippets, phrases, long-forgotten pieces of childhood advice — they came floating back to him in quick, gentle bursts, a brief gust of cold wind, a melodic trickle of water. The voices of his parents, friends, cousins, relations, some in English, some not.

Make the best of a bad situation.

Shikataganai. Can't be helped.

Don't dwell on it.

Move on.

Cockeyed optimist.

Don't be afraid.

Gaman.

Persevere.

Survive and persevere, at all costs.

Education. Edge-joo-cay-shun.

Take it to the bank.

He who turns and runs away, lives to fight another day.

Que será será.

No *monku.*

Quitcha bitchin'.

Got to give it up.

Take the points on an away game.

Too many cooks…get out of the kitchen.

A bird in hand…never looks a gift horse in the mouth.

Dites-moi, pourquoi. Tell me why.

"David, can you hear me?"

He'd carried Christine's limp, broken body down the hall to the crematory room and laid her on the smooth, metallic, slippery altar.

The body slid down into the furnace and a tin of ashes spit out the other end, like the plastic Buddha machines at Grauman's Chinese theatre.

"David? David, who was that woman?"

Just when he was getting used to living in an all-Japanese world, here was a familiar face that added to his confusion. Because she was white.

A hakujin angel hovering in front of him, who looked like his ex-wife. Only older and a few pounds heavier.

A brief flicker from the outside flashed in his brain. He took a step toward her. How had they greeted each other on the outside? It seemed so long ago.

He saw faces. Getting bigger. Closer.

But that was on the outside.

Japanese were not warm.

Japanese were not friendly.

Japanese were not demonstrative.

Everybody knew that.

A lesson he must learn.

He blocked things out. Ever since he's seen the latrine, rows of toilets with no walls between them.

Otherwise he'd still be constipated.

He felt the warmth of a cheek pressed against his. He felt arms around him, squeezing the breath out of him.

People hugged in camp. They were warm and friendly and demonstrative. And Japanese.

But she was hakujin, taboo, no touchie.

That's why we fought the big one.

To keep this sorta thing from happening.

But he knew those lips. He knew their softness, their wetness all over his body. He knew their taste.

He knew those eyes, tears welling up and dribbling down both cheeks. Those eyes, big and green with white flecks, that crinkled at the corners.

Those eyes that lit up her whole face when she smiled, as she was right now, at him.

Smiling at him like he was the only man in her life.

The only man in her life.

He looked at his arms, still a dark-brown gardener's tan below the T-shirt's short sleeves.

He hadn't changed color.

He saw the barbed wire fences surrounding them.

He was still Japanese.

Therefore, he must be succumbing to the typical Japanese male's fantasy of a white American female surrendering to him. The end result of, and reward for, world domination. Which must be avoided at all costs.

What he wanted to know was…if this was a fantasy, why did she look like a fantasy girl's mother instead of the fantasy girl herself?

Shouldn't the fantasy girl be young and firm and perky, twenty-two years old, tops?

Not that this woman wasn't attractive, but she was definitely …autumnal.

She held him tight and felt his heartbeat against hers.

He knew the feel of her.

She was warm and inviting, like a comfortable old jacket he'd never throw away.

Their stomachs were larger than they had been twenty-five years ago, but they still fit.

When he moved into her arms, it felt as natural as breathing.

After all this time and distance, they had found each other.

"Jenny," he whispered in her ear.

Then he was floating again, floating away on a cloud of uniforms.

Soldiers separating them. Carrying him off.

David craned his neck to look back and see the four women still in his life.

Kate holding the hand of her daughter Mary, his favorite niece in the whole world, with whom he had spent more of his time in camp than anyone else.

Mary holding the hand of his wife, or ex-wife, Jenny, with whom he had spent over half his life, with whom he thought he would spend the rest of his life, which wouldn't be much longer judging by the recent jump in the mortality rate in this place.

Jenny waiting by the end of the cremation machine to spit out a tin containing the ashes of his long-lost friend Christine, whose death he must answer for.

Just before David floated out the lobby and through the front door, he thought he saw, looming behind the four women, a giant praying mantis.

David's eyelids fluttered open.

It was daylight again.

How many days? Nights?

He tried to move but couldn't. He looked down and saw his arms strapped across his chest. He was in a straitjacket.

He'd never seen a straitjacket before.

He could feel the IV spike pressed into his arm, the tape securing it tugging at his skin.

He heard a voice speak. It was his.

"May I have some water, please," he whispered.

"Certainly," Lillian poured iced water from the pitcher into a plastic cup. "I wish real American kids were polite like you peo-

ple. They could learn the lessons you've learned. And practice. That's so important. To not only learn important lessons but to put them into practice, too."

Lillian held the straw to David's lips.

He drained the cup in two gulps and said, "May I have some more?" with an Oliver Twist flashback.

"You certainly may," Lillian refilled the cup.

He sipped slowly this time, tasting the bitter pipe residue in the water. He didn't care. It was reasonably clear, straight off the Sierra Nevadas. A little rust was nothing compared to the yellowish gray, chemically treated fetid sludge that crawled out of L.A. faucets.

"Are you hungry?" She lifted the cover off a hot plate of sausage, eggs and hash browns.

"Yes…" he suspected a synthetic substitute.

She began awkwardly aiming spoonloads of whatever she could shovel off the plate and hurl at his mouth. Most of it tumbled off the spoon onto his sweat-stained straitjacket.

He ate ferociously, trying to savor the tastes when he bothered to chew.

These were real, not powdered, eggs. Sausage made of ground-up things from animals, not soy. Actual potatoes, not from a box.

"Is that coffee?" his eyes were bulging.

As David savored the taste, he thought there was something odd about this coffee. For one, it didn't have that oil-drum taste that the mess hall's coffee-by-the-barrel had. This coffee tasted like something he'd last had in the early 1990s. Fresh-roasted, whole-bean, just-ground, pure-water, drip-filtered Kona coffee with real cream.

All of which gave David the eerie feeling of a pig being fattened for slaughter.

"All done? Good," Lillian quickly shoved the food tray into a corner, "Now, as I was saying, your family—"

He had drifted off again.

She made a notation on her clipboard to decrease his medication and turned back to the news on TV. The funny weather guy was on.

This was not a good sign. If her successful anti-terrorist operation was already pushed all the way back to just before the funny weather guy, she was going to have to really step up the campaign, which meant getting a former radical agitator leader to publicly endorse the Plan.

45

There was this gym teacher at Venice High, Mr. Smith—his name was really very appropriately Mr. Smith—fresh off the bus from Ohio or Nebraska or some very white Midwest state, for whom taking roll every morning was an adventure.

"Aw-gwiller?"

"Aguilar," pronounced Agg-ee-lar, with hard *g*.

"Okay," he checked the first name off and looked at... "Uh-kiam-aye. Ah-keemee-ah? Steve?"

"Akiyama," pronounced Ah-kee-yahmah. "Here."

"Branca," he said, like the pitcher who threw up the home run ball to Bobby Thom—

"Barrancas, here."

"Okay," an easy mistake. He stared at the list and smiled. An easy one. "Carnes? Lash-in Carnes."

"That's La-SHAWN, man."

"Okay, present. Chang?"

"Chong, here."

He was beginning to worry, just a little. It was as if every single one of them had a name from a foreign country.

"Ick-steen?"

"Eck-stine, here."

"Gun sales. Frank Gun sales?"

"Gonzales, here."

They were starting to giggle. Snicker.

Then he brightened at one he recognized. Kato. Like in the *Green Hornet*.

"Kay-tow."

"That's Kah-toh."

"No, it isn't."

"Yes, it is."

"It's Kay-tow."

"Cato's Greek. Mine's Kah-toh."

Mr. Smith was beginning to think they were deliberately mispronouncing their own names to throw him off.

"Puh-dilluh?"

"Pa-dee-yah," Danny Padilla said. "Here."

He stared at Sakaniwa for a good minute.

"Sack-uh-nigh-ya-ha-wa-yah?"

"*Sah-kah-NEE-wah*, here."

Finally. An easy one. "Sinj, Henry Sinj."

"That's Singh, the h is silent."

"Sine-juh?"

"Sing."

"Sinnn-guh."

"SING! SING!"

"Hank?"

"Henry."

"All right, movin' along. Tayk-day? Take-a-day? Tack-uh-day?"

"Mr. Tuh-KEE-duh…" Lillian called.

David didn't know how many days he had been doing this, plunging into deep, mind-numbing, drug-addled sleep then rolling out of a two-story bed onto a bucking corkscrew slide that lipped off into consciousness.

"Mister Tuh-KEE-duh," Lillian set the needle down, "your family has been not only a tremendous disappointment to me, but

a threat to the security of this temporary relocation center. Between you and your sister and her son—"

"They didn't do anything," David was surprised to hear himself speaking, considering he'd been in a drooling haze moments ago.

"The evidence indicates your nephew led a group of fifty terrorists who first held hostage and then murdered Dr. huh-YEAH-shuh-dah, the physician, Milton. Your nephew personally shot the doctor in the back in cold blood. Then he decapitated an American soldier, a member of the rescue team—"

"How many survivors?"

Lillian paused, then said, "One."

David didn't know how old he was when he'd stopped listening to his parents, when he'd turned cynical and started becoming an adult; but Graham had friends, cousins, people he grew up with, who moved away to be with one or the other parent, who moved back and forth with parents who threatened to kill each other, who moved in with aunts and uncles after one parent had killed the other, who were killed by one or the other parent, who were shot on the way to or from school, who were shot in school, who were shot standing outside their home, who were run over by drunk drivers, who were kidnapped and raped, who were there one day and gone the next, who got each other pregnant, who spent all their time playing video games, who didn't know what a melody was, who had never tasted clean water or breathed fresh air, who had never gone to school or a sporting event or a concert or any gathering of people without going through a metal detector, who automatically pissed in a glass or squeezed blood from an incision without question, who didn't know the difference between cynicism and maturity, who thought having sex was more important than making love, or worse, the same thing.

All before they were twelve years old.

"One survivor out of fifty?" David knew it wasn't Gray.

"Fifty-one, counting the missing hostage."

"Someone's missing?"

"The other Doctor Huh-YEAH-shuh-duh, the psychiatrist. We haven't located her body yet."

"Maybe they ate her."

David could see her contemplating that possibility.

"Who was the one survivor?"

"James…" she waved her hand, "something Japanese. But he died later…of complications."

The kid in the hospital ward David had tried to kill.

"You have a massacre on your hands, Lillian."

"It was a rescue mission."

"And not a very successful one."

David let her droning voice push him back into unconsciousness.

"Because of this unfortunate development, your services are now required…"

"Ma'am, we need you to identify a body."

Kate and Mary followed the corporal out into the hallway. Just as she suspected, they were in an isolated room in the outer compound, outside the gate.

The corporal whipped the jeep around the corner of the south barracks. The camp was shut down, soldiers standing guard outside the shuttered barracks.

The morgue looked like an assembly line. Tagged and ID'd on the slide, the bodies looked like loaves of bread lined on trays, ready for the oven.

The uniform handed his orders to the attendant, who walked quickly down the row, checking tags on toes.

He stopped at the front of the chute. "You just made it," and lifted a sheet.

Graham looked so grown up. He almost needed a shave. It looked like they'd hosed the blood off his face.

"Zat him?" the body-tagger whipped the sheet back over

Graham's face.

Kate pulled the sheet back down. "I'm not sure."

Graham had stubble on his chin. It could've passed for a smudge, but she could see the whiskers making their first appearance on her son's face.

"C'mon, lady. Is it or isn't it?"

"It might be," she stalled.

Something had taken a big bite out of the side of Gray's neck. She started to tug the sheet lower and saw a dark empty hole above his collarbone. She stopped, and covered his face.

"This is my son."

Kate bent down to pick up Mary.

"Come say goodbye to your brother, sweetheart—"

Kate straightened up with Mary in her arms just in time to see Graham's sheet-covered body disappearing into a black, wheezing shaft that belched a blast of heat and flame and the stench of burning flesh before it sucked shut.

Kate stood frozen, her hand still reaching out to her son's disappearing body.

"I wanted to say goodbye to my son."

"Go 'head," the attendant shrugged.

"I wanted to pay my last respects."

"Who's stoppin' you? C'mon, lady. We're backed up."

Mary hit her head when Mommy rammed through the swinging door. She was scared how fast her mommy was carrying her. She was making a funny, tiny, gurgling sound in her throat and it looked like she was about to cry.

The corporal caught up with them in the lobby. He hated those ghoulish, sadistic lifers in the cush jobs like morgue attendant. Army must've raided the psycho wards to fill that detail.

The corporal froze as the lobby doors smacked open and who should be standing there but the new head of security, Captain Chung. He snapped to attention as the captain strutted in, heels echoing in the empty lobby as he deliberately circled the mother

and child.

"Is there something wrong here, soldier?"

"No, sir," the corporal said to the hissing captain.

"Then explain this situation to me."

"They've just identified a body, her son, twelve-year-old son, blown to bits," he said out of the corner of his mouth, "and the body-tagger didn't help."

"What exactly did the morgue attendant do, corporal?"

"He rushed things and was…insensitive, sir."

"I suspected as much. Return the prisoners to their cell, corporal."

46

Lillian watched the beautiful, young, American National Guardsman with the most attractive hazel eyes being interviewed on TV. She no longer thought it odd to hear a somewhat-black voice coming out of a Caucasian face, obviously second-generation MTV.

"We knew goin in that them little Japs would put up a good fight. They wuz kam-uh-KOZZies," Billy said in his best yes-ma'am-just-followin-orders voice. "But when I saw my partner Kevin go down, who I have known since we wuz freshman at Dickwood High, I knew I had to make sure he dint die for nothin." He looked into the camera and gave his best Ben Affleck-confident-bordering-on-arrogant-tie-a-yellow-ribbon-and-drop-your-panties-ladies grin, "I'd like to say hi to my Posse and everyone back home. Operation Clean Sweep! Whooo!"

Lillian was pleased. After they'd made the rounds of the talk shows and sold their exclusive interviews to the tabloids, the security personnel should have a nice bonus for themselves. And this dead Kevin fellow would be a hero back home. Perhaps have a park named after him.

The lack of survivors still irked her. That first boy, James, would've been her perfect spokesperson. Not only for her and the

Plan. He could've sold the exclusive photo rights to a tabloid, possibly even the rights to his story for a based-on-a-true-story TV Movie of the Week.

Lillian averted her eyes when she saw herself on TV. She didn't have the younger generation's obsession with seeing themselves on television, even for a brief second, waving from a crowd. Although she had to admit, she looked good on TV. A thinner person would've seemed cranky and petty reading the body count. A younger person would've come across as inexperienced and callous. A man cold and homicidal.

Of all the men and women in the world who could project the determination and absolute belief in this solution, she was the one who best exemplified the American faith in the system that could elevate Japanese relocation into a doctrine of minority mass sterilization as the solution to American unemployment and morale.

But that jump would depend on her finding a convert. A former liberal who now renounced his foolishly radical ways. Although she'd settle for a token, the Plan would be much more effective if she had an Eldridge Cleaver as opposed to a Clarence Thomas for her stooge.

And here he was, right at her feet. The troublemaker. Instigator of the mess hall riot. Not to mention the key to finding those missing pieces that could possibly draw unnecessary attention to the clinical details of implementing this plan.

Lillian's voice, and something very powerful surging through his veins, dragged David out of his sleep again. He could hear his pulse pounding in his ears.

"You see, what I'm trying to do is restore the Japanese people to their rightful, traditional place in American society as a model minority. A symbol of how all our minorities ought to behave."

She spoke to the wall.

"Why can't you people be quiet and work hard like the

Japanese?" She pointed at the other wall, "The Japanese are never on welfare. They don't drink or take drugs. They send their kids to college and now they're all doctors. That's the American way. Why can't you people be like them?"

David tried to formulate a sentence, but all he could do at the moment was breathe deeply and blink a lot.

Lillian turned to him and smiled sincerely.

"That's why we're asking you as a representative of the Japanese people stuck in this country to make this sacrifice, to demonstrate your willingness to do anything to show the American people that you really want to belong."

Lillian shook her head.

"Not that you ever will. Except under certain conditions. But you knew that. For certain people in this country, there are always conditions."

"So," David finally croaked, "you're offering me a way of getting out—"

"And getting a guaranteed job outside. That's my main area of concern—this stagnation problem. These remaining residents don't seem to realize the opportunity they're being given. Lots of real Americans lost their jobs because of Japan. Lots of real Americans have been homeless since the 1980s. Lots of real Americans would gladly sacrifice half the Bill of Rights in exchange for a safe and secure place to live," Lillian was working up quite a sweat. "I don't think sacrificing your ability to reproduce in order to rejoin society as conditionally acceptable sub-citizens is such a big sacrifice, given your circumstances. So what I'd like you to do is assist me in spreading the word beyond the Japanese community. I think it's a trade-off most people on unemployment, on welfare, with no prospects and little hope for the future would take a good hard look at. Don't you?"

"Let me think about it," David pretended to be digesting her proposal and nodding off.

Lillian was steaming. She had the contract ready to be signed.

She needed to begin the PR blitz, but she had to have him in her pocket. She tried to remember if she had given him two or three injections then went ahead and pressed the syringe.

David's heart was already racing. He couldn't think. He could barely breathe.

"I have the authority to terminate your residence here at any time. But I'd rather not. I'd like your cooperation. I'd like it to be your choice. I think you'd make a much more effective spokesman for the Plan if you wholeheartedly chose this course of action of your own free will." Then she added casually, "and I'm sure your loved ones would appreciate your decision to cooperate, too."

David could feel the noose tightening.

If he could only get some rest, some real sleep. If she'd only stop talking.

But he was so wired, his mind couldn't slow down long enough to think.

He wasn't talking anymore. He was blurting. "Of course, whatever's best for my family, that sounds great."

Lillian asked, "Do you know one Bradley S. Koo-WAY-tuh?"

"Bradley Kuwata, yes."

"Were you intimate with him?"

"Intimate?"

"Did you have homosexual relations with him?"

"Can you be more specific?"

"You know…" Lillian corkscrewed her head.

"What do you mean? Holding hands? Kissing? Hugging? Impure thoughts? Mutual masturbation?" He enjoyed watching her dig a hole in the chair with her butt cheeks. "Sodomy?" he continued, "Pulling out? Baking cookies together? No swallowing? Fisting? Making kissy faces from across the mess hall? Oral sex? Going steady?"

"Something like that."

"No, we did not have a sexual relationship of any kind."

"Do you know where Mr. Koo-WAY-tuh is at this moment?"

"I never know where Bradley is at any moment—"

Then it dawned on David. He smiled.

"Bradley's on the loose? Did Bradley see something he wasn't supposed to see?"

"No, he didn't. And even if he did, his word doesn't mean a thing. I have documentation on video. Graphic and violent. Now," Lillian opened another file, "this rice strike nonsense. I wasn't aware of any dissatisfaction in this temporary relocation center."

"Not with the food?"

"No. Not the food or accommodations or anything within the entire relocation program. If any of our residents were dissatisfied, I'm sure they would've come to me."

"Yeah, if I wanted to confide the grievances of a very private community, you'd be the first person I'd come to."

She opened a folder. "Now, you were seen in the corridors of the medical center carrying, in a state of undress, ex-post-delicto, one Miss Christine Mary-kow Owe-KAY-duh."

David laid back on the pillow. His head was so heavy.

"Christine Oh-KAH-dah," he corrected. "I killed her."

"So, you admit responsibility for causing her death—"

"I broke her neck. I killed her."

"So, in essence, you are confessing to—"

He felt like he had to wind up and pitch each sentence. "She was suffering, she was dying, so I grabbed her head and snapped her neck like a chicken and she died."

"So," Lillian said triumphantly, "you admit killing her."

"Okay, you got me." David would've thrown up his hands if they weren't strapped across his torso. "I admit it. I did it. I killed her. Happy?"

"Mr. Tuh-KEE-duh," Lillian shouted. "In light of the evidence, on a charge of the murder of Christine M. Owe-kay-duh, I can make you disappear into the federal prison system."

David suddenly realized he'd been looking directly into

Lillian's eyes all this time. That she had been drilling him…with the Smile. She'd even threatened to make him disappear.

And none of it meant anything anymore.

"I thought killing one of us was only a misdemeanor."

"Like I need a reason," she sniffed.

Lillian shuffled through the file on her lap.

"You were reportedly seen in the company of a young woman…with whom you apparently had a sexual relationship."

"Okay, now *that* I'm still not too sure of."

"An underage female named Felice."

"Oh, her. Yeah."

"You admit that."

"Sure. What's consensual sex with a minor when you've already confessed to murder, right?"

"I think we have more than enough," Lillian leaned forward and rested her hand on the canvas sleeve where his hand should have been. "Now, I have a proposal for you," Lillian unfolded the contract. "I need the cooperation of former troublemakers to publicly rejoin the ranks of our model minority and endorse my Plan. Frankly, you weren't my first choice, but all the others are dead. So I want you to be my key spokesperson for this Plan."

"The one that includes mass sterilization?"

"Yes."

"Go to hell."

"I suppose you think that uttering blasphemous remarks at an official of the federal government is minor at this point. I'm telling you right now it isn't. Yet another infraction for your quickly growing file. And if you think your actions only affect you, then let me ask you this," Lillian smiled triumphantly. "Do you care what happens to your sister? And your niece? Their future quality of life depends on you."

She had him.

He tried not to let his reactions show on his face, but the drugs had laid him raw.

If he could let his head clear a little, see a little farther down the road…

"I agree," he stammered. "I could do a lotta good. Take care of my family while I'm at it. Just let me…" he got it, something that would buy him time, "…pray on it, okay?"

"Certainly."

David closed his eyes and everything started spinning.

Lillian waited, then jumped in, "I can help you pray on it."

"No, thanks."

"We can pray on it together."

"I'd rather do it myself. Thank you."

"I can give you guidance in prayer."

"I can handle it."

"You might not be doing it right."

"I'll take my chances. Thank you."

Lillian jerked the door open and, for the first time, David could see where he was. Through the hallway window, the outer fence, the main gate and southeast guard tower. He was in the outer compound. He was outside the camp.

"No one in this country ever got ahead by whining about their situation. Because there's always someone worse off than you. I guarantee you. Always."

He couldn't see her face, the sun behind her silhouetting her wide frame in the doorway, but he could hear the tightness in her mouth and see her head shaking in rage.

"My advice to you is…if you want to get along…deny your suffering. I do."

As he fell backward into another black hole, David knew he had to do whatever it would take to get Kate and Mary to a safe place, out of the country.

As for himself, he'd play the hand he was dealt.

Shikataganai.

Deal with it, baby.

47

Back when David was working the graveyard shift on the loading dock in East L.A., next to the Farmer John packing plant, the smell of whatever was being processed that night would drift over and color their night as they snatched boxes off the conveyor belt and stacked them inside the thirty-foot containers heading back east on the train by daybreak the next morning. Huffing and puffing, they couldn't avoid tasting the fumes that smothered them. On a bad night, it was liverwurst or headcheese. On a good night, it was bacon or ham.

Tonight it was bacon.

"*Oishi, ne?*" Ruth fed him another bite, dabbing the corner of his mouth with a napkin, flicking a crumb off the sleeve of his straitjacket.

Any BLT on white toast with mayo was delicious, but he hadn't seen real bacon, lettuce or tomato since the early 1990s and he wanted to savor it before he started in on that scrumptious ham sandwich waiting for him on the tray.

"Ruth," David munched. "Where's Dino?"

"Probably watching ESPN over at the rec hall, as usual," Ruth scowled. "I haven't seen Mits lately. Have you?"

"Not lately." David wondered why Ruth would ask him that in

front of Lillian.

As Lillian nattered on about syndicated talk shows, radio shows, everything from Geraldo to Larry King, David knew he was running out of time.

Lillian would not let her Plan sink into the federal quagmire of projects dying a whimpering death from lack of funding and congressional juice.

David turned to Ruth. "What's Dino gonna do?"

"Mister you-WAY-duh has chosen not to cooperate with his lovely wife Kee-ko and their children," Lillian interrupted, "and will remain in this detention facility indefinitely."

"It's a detention facility now? What happened to temporary relo—" David started to ask.

"For the uncooperative, it will be a detention facility, temporary or not, it depends on them. But," Lillian smiled, "none of that concerns you. Now, when you start making these public appearances, the most important thing to remember is the United States of America has been de-Japanesed. There are no names, references or remnants of Japanese influence remaining in my country."

"We don't say Nintendo," Ruth began as she fed him, "we just say video games."

"We don't say kerry-okey, we say vocals to prerecorded accompaniment," Lillian said.

"It's Columbia, not Sony," Ruth said, "and we don't say a skosh more room."

"Skosh being a derivative of the Japanese word soo-KOH-shee," Lillian said.

"*Sukoshi*," Ruth interjected. "No more sushi."

"Fish is meant to be cooked," Lillian said. "It has nothing to do with radical environmentalist claptrap about pollutants in the oceans. The American people have just had their fill of the barbaric Japanese custom of eating fish while it's still flopping around on your plate. We have reclaimed our right to enjoy good

old-fashioned American fish as it was meant to be eaten. Filleted, breaded and deep fried so you don't have that fishy taste."

"We don't say teriyaki or shoyu or soy sauce," Ruth said.

"We say Hawaiian sauce," Lillian said.

"We don't refer specifically to Mitsubishi, Matsushita, Nissan, Toyota, Honda, Sony, MCA, Mazda, Hitachi, Subaru, Isuzu, Suzuki, Panasonic, Sanyo or Yamaha," Ruth listed.

"We just say…the Japanese," Lillian intoned.

"We don't refer to specific Japanese people," Ruth said.

"They are just…the Japanese," Lillian smiled.

"Or the enemy," Ruth said in such a calm and accepting way that David, without realizing it, nodded with her.

"Let's finalize the details, shall we?" Lillian was beaming.

"I want my sister and her daughter exempted from the Plan as a condition of their release."

"If I do that, it would defeat the entire purpose of the Plan. You see," Lillian pounded the pencil tip flat on her clipboard, "I see the Plan as liberating, freeing people from their base animal desires, which are connected with aggression and the drive for physical and economic domination."

"But it's a guy thing, right? So you can exempt my sister and my niece."

"Au contraire. In my opinion Japanese women are even more of a threat. They're wily. Cunning. They promote this facade of docile servitude when all they're doing is wangling. Wangling their way into the hearts of weak American men."

"Still, I don't want them punished."

"This Plan is not punitive," she said, her lip vibrating noticeably. "If anything it's beneficial to everyone involved. It really is."

"This is not negotiable. I want safe deportation and relocation for my sister and niece. Otherwise, no deal."

The pencil snapped against the clipboard. "Fine." Lillian held out a pen and the contract. "Sign here—"

"I will sign this as soon as I hear from them, from another

country, that they're safe."

David hoped he hadn't pushed Lillian too far.

"I'm not comfortable with that answer," she was frowning and tapping the tip of the pen into her clipboard. "I hope you haven't forgotten we have stipulations. If you fail to meet the requirements as one of our representatives or if you are judged to have violated our rules of conduct, your contract will be terminated and you will be cut loose and subject to any outstanding warrants you may have."

"Rules of conduct?"

"For instance, under the general category of insubordination is expressing displeasure or balking at an order, not showing the proper deference to a superior, not showing the proper enthusiasm for carrying out all orders given to you by a superior and, worst of all, failing to always appear to be entirely and solely Japanese."

Lillian leaned in close to David's ear, the way she did when she made Wayne disappear.

"You see, Americans like things simple. This foolish idea of yours—an American of Japanese ancestry—is just too complicated a concept for the general public. So I'm warning you, act the slightest bit American, your contract is void and we'll grab you. And if they're still within our reach—and we have a very long reach—we'll grab your family, too."

Ruth popped the rest of the ham sandwich into David's mouth. That's all he wanted. Good food. No hassle.

He was tired of fighting it. He was tired of being Japanese. Or not Japanese.

All he wanted was to be just another working slob who did his job, came home every night, sat in front of the TV and got deeply, sincerely involved with every conceivable problem white folks can get themselves into.

All he wanted was to be finally accepted as part of his own country. If that meant he would have to turn himself into a

harmless foreigner in order to be accepted, that's what he would do.

Same old story.

Jenny washed dishes with sixteen-year-old Hmong mothers. None of them spoke English except Estella, the older woman in charge, a Salvadoran who was more comfortable conversing in Spanish. They waited for the men to bring in giant cartloads of dirty dishes and make passes at them.

"How's the new girl working out, Maria?" Lillian stood in the doorway at the top of the steps, refusing to descend into this pit of manual labor.

"Fine, *señora*," Estella answered.

"Good, but if she slacks off, feel free to beat her," Lillian smiled at Jenny. "Just kidding." She wasn't. She waved at the other girls.

Lillian loved the Hmong people. Hardworking and never complaining and quiet. Just like the Japanese used to be.

"Any complaints, Jennifer?" Lillian demanded.

"No, ma'am," Jenny said.

"Don't you dare call me ma'am," she seethed. "You aren't that young. You think your 'husband' still wants you? Well, how desirable do you think you'll be if I discontinue your estrogen replacement therapy?"

Jenny showed no reaction. This was how the Plan would maintain control over the internees after their release.

"Attention, residents, tonight's triple feature in the recreation hall is…"

She'd already found someone else to do the movie announcements.

"*The World of Suzie Wong*," Ruth intoned, "starring Nancy Kwan as the Hong Kong hooker who falls in love with William Holden in the hopes that he will take her away to a better life…"

Apparently, they were gearing up for the next phase.

"*Year of the Dragon* starring Ariane as a Chinatown moll who turns against her people when she falls in love with Mickey Rourke in the hopes that he will take her away from John Lone to a better life. And a PBS production of *Miss Saigon*, the Cameron Mackintosh musical extravaganza about a Vietnamese prostitute who falls in love with an American serviceman in the hope that he will take her away to a better life."

"Keep up the good work, girls," Lillian sang and waved cheerfully.

The Hmongs smiled uncomprehendingly and waved back.

"*Adiós, señora*," Estella called.

"Goodbye, Rosalita," Lillian called, and made a mental note to renew her membership in the Committee-For-English-Only-or-At-Least-Not-Spanish.

Lillian couldn't help but smile as she strode through the compound, down the clean, deserted aisles, unoccupied except for the security forces patrolling her perfectly secured temporary relocation and/or detention center.

With a single command, she had set into motion the actions that brought this facility into line with its stated guidelines and purpose. With one word from her, she guaranteed that fifty armed, drug-dealing, murdering terrorists would never be a threat to the United States again.

With one word from her, the Japanese problem was well on its way to being solved.

Her superiors would be extremely satisfied. Perhaps even the President.

A high-profile media event like this, as far as advancement was concerned, was almost as good as being part of his family.

With one word from her, God had provided.

48

"Whatchoo lookin' at, boy?" the new captain snarled.

"Nothing, sir," the grunt replied quickly.

"You were looking at my eyes, weren't you?" the captain leaned the brim of his cap against the grunt's forehead.

"No, sir."

"You were looking at my eyes and wondering how come they let a slanty-eyed devil like me on this detail, weren't you?"

"No, sir, it never crossed my mind."

"You calling me stupid, boy?" he whispered menacingly.

"No, sir."

"Don't you possess a good soldier's natural curiosity why they put a slanty-eyed devil like me in charge of security at this relocation center? You are curious, aren't you, boy?"

"Just a little, sir."

"Well, son, the answer to your question, why did they put a slanty-eyed devil like me in charge of clean-cut all-American Caucasian, Afro and Hispano-American boys like yourself is...NONE O' YA DAMN BUSINESS!!" he bellowed and cranked his head sideways. "Don't you EVER question my orders!! You got that, BOY!?!"

"Yessir," the grunt quivered.

The captain narrowed his eyes down to a sliver.

"You lookin' at my slanty eyes, boy?" he asked quietly.

"No, sir. All I see are captain's bars, sir. That's all that matters to me, sir."

"What if the captain is a slanty-eyed evil Japanese?"

"Ubb...ubb..."

The Captain smiled and backed off.

"Relax, boy, I'm not."

"I didn't think so, sir."

"What specific type of gook did you have me pegged for?"

"Korean, sir."

"What tipped you off?"

"A brief whiff of garlic, sir."

"Telltale. You didn't think I had the facial bone structure of a rural mainland northern Chinese?"

"Somewhat, sir, but the garlic."

"Perhaps I just had some scampi for lunch."

"That's possible, sir."

"Well, you're half right. I had linguini for lunch. But I am half Korean, half Chinese. My paternal great-grandmother was raped by the Japanese in Nanking, and my maternal grandmother was raped by the Japanese in Pyongyang, so I have plenty of reason to hate the Japanese but that's not my assignment. My assignment is to whip the sorry-ass security personnel at this temporary relocation center into shape. However, if I receive orders to kill all the prisoners, I will not hesitate to carry out those orders enthusiastically. If I receive orders to remove and barbecue the prisoners' genitalia for dinner, I will carry them out immediately and without question. I expect you to do the same. No questions asked, not one millisecond of hesitation."

Billy finally exhaled when the new captain turned and walked down the line and got out of his face.

Jus' what he needed, some hard-ass Korean on his ass. One minute he's a hero gettin' interviewed on TV, the next—shit, he's

headed back this way.

"Now, who's gonna be the first asshole to fuck with me?"

He stopped. Right in front of Billy.

Now Billy wuz usta these hard-ass gooks bossin' him around, all them Vietnamese and Chinese kids gettin' all A's in school like it was their birthright, which it kinda was cuz they had hard-ass parents that fought the communists just to get them here. They's probally scared to take home anything 'cept straight A's.

But this one, he was a robot. Billy knew it. The man had no blood, just gears and cogs underneath the almost human yellow skin.

Then the robot smiled.

"But first, allow me to introduce myself. I am the new head of security at this temporary relocation center. My name is Captain Chung."

He paused and slowly scanned the line of grunts.

"Captain Conrad Chung."

He focussed his laser beams on each grunts' eyes, pausing long enough to detect the slightest flicker.

"But if you're nice, you can call me Connie."

Lillian was very pleased with her new head of security. Captain Chung had earned her immediate trust, the way he had coordinated the outgoing rescue operation personnel with the incoming army personnel into a tightly run guard detail, although she had already learned to trust these children of the last wave of immigrants to escape communism. Their parents represented the best, and now only, kind of immigrant; the ones who would never go on welfare, who sacrificed to send their children to college, who would build their communities and stay there, then their children would become doctors and come back to their community and stay there, not allowing themselves to be polluted by the false idol of intermixing like the Japanese.

Once again, it was time for her to face the enemy: the liberal media.

She was getting used to this barbaric form of gathering information, the media interrupting each other, shouting their questions at her rudely.

They looked like monkeys in a cage, especially these two pushy ones, the Mexican girl who looked uncomfortable in a dress and her colored cameraman.

"…Vicky Rrrrod-rrriguess, KFRN Fresno," yelled the loud Mexican girl. "How do you answer critics of this program who say that if this plan is successful and is applied to federal and state-funded programs and other institutions, that applicants, especially minority applicants, would have to undergo some form of sterilization in order to be hired for a job or rent an apartment or qualify for a car loan? That this mass sterilization plan is one step short of genocide?"

"What critics?" Lillian answered with the smoothness of a tobacco industry lawyer.

49

As David was floating in the darkness, he thought he sensed a presence in the room.

He blinked to make sure his eyes were open. The crust at the corners fell off. He was parched. His mouth was glued shut by dried saliva. He swallowed with difficulty. He pried open his mouth and smacked his lips noisily.

"Would you like something to drink?" a voice came gently from the darkness.

David jumped. He stared into the black shadows.

"Who's there?" he croaked through his stale throat.

"Guess," the voice said. Then there was a face, inches from David's face.

"Bradley?" David brayed in surprise.

"Shhh," Bradley put his soft fingertips to David's mouth. "Guards outside." He lifted David to a sitting position and held the straw to his mouth.

David sucked greedily.

"Don't drink too fast," Bradley warned, "and for God's sake, don't make that Godawful slurping noise at the bottom of the cup. You might as well ring a bell."

"How'd you get here?" he gasped. "Where've you been?"

"You know," Bradley whispered, "your ex-wife is my idol. With her creative administration, they'll never find everyone on the computer. So we just might be getting out of here relatively intact, if you know what I mean. Now the tricky part is gonna be finding out where they're keeping her and everyone else and coordinating this whole mass-transfer thing, but it's do-able, so sit tight, okay?"

Bradley put his fingertips to David's mouth.

Footsteps in the hall. A chair scraping. Two men talking loudly and clearly outside the door.

"Gossome liquid refreshment 'fyou want it, *browe*. Relax, *browe*. No one's around."

"I wouldn't count on it, Billy," the other voice said.

They heard a cap on a metal container being unscrewed then the first voice, Billy, swallowing and letting out a big, "Ahhhhh. This is the life. Wan' hear something funny? I got busted for torching the last bitches' abortion clinic in town, which shouldn't even be a crime, but they tell me prison or army, so here I am." He took a swig. "But they never nailed me for the big one I did." A chair screeched. "Last summer. On the 405 south during the middle of rush hour."

Bradley saw David flinch and clamped a hand over his mouth.

"The usual stop-and-pop, our girl gets in front, slows down, stops. We know the dude in back of her is watching her, cuz she fine. Me and my Posse freeze this dude, surround him, and it's a Jap! Our lucky day! And he gets out of his car and starts gettin' uppity with us! Can you believe it? So we knock his brains out. Literally."

David tried to wrench his mouth free of Bradley's hand.

"No," Bradley held on, whispering softly into David's ear. "I'll take care of it. I promise."

"My partner Kev, God rest his soul, took a couple swings, then I got two good home run swings on him. But you know the worst part? The dummies I'm with torch the Jap's car. This short was

primo. 1960 Chevy Impala, browe," Billy crowed. "Speckle metallic-green paint job, black tuck 'n' roll interior, all up in smoke, man."

David screamed into Bradley's hand.

Bradley wiped the tears from David's face. "Let me handle it, okay?"

They could hear the cap being unscrewed and a satisfied, "Ahhhh," then the cap being screwed back on. "So look where I end up," Billy said. "Ironical, huh? Like I always say, when ya got it, ya got it."

Bradley whispered, "I promise you, I'll take care of it."

David closed his eyes and nodded his head. Bradley slowly removed his hand from David's mouth.

"Save him for me," David whispered.

"Hang tight until I get back," Bradley whispered to David, "then we'll get you out of here."

Bradley crept over to the door and as soon as he heard the cap unscrew and the glug-glug of the pocket canister, he snatched open the door and roared, "WHATHAFUCKYUDOIN, SOL-DIER!?"

A mad scramble as they jumped to attention. A shrill voice screeched, "Nothing, Captain Chung, sir!"

Standing in the doorway, illuminated by the overhead lights, in army camouflage fatigues, his cap pulled down on his shaved head, Bradley was a chilling sight.

Especially to the two uniforms in the hallway. Not as much to the black Mormon corporal whom David recognized from the yard. More so to the cooler-than-cool, blacker-than-black Billy, vodka burning his clenched throat and dribbling out his nose as he stood at attention, contemplating the end of his life.

"Are you drinking liquor while on duty, private?" Bradley hissed, brim of his cap poking Billy's eyebrow.

"Nosir I'm off duty sir," Billy gargled.

"Do I look stupid to you, asshole?" He began circling.

"Nosir you do not sir."

"Then why you liiiiiie to me, fuckhead?"

"I'm not lying sir I waited until I was relieved of my post before I had my first drink sir."

Bradley stood in front of Billy. And simply stared at him. He waited. And waited. For just the slightest hint of defiance. Or collusion.

But Billy knew better. He knew exactly when to pucker up.

"Report to the cremation center for duty now." Bradley decided to remove him from David's presence.

"But I just got off duty, sir."

"You just drew double duty, soldier. Move your lazy ass before I kick it all the way over there."

David heard his brother's killer's footsteps scurry down the hallway and out the door.

As ugly as it was, David had a reason to live.

"Corporal?" Bradley asked quietly.

"Yes, captain?" replied the black Mormon.

"Do you possess a set of regulation electric hair-clippers?"

50

The media was given limited access to the cooperating residents, so Ruth supposed it was all right to let Captain Chung escort the prisoners to a conference room. Not that she could do anything about it, except report to Lillian. Although she knew of no applicant interviews scheduled, especially this late at night.

Ruth already had several applicants on the outside requesting her services. All fine, upstanding, family men who would be kind.

The one Ruth really felt sorry for was Jenny, the hakujin girl. She looked miserable when Captain Chung had taken her away in handcuffs. The new judges were all strict and did not look kindly on race traitors.

But now, as he removed Kate and Mary, she didn't feel pity at all. More like relief. As the families of the dead terrorists were transferred out, the cooperating families like hers appeared to be less tainted.

Ruth kept staring at the captain. All she could see was the brim of his cap resting on his nose and his tight, stern mouth and clenched jaw.

Still, he looked familiar.

You know, she thought, maybe it's true that all Orientals look alike.

Vic was nervous. It had been three weeks since Jenny had called. Vic had stuffed a gym bag with clothes and all the cash she could muster, left the house in the care of some DJ friends, and took off for Chino where she had Greg's battered and patched rear end released to her custody. From there they drove to a trailer park in Barstow where Celeste had ended up, then to a used RV lot to buy a van, then to a rented garage where they turned it into a mobile TV unit, then to this place, where they had to wait for the signal and she had to learn how to act like a damn TV reporter, all of whom she detested as a species.

Celeste had been so sweet, apologizing profusely for losing Vic's hand-painted Los Lobos jacket to one of the many guards and police who'd handled her after her arrest.

Vic enjoyed this girl seducing her as Celeste sat on her lap and stroked her cheek lightly, but she was wary. It was a hard, cruel world that had taken a dump on her lesbian butt once too often. But if the poor girl needed a little tenderness, Vic thought, it might as well be mine.

Greg was antsy. People he loved were behind that barbed wire, and it wasn't like you could flash paper and take custody like Vic had done with him at the prison hospital.

No, they had the army and barbed wire and towers with machine guns, a wonderful plan only white folks coulda thought up and that Lillian bitch, who was scarier than all the white people in the world he ever met combined.

He jumped when the phone rang.

Vic picked it up, said, "Okay," and hung up. "Let's go." She headed for the door.

"Are you a Mormon?" David asked.

The black Mormon corporal's name was Carlos Brown, who

recognized this dude from inside the fences by his long ponytail. He had never shaved an inmate in a straitjacket before, but the Captain ordered him to, and Carlos asked no questions.

"Baptist," Carlos snapped open his kit and shook out the plastic cape.

"Gangster? Criminal?"

Normally, a complete buzz with no details was reserved for fresh-meat raw recruits or the condemned.

"No," Carlos tied the cape around David's straitjacket.

"Then what are you doing here?"

"I volunteered," Carlos plugged in the clippers.

"Why?"

"No job. No home. No family left."

"Man," David shook his head. "Scary when black folks lose their whole family."

David closed his eyes as the electric clipper cut a path across his head like a power mower through a half year's weeds.

"Sit still," his Mom said as her clippers thudded against his skull, hot and pulsating as they buzzed his head clean.

David sat on the stepladder chair in the middle of the garage. The hair sprinkling down on the plastic cape wasn't more than half-an-inch long.

Johnny sat on a bag of fertilizer in the corner, kicking the bag with his heels at a gallop, waiting his turn.

"At least your hair isn't as thick as Dad's." Mom always said the same thing when she cut David's hair. She'd pick out a sliver from her hand, which turned out to be one of David's clippings, and say, "Dad's hairs are like splinters."

After David was done, John would get his hair cut. Then David would sweep up all the clippings and Johnny would hold the dustpan and empty it in the trash can.

It only took minutes, but everything seemed to take too long back then.

The summer was too short, the sky was bluer, the air fresher,

the water clearer, and Johnny always followed David everywhere like a shadow.

Carlos clipped off the last of the man's hair, this man in a straitjacket, whose magnificent head of hair now lay in a pile on the floor, a single tear trickling down his cheek, and it wasn't because of the hair.

He wasn't a new recruit. He was a condemned man.

Kate was really confused.

First, Ruth turned. She couldn't be trusted.

Then Captain Chung came in to take them away. Then Captain Chung turned to her and said, "Oh, Kate honey, I'm so sorry about Ray. I know we had our differences because I'm gay and he's, you know, homophobic, but he was a good daddy." Then he was hugging her and she was thinking, If this is Bradley, is he in the security force? Is he a trustee now? Has he turned, too?

Then as he was leaving he said, "Now you just hang with these nice people, okay?"

Then Vic walked into the isolation room, looking like Kate had never seen her, with makeup, in a dress, followed by someone who looked like Greg's father, Mr. Wiley, and Kate could barely keep from screaming in excitement.

At first Lillian was enraged.

How dare he cut his hair? What good was an old hippie without hair? Was he stupid or was he deliberately trying to sabotage her media campaign?

Then she realized he was still in his straitjacket and therefore couldn't have shaved his own head.

When the soldier on guard duty told her he was ordered to shave her future spokesperson's head by Captain Chung, she

knew she'd have to defer to her new head of security, a man.

A bee landed on David's arm. He watched it bopping along. He blew at it. It stung him.

David snapped awake. His mind hit the ground running. Whatever Lillian was giving him to wake him up was probably going to give him a heart attack.

"Well," Lillian said. "I see you've gotten a haircut."

"Well, if I wanted to look Japanese-Japanese, I woulda got blue streaks. But I still look like a tourist, huh?"

"Actually," Lillian's eyes jerked back and forth, "you increase your value by increasing your Japaneseness. Can we sign this contract now?"

"Not until I hear from my sister."

"That could take days."

"I ain't goin' anywhere."

Lillian turned around and looked to the ceiling.

David could hear her muttering to herself, then she turned to him and smiled.

"Don't you love computers?" Lillian paced across the room, staring at the walls. "The best thing about computers is if I wanted to invent an individual, totally out of the blue, I can generate a complete history and make him the second coming of Osama bin Laden, Saddam Hussein and Bill Clinton rolled into one. Then just send it out over the Net and within minutes millions of geeks with their heads in the screen see it, start talking about it among themselves and it instantly becomes real."

Lillian sat down on the chair at the foot of David's bed. "Forget the contract. I don't need you to be my spokesman. In fact, I don't need you at all anymore."

He heard the lock unsnap, then the clink of metal, like silverware being set.

"I'm sure we can work something out—" he suggested.

Then she was standing by the side of his bed and looking down at him.

He kept talking to buy time. "I think a real, live spokesman who can make personal appearances…"

"Computer-generated imagery," she whispered.

"…and answer questions…" he threw out.

"On the Net, who'd know the difference?"

"…at press conferences, live and in-person…"

"By phone or by remote TV, who can tell?"

"Eventually, to be really effective," David almost pleaded, "you have to have a real, live human being to testify on behalf of the Plan."

"I'm still not entirely comfortable with your answers," Lillian admitted. "But I do have a little litmus test that tells me if you've completely and sincerely accepted your new status as a conditionally acceptable Japanese."

David tried to see her hands. She kept the right one behind her back.

"Now…repeat after me…Jap is an abbreviation."

"What?"

Lillian continued. "Jap is a colloquialism."

"Well, which one is it?"

Lillian narrowed her eyes. "Jap is not derogatory."

"Is this your Top Ten list?"

"Jap is an acceptable term for me to be called." Lillian took a deep breath. The corner of her mouth turned up and there was a twinkle in her eye. "Repeat after me…I don't mind being called Jap. In fact, I like to be called Jap."

She waited, pleased that she had gotten to him.

"You know, if you people and the Jews and the Negroes weren't so PC, we'd all get along much better. Jap doesn't bother all the real Japanese I've talked to."

"That's because they don't understand what the word means," he tried to control his anger. "And neither do you."

"Say it!" Lillian bellowed. "You're about to get neutered. What's a little word like Jap mean to you?"

"It is a racial slur," David said solidly. "It is derogatory. It is the worst thing you can call me. It offends me."

"I knew I couldn't trust you," Lillian said triumphantly. "You can't be my spokesman. You're out. You can stop using," Lillian reached down and grasped the tube, "government property."

She reared back and ripped the catheter and the adhesive tape from his penis, which to David felt as though she had already performed her operation.

He saw the scalpel in her hand and as he rolled off the bed away from her he felt something inside him explode.

His bowels had let loose and, combined with the catheter tube squirting urine like a fire hose from a full bag, created a slippery, pungent pool for her to wade through.

His legs collapsed under him, and he nose-dived into the cold linoleum. He saw her white shoes skidding beyond the periphery of the bed and tried to stand up by bracing himself against the wall.

It was too late. She was on him.

He fell to the floor again and his bowels let loose again, which may have been his best defense at that point.

Lillian bleated disgustedly and jumped back.

David crawled toward the door like an inchworm on speed. He put his face down to the cold floor and tried to push himself up into a sitting position. He kept reaching for the door handle, forgetting that his arms were still bound.

Lillian skidded around the other side of the bed.

David kicked the bed at her. It barely moved.

He flailed his urine-and-feces-splattered legs at her as she came closer, trying to pin him down.

His right foot waved weakly at her, and she latched onto it. He jabbed his left foot at her, but there was no power or accuracy behind it. He tried to head-butt her or elbow her or shoulder-butt her but, seated on the floor, his legs in front of him, he had no leverage.

She waited until he stopped thrashing and squirming and lay

back against the wall, exhausted, awaiting the inevitable.

David saw the scalpel inches from his face and somehow found within his swirling thoughts a rational argument.

"If you go through with this plan, it means the extinction of my people."

Lillian's face softened, but not her grip.

"Just the ones in this country," she said.

"I have no other people."

"But you do! You have a whole nation on the other side of the world you can belong to. Why don't you just relax and accept your eternal foreignness?"

"We're Americans. Why can't we do what all other Americans do?"

"Because you're Japanese," she smiled, her eyes glistening with tears. "Can't you see how much I love the Japanese people?" Lillian sat back and readjusted her grip on the scalpel. "Don't you know," she beamed at him proudly, "that I'm trying to save you?"

"Lillian," David looked directly into her glazed, dead-blue eyes, "you are out of your fucking mind."

Lillian brought the scalpel slowly down.

David held his breath and waited to feel the burn of the cold steel.

Suddenly the door exploded open.

When Lillian turned her head, David lurched away, sending her flying off balance.

He squirmed out from under her, leaving her sitting on the excreta-covered floor, looking up at the two uniforms who had entered the room.

"Captain?" Carlos, the black Mormon corporal who wasn't a Mormon, turned to his commanding officer for advice.

"My goodness, Lillian," Captain Chung scolded delicately. "You are a mess."

51

Dino's heart sank when the barracks door cracked open and he saw who it was, that hakujin woman from the front office, probably checking to see who was missing and report to Lillian. They were sunk.

"Over here," he said dejectedly.

Then she came tiptoeing rapidly over to him. "Dean Uyeda?" she whispered.

"Yeah?"

"Here are your papers," she began shoveling documents at him. "Transfers, certificates of sterilization, occupational confirmation receipts…"

Dino grabbed the papers. Their ticket out.

"The truck will be here shortly, I hope," Jenny said. "Is everybody ready to go?"

"WHATTAYADOIN, SOLDIER!?" Captain Chung bellowed.

Billy jumped to his feet and snapped to attention.

Geez, he never let no coloreds sneak up on him.

"There was no one here, so I just stood my post, sir."

"You did, huh?" Captain took Billy's M-16, propped up against the

wall next to the cot he'd fallen asleep on, and handed it to Carlos.

"Your belt," Chung said, holding out his hand.

Billy looked at Carlos, who wasn't giving him clue one, and unfastened his ammo belt with his holstered .45.

"Now, I want you to answer this man's questions," Captain said, nodding at David.

Billy looked at David and nearly burst out laughing.

"Why?" he sneered.

Chung leaned in real close. "Because I just told you to, asshole."

"Yessir." Billy dint like it. Sumthin is definitely wrong when a white American hasta answer to some slopes.

"I heard you talking to this man," David nodded at Carlos, "about an incident on the 405 about a year ago."

"I don't know what you're talking about, ssss," Billy stopped short of saying 'sir'.

"You admitted participating in the murder."

"It was an argument that started in a bar and got out of hand," Billy recited the Vincent Chin excuse, a smirk creeping up onto his face.

David stood directly in front of Billy.

"My brother John had a real nice car. A 1960 Chevy Impala, custom-designed metallic speckled-green paint job, tuck 'n' roll interior. Know where he died?"

"Hey, my word against yours," Billy shrugged. "See you in court."

Then the stinky little slope got real close to him.

"This one ain't going to court."

Billy saw the scalpel in his right hand. He screamed and pushed David away and ran. But the chink and the nigguh wuz blockin his way.

And he thought they wuz cool.

David stalked the screaming private across the room, cutting off the ring, cutting his prey's space tighter and tighter, finally cornering him by the crematorium slide.

He feinted with the blade, drawing his prey's arms up, and battered his midsection and groin with elbows and kicks.

David pressed his forearm into Billy's throat and stood him up against the wall. He could slice him, or filet him, or just open up his lower abdomen and watch his intestines unravel onto the floor.

Just like those atrocities in those World War II Japanese prison camp movies. Or Vietnam, or one of the other wars against the sadistic Asiatic barbarians.

Billy had wet his pants and was blubbering like a punk, snot hanging from his nose, clawing at David's chest with his wet, wormy, trembling fingers.

"Answer honestly and truthfully, for the last time in your life," David said slowly. "Did you kill my brother?"

"I didn't mean to," Billy sobbed.

"Did…you…kill…my…brother?"

"Yes," he gushed, "I killed him. On the 405. With a baseball bat."

David strained to push the weeping man back up against the wall, the scalpel wet and slippery in his numb right hand, his arms dragging heavier, his own breath short and tight.

If he was going to kill this man, he'd have to do it soon.

Then a huge wad of mucus flopped out of Billy's mouth and, through the tears, he said, "I'm sorry."

David stopped. "What'd you say?"

Billy took another huge gloppy breath and said, "I'm sorry I killed your brother."

Goddammit, another goddam charming white boy trick to get off easy. Not this time. Not this time.

If he smiled, David would cut him.

"He was my brother," David jerked his elbow up into the grunt's neck, "and you beat him to death like an animal."

"I'm sorry," he gurgled. "Please forgive me."

"God damn you," David pinned him to the wall. "If I wasn't holding this knife, would you be apologizing?"

Billy sucked a wheezing breath down his throat past David's

forearm and blinked. "No."

David dropped the scalpel and beat the crying man, slamming him wildly, out of control, until, exhausted and drained, David simply hurled his fists at the slobbering mess, so weakly that the blows couldn't be heard over his enemy's sobbing.

"What do you want me to do with him, David?" Bradley's face loomed in front of David on the floor.

"Nothing," David crawled to his feet.

"Okay," Bradley stood up. "Corporal Brown," his captain's baritone echoed through the room, "escort this prisoner to the showers." He handed Carlos a folder. "Then read this and consider your options."

"Yessir," Carlos was puzzled, but he followed orders and led David away.

Billy's eyes popped open when he felt the sting of the needle in his arm. He was lying on the crematory slide, between bodies, his mouth, feet and hands bound with adhesive tape, and Captain Connie in his face, as usual.

"That man may forgive you," he said, "but I don't."

The last thing Billy saw before he lost consciousness again was the Captain preparing another syringe and laughing evilly, just like in the movies.

David stood under the shower and flexed his aching arms and shoulders, trying to regain some mobility after days in a straitjacket. He scrubbed his body with the soapy washcloth and let the hot water carry off a week's worth of oil and grime, his own filth and the punk's snot. He cursed his cowardice and hid under the hot water.

Carlos examined the file Captain gave him. His file. He wasn't exactly sure what he meant by options except that he could walk out of this camp with these files, and there would be no trace of him ever being there or anywhere.

Carlos had never considered options. He thought he was out of them before he joined the army. He didn't know there was anything better out there.

Then David turned around to rinse and Carlos saw.

He'd never seen anyone outside his family with the mark. Big, ugly, purple welt that just grew out of nothing and never went away. His cousin Marvin had one that looked like a big slug had attached itself to the side of his neck. Little sister Charmaine had one on her shoulder, but everybody thought that was a scar from a polio shot. His father had the same one as the man under the shower, in the center of the chest. Only this man had two smaller ones running parallel below the top one, familiar looking, like an old album cover he'd seen in his father's collection of his jazz-fusion LPs from before he was born, from the early '80s.

David always had to wipe his eyes before he opened them when his face was wet. One of those Mongolian flap things.

He saw Carlos watching him. Staring at him and fingering the second button of his unbuttoned collar.

Bradley winced when the brakes squealed outside 24E.

Jenny opened the barracks door and peeked out. She had to make sure it was Bradley, especially with his new haircut. "Let's go," he whispered and lowered the back gate.

Jenny counted heads as they scurried past her.

In a matter of seconds, the men picked up their kids and tossed them into the back, helped their wives up then each other. It looked like the wall-climbing scene from *Go For Broke*. Teamwork. Maybe it was a *Nihonjin* thing, Jenny allowed herself to think as she hopped into the front seat.

Bradley eased the truck away and coasted to the showers, where Jenny saw a black soldier walk out with a monk, a naked Asian man wrapped in a blanket, his bald head steaming off the towel draped over his head.

"Who's that?" Jenny asked as the men jumped in the back.

"A dangerous prisoner and a member of my security force," Bradley handed Jenny a stack of the transfer forms she'd smuggled out.

Jenny still wasn't used to Bradley in his macho mode.

"Does the corporal know what this is all about?"

"He does now."

"Gentlemen," Bradley thrust the papers out the window at the guards on duty. "Transfers. Check 'em."

One counted papers. The other shined a light in back.

"Hey, Charlie," he chirped at Carlos, then muttered under his breath, "so you got stuck with Connie, huh?"

"Yeah, I don't mind," Carlos smiled.

"Whoa," the grunt jumped when his light hit David, "one lobotomy, coming up."

"These goin' to China Lake, too, Cap'n?" the first said.

"Is this the last personnel carrier to disembark?" Bradley asked.

"Yessir," he handed the papers back to Bradley. "Looks like half the camp's transferring out tonight, huh?"

"Yep," Bradley put the papers away, "China Lake's got the facilities to handle an operation this big. Or should I say, operations?" and winked.

The guards waited until the truck ground though the outer perimeter, headed west down the desert road and disappeared over the horizon before high-fiving each other, relieved to be rid of another over-efficient Oriental riding their ass.

The children whispered and giggled as the naked man slipped on an old pair of jeans and a Laker T-shirt, socks and hiking boots. David leaned back, exhausted. But every time his eyelids dropped, a crunch from the hard, cold metal bench of the army

personnel carrier belted him up the spine and tossed him against Carlos, who clung tightly to the folder Bradley had handed him in the morgue. David looked out the back of the truck and watched the stars disappear and the deep-purple desert sky turn lighter and cool up over the horizon behind them as they drove west into the mountains.

Kate was sure the maniac at the wheel was going to kill them. Ever since Greg put on that Stevie Wonder CD, he never seemed to see a curve coming. He just kept singing and pounding the steering wheel, and with those shades and that swaying head, bore an amazing resemblance to Stevie. Especially the way he drove.

Mary was tired. She thought Greg was singing about her, but she didn't want to be a superwoman.

Vic, who was sleeping with Celeste in back, finally yelled, "Hey, Parnelli, make sure we get there in one piece."

Mary drifted off peacefully, her head on Kate's lap, cradling the animal cracker tin of ashes that Vic had gotten from Bradley. Not Graham's. Uncle David's friend Christine's.

But now, as they entered Death Valley, all Kate felt was alone.

She tried to quietly cry herself to sleep.

She missed Ray terribly.

David jerked awake. He thought he heard a siren go off.

Not the stupid little car alarms that interrupted the city nights, but the air raid siren of his youth. Big yellow horn perched atop the telephone pole a block away, on the corner of Walsh and Centinela, let loose the last Saturday morning of every month, just in case he tried to sleep in.

Just testing. Back in the days when people thought they could do something in a nuclear attack. Like duck under a desk or jump into your homemade fallout shelter.

A long, slow wail into the air, warning of incoming missiles. Or escaped prisoners.

He listened hard. Was it a siren?

He peered into the distance. The machine gun tower lights were no longer in sight.

It was the brakes on the truck, screeching as it slowed to a halt.

"No noise," Bradley lowered the gate. "Everybody out and straight into the bus."

David and Carlos hopped down and helped the others, who ran to the idling bus, where Ozzie sat at the wheel.

"All the way to the back," Ozzie whispered with the same calm, hushed urgency he'd had as director of the Christmas choir, standing at the podium and raising his baton.

The door hissed closed, and Ozzie pulled the yellow school bus onto the road heading south.

David never imagined an ancient school bus would feel like a waterbed in heaven, but compared to the army truck, it floated on clouds.

The seats were sticky and smelly from years of school-kid abuse, but they were soft.

He stretched out on the bench seat in the back of the bus.

He could hear the parents whispering to their children, trying to get them back to sleep after their chilly sprint to the bus.

A few asked questions, always the same kid questions.

"Where are we?"

"Where are we going?"

"Are we there yet?"

Soothed by the same mom-and-dad answers.

"Just go to sleep and we'll be there when you wake up."

52

David's family had done all the standard, American family vacations: Big Bear, Arrowhead, Yosemite, Sequoia, Carlsbad Caverns, Crater Lake, Yellowstone, the Grand Canyon.

They drove to all of them. Drove a day or two to camp out two or three nights before starting the long trip back, so Dad wouldn't miss more than a week's work. His route was covered for the week by Uncle Dave and Uncle Jack and fellow members of the Nisei Gardeners' Association.

They drove to all these places in the same 1960 Chevy Impala that lasted them through the '60s and half the '70s.

Dad liked to get an early start, before the sun came up. Beat the traffic out of town. They left in the middle of the night, trying to get across as much desert as possible before the sun came up. Had to, because they didn't have air conditioning. Didn't believe in it. It was unnatural.

David slumped in one corner of the back seat, Johnny and Kate in the other, sleeping, once they stopped bickering, their legs entangled and overlapping.

As they drove in the middle of the night on their way to America's vacation paradises, everyone slept.

Mom, Johnny, Kate.

David pretended to be sleeping, which meant he had to resist not asking questions like "where are we?" and "are we there yet?" every few minutes, and he watched.

He watched the stars, thick and bright, more stars than he'd ever seen in the city by a thousand-fold. He watched the lights go by: oases of lights off the highway, an all-night gas station or truck stop, a small town at the foot of a mountain.

David watched the back of Dad's head, closely cropped by Mom, like his and Johnny's, but thick and bristly and flat on top, the back of his neck burned a dark brown, darker than his fore-arms, from years of working every day under the sun, bent over a lawnmower, raking leaves, trimming hedges, pulling weeds prop-erly, by the roots, so they wouldn't grow back.

David's uncles and aunties always kidded Dad about being a hothead from their days growing up on the farm when they'd bully and tease him until, inevitably, he'd explode at them, no matter how much bigger they were.

Dad's bowling partners always brought up that time in Sacramento where they all drove up for a Nisei Bowling League tournament. Walking through the parking lot, a wino sitting on a trash can by a fence called out "Jap" as they were walking by. His friends ignored the bum, but Dad quietly steamed.

David graduated from Venice High School in 1971. The Class of Summer '71, straight into the lottery for the draft to go fight in Vietnam. His dad graduated from Venice High in 1942. He wasn't around for graduation. In his yearbook, below his photograph, was his name and in parentheses *Evacuated in April*. A couple of his pals from the varsity baseball team brought his yearbook out to the Santa Anita racetrack, where they were temporarily housed, signed by all the classmates who wanted to sign it.

When Dad's family moved back to Venice from Michigan, the family farm was gone, so all the brothers became gardeners. Not because they grew up on a farm, which only taught them about growing celery, but because the family lived and worked in a nurs-

ery in Michigan from the last year of the war until they left in 1949.

Dad used manual tools for his gardening: old-fashioned clippers, shovels, hoes, hoses, rakes. When David was in junior high, Dad got a gas hedge-trimmer that was heavier and required more muscle than cutting by hand. He never used a ramp to load his lawnmowers onto the back of his pickup. He'd just grab hold of the wheel base and blade cover of the lawnmower and, barely bending his knees, lift it onto the back of his truck, dozens of times a day, six days a week.

In high school, in the days before muscle-building vitamin supplements, David's buddies on the football team would be feeling pretty good about themselves after a workout in the weight room, until they came over and got a load of Dad's forearms.

Dad, though hot-tempered as a youth, developed a slow fuse as he grew older. The thing that kept Dad's brothers and sisters and friends and bowling buddies entertained was that they never knew how long that fuse was.

He stewed through the bowling tournament that whole night in Sacramento. His friends recognized the telltale sign of Dad's brewing temper—him talking even less than usual, which wasn't much to begin with—and tried to put the unpleasant incident behind them with good-natured banter.

When they came out of the bowling alley, things seemed to be okay, but when the bum saw them he started to say something again. Without saying a word, Dad set his bowling bag down, grabbed the bottle jockey by his throat and belt and threw him over a five-foot-high cinder-block wall. Then he picked up his bowling bag and walked away while his friends checked on the wino. They heard moaning from the other side of the wall and figured he was all right.

On their last vacation to Yosemite, as they unloaded their camping gear at their campsite, Dad said to David, "You know that s.o.b. that nearly ran us off the road back there?"

Of course, David remembered. It had just happened that after-

noon on the way there. Dad had to swerve to avoid the asshole who'd cut them off, fishtail and fight the sandy road to regain control. Then when he pulled into the next filling station, the asshole was already there gassing up. He smirked at Dad and said, "That's how we drive in this country."

"In this country…" Dad said it like a curse.

David saw the intensity with which his father rubbed his weathered, worn hands over his thick, powerful forearms, and he felt the anger his father felt.

"Stupid idiot coulda got us killed," Dad said simply.

David kinda wished that the fool was stupid enough to make one more comment so David could've actually seen Dad snatch that idiot up and toss him over a fence.

"Don't let 'em get to you," his father said, "They act that way because deep down they know, you're better than they are."

David sometimes got the feeling that his dad felt guilty about losing his temper, but David could never blame him, not for a man for whom little insults were a daily occurrence.

David was glad Dad had passed on so soon after Mom, before he'd seen that a lifetime of holding your temper and turning the other cheek, of everyday, decent, law-abiding Christian behavior in the end meant as little now as it did then.

It was quiet in the back of the school bus. The little ones were finally asleep. David gazed out of the back window of the bus and watched the familiar moon and the stars blanketing them, as though he were home in his bed, huddled under his old comforter reading comics by flashlight.

Dad always drove in silence.

No radio on. The radio would wake the kids up. Besides, there were no stations way out in the sticks.

Alone in the darkness, a clump of lights ahead and then left behind.

Dad would occasionally clear his throat, the only sound he'd make, driving quietly with his thoughts.

David would try to stay awake for the whole drive, to see how close he was to taking over the driving duties on family vacations, but after an hour he'd drift off, lulled to sleep by the drone of the engine and the lights sailing by.

Eventually they were all asleep, but Dad was always awake.

Driving. Looking out for them.

53

The sun had just begun to peek over the eastern horizon to their left when the bus shook to a halt. The ones who needed to take care of business found a bush or shrub to duck behind but David guessed his bowels had never been emptier so he headed for the sandwich line.

"Morning. These are from Estella and the girls in the kitchen. Morning—" Jenny froze when she saw David standing in line. When Dino gently removed the wax-paper-wrapped sandwich from her hand, she smiled and asked Dino's oldest daughter Stephanie to take over.

Jenny took a sandwich and a can of Shasta black cherry soda and walked slowly, shakily toward him.

When they had switched over to the bus, he'd walked right past her without recognizing her. Granted, it was dark and everyone was running, and she had barely recognized that the naked bald monk was now in jeans and he was David.

Now that she could see him in the early morning light, she thought he looked terrible. He'd lost weight and his arms were tattooed with needle marks and discolored with bruises.

Worst of all, with his long, beautiful hair shaved off, he looked like an escapee from a mental ward.

When they'd first met at Long Beach State, people would turn and look at them, she thought, not because of the unusual sight of an Asian guy with a white girl or their colorfully patched, worn, torn jeans and T-shirts decorated with slogans or pictures of rock stars or concert posters.

It was their hair.

They'd stand next to each other like two horses tossing their manes. Hers long, straight, bleached blonde like a yellow-white neon beacon striding across campus. And his long, thick and jet black, hanging down his back like a regal banner.

Now it was gone. With what else, she didn't know.

"Hi," she said as she approached him.

"I can wait," he waved her off and squinted up into the morning sun beside her face.

"Can we talk?" She handed him the cold soda.

The icy, wet can hit his hand simultaneously with the sudden awareness of that voice, saying those ominous words, from somewhere in his past.

A long time ago, when he was married. When it was a struggle and information had to be pried out of him. Like how he was feeling. What he was so pissed off about. What she could do to somehow salvage the situation.

"I don't know. Nothing," he nearly replied out of habit.

A familiar smell, an older, more familiar and distinctly different odor than Celeste. Warm, Caucasian sweat and a quick stroke of Mennen. Jenny's.

Which confused David. Her distinctly hakujin body odor which she covered up with Mennen Speed Stick deodorant, which made her smell like his dad.

His eyes fluttered open out of his drug-recovery haze for a brief second.

He saw the blonde hair and big green eyes and at first thought she was one of the nurses at the emergency room from a couple years back when he'd gotten jumped and his jaw was broken

and wired shut.

It was his worst nightmare.

"Does he speak English?" one asked coldly.

Yes, David nodded his head 'til his eyeballs hurt.

Goddammit, yes, I speak English, you dumb mother.

It was like the Richard Pryor bit, when he had his heart attack and woke up in the hospital and saw all these white people standing over him and he thought, "Oh God, I died and went to the wrong heaven."

Then David wondered why this nurse was caressing and kissing his face. Now that never happened at Daniel Freeman Hospital.

Then he saw someone from long ago, sitting on the back-porch railing of a mountain cabin on an early winter morning in 1972, strumming a guitar and singing a Joni Mitchell song, "Ladies of the Canyon," a fresh-picked flower in her hair, morning sun silhouetting her slender, underwearless figure through her flower-print hippie dress.

David always thought it was the sadness in her face when she sang that first attracted him to her.

He sat down next to her and sang harmony on the chorus.

She never told him how surprised she was then to see someone of his race sing harmony on a Joni Mitchell song.

Then she smiled. A smile that lit up her entire face. Her eyes shone and crinkled. Her cheeks raised in joyous celebration.

At first he thought she must naturally be a very happy person, never noticing that she never smiled as brightly around anyone else. All he knew was she couldn't possibly be smiling that much because of him.

But she smiled at him and changed his whole life.

Jenny looked at David carefully. He had that too-happy, glazed look on his face that she hadn't seen since the last time he scored high-grade sensemilla decades ago.

"David, do you know who I am?"

David closed his eyes. This was one weird dream. This was the woman he had spent over half his life with, had shared his dreams with, had wasted his youth with.

But she couldn't be here.

"You're not Celeste," he said finally.

Of all the thousands of faces she'd registered, Jenny knew somehow that David would find the beautiful face named Celeste, damn him.

But this was not the time for jealousy, especially since she was now in his arms and he was holding two handfuls of her love handles, which were threatening to become love slabs.

Then she thought, Oh God, they've done something to his brain. They put more than saltpeter in the food.

"David," she repeated carefully. "Who am I?"

He thought, were they putting collaborators in camp, too? Race traitors, fraternizers past and present? Ex-wives?

But they were in the process of escaping. What was she doing in the middle of all this?

He circled around her until the sun was at his back.

"Jenny?"

"Yes!" she started crying. "Yes, yes, it's me."

Of course it's you, he thought as she pounded her forehead into his chest and squeezed the breath out of him. You were always the cryingest person I ever knew. Crying when you were upset. Crying when you were happy. Crying the first time I told you I loved you. And the last, too.

So it was only natural she'd be crying in his dream.

If it was a dream.

"I thought you didn't recognize me," she shuddered with relief.

"I couldn't see your face," he explained. "I was looking into the sun."

She buried her face into his neck. The woman who was always crying because of something he did. Good or bad.

"Is this for me?" David asked, tapping the sandwich she was

pressing against his face as she clung to him.

"Sorry," she fumbled it at him. "You must be starving."

"Mmmm, baloney sandwich," he chomped off a third of it.

"Us girls in the kitchen made them last night."

"You were working in the kitchen?" David asked, thinking without saying, That's a first.

"Lillian caught me trespassing—I found Kate and Mary in the terminal ward—"

"Kate and Mary? Where are they?"

"They're with Vic and Greg."

"Vic and Greg?"

"Yes, Celeste called Vic in L.A."

"Celeste?" David was reeling. He stuffed the last of the sandwich into his mouth, chewing mightily, and popped open the can and chugged half of it down. "You know Celeste?"

"They're in the last truck. We won't have any contact with anyone until we all meet up again."

"Where's that gonna be?"

"I don't know. Bradley won't say."

"Bradley did all this?"

"Yeah, everybody who wanted to go, he got 'em out."

Carlos, now dressed in a light-blue jumpsuit, a bus driver's cap and a pair of work boots, switched the hand pump to the last barrel of gasoline that had been waiting for them and jammed the nozzle back into the bus' tank.

As he pumped the handle he watched Dino toss a match into one of the empty barrels and the last bits of the shredded contents of the folder Bradley had given him started to blow away like confetti in the wind.

Carlos was officially a free man with a world of options.

On the other side of the bus, Bradley and Dino were putting the finishing touches on a hand-painted, bus-length, butcher-paper sign on the side of the bus that read, First Laotian Baptist Church of Fresno.

Ozzie flipped the destination sign over the front windshield so it read Grand Canyon and gunned the engine.

Jenny and David sat next to each other on the bench seat in the back of the bus, holding hands like third graders with their first crush.

"I thought you were a dream," David said quietly. "I was looking for someone else and I thought you were a dream."

54

Ruth woke with a start. She'd fallen asleep in Lillian's office.

The sun was coming up and Lillian wasn't there.

Ruth paged her, rang her. No answer.

Ruth turned on the intercom and posted a Code Blue Alert. She didn't know how else to sound a missing boss alarm.

She walked down the hallway to the first isolation cell, where Kate and her daughter were being held. The room was empty.

She checked the other isolation cell around the corner where David was being held. The guard was asleep in the chair outside the door, his legs stretched out across the doorway.

Ruth cleared her throat.

The guard scrambled to his feet and snapped to attention. Until he saw who it was.

"What?" he snarled.

"Is the prisoner secure?" Ruth asked.

The grunt chuckled to himself. Judging by the amplitude of log-sawing behind that door—it sounded like a moose with severe adenoidal sinusitis—it'd take two or three shots to wake up that dude.

"Can't you hear? He sounds like a grizzly in hibernation." The guard listened closely to make sure nothing had changed since he

last checked, when it was still dark.

Ruth hurried over to the locker room at security headquarters.

"Have you seen Lillian?" she demanded of the first guard she saw, who was shaving.

"No, ma'am," he said, barely looking away from his reflection in the mirror.

"Where's Captain Chung?"

"Transfer run last night. Be back around noon or so."

"Transfers? Have him report to me as soon as he arrives," Ruth ordered, "and find Lillian." She stormed out.

"Yes, ma'am," said yet another lifer, a man who'd been busted down too many times. He maintained his smooth, even stroke, stopping to dunk his razor in the dirty sink water, over and over again. "Right away, ma'am," he muttered as he continued shaving, slowly and deliberately.

The compound seemed eerily quiet, and even at this early hour of the morning, more empty than usual. As she pounded a path of dust toward the terminal ward, Ruth saw no early risers on their way to the latrines, no children who were dressed and outside playing at the crack of dawn.

The guard outside the crematorium stood up when he saw her come stomping in.

"Have you seen Lillian?" she asked, looking around.

"No, ma'am," the guard said, following her gaze.

Ruth stopped and cocked an ear. "Do you hear snoring?"

"That might be me, ma'am. I've been having a problem with post-nasal drip ever since the winds kicked up."

"No, no, listen," she held up her hand. "There," she stopped at the bags on the slide. "This one's breathing."

"Are you sure, ma'am?" he walked up to the slide.

Sure enough, the bag was moving, and snoring.

"Open it," Ruth ordered, although the guard's hand was already on the zipper.

The bag split open.

Billy sat up and screamed through his nose and the adhesive tape over his mouth.

The guard drew his weapon and situated himself between the woman and the screaming, thrashing man in the bag.

Billy flopped onto his back and frantically pushed his pants down, then sat up and examined his genitalia, laughing in relief, taking and retaking an inventory.

Ruth ripped the tape off his mouth, taking some lip and half a partial moustache with it.

Billy screamed in pain, holding his mouth with one hand and protecting his crotch with the other.

"Have you seen Lillian?" Ruth yelled at the masturbator.

Billy just sat there, crying and smiling and stroking his equipment lovingly.

Ruth stomped out of the med center.

Lillian was still missing, and all she could get out of that idiot guard was some drivel about Connie Chung while he played with himself.

Bradley made his way to the back of the bus.

As much as he liked Jenny, knowing how much she had done to smuggle him transfer papers and coordinate all the outside details of the break, he still couldn't help but feel resentful and envious when he saw David asleep in her arms.

Since the plague began during the Reagan era, Bradley had watched too many of his friends die. Too many couples suffering through the slow, painful death of one. Too many survivors cut out of their lover's lives by families that had long ago discarded them. Too many old queers living the remainder of their miserable lives alone.

Bradley thought Jenny was asleep, but she was watching David as intently as a new mother watching her baby.

"Hi, Bradley." She had a smile that could melt a glacier, and

he couldn't help but smile back.

"Cookies?" she nodded at what he was holding.

"Oh. No." He fumbled with the old canister that read Famous Amos' Cookies. "These are Graham's ashes."

She hugged him tightly around the neck and held his face when she released him, "Thank you."

Bradley had planned on telling Jenny about Christine. Instead he bent down and kissed the sleeping David on his cheek, then went back up front.

The children were starting to get restless.

"Hey, kids," Bradley called, "how about a song?"

"Yeah!" Ozzie bellowed from the wheel.

"Let's do some Sondheim!" Bradley clapped, then started singing, like any good stage actor, to the last row.

Ozzie could see in the rearview mirror the quizzical looks on the faces of just about everyone in the bus, especially Carlos and others who, in the mad scramble in the middle of the night, still didn't recognize Bradley and couldn't understand why Captain Chung, the head of security, had decided to lead them in a sing-along of another obscure song they didn't know.

Ruth couldn't breathe. She couldn't scream. She could barely think. But she didn't want to cause a panic.

Her girls were gone. So was Dino.

She ran from place to place, the rec hall, the ESPN barracks, the mess hall, but she couldn't find her girls.

Kyoko and Keiko. Her girls that made her such an attractive package for relocation and placement.

No one was talking. They claimed to have seen nothing.

They were jealous of her.

Because she was getting out.

Ruth didn't want to cause any alarm. Like a good Japanese, she didn't want to cause any unnecessary trouble. But she was

starting to worry.

Mary could tell Uncle Greg and Auntie Vic were angry but not with each other.

Celeste was a *monku-tare*. A complainer. *To da max*, like Daddy used to say.

"Are we there yet?"

"This tape sounds like it was made before I was born…"

"If it gets any hotter, I am going to vomit…"

One time Mary heard Auntie Vic mumble to herself, "Jesus Christ, she's twenty-five going on twelve," which to Mary was kinda an insult.

"Are you sure you're going in the right direction?"

"Who is this singer? I hope she's dead."

"What moron made this map? I can't read it."

When Auntie Vic took over driving for Uncle Greg, Celeste seemed to be excited, but she was still *monku*-ing, real loud.

"Maybe now we'll make some time or at least stay in the general vicinity of the road."

"I'm gonna kill her," Uncle Greg grumbled as he collapsed on the bed in the back of the van. "When I wake up, if Vic hasn't already done it, I'm gonna kill her."

"It's kinda like, all her life, she's never been allowed to complain," Mommy explained quietly to Mary after Uncle Greg had started snoring. "And now that she's finally free to complain," Mommy sighed, "boy, is she ever."

"Thank God, you're finally turning away from the sun," Celeste moaned. "I was getting a headache. So what, we're heading south now? East then south? Are we going to Las Vegas? Where are we?"

"Death Valley," Vic said.

"Huh," she snorted, "that figures. Are you sure the AC doesn't work?"

"Yes, I'm sure," Vic snarled.

Vic didn't look at Celeste, just at the road, and out across the desert, miles and miles of Death Valley, where a body could lie undiscovered for weeks, perhaps even years.

"I have to pee again," Celeste whined, hitting a frequency that went directly to everyone's inner ear.

Mary woke up when she heard Auntie Vic go, "Oh, thank God!" She thought it was something neat, but it was just the sign for the Nevada border ahead and a place called Beatty.

"That's it, isn't it?" Celeste sat up. "Beatty. You got to be kidding me. Finally."

"Yeah, that's it," Vic gratefully yanked the wheel and turned off onto the small dirt road just before the sign.

"Where are you going? Aren't you stopping? Where are we?"

Vic set the parking brake, turned in her seat, left hand slouched over the steering wheel, and glared at her.

"What's it to ya?"

"Just wondering," Celeste shrugged innocently.

As they rocked over the lumpy road, Mary saw what looked like the front of a Winnebago sticking out of the hill.

And then, to her amazement, walking out of the shadows, Dr. Sid.

She heard Celeste say real quietly, "She's supposed to be dead."

She and Mommy jumped out of the van. Dr. Sid was real happy and relieved to see them.

Then they were nearly knocked down by a big black shadow.

"Tuesday, sit!" Sid commanded.

Tooz sat on Kate's foot, smiled lovingly at her and mopped their faces with her tongue.

Mary liked Tuesday, except for her tail, and as she hugged the slobbering dog, she didn't see Dr. Sid place a hand on Kate's arm and say, "I have to talk to you."

Mary wiped the dog slobber off her sopping face.

Then Tuesday saw a familiar sight coming out of the van.

"Woof?" Tuesday inquired.

"Tooz?" Greg replied.

Tuesday took two full strides then launched herself, paws fully extended, tongue hanging out of the side of her smiling mouth, and caught Greg square in the chest, which worried Mary.

When she'd found out Uncle Greg was recovering from a gunshot wound, she'd looked for signs that he'd been shot. A scar, a limp, an odd whistling sound when he breathed.

"Get off me," he laughed and tried to grab the boisterous dog, who leapt up and went bounding to Mary.

Mary scratched Tuesday all over and Tooz did the leg thing. Mary stopped when she felt a deep rumbling under her hands. A low, deep, angry growl vibrated through Tuesday's body. Her short, coarse black hair stood up all along her spine.

Mary leaned slowly back and saw the bared teeth, the sabertooth incisor exposed by the quivering upper lip.

And the stare. Fixed like a laser on...Celeste, huddled in the doorway of the van.

"Will somebody curb this animal?" Celeste stuck one foot out the doors then jerked it back in as Tuesday lunged at it, gnashing teeth brushing her ankle.

"What is wrong with that dog?" she screamed. "Somebody shoot it!"

Tuesday jerked her head up, ears perked, at the sound of a whistle, and sprinted off to Dr. Sid, who was huddled up with Vic and Greg and Mommy.

"Stay here," Greg walked over quickly and pushed Celeste back into the van as he got behind the wheel.

"Now what? What is going on?" Celeste whined.

Dr. Sid pulled the RV out of the cave in the side of the hill and Greg pulled the van in.

"Wait here," he said and hopped out the back door.

"Why not?" Celeste grumbled. "I'm not going anywhere."

Celeste was so pissed she didn't even care what Dr. Sid was telling Vic or Kate or the kid. Or that they were all looking at her.

"What did Lillian offer you to turn us in?" Vic asked as she and Dr. Sid got in the van.

"I don't know what you're talking about."

"Did you know my son at Manzanar?" Kate asked. "Is that why he's dead now?"

"I had nothing to do with his death."

"Were you going to wait until we all met up in Vegas?" Dr. Sid grabbed Celeste by the wrist.

Kate handcuffed her wrist to the steering wheel.

"What are you doing?" Celeste protested.

"Buying us some time," Greg said, walking by with a handful of cables.

They were all leaving. Celeste tried to latch onto the only one remaining. Vic, who was disconnecting the communications equipment.

"I don't know why they're saying all those things about me," Celeste protested indignantly. "I escaped with the Indians. I didn't have to call you in L.A. and go back."

"We talked to our friends on the rez," Vic said. "Lillian put you on the Quakers' bus."

"Come on," Celeste stroked Vic's arm. "We'll just go our own way. We don't need those others."

"You probably haven't had a pleasant life," Vic removed Celeste's hand. "But you were trying to buy your freedom with ours. That makes us enemies."

Vic stopped at the back door.

"There's food and water. I imagine they'll find you before your supplies run out, but you'd better ration them, just in case. Don't burn anything to signal, there's still gas in the tank. No starter but there's gas."

"They'll find me, all right," Celeste's voice was low and menacing. "Then I'll be set for life. I won't be old and alone like all

you other losers."

Vic turned back to Celeste.

"I wish—"

"Get lost, dyke."

As her mom pulled her into the RV, Mary made a mental note to ask Uncle David why that word made Auntie Vic cry, even though she tried to hide it.

Vic dropped the camouflage net over the entrance to the cave and quickly flicked away the unexpected tears before hopping into the mobile home. "Let's go."

"Which way?" Greg eased onto the dirt road.

"North to Tonopah," Dr. Sid pointed. "We're taking the long way around Vegas."

"Dr. Sid," Greg downshifted into second and cranked it up another hill, nice and slow, "how far east are we going?"

"Up the 6 to Ely, then east on the 50, straight across southern Utah to the 191 and then south into Arizona."

"Utah?" Greg moaned, "Arizona?"

Ever since they'd crossed over into Nevada, Greg felt like a flea in a snow bank. All this meant was tons more white folks. Police waiting around every bend, behind every billboard, just itching to pull over any dark-skinned visitors from the city. Might be terrorists.

Stop the city folk at the border. If they want a vacation, let 'em stay in town and shoot at each other.

More police meant getting stopped, getting hassled, the last thing they needed right now. Last thing he needed any ol' time.

"From here on, we're just church folks visiting the reservation," Dr. Sid explained.

Of all the necessities in modern-day California, only the highways were still maintained adequately. Especially this far from the cities, where the people took pride in their roads and the police kept a real sharp eye out for any of those city troublemakers trying

to foment revolution in God's country.

But what could be more wholesome than a school bus full of Laotian Baptists from Fresno headed to the Grand Canyon?

They pulled into the Tehachapi McDonald's, the only fast-food franchise to survive countless poisoned-meat and accidental massive death scares, and formed a line directly into the restrooms while their Korean pastor and American sponsors went inside and ordered four dozen Big Macs, plus fries and drinks, to go, as their Negro bus driver filled up the gas tank at the Chevron station next door.

Bradley had placed the order in a vaguely Oriental accent with the slightly peeved cashier and was waiting the interminable minutes it would take to fill the order when he looked up.

In every mall food court, doctor's office, lobby, elevator, super-market check-out line, and fast-food take-out restaurant, hanging from the ceiling, in front of anywhere there might be a line, was an American-made, standard-issue TV monitor, replacing Muzak with twenty-four hours of be-on-the-lookout programs—in this case one featuring the daring kidnapping of two young girls from a temporary relocation center by their desperate, probably drug-addicted and hideously Japanese father.

Bradley suppressed a vocal reaction, like a blood-curdling scream, as the soft-focus color photograph of Ruth holding Stephanie and Nicole in front of a Christmas tree faded to the stark, black-and-white, camp registration mug shot of Dino, who did indeed look desperate and doped and well into his second day of the trots.

Bradley reached for Ozzie blindly, finally catching his sleeve as an interview began with a hysterically crying Ruth, Lillian standing benevolently behind her.

"Oh my God," Ozzie turned and tried not to sprint full bore out the door.

"You from China?" a truck driver asked, glaring at Bradley.

"Here's your order, sir," the high school kid said with a smile

as she shoved a cardboard box filled with Big Macs across the shiny clean counter.

"Thank you, thank you," Bradley grabbed it and nearly ran over the truck driver. "Bless you, bless you."

Jenny saw Ozzie long-striding out of the restaurant and knew there was trouble.

"They got Dino, Stephanie and Nicole's pictures on TV," Ozzie blew by. "Get the girls on the bus."

"Back on the bus," Bradley rounded up the boys, trying to keep the panic out of his voice. "Quickly."

Ozzie knocked lightly and rapidly on the men's restroom door. "Dino," he whispered.

Dino had just sat down with the sports page. All he wanted to do was take a decent crap.

"Go 'way!" he bellowed.

"Dino, we gotta go."

"So do I, Ozzie, so get lost," Dino scowled. Bad enough the guy leads the whole damn bus singing songs he never heard of. Now he's trying to make him rush his kukae.

"Dino, Dino," another voice whispered through the ventilation grate on the door.

"What?" Dino yelled. Now it was that fruit, Bradley. Probably wanted to watch.

Then Bradley whispered, enunciating clearly through the grate, "They got you and the girls on *Be On the Lookout*."

Ruth was doing wonderfully, making her tears well up and brim on the edge before gushing over, making her voice quiver and shake when she described how her monster of a husband kidnapped her poor little daughters and escaped with a known murderer.

As the next news team stampeded into the office, Lillian noticed that the Hispaniard girl reporter from Reno had the same name as that other one from Fresno. She'd have to check with

that station, but Lillian supposed Rod-dra-gweez among Mexicans was like Johnson among Negroes.

Ruth managed to tearfully convey just enough information, then came the flood of tears, right on cue, and the pushy cameraman came crawling in for a close-up.

Yes, Lillian thought, even if her little spy didn't get back to her soon, all of America will be on the lookout for the renegade Japanese.

That's how fugitives were tracked down in twenty-first century America: on TV.

She didn't want to issue a terrorist alert. Too much media attention. Just a nice little buzz, something less than suspected terrorists and more than the nightly car chase.

Then, hopefully, those three would lead her to the rest, because she wasn't exactly sure how many were missing.

55

Each night after dinner, Rodney Knifewing would slowly stare off into the walls the same way he often sat outside looking up at the stars. He would respond with a kiss when Roberta brought the two little ones out to say goodnight to Daddy. By the time he had absentmindedly kissed Roberta goodnight and made his way to the easel in the corner of the living room, he was no longer on this planet. He was, brush in hand, lost inside his current work-in-progress. He would often paint through the night silently, undisturbed now that the kids had outgrown their childhood maladies.

Here in the middle of the Dineh nation, he could see through the huge picture window the rare visitor approaching from miles away, the lone pickup truck rattling along the main road before their headlights got bigger than pinpoints.

No one lived this far out of town, in the middle of nowhere, except a painter who needed his solitude, which had been easier to come by since the second plague, an unknown disease that killed hundreds of people in a hundred mile radius, twice in one decade.

Rodney was lucky. He'd only lost one daughter. Others lost whole families, whole generations.

Mystery illness. Official cause: rodent droppings.

Nothing to do with all the nuclear testing, toxic-waste dumping, polluted water that the *biligana* had poisoned their land with for generations or even the more recent threat of terrorist chemical or biological weapons. Not in this sparsely populated part of the country.

No, the unsanitary living conditions of the filthy Indians was to blame. Like every other plague of the last twenty years, it was the victims' fault.

Rodney tried not to be bitter. He tried not to remember his little girl's suffering face and all her questions he couldn't answer.

Most of all, he tried not to compare. The death of a human being was the death of a human being. One no more acceptable than another. No one's suffering could be measured against another's. He wouldn't play that game.

Rodney had been too intent on sketching the eagle within a cloud formation on his canvas to notice two pairs of headlights that didn't turn off the road where everyone else usually did. By the time he noticed, they had stopped in front of his house.

Just as he was thinking the bus engine might wake the children, it shut off.

He walked out onto the porch. He didn't recognize the *biligana*, the white man behind the wheel of the orange school bus with the big sign on the side or the black man in a bus driver's uniform. Or any of the little dark-haired children that poured off the bus. He thought they were either very quiet Dineh or Asian.

Then Charlie Black Hill's daughter, Kerri, got out of her jeep. She must've escorted the bus onto the reservation.

Then someone else he recognized got off the bus.

The blonde woman who had first come out to the rez fifteen, twenty years ago and who brought her husband, the Sansei, to the pow-wows in Santa Monica and even stopped by their house when they were on vacation, on their way to see the Grand Canyon. Long time ago, before the first plague.

"Hello, Jenny. How are you?" Rodney said as she wrapped him

up in her cool, soft arms like a calming breeze. Then he peered into the darkness at the man standing behind Jenny. He almost didn't recognize him. With his head shaved like that, he looked very Japanese. "*Yaa'eh t'eeh*, David."

"*Yaa'eh t'eeh*, Rod," David grasped his hand.

It had been several years since they'd last seen each other. Rough years. They could see that in each other's eyes.

Jenny introduced him to their organizer, Bradley.

"I'd better tell Roberta—oops, too late."

Roberta Knifewing, a short, dark, striking woman with a mane of straight black hair, seemed to float out the front door in a white cloud, which was actually an XXL Minnie Mouse nightshirt. But her carriage and elegance gave it a gown-like quality. She began taking her newfound guests into her home and tucking them away in as many open spaces as she could find.

"Kerri," Rod called to Charlie Black Hill's daughter. She was a long-legged, slender young woman with long, straight black hair and deep-blue almond-shaped eyes. "These are my friends from Los Angeles," Rod introduced them. "This is Kerri Kuroyama."

"Kuroyama?" Jenny said. "That almost sounds Japanese."

"It is," Kerri said, her voice clear and eager. "I'm happa. Actually, one quarter Japanese. My grandfather's a Nisei who came back to the rez after the war. My grandmother Rose is Dineh," she enjoyed telling this story. "They decided to take the translated name Black Hill when he was accepted into the tribe. My father, Charlie Black Hill, married my mom, Pat Dennison, who was *biligana*. You know, hakujin. They died during the second plague. When I was at college, ReVac was ordered, so I changed my name back to Kuroyama as a protest. I kept waiting for them to come for me because of the twenty-five percent rule, but I guess no one was checking out here or else they thought it was a Navajo name."

David thought she couldn't be too Japanese if she was this enthusiastic. Then he remembered a time when he was, if not

young and eager and idealistic himself, surrounded by those who were. In college. In the Movement. Energetic and optimistic and too young and naive to believe that they couldn't change the world. People like Christine.

"You came back here after college?" David asked.

"Yes, I'm teaching at the school in Lukachukai."

As Kerri spoke, David noticed that the front of her blouse was unbuttoned so that her bra was showing. But it wasn't her bra he noticed, or her magnificent breasts, much. It was the small purple welt just above the front clasp. A keloid.

She saw him staring and started to put her hand over it.

"You knew we were coming, didn't you?" David said.

Kerri looked at him quizzically then said, "Yes."

"We must be related," he tugged down the collar of his shirt to reveal his top keloid to her.

"I knew it," Kerri smiled and hugged him.

Jenny should've been used to this, this babe hugging her husband right in front of her. Women liked to hug David, especially the young, pretty, firm ones.

"Hey," Kerri grasped Jenny's arm. "Granpa's gonna be real glad to meet you. In fact, there's another Nisei man who got here last week."

With the Knifewing house filled, David and Jenny ended up back on the bus, curled up on the bench in the back.

They had a tradition. It didn't start out as a tradition or something they did deliberately. Perhaps it was the excitement of being in a new place, or just a nice change from the same old bed. But whenever they arrived at a new hotel room or bed-and-breakfast or any overnight stay away from home, they initiated the room. Usually in the middle of unpacking, sometimes at inconvenient times that caused them to be late for the wedding they'd driven half a day to get to. It would start innocently enough. A little kiss.

A "Whew, we got here okay" peck.

Then the realization that they were alone, in a new place, where they wouldn't be disturbed for possibly minutes.

Then they were all over each other like college kids.

Like when they first met.

"I missed you," she said.

There were others on the bus. Up front. Hopefully sleeping.

It was like slipping into your favorite old jacket. The one that kept you warm in autumn and warm enough in winter.

The one you'd never part with.

Lillian smiled regretfully at the handsome, young American serviceman in the hospital bed. Now here was another young person who would've had an excellent future in public service. But he was lying to her and she knew it.

"Gosh, ma'am," Billy looked down and shook his head Reaganesquely. "I heard stories about the black market, but I stay away from that sorta thing."

She wanted to believe him. But when a complete medical examination results in positive tests for drugs, particularly Ecstacy and steroids, well, there isn't much to say except dishonorable discharge pending criminal charges.

"Ma'am?" Billy sat up and put on his best who-me?-innocent-as-a-babe-in-the-woods face. "I have never knowingly taken drugs in my life. I swear."

"So you are denying it despite the medical evidence to the contrary?"

"Yes, ma'am," Billy said solidly. "I was knocked out. That's when they musta done it."

Ruth knocked once and opened the door.

"We've located the bug."

"Well, then," Lillian wrote him off. "If they must have been administered against your will, you might survive a court martial,"

and she left him there.

"They found her handcuffed in that TV van one hundred miles north of Las Vegas," Ruth wheeled the videophone unit in front of Lillian. "Here you go."

They could see Celeste talking to someone off-screen, the camera operator.

"It wasn't so bad," she was saying. "If they had a mall instead of that crummy PX, it might've been okay. What does PX mean anyway?"

"Can she hear me?" Lillian shouted into the headset.

Celeste reeled back from the screen.

"Not so loud," Ruth whispered to Lillian.

"All right," Lillian sat back. "So, you were supposed to get me information, dear."

When Celeste turned to the screen, her entire demeanor changed.

"I'm sorry," she said meekly. "They found out about me. I don't know how," Celeste whined, "but they did."

"Who found out about you?"

They saw her turn from the screen.

"Can I have something to drink?" she whispered, then smiled demurely as someone handed her a canteen. She took a drink, wiped her mouth and said, "Dr. Sid was waiting with a mobile home."

"She's still alive." Lillian shook her head, "I knew it."

Celeste raised the canteen to her lips and drank greedily, water spilling from her mouth.

"What is their destination and which way did they go?"

A hand came on-screen and gently pushed the canteen down. "Not so fast," a male voice said gently.

Celeste wiped her mouth with the back of her hand, not taking her voluptuous eyes off the face beside the camera.

"Well?" Lillian was getting impatient. If she was to minimize the potential damage, she would have to control the information. One tip to that TV station in Fresno was quickly discounted, but

if dozens of Japanese were spotted running around loose all over the country, people could become alarmed. And if she had to admit there had been a breakout, she'd have to ultimately take responsibility for the behavior of her security personnel, as unfair as that was, since the best-of-the-best were stationed in the Middle East, leaving the not-so-best to handle Homeland Security, and the far-from-best to occupy the nonterrorist assignments.

But this was not a terrorist situation. Not by any means. Just a little glitch.

How little would depend on the number of missing or unaccounted for residents, and with the computers malfunctioning, that would be impossible now.

"South," Celeste said. "They're all going to meet up in Vegas. They said they wouldn't stand out in Vegas."

Celeste was staring intently just to the left of the camera again. She bit her lip.

"That's right," Lillian brightened. "All Orientals love to gamble. All right, get back here as fast as you can—"

Celeste refocused her smile on the camera.

"If I do, I won't arrive back at the facility until tonight," Celeste gently countered. "I think it would be more pragmatic if I accompanied the sergeant," her eyes twinkled to the left again, "to Las Vegas and attempted to locate the fugitives while you're coordinating the search parties."

"Oh, you do, do you?" Lillian said skeptically.

Ruth leaned over and whispered, "Her ETA is five hours at the earliest. She's only ninety minutes from Las Vegas."

"Nooo," Lillian suspected ulterior motives. "I don't think so."

"I've contacted Las Vegas police," Ruth said hurriedly. "There are busloads of Orientals traveling in and out of Las Vegas at any given time, but they tend to congregate downtown at a hotel called the California Club. Between the security patrol and Celeste they know what the missing servicemen, the phony TV people and the suspected missing residents look like," which was

already numbering in the hundreds, now that Ruth was starting to get a clearer estimation of how many files Jenny had deleted.

"All right," Lillian said to Celeste. "I've decided it's more expedient for you to continue on to Las Vegas with the patrol there and search for the missing residents and that alleged television reporter and her cameraman."

Celeste poured water from the canteen onto a handkerchief and slowly wiped her face, the back of her neck, then squeezed the cloth out under her chin and let the water trickle down the front of her shirt and plaster it against her chest.

Lillian said, "Sergeant, I want those people."

"Yes, ma'am, I copy," came the voice from the man Celeste hadn't taken her eyes off of.

Celeste was zeroed in on her target. He was dead meat. A bit too easy, but she'd hook up with someone else later, anyone who could do her more good than this one.

"*Yaa'eh t'eeh*, Miss Black Hill," Chester Valdez greeted Kerri Kuroyama as she approached his post at the north gate. "You expecting more visitors?"

"Church people from California," Kerri said.

They watched the headlights coming off the road from Blackrock, the RV pull up to the gate and the motley load of people fall out.

The woman who had been at the wheel, who looked Dineh, stretched and roared like a lioness, then started coughing.

The black man, who looked like Isaac Hayes, lurched from the van, dragged by a black Labrador dog with a funny smile.

Two women and a girl, who from a distance looked Asian but as they got closer appeared to be Dineh, looked worried as they waited for the driver woman to stop coughing.

"If I smoke one more cigarette," Vic wheezed, "I'm gonna puke."

"These folks look like they might be from California," Chester said.

56

Father Pete had been up for hours by the time they arrived, cleaning up and airing out the deserted old school building. A fortyish Navajo man with wire-rimmed glasses, a plaid cotton shirt and khaki pants, he cheerfully greeted the visitors getting off the bus from the Knifewing home by the back steps of a small church, a modest, white, Baptist-plain wood structure with a simple wooden cross on the steeple—which along with the gas station and school comprised the whole town—and led them down the hill to the school dormitory, a large, faceless, century-old, whitewashed, two-story former school building where many a child had the Indian beaten out of him.

David saw Bradley walking up the hill. He seemed to be staring off into the clouds, stumbling over the uneven ground.

"Hey," David caught up to him at the top of the hill in the shade of a lone pine tree, "where you going?"

Bradley stared off at the horizon.

"This looks like a nice place to stay."

"After all that time in the desert, you wanna stay here?"

"I'm from Seattle. I can't get enough sunshine."

An old beat-up Ford pickup churned up the path to the school, honking its horn like a bleating sheep.

An old Navajo couple got out of the cab. Then another man got out of the passenger side.

David squinted down through the sun. "Mits!" he shouted.

As Mits introduced everyone to Kerri's grandparents, Rose of fry bread fame and her husband, Jim Kuroyama Black Hill from Bakersfield, Bradley and Father Pete went into the church. David waited for Rodney, who was pulling up in his pickup, to walk in together.

The office in the back of the church doubled as the local post office, satellite communications center and all-around cluttered place to hang out.

Bradley and Father Pete were seated in front of a desk with a small video monitor, staring at the screen.

"An apparent illegal alien smuggling scheme has come to a tragic end here in Death Valley," a TV reporter gushed excitedly. "This van full of illegal Chinese dayworkers was found here this morning. Forty-two men, women and children were locked inside, all of them suffocated to death. The driver of the van was shot to death, police have concluded, by a rival smuggling gang in an apparent dispute over territory."

David groaned as a shot of the dead driver was shown.

It was Annie, the Kanaka toilet scrubber from the women's latrine who had started the rice strike.

"Who was in that van?" David asked.

"Fred and Donna Taniyama, Amber's parents, some junior high girls, some single guys, I don't know, forty-two…" Bradley trailed off.

"Who was the guard on that truck?" David said.

"One of my men," Bradley shook his head. "The drivers who didn't want to go along with us were dropped off in the next county. They haven't said what happened to this one. He could've turned on us. He could've been shot. I don't know," Bradley waved helplessly.

They watched the pictures of the bodies in the back of the truck collapsed over each other like a Jonestown ditch.

"What a horrible way to die," David said.

"They weren't out there long enough," Father Pete said.

"They were found early this morning," Rodney said, "not long enough for the heat to kill 'em."

Father Pete said, "And there is no illegal Chinese smuggling ring in the middle of Death Valley."

"If they find us here," David turned to Bradley, "we're putting everyone in jeopardy."

Bradley looked at the screen and groaned.

"...no truth to the unsubstantiated rumor," Lillian was on TV, holding a press conference, "that this tragedy involving illegal Chinese aliens is somehow connected with the operation of the nearby Japanese temporary relocation center..."

Rodney always wondered why Father Pete didn't get thick, red carpeting like the Catholic church in Chinle. He always felt bad clomping his thick-heeled boots across the bare floor, especially when he was pacing, so he hovered outside the entrance.

"How many more you got coming?" he called into the room.

"One more truck," Bradley said. "All the others went north to Nez Perce, Flathead, Cheyenne, Lakota territory."

There were Indian reservations everywhere, but most of them were open, because of the casinos, so Bradley had sent the other buses to independent nation reservations that could repel an army. Maybe they were too far away. Maybe none of the others made it. He just didn't know.

"Is our presence putting you in danger?" David asked.

"No, we're all safe here," Rodney said.

"Because this is sacred land?" David asked.

"No, because ever since the Mohawk wars of the 1990s, some nations are not only sovereign, but nontrespassable by any government forces under any circumstances. Of course, if someone orders an air strike, there's not much we can do."

The phone rang and Father Pete picked it up.

"That was Chester. Your last truck just passed through."

A crowd gathered and word quickly spread. All of them knew the dead. They had eaten together and shared living quarters for the past year.

Dino didn't want to think about her, but he could hear Ruth's voice braying triumphantly, "See? See? I told you not to take chances. I knew you were going to get caught. And now you've made it worse for everyone else."

Dino wondered how divorced couples avoided poisoning their children's minds against the other. He didn't know if he was up to it.

David was about to give them some good news when Kerri's jeep roared up the path followed by the RV with Vic at the wheel.

The crowd, still digesting the bad news, moved en masse to greet Kate and Mary and Dr. Sid as they jumped out of the mobile home.

"Look out!" Jenny sidestepped the big black blur skimming the edge of the crowd. It flew at David, and the two ended up on the ground in a wet, slobbering heap.

"Tuesday," David grimaced under the mop-like assault.

Suddenly there were two familiar faces looking down at him.

Greg reached down and lifted David to his feet. Not as forcefully as he used to but he still managed it. He kissed David and wrapped him up in a big bear hug.

Vic gave David a kiss on the mouth and hugged him fiercely. "I got the police report and went out to where you two were arrested. The van was still there. No wheels, seats or engine, and a family of five living in it. Oh, *mi hijo*!" Vic laughed. "Where's your hair?"

"Aw, man," Greg rubbed David's head like a genie's lamp. "Now you look like one of them youngsters."

"I can't believe it," David stepped back to make sure he really was seeing what he was seeing. "I thought you were dead for sure. Celeste said—"

"*Puh*," Greg puffed, brushing away the thought of her with a

flick of his hands. "She was gonna drop a dime on us, so we cut her loose in the desert."

"You didn't…"

"No," Vic said, "she probably had some kinda tracking device on her, or in her, so she's been picked up by now."

Then Navajo Uncle George from the fry bread days, whose real name was Sam, cleared his throat and said, "On behalf of the tribal council, I'd like to welcome you to our home. In honor of your arrival, we will have a ceremony and feast tonight."

David was amazed how much Sam sounded like his Dad or any other Nisei who wasn't used to public speaking.

David saw Jenny calling to him from the crowd. She was hugging someone.

"Katey!" David said, feeling pretty stupid for forgetting about his sister, and the little girl running at him and leaping into his arms.

"Hey, babe," David said.

"Hey, babe," Mary replied.

"How ya doin'?"

"How *you* doing?"

"All right."

"Mommy's sad. Her friends died."

David could see Dino and Jenny standing with Dr. Sid and Kate, giving them the bad news about the van in the desert. As David carried Mary toward her mother, he wondered why Jenny was handing Kate a tin of Famous Amos' Chocolate Chip Cookies.

Kate took the tin carefully from Jenny. She held it to her chest and cradled it in her arms.

Mary squirmed loose from David and ran into Kate's arms.

David saw Kate showing Mary the tin and Mary putting her hand to it tentatively. Kate hugged Mary and the tin tightly. Mary scooted out of Kate's arms and ran off, back to her friends.

Kate saw David approaching, held up the tin and sighed.

She had tried to keep her family together, the way Obachan

had kept her mom's family together in Rohwer during World War II, as son after son went off to fight in Europe, after Mom's oldest brother Tom died in France, as the older sisters got married and went to live in other camps with their husbands' families, then getting out and going to New Jersey, Detroit, Colorado.

Kate couldn't even keep her little family of four together for half a year.

When she'd found out Graham was dead, it hadn't surprised her. As implausible as her son dying in an anti-terrorist operation executed by an attack squad of elite U.S. forces was, she wasn't the least bit surprised.

She'd been preparing for this moment for years.

How different it was when she was young. For her kids, walking to school, sitting in class, walking through the hallways, staying too late after school, going to football games on Fridays nights, driving with his friends, hanging out with a group could all be dangerous.

She'd told herself she'd drive herself crazy if she worried about every little thing that could go wrong. But that hadn't stopped her from worrying every time he left the house.

Wonder if it'd be the last time she'd ever see him.

Then she'd seen how other boys seemed to look up to Graham. A subtle hesitation, waiting for his approval, for him to make the first move.

She'd seen how he was becoming a man, how he struggled and watched and noticed how respected men behaved and tried to do the same.

In the short time he had.

It occurred to her that she could stop worrying now, which made her start laughing.

Then she felt David's arms around her and thought she should stop.

She shrugged and tried to talk.

"My son…" her voice broke.

David cradled her protectively, murmuring, "Katey, it's okay," over and over.

Greg needed a nap so he headed for the shade under the big, lone, cottonwood tree at the bottom of the hill. He didn't see the other men already sitting in the shade, the older man who'd gotten out earlier and the young brother who'd come on the bus.

Carlos was listening intently to Mits so Greg silently found a soft spot and crashed.

As he lay there, Greg saw Bradley and Dr. Sid come out of the church and walk slowly in step toward the lone pine. Halfway up the hill, she took Bradley's arm.

"They know how to recognize what each person has to give to the tribe," Mits was saying to Carlos, moving his hands in a way Greg thought was distinctly Japanese.

Greg saw Dr. Sid and Bradley squat down in the shade at the top of the hill. He was doing all the talking and she sat there, nodding, watching him intently, her face following his up and down, leaning each way to maintain eye contact.

"Drum, fish, cook," Mits thought hard, "paint, garden, clothes, shoes, flute, roof, light, rug, pottery, basket, engine, machine, crystals, healing, spirit, medicine, song. Each different person should be encourage to do what they good at. That's what tribe, family, is for. Mo' better for tribe."

Greg could see Bradley put one hand to his face, then his shoulders shaking as he collapsed into Dr. Sid's arms.

"I'm not leaving," Mits smiled. "I'm gonna die here."

"I heard that," Carlos nodded.

Greg saw Bradley go limp and melt against Dr. Sid as she stroked his head.

"At sundown, if you'd like to join us," Greg looked at Mits and Carlos, "Rodney's gonna take us up to the Wheel."

57

At first Mary wanted to stay at the school and play with her new friends, but their moms called them in to help prepare the food for the ceremony and besides she wanted to ride in the back of Rodney's pickup truck with everyone up into the hills, to this medicine wheel they were talking about.

Ozzie wanted to come, too, but he'd already cornered one of the drummers into teaching him the ceremonial songs.

So did Mits, but he'd *enryo'd* and stayed behind.

The rocks turned red as they got higher and higher.

At first she thought it was the sun going down, but she looked down at the mud and it, too, was a deep dark-red, still muddy from the spring rains. Pink-and-white flowers bloomed in patches along the road.

She could tell Auntie Jenny and Uncle David and Auntie Vic and Uncle Greg had done this before. They were enjoying the scenery and smiling. Like Uncle David used to say, "they had a good buzz on," which she promised to never repeat.

Carlos looked worried. Mary didn't think Greg told him much about what they were doing. Bradley and Dr. Sid sat real close together. Bradley also looked worried.

Mommy looked happy and excited.

Mary sometimes joined her when she was meditating, although she thought Mommy wanted her to meditate just so she'd be quiet for a little while. But Mommy looked like she was going on a great adventure. Like a new ride at Disneyland.

Rodney drove on, even after he ran out of road, deeper and deeper into canyons and cliffs.

When he finally stopped, they all jumped out and followed him down a dirt path that dipped and turned between trees and big rocks. Good thing it was still light because he walked fast. It seemed like they were going downhill slowly. Then up. Then around. Until finally they came to a clearing on the edge of a cliff that looked out over the valley. They could see way down the mountain they had just driven up and way down below them she could see the church and the dorm.

In the clearing someone had formed a big circle with rocks the size of cantaloupes. In the middle of the circle were two straight lines of rocks crisscrossed. In the center of the cross was a smaller circle of rocks.

They all gathered wood for a fire and then Rodney opened a big leather pouch stitched with pretty bead designs and took out a flat, wide drum that looked like a big tambourine covered only on one side. He also had a drumstick that looked like a tennis ball wrapped in leather tied to the end of a big stir-fry spoon.

He scooped up a pinch of dirt and held it above his head, then tossed a little to the left, right and over his shoulder, then in front of him as he stepped into the circle, very carefully. Mommy said it was like an offering when you enter a church.

They all followed him as he stepped clockwise around the inner circle over the rocks and sat down cross-legged, which looked real uncomfortable for Uncle David and Uncle Greg with their football knees.

They all put the wood in the center. Rodney didn't need to use half a can of lighter fluid to light it like Daddy used to on the barbecue, just some dry twigs and a Bic lighter.

Then he started beating the drum and if he was singing a song, Mary thought, it sure was a weird song.

It reminded her of the time when she was really small and the whole family, all her aunts and uncles and cousins, went to Imperial Gardens in Hollywood for Great Jiichan's 98TH birthday party and after they sang Happy Birthday and he, with her and her cousins help, blew out all the candles and people were going, "Speech, speech," he got up and sang one of his Japanese songs. They were seated in the middle section where you sat on the floor and everyone in the restaurant, even on the second floor, got real quiet and listened to him. So he did one more.

Rodney was wailing and pounding with his eyes closed, and she couldn't understand the words.

One time, when they went on vacation to Hawaii, Mommy dragged Daddy and them to a small island to see a *kahuna* that one of her friends told her about.

The way Rodney looked, pounding and wailing and the light from the fire reflecting off his face, reminded Mary of the *kahuna*.

And Great Jiichan.

Then they all stood and Rodney lit a wrapped-up bundle of sticks that looked like a little tiki torch. He went around to each of them and used a feather to brush the smoke up and down their bodies, saying, "*mee-tah-kee-oss*," over and over again in a low whisper.

"Smoke is the way we cleanse our spirit and the way we send messages to the spirits," Rodney said. "*Mitakuye oyasin*."

Then he opened the other leather pouch he was carrying and took out a big pipe almost two feet long with a beautiful, carved, redwood stem and a bowl carved out of marble in the shape of a white buffalo. He took out a little pouch and began stuffing the buffalo.

He explained that when he brought the pipe around to each person, they were to take three puffs and with each one say, "*mee-tah-kee-oss*" like he was saying. It meant "to all our relations," that

there were four nations on earth, red, yellow, black and white, and everyone was related.

Mary wondered if her Mommy would let her take a puff.

Rodney handed the pipe to each person and lit it with his Bic lighter as they said, "*Ah-HO, mitakuye oyasin,*" and he said, "*Ah-HO!*" in reply.

But when Rodney offered the pipe to her, Mary hid behind her Mommy and shook her head.

"That's okay, too young," Rodney said, then handed the pipe to Mommy and said, "*Ah-HO!*"

Mary stared up at Mommy as she put the pipe in her mouth. She held the pipe with one hand while Rodney lit the buffalo and held tight to the tin of Graham's ashes with the other. Her face was calm, but tears were streaming down her face. She repeated the phrase that Rodney said and blew out a long stream of smoke high into the air as he said, "*Ah-HO!*" She took another deep puff as he mumbled the phrase over and over again the way Reverend George blessed each step of a ceremony by saying "*namu ami dabutsu*" at the Buddhist Temple.

By the time the last person got to smoke the pipe, Mary was very tired. They all sat down and she put her head in her Mommy's lap.

Then a fierce wind came up and put the fire out. The smoke rose straight out of the dead fire like a chimney.

Rodney said make your most powerful requests, and the smoke would carry that request up to the spirits.

Then he started singing again and everybody began to take deep, long breaths, and the beat of his drum seemed to remind her it was her nap time.

As Mary's eyelids fluttered shut, she remembered seeing the big formation of red rocks on the cliffs above her. They had a face that looked like Daddy. And the little one next to him looked like Gray.

Carlos didn't know what they were smoking. It wasn't very harsh. It smelled like alfalfa. It definitely wasn't a hallucinogen. Not a major one.

It wasn't the altitude. They weren't that high up and someone in his condition should not have been affected by a slight elevation in altitude.

Never having meditated, he couldn't say for sure whether the near-hyperventilative breathing technique was causing this lightheadedness or if it was something else.

He didn't inhale deeply like smoking weed so the potency of the substance shouldn't have affected him this much.

But this was good.

Maybe it was the drum.

But as he stared up at the smoke rising up into blue sky and joining the white clouds, at the pink cliffs and red rock hovering over them, at the trees and the wind and the tiny purple flowers in front of him, he was surprised to discover that the world was not gray.

Dr. Sid had never put much credence in shamanistic activities of any type, having written several papers debunking them and their attraction to the psychologically dependent. Neither did she think they were as dangerous to children as the fundamentalist fanatics did. But then those intolerant extremists seemed intent on making the government their partner in enforcing their narrow-minded view of faith, which she found more indicative of their own sexual insecurity, in her opinion.

Certainly it was pleasant, being in this beautiful environment, participating in a ceremony fairly unknown in an accurate manner by most Americans, but she was not about to be carried away by all this mumbo-jumbo.

A brisk wind came up. She should've brought a jacket. She tried to get a little shelter from Bradley.

She thought it was hay they were smoking. It wasn't harsh at

all. She hoped it wouldn't trigger her craving for cigarettes and ruin three good, hard years of quitting and resisting and regaining her sense of taste.

That wind. Now it was blowing smoke in her face. She shifted again and felt her knee brush against Bradley's.

Which reminded her to stay with Bradley as much as she could. He would need her for a while.

She attributed this to her natural, female, helping and caring instincts as a caregiver and doctor. She was still, after all, a professional.

But, she wondered, what was real and what was voodoo? Or was voodoo really real? And if there really was voodoo, then what was hoodoo?

And it didn't explain why that mountain was smiling at her. And why, the longer she stared at it, the more it looked like her brother Milt.

Greg could hear Coltrane's tenor floating on the wind.

Greg is sitting on the side of a bandstand in a dark nightclub thick with smoke and the tinkle of ice in a glass and scattered applause as the Man ends one tune and turns to his band.

Coltrane doesn't say anything, but everybody knows this is the new piece.

A piece so unique and different it would change the course of history. Or music. Or at least, jazz.

Elvin Jones strokes the chimes and starts brushing the cymbal and high-hat.

McCoy Tyner adjusts his seat at the piano and drains a glass.

The Man wets the reed on his mouthpiece and blows.

"A Love Supreme."

Long intro. Long intro, then McCoy finally joins in.

Then just as he's about to kick in, Jimmy Garrison gets up from his chair, lifts the neck of his bass off his shoulder and holds

it up to Greg and says, "Take it, man. It's yours."

Greg wished this was a different world. He used to wish for the revolution that would not be televised. But now he just wanted the whole damn thing to start all over. Things were too far gone to be saved.

Then he looked closely at the face of a cliff. There were ridges sticking out and from this angle, they looked like a row of faces. The first one looked real familiar.

"Gramma?" Greg said wondrously.

He stared at the first formation, expecting it to move. But it didn't.

It just looked like his grandmother with her eyes closed, like the last time he saw her. In her casket.

But she was sitting up now. And looking at it again, he saw her eyes were open.

Then he saw the face behind her, just behind her right shoulder, the one that looked just like Gramma only the face was rounder, with a flatter nose.

And the one behind it, that could be Gramma's gramma.

And Uncle Irv, Aunt Gloria, Mom, Dad, his brother Jerome.

All down the line, until they disappeared into the next range of hills.

Long line. Long line.

Vic thought, this was an odd high. She was expecting something like shrooms, only more religious. Something more ceremonial. Maybe that came later.

But this was good.

Something was picking her up and lifting her up, way up into the air until she could see the tops of the mountains surrounding this gorge, then letting go and she'd float to the ground like she had wings.

She was eye to eye with a hawk.

Then when she was just about to hit the ground, she'd keep on going, melding with the ground, becoming part of the red rock. Her

feet and legs would sink into the earth, but she didn't feel like she was being swallowed up.

She felt like she was becoming part of the rock, like her toes became roots that sank quick and deep down into the earth, sinking deeper and deeper until she was looking up at the wheel from below, like she'd been many a time, waking up passed out, looking face up through a glass coffee table. This time looking up through the ground, seeing the others seated around the medicine wheel, up into the sky.

She could smell the smoke. It smelled like Christmas day, roasting chilies until the skin was black and could be peeled off. It smelled like *masa* being spread inside a corn husk and stuffed with beef and sauce to make tamales. It smelled like her mom and aunties pinching off wads of *masa* to flatten on their palms and slap on a grill to make corn tortillas.

Tamales steaming, turkey roasting, corn grilling.

It smelled like home.

Mary slept with her head on her mother's lap and dreamed of bowling balls.

Grandpa Dan, her jiichan on Mommy's side, used to bowl all the time. In the Nisei Bowling League, the Nisei Gardeners' League, the 442ND League. Mommy and Uncle David and Uncle Johnny spent a lot of time in bowling alleys when they were small. No video or Nintendo back then. They only had pinball machines and other game machines that cost a nickel or a dime and weren't much fun.

Grandpa Dan's best friend, Mr. Kajimoto, owned a bowling ball-and-trophy shop in Gardena, so Grandpa Dan was always trying a different ball or a different grip every time his average dipped.

When Grandpa Dan retired from the post office, he said he was too old to bowl and started playing golf. But he still had all these bowling balls.

So he put them out in his garden in the backyard. Scattered them around the edges, placed them in empty spots, with their finger holes

looking into the air like eyes. And grew his green onion, *nasu*, cucumbers, zucchini, daikon, tomatoes and string beans all around them.

It was kinda like a Japanese rock garden.

Only this was a Nisei bowling ball garden.

Mary dreamed she was lying on the grass near Grandpa Dan's garden.

Next to Graham.

They were looking up into the clear deep-blue sky to see if they could see what all the bowling ball faces were looking at.

Bradley was singing.

He was too young to catch Pat Suzuki in *Flower Drum Song* or Mako in *Pacific Overtures* on Broadway, but he had done *Flower* in Seattle and *P.O.* at East West in L.A. He'd met guys who'd done Broadway. Some snotty, some prima donnas, some really talented, others just lucky, but every program of every show they'd ever do from then on would say they had been on Broadway.

He should've been a rock musician. Stayed with the garage band stuff. Then he wouldn't have been spent hour after grueling hour in class after grueling class, studying acting and dance and movement and voice, going out on audition after disappointing audition, spilling his guts in front of a table full of casting machines that were only looking for the right type, the right face, the right look. Finally getting a role, a paying gig, doing a lineless week as a kung fu killer or an evil businessman or the doof who's the punch line in a gag. Scream and kick, smile and bow. Laugh evilly.

Just waiting for his shot.

Bradley is singing.

On a Broadway stage.

To an SRO full house that gives him a standing ovation that lasts so long it interrupts the flow of the show.

But that's okay. This is what actors live for.

He soaked in the applause.

He was going to enjoy this.

It had been a long time since Jenny had meditated in front of others. Since the crackdown on alternative, non-government-approved religious practices, it was unsafe to brandish crystals and fetishes and other illegal trinkets publicly, and with all the police spies and DEA plants infiltrating any suspected meditation groups, it became counterproductive to screen everyone who may have been sincerely seeking a different form of prayer.

But she held the clear crystal quartz her dear friend Julia had given her when she first started meditating. And she wore the beaded necklace with the purple amethyst that her dear friend Zane, Julia's husband, had made for her.

She prayed for their safety and now, in the company of people she trusted, it was safe for her to pray in her unorthodox, illegal way again.

She'd left her home in Orange County and became a part of David's world in Venice because she'd wanted to. She'd been made to feel welcome and, by the time of ReVac, more than half her life had been with David and it wasn't his world anymore.

It was their world. Again.

Jenny rarely tried to see the future. But this time, she wanted to know. What to do next, what lay ahead for them, what they could do to make things better.

She got no answers.

She saw angels hovering above the wheel.

She saw a hawk flying among the faces in the mountain.

She heard and felt and was enveloped in the one, simple truth that carried her from Orange County to Venice, from L.A. all the way across the country to Atlanta and back to Manzanar to this safe place: Love will conquer all.

She would never stop believing that.

David saw animals locked in futile embrace. Frozen in death inflicted upon each other.

A rat gnawing its way out of the belly of the snake that had swallowed it.

A frog secreting poisons to kill the babies of the owl that was shredding it to pieces as it carried it back to the nest.

A mongoose and a coyote, jaws locked around the other's throat, neither of them relenting as they crushed the life out of each other.

A mouse, snatched up by a hawk, about to be sliced and diced by the powerful talons, squealing, "Can't we all get along?"

The trees were coming to life. The cottonwoods and tamerisk, nonindigenous to the area, planted for erosion control in the 1930s, now threatening to monopolize large amounts of precious water in this desert. Intruders draining the life force of the land.

As they would if they stayed on this reservation that barely kept the Dineh alive.

Johnny was sitting in front of him. In the fire.

He said, "Do you know how much I suffered when they killed me?" David said to him, "I didn't kill your murderer when I had the chance."

"Oh yeah," Johnny said sarcastically, "that would've solved everything."

"I regret it now. I should've avenged your death."

Johnny said, "You know, when God said, 'Thou shalt not kill,' He really meant, 'Don't kill.' Not, 'It's okay to kill when you're really pissed off' or when you think no one's looking, or when you confront your brother's killer. What He was really saying was, 'Do NOT kill. I mean it.'"

"I've killed," David said, clinging to the red animal-cracker tin full of Christine's ashes.

"In answer to my own question, I suffered very little when they killed me," Johnny said, "in comparison to how much my killers will suffer. I was ready to go a long time ago. Maybe that's a real L.A. attitude," he shrugged, "but what are you gonna do? Never go

out? Stop living?"

"You aren't going to give me any answers, are you?"

"Me?" Johnny said. "You're the big brother."

"But you're the dead one."

"So? Is that supposed to give me some special insight into earthly dilemmas?"

"Why not?"

"Why should it?"

"Because you're dead!"

"Hey, it looks the same from this side."

"Oh, great."

"No, no, that's good."

"I'm not getting any help from beyond? That's good?"

"No, that means that you already have all you need to solve all your problems right there."

"I do?"

"Yes. It's within you."

"Okay."

"Tell you one thing," Johnny was starting to elevate above the fire in the center of the wheel. "It's real nice here. Mom and Dad are here. The whole family. Mago's is open twenty-four hours a day. Kenny's is open up here, and Ketchie's, too."

Johnny crossed his legs and hovered above the fire.

"It's weird. It's like the carnival when the community center was all dirt. People just dropping by. And it's not just relatives or people from the community. It's like everyone I've ever met in my entire life. All the kids in all my classes, parents, fellow teachers, everybody. Like there was a reason our paths crossed at one tiny little point for one brief moment in our lives and that's enough to make an impact on you, whether you realize it at the time or not. And you know what?" Johnny floated down next to David and whispered in his ear: "There's no such thing as coincidence. Everything happens for a reason."

He stopped.

"I saw them. My killers. All of a sudden, there they all were,

right in front of me. I was like," he squinted up like an old school-teacher, " 'Well, young men, you have plenty of explaining to do,' then they all start making excuses. 'It wunt mah fault...It wuz his idea...I wuz drunk...I been outa a job all my life.' Like they thought I, of all people, would go, 'Ohhhh, poor baby, no wonder you had to kill me. You just couldn't help yourself.' So I'm trying to formulate something in my mind, something beyond 'Be a *mensch*, dammit. Stand up and be a man for once in your life and act like a human being,' but they kept on giving me their lame-o excuses and I just said, 'I give up,' and then"—he whistled—"They were gone. Just like that."

Johnny's smile disappeared from his face.

"You know what's weird? Cindy isn't here. Or Nikki. Of all the people, you'd think that your own ex-wife and daughter would be here..."

"I don't think you should worry about it," David said. "It doesn't sound very logical, the way it's set up."

Johnny pointed down at David's left hand.

It was resting comfortably in Jenny's. He hadn't realized.

"Some things do survive. This I do know something about," Johnny started slowly floating up with the smoke. "How to save your ass down there, I don' got a clue, mon."

"That's okay," David said. "I'm just glad there's something else besides this—"

Johnny was gone.

Most of the others were standing up and stretching. The fire had long gone out. Jenny was sitting next to him, watching him, waiting patiently, as usual.

Rodney was standing out beyond the circle out on a ledge with Dr. Sid. He handed her a handful of dry leaves and dirt and she tossed it over the ridge. When Bradley helped her back, David could see she'd been crying.

Kate stood next to Rodney on the ledge, one hand holding Mary's, the other cradling the Famous Amos tin. Her shoulders heaved and shook, and they could see her tears fall from her face. She knelt next

to Mary, who waved goodbye as Rodney, the toes of his Adidas strad-dling the tip of the rock jutting out over the canyon, shouted into the wind then tipped the canister over.

Graham's ashes seemed to move in a cloud straight out from the cliff then dip down into the canyon, flitting above the tips of the trees grown up from the bottom of the valley below. They disappeared into the highest branches of the trees as a hawk flew up into the sun.

Rodney turned and helped Kate and Mary off the ledge, then held out his hand to David.

David didn't know if it was a stereotype that Indians weren't afraid of heights, but his Dineh friend Rodney was standing out on the very edge of a cliff that David would only go near if he were tied to a tree with a rope and a parachute.

David crept halfway out onto the rock and handed him the animal cracker tin. If the wind swept David over the edge, he'd take Jenny and a nearby tree with him.

Rodney's wailing voice carried down into the valley as he held the tin above his head.

David remembered the vibrant young woman dancing by herself to War's "All Day Music" at the Movement picnic at a park in Long Beach.

He remembered the diseased shell of a woman in the bed for the dying and asked her forgiveness once more.

He remembered her sitting on a lawn between classes on campus, Gil Scott-Heron singing "Must Be Something" behind her, never giv-ing up the fight.

"No more eulogies," he said quietly, then nodded to Rodney. "Let her go."

Rodney tipped the tin and Christine's ashes flew away from them, into the earth, into the trees, into the sky.

58

When Kerri went in to check on Father Pete, she could hear the TV from the back room.

"…in a story related to the success of ReVac, the woman whose Japanese husband kidnapped her two children, apparently overcome with grief, committed suicide, during an interview, and we caught it live on tape…"

He turned the sound down when he heard her footsteps echo in the hall.

"Father Pete," she watched the chaos onscreen, "anyone else get here?"

"No, no one else," he turned the screen away from her.

"You hungry? Pow-wow's starting."

"Go ahead. I'll just be a minute."

When he heard Kerri's boots hit the dirt, he turned the sound back up.

"…once again, be forewarned, this video is graphic and violent…"

Ruth stared at the TV.

It was her.

She was watching herself on TV.

Crying, like she had been before. Only this time she lurched at the camera, knocking it over. She could hear the thud of the microphones colliding with bodies. People shouting. The camera being uprighted .

She saw herself shrieking hysterically.

Someone shouting, "She's got a gun!"

She saw herself backing up. Jamming the barrel into her mouth. Both hands wrapped around the revolver.

A dull explosion, a flash of light illuminating her face like a lamp.

The back of her head splattering onto the wall in back of her.

Her body collapsing limply to the floor as she heard Lillian cry off-camera, "Oh my God!"

Ruth stared at the TV screen.

The reporter we all trust was standing outside the communications center, wrapping up this awful but unavoidable tragedy and sending it back to the studio.

"Isn't it amazing what these young people attending film school can do," said Lillian, who sat calmly next to her. "And they never ask questions."

"What?" Ruth said.

"Congratulations, Ruth, our mission here has been accomplished. I've been promoted. It really was quite unexpected. I was just trying to do my small part in supporting the President. Fortunately, efficiency is appreciated and rewarded."

Lillian rewound the videotape.

For those who wanted it, this Temporary Relocation Center was indisputably a happy camp. With happy campers working diligently to move forward with their new Japanese lives. In their family quarters, at their government-sponsored schools, at their temporary scholarship-type jobs, with food, shelter and entertainment provided by generous American taxpayers, with the tiniest provision that the residents not leave until they had attained skills

for this new Japanese phase of their lives.

Lillian could guarantee her successor that everyone left in camp was enthusiastic and content.

There was no mistreatment. There was no hardship.

Concentration camp? Ha!

This Temporary Relocation Center was a well-oiled machine that could easily be converted from Japanese to Afghani or Arabic or whatever Homeland Security dictated.

And if there were any missing residents, she knew of no record of them ever even having been in this Temporary Relocation Center.

That's how it read in the computer.

Computer is truth. Truth computer. Amen.

Simpler than verifying and providing documentation for the obvious results of an election.

"What does this mean?" Ruth asked.

"Well, basically, it means I don't need you anymore," Lillian said. "But thank you for your fine work. Although there is one more minor detail I need you to take care of."

Lillian winced at the awkwardness of the request.

"For the autopsy. Here. Put this in your mouth."

"What?"

"I need a body. It's so much more effective visually to make that lasting impact. Open your mouth."

Ruth wanted to object, but no words came out.

"A permanent image of the damage inflicted by Japanese men. Say *Ah.*"

Ruth obediently opened her mouth.

Lillian smiled, pleased.

She put the muzzle up to Ruth's mouth and slid it in.

Instead of resisting, Ruth wrapped her lips softly around the barrel.

Lillian was almost moved to tears by this gesture of acceptance.

Now why couldn't they all be good Japanese like her?

As Father Pete turned off the lights in the back room of the church and slowly walked out, he wondered how secure contemporary white man's treaties were.

By law, Indian nations were places of sanctuary, but it was still white man's law.

Just another piece of paper.

He tried to take comfort in the fact that now most Indian nations were not only sovereign and self-sufficient but stocked with enough arms to repel any small invasion force.

More importantly, their lawyers were better than the government's.

59

They hopped out of Rodney's pickup and followed him over the hill, past the lone pine and into the small valley, hidden from the roads. A big bonfire crackled, the valley's natural funnel blew the smoke and sound away from the church and school and dissipated any signs of a gathering except to the most practiced eye.

As they got closer, the sound of hundreds of bells on ankles and wrists grew louder. They saw people preparing tables of food, jingling as they walked, dressed for a celebration.

Sam greeted the visitors and introduced them to an old, old man with shoulder-length shocking-white hair.

"Stanley Greyhawk...these are my cousins."

David's paternal grandmother had lived to be 101, his maternal grandparents well into their nineties. The lines in this old man's face were deep, his skin weathered, his eyes perhaps not as sharp or alert as they used to be, but they were wise and solid and peaceful, and David knew he was looking at the leader of the tribe.

"Please," Stanley Greyhawk motioned to the tables beside him, "join us."

Jenny knew this was a great honor. The others were getting a kick out of seeing Mits sitting at the big drum, pounding away with one of Jim's custom designed *taiko* drumsticks, Ozzie joining in.

The people of the tribe, young and old, men and women, some dressed in their finest ceremonial robes, some in T-shirts and jeans, danced around the fire, shuffling, stomping, stepping to the incessant beat of the drums, bells jingling like waves breaking on shore.

Food was passed. Spit-roasted chicken, baked beans, corn, fry bread, tortillas. They ate mightily and gratefully.

Large wooden flutes that resembled *shakuhachis* appeared, Sam on one of them. Roberta and all the women did a dance together, moving counterclockwise around the fire.

Then Kerri walked out. She was dressed in a kimono. A full-length, dark-indigo silk kimono with a floral pattern of large, white orchids and a crimson red *obi* wrapped around her waist. Her long, straight, black hair was pulled back into a loose bun.

When David saw her, he thought he was back at the Venice carnival.

Summer sunset, smoke from barbecuing chicken on the fire, children dressed up dancing in a circle to the drums, warm summer nights, T-shirts, cut-offs and zories.

And in Venice, there were always happa kids. Little blue-eyed kids with black hair. Dark-brown-skinned almond-eyed kids with dreadlocks. Blond-haired, brown-eyed kids with high cheekbones. Beautiful, beautiful children, dressed in kimonos, dancing in the *ondo*, at sunset, at the carnival, in the *obon* festival.

Kerri scooted before the first table and bowed to Stanley Greyhawk.

"These are *ondo* dances that my great-grandparents brought over from Japan over a hundred years ago at the turn of the nineteenth to the twentieth century," she announced. "Folk dances originating in the peasant culture to celebrate successful farming and mining. These dances are no longer performed in modern Japan and have only been carried on by the Japanese American community in the United States. I offer these dances and this *obon* festival, these three days that the dead come back to visit and are set free, to demonstrate how our cousins can contribute to the

longevity and spirit of our tribe."

Kerri took her place in line with the others.

The drums began. More syncopated this time, a heavy down-beat on one and three. Then Mits and the others added a click off the rims on two and four.

Then Sam led the flute players in a tune that sounded familiar to David.

It sounded like childhood, summer nights and snow cones.

They danced around the fire: step forward with a shoveling motion right and left, step forward with a backward motion over each shoulder, look right, look left, both hands pushing the cart right then left, smooth hands, clap three times.

The movements were familiar. Like something David had seen all his life: *ondo* at the carnival.

"Come on!" Kate shouted and she and Mary and Dr. Sid got up and joined the line, and since it had been several decades since the Sansei women had done this, they followed the lead of Kerri and the Dineh women.

It came back to them quickly and on their next pass, they grabbed Greg and Vic and Ozzie and Carlos and Rodney and pulled them into the line, followed by Dino and his girls and the rest of the guests.

The tables were empty by then, except for David and Jenny and Stanley Greyhawk, who was smiling and enjoying his people's new dance, his hand resting on Tuesday's dozing snout on his knee.

"Ever since Dineh started travelling south, we have always been joined by other tribes," he said to them, eyes still on the dance. "Utes, Pueblo, anyone whose numbers were decimated by drought or war. We live alongside the Anasazi at Hopi and Zuni, the Rio Grande Pueblo, Spanish and Mexican. Our tribe has grown and been replenished by people joining us. Our brother Jim grows gardens, using techniques for growing on dry, rocky land that his father brought from Japan. We can learn from each

other and get stronger, if you wish."

Stanley stopped when the music ended, and they applauded the dancers as they mopped their brows.

Dineh drums started up again, more animated, and the dance continued, more complicated this time, as the younger men in full regalia danced aggressively on the perimeter of the larger group moving closest to the fire.

David didn't see too many young men. As in the rest of the country, many of the young men had gone to war or died violently in this country.

As the bonfire's shimmering, flickering light grew and shone on the dancing faces, he thought he caught quick glimpses of old, familiar faces dancing next to the new faces.

Some faces long gone from this earth and some he hadn't seen in a long time.

He thought he saw Grandma and Grandpa, Obachan and Jiichan, aunts and uncles, cousins he'd grown up with, folks from the neighborhood, swirling around the fire.

Coach Rose and Iha, his karate *Sensei*. Officer Chuck Khountavong. Pudge and Dora Clark.

Lisa humming *Summer Breeze* from the summer of '72.

Celeste.

Were they all dead now?

No, there was the spirit of Stanley Greyhawk, his white hair standing out like a beacon among them, and he was still sitting at the table between Jenny and the Tooz.

Old and new faces, dead and alive, colliding into a big carousel of shining bursts of recognition.

Dr. Milt with his arm around his sister, Dr. Sid.

Greg standing with Joey Rodriguez, the Bee football teammate at Venice High, and Vic, with her brother again.

Annie the benjo scrubber and the Taniyamas, Fred and Donna and their daughter Amber.

Kenny and Kay, from Kenny's Cafe, and their kids.

He saw Kay hand something to Mary and point to David. Mary broke away from the circle and ran over to David and handed him a folded sheet of green paper. The front read:

Kenny's Cafe
JAPANESE AMERICAN COFFEE SHOP

The menu from Kenny's Cafe. He didn't need to look inside. He knew it by heart.

David looked up and caught a glimpse of Kay holding her tablet, pencil poised in her left hand, ready to take his order, before the swirl of dancers swept her away.

He saw Kenny's assistant, Mrs. Nakamura, with her white bandana, in her white apron, standing with her husband Mas and their two beautiful daughters—Tina, who was taken from them in 1996 and her younger sister Terrie, who bravely went on TV to frantically plead for her sister's safe return as they waited helplessly for that one, awful week before Tina's body was found.

They were all together again.

He saw Christine, young and vibrant and alive, as she wanted to be remembered.

Rodney Knifewing dancing and holding the daughter he lost to the plague, his face to the sky, weeping.

He saw Kate and Mary, surrounded in light with Ray and Graham.

He saw Johnny, stomping in the circle, smiling at him, and David said quietly to him, "You will not be forgotten."

Johnny nodded and said, "I know."

Then a cinder popped and with a flash, he was gone again in the pounding, pulsating cloud of smoke and dust around the flickering fire, gone with the tinkling of a thousand bells.

When the smoke cleared, they were all gone.

The throbbing pulse of the Navajo drum, the entire tribe and its newcomers stomped a circle around the fire in a dance of celebration.

"Don't be so *hazukashii*!" Kate scolded. "Come on!"

"If you decide to stay," Stanley said quietly, "you must realize that you will change and we will change. Dineh strength is that we adapt and survive, as you have."

Stanley smiled at them.

"You may not be part of this country, but you are part of this land."

When David and Jenny joined the others in the dance, they were immediately enveloped by whoops of approval and a cloud of dust from the stomping, smiling tribe.

Occasionally a familiar face appeared, lit momentarily by an unblocked glare from the fire.

Vic's face smiling up dreamily at the night sky.

Father Pete watching and laughing from the side.

A glint off Greg's glistening shaved head.

Bradley, who seemed sadder since they left Manzanar, as though there were no challenges left for him.

Dr. Sid with a look of surprise and joy on her face.

Carlos wearing a necklace of white shells that shone off his dark, shirtless torso.

Ozzie red-faced and puffing along happily.

Dino screaming happily, throwing his arms in the air, signaling "Touchdown!"

Kate and Roberta with their daughters between them.

Mary with her new friends, having a great time.

Within it all, among the beaded leather and bells, silver-and-turquoise and feathers, was Kerri, floating by angelically.

David watched the determined one-quarter Japanese, one-quarter Dineh, half-Caucasian, all-American, militant *happa* woman, with her long, straight, black hair and almond-shaped ocean-blue eyes, in her kimono.

He felt like he was watching the future of this country, the hope for this planet.

Fry bread wouldn't replace short-grain white rice and Navajo

drums wouldn't move his internal organs the way *taiko* drums did, but for the first time in his life, David could believe that his people's presence in this country wasn't a gigantic mistake.

It felt like the end of the carnival late Sunday night at the community center, when all the moms washed up the cooking pans in the community center kitchen and all the dads loaded up folding tables and chairs and ice chests and Coleman stoves onto their gardening pickup trucks and vans.

Dino was helping load a flatbed. There was always a guy like Dino who was always pitching in, just 'cause he was raised that way.

David and Jenny helped Rodney tend to the dying embers. He kicked dirt on them, stomped the stubborn ones out.

"Good day today, huh?" Rodney said.

"Yes," David said quietly.

"You know when your tribe came over the bridge to here? Long time ago?"

"You mean, across the Bering land bridge to Alaska down to here, thousands of years ago?"

"Yeah," Rodney said. "Well, we were already here."

"You were waiting for us?"

"Yeah," Rodney nodded. "Just like now. Don't mean we don't want you here."

A few trucks over, David thought he saw someone he knew. The wide, muscular back, trying to lift a table onto the back of a pickup truck by himself.

"Dad?" David called.

The hair was the same. A brushy salt-and-pepper parted on the left and trimmed clear of the ears. The back of the neck was tanned a deep brown, the arms thick and strong.

Dad strained against the weight of the heavy six-foot serving table, the kind that churches used forever. He lost his grip on the

table, caught one end and struggled to lift it high enough to grab the bottom.

David ran up and braced the table against his shoulder, and the two of them shoved the table up onto the truck.

David saw it wasn't his Dad.

He was Navajo but could've easily been an uncle.

"Thank you, brother," Uncle said.

David nodded without saying anything as Uncle got in his pickup, an old yellow Chevy like one of his Dad's old trucks that used to be stuffed to overflowing with gardening equipment, and drove off.

David suddenly missed L.A. Especially on warm nights like this, when he could stand out in the backyard at night and catch an ocean breeze, smell the jasmine blooming. When he could smell summer just around the corner. Warm, optimistic summer nights.

For the first time in a year, for the first time since he left the barbed wire behind, he could smell summer.

"When you go back to L.A.," Kerri strode by, her hair down, her kimono untied and open, revealing a Utah State T-shirt and bicycle shorts underneath. "I want to go with you."

"L.A. isn't L.A. anymore," he said.

"I know." Kerri smiled. "But I want to be there when it rises from the ashes."

Jenny joined David and Rodney as they strolled down the road toward the church.

"I talked to my brother today," David said. "Up at the wheel." Jenny slipped her hand into David's.

"We had a nice talk."

"Is he at peace?" Rodney asked, looking out at his moonlit valley.

"Yes," David said. "More so than me."

Rodney started toward the church, "Be right back."

A few lights glowed in the school dorm windows. People were still lingering outside the old building, saying their long goodnights.

Mary walked toward them, turned and called, "Tooz!"

They heard a grunt, then saw a black shadow shake itself up off the ground and jog toward them slowly. Jenny grabbed the sleepy dog.

Mary slipped her hand in David's.

"Hey, babe," she chirped.

"Hey, peanut." He picked her up.

"You know that girl you were looking for?"

"I heard."

"You would've been disappointed."

"You're my girl, sugar."

"Better believe it." She looked at the gathering below. "Are we going home soon?"

"Might be a while."

"That's okay. I like it here."

A whistle from down the hill. Tuesday bounded toward the crowd like a runaway train. Mary leapt out of David's arms and took off after her.

Vic heard the stampede coming and, going to one knee like Mike Scoscia blocking the plate, caught the Tooz and scratched her into submission as Mary ran into Kate's arms.

David looked at his people gathered by the school dorm.

Kate and Mary together and safe.

Bradley showing Kerri how to properly fold her kimono.

Kate and Dr. Sid shouting and pointing and laughing when Bradley had to start over.

Ozzie and Carlos and Vic and Mits and Roberta watching happily.

Greg lifting Mary onto his good shoulder.

Dino, once he'd put his girls to bed, demonstrating the finer points of holding a fan, looking like Dick Butkus attempting to hold a saucer and teacup daintily.

Jim standing with Rose, his arm around her waist.

All of them smiling and laughing, their heads thrown back, laughing unashamedly.

Rodney came out the back door of the church.

"I've been painting so much lately, I haven't done much silverwork, but I still had these." Rodney held out to each of them matching silver feathers emerging from blue lapis beads dangling from black leather cords.

On this journey, David had lost the silver feather he'd gotten from Rodney years ago.

He'd lost everything on the way to this place.

Kerri saw Greg put his hand softly over the center of his chest where his keloid, or his heart, would be and nod at David, who unconsciously did the same.

David slung the cord around his neck and, hand resting on the feather that brushed the keloids that formed the *kanji* symbol for third generation on his chest, smiled at Kerri, connected by their primal markings, as her voice and Ozzie's guitar came drifting up the hill.

David looked at his people and thought, I don't see a grayhaired white man who teaches music strumming on a borrowed guitar. I see Ozzie.

I don't see a female Sansei doctor watching him affectionately. I see Dr. Sid.

I don't see an old Nisei and his Dineh wife. I see Jim and Rose Kuroyama Black Hill.

I don't see a young African-American soldier, smiling and peaceful. I see Carlos.

I don't see an Asian guy from Fresno who seems like every Buddhahead I've ever known. I see Dino.

I don't see the warm Dineh woman holding her sleeping youngest child, the wife of their gifted friend, who had welcomed all of them into her home. I see Roberta.

I don't see one of the last Nisei men who could be one of my uncles. I see Mits.

I don't see a beautiful Chicana lesbian woman. I see my good friend Vic.

I don't see a big, gentle black man with a shaved head. I see

my dear friend Greg.

I don't see a gay Sansei man sitting pensively to the side, the man with whom I spent the most time at Manzanar and who had the most to do with our escape yet still seemed so dissatisfied. I see Bradley.

I don't see a beautiful *happa* girl singing what sounded like an old, obscure Nanci Griffith song. I see Kerri.

I don't see what ought to be typically American but rarely is.

I see family.

Family that just happens to you.

And, he thought, I don't see a white woman, a chubby, graying hakujin woman I've known since she was blonde-blonde and thin as a rail. I see Jenny.

And he knew that it was right that this woman, whom he was lucky enough to find again and again, was as much a part of his family, his people, his tribe as he was.

David drew Jenny close to him and held her.

"I love you," he said softly.

Jenny turned to him, that blindingly radiant smile bursting from her face, and said, "I love you, too."

Jenny knew things were almost back to normal when David reached down, a lot lower than he used to have to, and gave her left buttock a familiar, affectionate squeeze with a Harpo Marx honk.

She laughed and rested in the arms that were made for her.

He looked around at this strange new land, barren and alive, clouds dancing in the moonlit sky over red mountains that seemed to breathe, as foreign to him as anywhere in his own country, the United States of America.

They were still in the middle of the desert in continental North America but it felt like a different country. It felt like a different planet from where they had been.

Manzanar.

Manzanar was the way people were treated in the U.S on planet Earth when the ones in power betrayed the Constitution,

convicting the loyal of guilt-by-race and leaving them with hope-lessness and despair.

Yet he had found refuge in a land of exile and discard that had been reclaimed by its original inhabitants.

Here, on Dineh land, he wasn't home yet.

But he wasn't lost anymore.

This was land where his body and mind could regain strength, where his faith could be restored, where his battered dream that it would someday be safe to be Japanese in America could be revived.

He caught Greg's eye as Greg was rocking gently back and forth to the music with Mary. Greg smiled at him, and they exchanged a look they both understood at once.

They knew they weren't home, but this was a good place to be for now. And they knew they'd never be home until they got back to L.A..

To Venice, California.

L.A. as it was today wasn't home to David anymore, but it was still the city where dreams had a chance to live. It was the city of possibilities, where the misfits of the world who had voluntarily orphaned themselves from stifling disapproval gathered in giant, floating families and comforted each other as they rebounded from temporary little failures again and again.

It was the only home he knew, and now he could understand why Dad, after being evacuated, interned, drafted, told to serve his country while it imprisoned his family, still came back to Venice.

David wanted once more to walk over to M&S Pharmacy on Centinela Avenue.

He wanted to pull into his own driveway.

He wanted to hear Ted Hawkins singing on the Boardwalk one more time.

He wanted to kick back in his living room and listen to "Pet Sounds" in the dark.

He wanted to put shoyu on scrambled eggs and rice at his favorite local diner again.

David held onto Jenny, the one thing in this world that would never betray him, and knew the one thing he could be certain of in his life.

Wherever there was Jenny, there was love.

And, with love, hope.

David shook Rodney's hand and tried to say thank you without speaking and knew, through Rodney's eyes, that he had.

"As long as you need to stay," Rodney said, "you are welcome."

And we were.

Note: This glossary contains Japanese words, Nisei slang, Hawaiian slang, American slang, Navajo, and Spanish, as it is used in this book, correctly or not.

Pronunciation for Japanese words: Pronounce every syllable, all vowels have the soft sound.

A = ah E = eh I = ee O = oh U = oo

Os are pronounced open like "Oh," not closed like "bowed."
Rs are pronounced like a lilting D.

GENERATIONS

Issei (EE-say): first generation, immigrants from Japan.

Nisei (NEE-say): second generation, American-born children of immigrants from Japan.

Sansei (SAHN-say): third generation, grandchildren of immigrants from Japan.

Yonsei (YOHN-say): fourth generation.

Nikkei (NEE-kay): a general term for Japanese Americans.

Abunai (ah-boo-NYE): dangerous.

Altarcito (Spanish): small shrine or marker on a memorial site.

Amabo (ah-mah-BOH): babyish, whiny, slang derived from amaembo (spoiled brat).

Azuki (ah-zoo-KEE): sweet red beans.

Bachan (BAH-chahn): grandma; familiar variation of obachan.

Bachi: bad karma, omen.

Banzai (BAHN-zye): battle cry.

Benjo (slang): toilet.

Bento (BEN-toh): box lunch.

Biligana (Navajo): white man.

Bonsai (BOHN-sye): mini-tree.

Buddhahead: originally slang for Hawaiian of Japanese ancestry; later also American of Japanese ancestry or any Asian.

Bushido: samurai warrior code of behavior going back centuries; emphasizes loyalty, honor, bravery and self-control.

Cha-shu: Chinese style barbecue pork.

Chawan (CHAH-wahn): rice bowl.

Daikon (DYE-kohn): long, white radish.

Dineh (Navajo): the Navajo people.

Dojo: martial arts school building.

Enryo (en-rYOH): holding back, sacrificing unnecessarily.

F.O.B.: recently arrived immigrant (fresh off the boat).

Footballs: inari sushi, fried soybean curd stuffed with rice.

442nd: the 442ND Regimental Combat Team comprised of Niseis (second-generation native-born Americans of Japanese ancestry, mostly from the mainland) combined with the 100TH Batallion, Japanese Americans from Hawaii to form the most decorated unit in U.S. military history.

Gaman (gah-MAHN): persevere.

Gohan (goh-HAHN): rice.

Gobo: burdock root.

Gotso (GOH-tsoh): delicious food (correctly gochiso).

Gotsosama (GOH-tsoh-SAH-mah): thank you for the good food — (correctly gochisosama).

Hakujin (hah-koo-JEEN): Caucasian.

Haole (Hawaiian): white man.

Happa or hapa (HAHP-pah): multiracial, mixed race.

Hazukashii: shy, bashful.

Hiroshima (Hero-SHEE-muh): if you're referring to the Asian American band that was playing dances in the late '60s and early '70s; otherwise, the city in Japan (hee-ROH-shee-mah).

Itadakimas(u) (Ee-tah-DAH-kee-MOSS): a simple grace; literally, thank you, start eating.

Itazura (ee-TAH-zoo-rah): mischievous.

J-A: Japanese American.

Jiichan (oh-JEE-chahn): grandpa; familiar variation of ojiichan.

Jiisan (oh-jee-SAHN): uncle, male, familiar man; affectionate variation of ojiisan.

Kahuna (Hawaiian): Hawaiian spiritual man.

Kamaboko (kah-mah-BOH-koh): fish cake.

Kampai (kahm-PYE): a toast with drinks.

Kanaka (Hawaiian): slang for Hawaiian.

Kanemochi (kah-nah-MOH-chee): rich person.

Kanji (KAHN-jee): the most complex Japanese character writing, derived or directly taken from Chinese; simpler styles are hiragana and katakana.

Kasu salmon (KAH-soo): salmon filet, salted and cured in sake curd; properly, salmon kasuzuke.

Kawai-so (kah-WYE-soh): how sad.

Kiai (kee-EYE): the explosive shout that accompanies and enhances kicks and punches.

Kinako (kee-NAH-koh): sweet soybean powder for dipping boiled mochi.

Kintoki (KEEN-toh-kee): azuki beans poured on shave ice.

Kitanai (KEET-tah-nye): dirty, unsanitary.

Koden (KOH-den): offering to family at funeral; Buddhist origin, ko (incense).

Kukae(koo-kye)/(Hawaiian slang): poop.

Kusai (koo-SYE): stinky.

Manju (MAHN-joo): sweet rice confections.

Mazegohan (MAH-zeh-goh-HAHN): sushi rice with vegetables diced in.

Mi hijo (MEE-ho): Spanish for my child; term of affection.

Miso (MEE-soh): fermented soybean paste.

Mochi (MOH-chee): sweet rice pounded and formed into cakes.

Monku (MOHN-koo): complain.

Moyashi(moy-yah-SHEE): bean sprouts.

Musubi (moo-soo-BEE): rice ball.

Nappa (NAHP-pah): leafy cabbage.

Nasu (NAH-soo): Japanese eggplant.

Nezumi (NEH-zoo-mee): mice.

Nihongakko (nee-HOHN-GAH-koh): Japanese school.

Nihongo (nee-HOHN-goh): Japanese language.

Nihonjin (nee-HOHN-jeen): Japanese person.

Nonki (NOHN-kee): easy-going.

Nori (NOH-ree): dried seaweed.

Norimaki (NOH-ree-mah-kee): various vegetables rolled in seaweed.

Obachan (oh-BAH-chahn): grandmother; term of affection.

Obasan (oh-bah-SAHN): auntie, female relative, familiar woman.

Obon (oh-BOHN): fall festival of Buddhist origin to welcome ancestors who've passed away.

Ocha (oh-CHAH): tea.

Ochazuke (oh-CHAH-zoo-keh): bowl of plain rice and tea.

Ohagi (oh-HAH-gee): sweet rice wrapped with azuki beans.

Ohashi (oh-HAH-shee): chopsticks.

Oishi (OY-shee): delicious.

Ojiichan (oh-JEE-chahn): grandfather; term of affection.

Ojiisan (oh-jee-SAHN): uncle, male, familiar man.

Okole (oh-KOH-leh/Hawaiian slang): rear end.

Okosho (oh-ko-SHO): exclamation of exertion, sim. to upsy-daisy.

Omiyagi (oh-mee-YAH-gee): gift for the host.

Ondo (OHN-doh): obon dance.

Rafu Shimpo: The oldest Japanese-language newspaper in Los Angeles.

Saimin (SYE-min): ramen, big bowl of soup with thin noodles.

Sake (SAH-keh): rice wine.

Sekihan (seh-kee-HAAN): sweet rice with azuki beans and sesame seeds.

Sensei (SEN-say): teacher.

Shibai (shee-BUY): play-acting, also slang for b.s.

Shikataganai (shee-kah-tah-gah-NYE): can't be helped, that's the way it is.

Shiko (SHEE-koh) children's term for pee, also shi-shi.

Shoyu (SHOH-yoo): soy sauce.

Spam musubi: a slice of Spam in a rice ball wrapped in nori; a Hawaiian staple.

Stink-eye (Hawaiian slang): dirty look.

Suzuko (soo-zoo-KOH): salmon eggs, salted and cured in sake curd.

Tabemasho (TAH-beh-mah-SHOH): let's eat.

Tabenasai (TAH-beh-nah-SYE): please eat.

Takuwan(TAH-kwahn): pickled daikon.

Tamago gohan (tah-MAH-go go-HAHN): raw egg and rice.

Tsukemono (TSOO-keh-moh-noh): pickled vegetables.

Udon (Oo-DOHN): soup with thick noodles.

Umeboshi (oo-meh-BOH-shee): pickled plums.

Unko (OON-koh): children's term for poop, also un-un.

Veladoras religiosas (Spanish): religious candles.

Yaka (YAH-kah): slang for stubborn.

Yogore (YOH-goh-reh): troublemaker; derived from yogoreru (dirty).

Yokan (YOH-kahn): jellied azuki or lima-bean jelly.

Zories (ZOH-reez): flip-flops.

SPECIAL THANKS TO:

My family and my friends for their support, and my community around Centinela Avenue in our Venice, California.

My grandfather, Leo Kamezo Suzuki, a poet who lived a life of dedication and humility.

Mom & Dad, Perry & Alice Miyake, for the example you set, the help on the glossary and your prayers.

Dorothy Komae, who patience and generosity gave me the time to appreciate our neighborhood.

Leona Bodnar Nagasugi, for her love and support, haircuts and lunches.

Salley McLin for teaching Computer for Dummies in loving brother-in-law shorthand.

Lanette Dolinsek, for her resilience, enthusiasm and love.

Patty Toy Chung, who knows how long this took, for her understanding and enthusiasm.

Dorinne Kondo, whose insight and appreciation helped me make it through the 90s.

James Leo Herlihy, for his early, kind words of encouragement and warning.

Frank Chin, Lawson Inada, Saachiko & Dom Magwili, Stanley Lee, Rod Bearcloud Berry, Knifewing Segura, John Trudell, Kelly & Jesse Ed Davis, Lane Nishikawa, Amy Hill, Brian Wilson, Curtis Mayfield, Joni Mitchell, Stevie Wonder, Nanci Griffith and Mr. John Randolph for their inspiration.

Annie Pantoja, Jeff Cooley, Steve "Stevie Ray Manner" Poltorak, John W. Shaw, Julia & Zane, Ralph Alvy, Grace Zandarski, John & Patty Chung and my old friends who get together every Christmas to make tamales at Craig & Cheryl's, for their support through the years.

Ken & Jill Ito, Mike Shibata, Nelson Mashita, Lissa Lee and my Doughball people, Marilyn Tokuda, Tim Dang and all my friends at East West Players and Cold Tofu.

Nancy Burkhart, Ky Springer, Rik Sanchez, Michelle Tufo and all my friends who've passed through Penny Lane.

The Uyehara family and Aloha Market; the Sakamoto family & Maxine & David at M&S Pharmacy, Fumio Ozaki, trusted friend of the family.

Kenny and Kay Yamanaka and their children for their years of dedication, and anyone who ever ate at Kenny's Café.

And, for rescuing me, Nina Wiener and Mari Florence, Susan Jonaitis and everyone at Really Great Books.

IN LOVING MEMORY OF:

Jo (JoAnne Morimoto Suyama), who really would've appreciated this,

and Larry Miyake, David Ikkanda Jr., Janet Kamimura, Kenny Shimoide, Steve Tatsukawa, Howard Tsukamoto, Dino Matsumura, Bruce Ariyasu, Tina Nakamura, Norman Tanaka, Terry Tam Soon, Jerome Cooley, Duane Ebata, Leigh Kim, Ben Lum, Betty Muramoto, Gale Morikawa and all Sanseis gone too soon.